THE ARA PACIS AUGUSTAE
AND THE IMAGERY OF ABUNDANCE
IN LATER GREEK AND EARLY
ROMAN IMPERIAL ART

David Castriota

THE ARA PACIS AUGUSTAE

AND THE IMAGERY OF ABUNDANCE IN LATER GREEK AND EARLY ROMAN IMPERIAL ART

PRINCETON UNIVERSITY PRESS

Library of Congress Cataloging-in-Publication Data

Castriota, David, 1950–
The Ara Pacis Augustae and the imagery of abundance in later Greek
and early Roman imperial art / David Castriota.
p. cm.
Includes bibliographical references (p.) and index.
ISBN 0-691-03715-9
1. Relief (Sculpture), Rome—Italy—Rome. 2. Marble sculpture,
Roman—Italy—Rome. 3. Friezes—Italy—Rome. 4. Sculpture,
Hellenistic—Influence. 5. Peace in art. 6. Plants in art. 7. Ara
Pacis (Rome, Italy) I. Title.
NB133.C37 1995
733'.5'09376—dc20 94-23503
 CIP

This book has been composed in Palatino

Princeton University Press books are printed on acid-free paper and meet the
guidelines for permanence and durability of the Committee on Production
Guidelines for Book Longevity of the Council on Library Resources

Printed in the United States of America

10 9 8 7 6 5 4 3 2 1

DESIGNED BY LAURY A. EGAN

11586335

RO

In memory of Alfred Frazer

Contents

 Acknowledgments

My interest in the Ara Pacis Augustae grew out of a broader concern, the use of floral ornament among the peoples in the regions around the ancient Mediterranean. This interest was first sparked by the pioneering insights of Alois Riegl's *Stilfragen* and the long line of subsequent scholarship that has devoted itself to studying the evolution of such decoration. In time my studies led me to produce a critical commentary for a new English edition of *Stilfragen* that sought to situate Riegl's contribution within the context of modern research on classical floral ornament. In the course of preparing this commentary, however, I became ever more aware that the lion's share of such research has concentrated on issues of formal development and stylistic analysis. Rarely have scholars attempted to probe the iconographic dimension of the floral patterns that may well have constituted the single most widespread mode of ancient decorative art. Almost inevitably, I came to focus on the monument that seemed to offer the greatest potential for redressing this imbalance—the Altar of the Augustan Peace.

Initially my studies resulted in a lecture presented at the College Art Association Meeting in 1984. I continued to develop these ideas in a series of undergraduate seminars at Duke University and, more recently, at Sarah Lawrence College. I am first of all indebted to the many students who participated in these courses over the years, for it was largely in response to their curiosity and intellect that my own thinking on the Ara Pacis began to take shape. Eventually, I realized that the problem of the floral ornament of the Ara Pacis and the issues that it raised within the larger context of classical art could be treated effectively only as a book-length study. Here I wish to express my gratitude to the many friends and colleagues who shared their wisdom and insight with me by reading and criticizing the various drafts of the book as it progressed.

I am indebted especially to the late Alfred Frazer, whose advice was instrumental early on in reconstructing the Pergamene altar that is central to much of the discussion that follows. As a scholar, teacher and advisor, he always demonstrated to me the indispensable role of meticulous analysis of material remains as the *sine qua non* of interpretive archaeological investigation. I am also grateful to my colleagues Gerhard Koeppel and John Pollini for reading initial drafts of the book. I will never forget their unqualified enthusiasm and support for my work when I needed it most,

and I must say that this project would never have been completed without their help and involvement. I wish to extend special thanks to those who contributed in the later phases of the work as well. I am grateful, as ever, to my mentor Richard Brilliant for his careful reading and many useful comments. Similarly, I am extremely grateful to the outside readers, Hugo Meyer and Edward Champlin, for the thoughtful advice and recommendations that helped to bring the book to its final form. I want to thank my friend and colleague Joe Forte for the constant exchange of ideas that has made an impact here as elsewhere in my work.

Those who facilitated the on-site study of the Ara Pacis and the comparative material also deserve recognition. I want to thank the University Research Council of Duke University, the American Philosophical Society, and the National Endowment for the Humanities Travel to Collections Program for their generous funding of my research in Italy, Greece, and Turkey. I am grateful to Sarah Lawrence College for awarding me a Marilyn Simpson Grant to help defray the cost of the photographs for the book. I owe a special debt of gratitude to Maria Laura Cafiero of the Soprintendenza Comunale ai Musei d'Arte Antica in Rome for making all the arrangements for me to study and photograph the Ara Pacis. And I would like to thank the staff of the Archaeological Museum at Bergama for allowing me access to the relevant material from the excavations at Pergamon. My thanks as well to the Vatican Museums, the Museo Nazionale Romano delle Terme, the Museo Archeologico Nazionale in Naples, and the Archaeological Museum in Istanbul for allowing me to study and photograph material in their collections. I also want to express my gratitude to my colleague Cameron Afzal for all the time, resources, and formidable word-processing skills that he put at my disposal during the final editing process. And finally, I wish to thank my editors, Sharon Herson and Tim Wardell, for their diligence and expertise in the final preparation of the text.

List of Illustrations

(Unless otherwise indicated, all drawings and photographs are by the author.)

List of Abbreviations

AA	*Archäologischer Anzeiger, Beiblatt zum Jahrbuch des Deutschen Archäologischen Instituts*, Berlin, 1889–.
ABV	J. D. Beazley, *Attic Black-Figure Vase Painters*, Oxford, 1956.
AJA	*American Journal of Archaeology*
AM	*Mitteilungen des Deutschen Archäologischen Instituts, Athenische Abteilung*, 1876–.
ANRW	*Aufstieg und Niedergang der römische Welt*
ARV	Beazley, J. D. *Attic Red-Figure Vase Painters*. 2nd ed. Oxford, 1963.
AVP	*Altertümer von Pergamon*
BCH	*Bulletin de correspondence hellénique*
BABesch	*Bulletin van de Vereeniging tot Bevordering der Kennis van de Antieke Beschaving*
BICS	*Bulletin of the Institute of Classical Studies of London University*
CAH	*Cambridge Ancient History*
CIG	*Corpus Inscriptionum Graecarum*
CIL	*Corpus Inscriptionum Latinarum*
CRAI	*Comptes-rendus de L'Académie des Inscriptions et Belles Lettres*
IG	*Inscriptiones Graecae. Consilio et auctoritate Academia Litterarum Regiae Borussicae editae*, Berlin, 1873–.
IM	*Mitteilungen des Deutschen Archäologischen Instituts, Istanbuler Abteilung.*
JDAI	*Jahrbuch des Deutschen Archäologischen Instituts*
JHS	*Journal of Hellenic Studies*
JRGZM	*Jahrbuch des Römischen-Germanischen Zentral Museums*
JRS	*Journal of Roman Studies*
JWCI	*Journal of the Warburg and Courtauld Institutes*
LIMC	*Lexicon Iconographicum Mythologiae Classicae*. Munich, 1981–.
MAAR	*Memoires of the American Academy in Rome*
MEFRA	*Mélanges de L'École Française de Rome, Antiquité*
NS	*Notizie degli scavi*
RA	*Revue archéologique*
RE	*Paulys Real-Encyclopädie der classischen Altertumswissenschaft*
REA	*Revue des études anciennes*
REG	*Revue des études grecques*

RM *Mitteilungen des Deutschen Archäologischen Instituts. Römische*
 Abteilung, 1886–.
RVA A. D. Trendall and A. Cambitoglou. *Red-Figured Vases of*
 Apulia. Oxford, 1978.
TAPA *Transactions of the American Philological Association*

THE ARA PACIS AUGUSTAE

AND THE IMAGERY OF ABUNDANCE

IN LATER GREEK AND EARLY

ROMAN IMPERIAL ART

 Introduction

Since the later nineteenth century a voluminous literature has grown up around the *Ara Pacis Augustae*, the altar dedicated in 9 B.C. to the *Pax Augusta*, the era of peace and stability established by the reign of Augustus. After nearly a century of critical examination by many of the foremost historians of classical art, the altar remains a touchstone for the study of early Roman imperial public monuments, and rightly so. The Ara Pacis was a complex creation intended to embody the ideology of the Roman state at a pivotal stage of its development. The gradual rise to hegemony of the Greek world during the later Republic had imposed many new demands upon the Roman leadership. In assuming this role the Romans had inevitably assimilated much of what comprised the intellectual and material culture of Hellenism, but not without acquiring as a result a new and acute need to define and assert their own, distinctive cultural traits and values. By the late first century B.C., Augustus and the ruling Roman elite were intensely conscious of Rome's position as heir and administrator of the Greek legacy in all its cultural, political, and economic ramifications. But they were also committed to the belief that the Roman state could meet the imperial challenge only by renewing and revitalizing popular belief in the national mores and institutions which had been progressively eroded by the decades of military and political strife, social unrest, and cultural confrontation endemic to the Late Republic.[1]

To modern observers, this may appear as something of a paradox; it may seem that this concern with nationalist ideology was fundamentally at odds with the acceptance of Hellenism that had become basic to Italian culture by this time. But more often than not, political rhetoric has little to do with reality, and one can, moreover, trace such contradictions to the very inception of the Late Republican urge to retain or recover pristine Italian virtues. Scholars often emphasize Cato's opposition in the early second century B.C. to the influx of elegant Greek sculptures that outshone the terracotta pedimental decorations erected by the Romans of old.[2] But archaeologists today can recognize that the "traditional" temple decoration so readily associated by Cato with old-fashioned Roman values was in origin just as Greek as the new-fangled marble sculptures which he decried as opulent tokens of advancing Hellenistic decadence.[3] More recent appraisals of Cato have also disclosed his abiding interest in

and familiarity with Greek language and literature, and the impact that this exerted on his own thought and writings, despite the apparent anti-Hellenic stance of his politics.[4] Thus it comes as no surprise that a century and a half later when Augustus and those around him finally undertook to resolve the dialectic of *Romanitas*, they did so not by rejecting Greek forms and concepts, but rather by absorbing them unproblematically in the service of a cultural and political agenda vigorously touted as an ancient, indigenous tradition. Perhaps more than any other single monument of the period, the Ara Pacis vividly illustrates how eloquently the diverse iconographic formulae of Greek art could be made to express a newly coined Italian ethos as a tool of ideological justification for the Augustan Principate.[5]

It is in this regard especially that Augustan monumental art parallels contemporary poetry, rhetoric, and historical writing, all of which similarly adapted and resynthesized techniques and genres inherited from Greek literature in order to advocate or celebrate the moral and cultural revitalization of Roman traditions, especially under the new Princeps. Indeed, historians of Roman art have tended overwhelmingly to exploit the rich and extensive evidence of Augustan poetry in interpreting the imagery or programmatic content of the Ara Pacis and the other public monuments of this period; such works have largely come to be understood as visual artistic counterparts to the epic and lyric panegyric of Vergil and Horace, or to the pastoral and elegy of Tibullus and Propertius.[6] It has also proved extremely useful to examine the altar against the background of Roman law and religious ceremonial.[7] Yet in either case the approach here has become increasingly synchronic and Italocentric in its orientation. Like the closely related poetry of this period, it is questionable whether highy synthetic works such as the Ara Pacis can be understood solely or primarily against the background of contemporary Roman belief and ideology.[8]

However, our understanding of the Ara Pacis and its imagery has also been constrained by the working methods that most scholars have applied; study has so far focused overwhelmingly on the figural reliefs that decorate the upper portion of the exterior walled enclosure and the altar itself, instead of considering the monument as a whole. In actuality, much of the work, indeed more than half of the exterior walls, consists of a complex network of stylized floral or tendril ornament: the pilasters at the four corners of the enclosure, four rectangular panels below the mythic and allegorical scenes on the east and west facades, and the lateral friezes beneath the long ceremonial processions on the north and south (figs. 1–2). On the interior of the enclosure, the upper third of the wall surface is given over entirely to elaborate foliate garlands (figs. 40–41). These portions of the Ara Pacis have certainly been the subject of in-

tense specialized scholarship, but such studies have concentrated primarily on the formal morphology and stylistic origin of the floral ornament rather than on the possible significance that it may have held within the larger program of the monument.[9] Nor does this seem to be due to the formalist proclivities of specialists in classical decorative arts. It results more from a widespread attitude among historians of pre-modern art which tends to privilege figural or anthropomorphic representation as the primary locus of visual signification, while relegating the decorative arts or "ornament" to a subsidiary role. Thus, only two decades ago, Andreae could comfortably dismiss the floral friezes as "purely decorative" in purpose; Bianchi Bandinelli was less certain that these friezes served essentially as ornament, but he remained skeptical that they were intended to function in any profound or logical relation to the program of the figural reliefs.[10] Yet even at face value, it seems inconceivable that the planners of such a lavish and complex monument would have consigned so much of its surface to features that were not vitally related to the major themes of the figural reliefs and the function of the overall project. And so the extreme views of Andreae or Bianchi Bandinelli remain isolated. Still, to a great extent, scholars see this ornamental vegetal imagery only in the most general terms as a decorative suggestion of ebullient earthly prosperity appropriate for an altar dedicated to the *Pax Augusta*.[11] The interpretation of the floral friezes along these lines has rarely been pursued in any depth or detail.

To date there have only been several systematic attempts to probe the symbolic dimension of the floral decoration on the Ara Pacis as an integral and central feature of the overall program. The first of these appeared thirty years ago in the form of a brief but seminal essay by L'Orange.[12] L'Orange's study built upon the general view of the floral friezes as images of abundance and fruitfulness intended to evoke the blessings of the *Pax Augusta*. But in keeping with the dominant trend of scholarship on the figural decoration of the monument, L'Orange opted to substantiate and sharpen this interpretation through the analogy of contemporary poetry—the imagery of pacific bounty in Horace, Tibullus, and above all Vergil. Against the background of Vergil's Fourth Eclogue, L'Orange explained the floral friezes as a visual embodiment of the returning Golden Age, a new era of blessedness in which the limitless flowering of the earth is contingent upon the efficacious presence of a divinely appointed sovereign, Augustus himself. Expanding upon the earlier suggestions of Petersen, L'Orange focused more specifically on the swans and laurel interspersed among the coiling tendrils, interpreting them as symbolic allusions to Apollo, the divine protector of Augustus and prophetic guarantor of the coming Golden Age.[13] Other details of the friezes—the trails of ivy mixed among the acanthus—could be seen as visual counter-

parts to Vergil's depiction of the burgeoning *aurea saecula* in the Fourth Eclogue, lines 19–20.

L'Orange's essay marked a turning point in the study of the Ara Pacis, for it dispelled once and for all the view that the floral friezes were a semantically discrete or subordinate feature of the monument. Instead they began to assume their proper place as a unifying foundation for the entire program, intimately related to the overriding Augustan themes of renewed Roman peace, stability and prosperity, with an imagery equally susceptible to the modes of analysis that had been applied to the figural decorations.[14] It is therefore unfortunate that L'Orange, concentrating for the most part on the corresponding imagery of earthly abundance in the so-called "Tellus" relief, did not pursue the connections between the floral and figural zones of the monument more thoroughly.

In contrast, Büsing looked specifically at the relation between the processional reliefs and the long floral friezes on the north and south facades of the Ara Pacis.[15] His analysis has shown convincingly that the schematic distribution or structure and approximate symmetries of the acanthus tendril compositions were carefully coordinated with the positioning, orientation, and dynamic rhythms of the figures in the processions directly above (fig. 2). But although Büsing's study revealed a substantial visual unity between the floral and figural decorations, he preferred not to consider its implication or significance within the program of the monument.

Several recent studies have addressed the semantic dimension of the floral friezes in far more substantive terms. Kellum has focused primarily on the array of tiny insects, reptiles, frogs, and birds that inhabit the tendril compositions, explaining them as symbols of regeneration or metamorphosis in conjunction with contemporary Roman animal lore. Pollini, in contrast, has concentrated primarily on the acanthusized treatment of the main tendril itself, as well as on the swans and palmettes that crown and punctuate the overall composition. Moving beyond the initial arguments of L'Orange, he has made a much more convincing case for interpreting these vegetal and animal features, especially the acanthus, as attributes of Apollo in connection with the prophetic renewal and transformation ushered in by the Golden Age.[16]

Sauron too has attempted to build upon the the work of L'Orange, and that of Büsing as well.[17] Like L'Orange and Petersen before him, Sauron identifies the swans and laurel in the friezes as specific references to Augustus's patron, Apollo. But in his interpretation of the ivy vines which also grow amidst the spiraling matrix of acanthus, he departs radically from the Vergilian theme of harmonious earthly blessing posited by L'Orange and sustained more recently by Pollini. Instead Sauron sees the ivy as the specific attribute of Dionysos or Liber, in deliberate contrast to Apollo's laurel and swans. For Sauron, this opposition ultimately alludes

to the struggle between Apollo's protegé, Augustus or Octavian, and Antony, who had claimed Dionysos as his divine analog and protector.

In Sauron's view, the tendril frieze is a floral or vegetal allegory of Actium and the divine forces that were believed to have determined the outcome of the battle. The approximately circular massing of the portions of the tendril frieze in which the laurel faces the ivy correspond to the "shield of Aeneas" in Book VIII of Vergil's *Aeneid*, where the battle of Actium is prophetically depicted (fig. 2, bottom right). Certain of the split palmetttes which crown the tendril friezes are triremes; others symbolize the acroteria of the mausoleum of Antony and Cleopatra in Alexandria (figs. 2–4), lower zone). However, the full sense of Sauron's Actian allegory builds upon the sort of formal correspondences between the floral and figural friezes emphasized by Büsing, since the main area of floral conflict or confrontation in the shieldlike mass of tendrils seems to occur approximately below the point where Antony's descendants appear in the procession of the Julio-Claudian family (fig. 2, right). Along the same lines, Sauron suggests that certain tridentlike floral crowning elements of the tendrils are symbols of the Dioscuri, the brothers Castor and Pollux. The location of these components below Agrippa and Augustus in the procession above would then refer to their respective roles as the adoptive fathers of the boys Gaius and Lucius, who were often assigned the guise of the Dioscuri, and who appeared in the procession as well. Thus Sauron also explains the sprawling tendril composition as a dynastic metaphor, literally the "family tree" of the Julio-Claudians above (fig. 2).

Sauron's hypothesis is highly elaborate and ingenious, and like the studies of L'Orange, Büsing, and Pollini, it strives to portray the decoration of the entire altar as a coherent unity and a work that corresponded extensively to the thematic concerns and imagery of Augustan poetry. All the same, his interpretation of the Apolline and Dionysian plants as opposing symbols of divine conflict is highly problematic on various grounds, as the subsequent discussion will show. Yet even apart from such considerations, it is questionable that the ornamental format utilized on the Ara Pacis could on its own terms have communicated such a highly particularized and idiosyncratic program of imagery to the average Roman spectator, or even to those thoroughly familar with Vergil.

Fanciful agonistic encounters between symbolic plants of various sorts were certainly an established literary *topos* or genre by Hellenistic times, as Sauron indicates, but there is no evidence that Greek or Roman artists ever adapted this form of expression to the visual media of sculpture or painting.[18] Certainly, there is no basis for interpreting in this way the various types of floral ornament that had become current in the course of the Classical and Hellenistic periods. Nor can we assume that ancient spectators would have been inclined to read familiar and widespread veg-

etal stylizations like the split palmette specifically as reminiscences of ships' prows or sepulchral acroteria, however similar all these forms may appear to modern sensibilities. As Sauron explains it, the Ara Pacis would appear as a unique and isolated creation without any real precedent or analogy in ancient art, both in its programmatic content and in its mode of presentation.

Yet the issue of artistic precedent is in fact fundamental to the whole question of intelligibility. The Ara Pacis was a public monument, a work intended to influence and impress a wide and varied audience. As such, it could only function effectively by remaining within the parameters of religious belief and artistic practice that had already achieved currency in the cult and celebration of earthly abundance—familiar concepts and forms that could be readily assimilated by the Roman public. It is also well known that Augustan art relied extensively on the manipulation of established or traditional forms, styles, or modes as a primary means of evoking cultural and political stability, continuity, and legitimacy. In view of this it is indeed surprising that Sauron and even L'Orange approached the semantic function of the floral friezes essentially as if such decorative floral symbolism were a completely new, Augustan phenomenon.

This is especially striking since students of the Ara Pacis have long investigated the Classical and Hellenistic precedents that informed the design and content of the allegorical panels and the processional reliefs. The study of the floral ornament on the altar enclosure, moreover, has concentrated almost entirely on the issue of Greek and earlier Roman precedent. But this research was concerned only with stylistic origins. And significantly, when L'Orange or Sauron turned to the problem of artistic prototypes, they too did so purely in terms of stylistic background.[19] Here one begins to sense a peculiar methodological disjunction or inconsistency, and as a consequence, the issue of Greek and earlier Roman *iconographic* precedent for the floral decoration on the Ara Pacis and the interpretive evidence that this could provide remain largely unexplored. To date, our understanding of the symbolic function of this decoration has rested primarily on the evidence of contemporary poetry.

The reasons for this are complex. Historians of art often tend to approach major monuments by emphasizing the distinctive and innovative factor. The importance of a "masterpiece" is gauged by the primary, trend-setting impact that such a work may seem to exert upon subsequent developments, or alternatively by its function as a major index of larger historical and cultural change. In its reconstructed form, the Ara Pacis has become the physical embodiment of the profound and lasting transformation that shaped the political and adminstrative structure of the empire for centuries to come. In such an outlook it somehow seems more appropriate to portray the monument as a bold new beginning

rather than the judicious adaptation or culmination of the artistic tradi-
tion that had preceded it. In reality it was both.

In addition, one must reckon with the role that Augustan poetry has
come to assume for the hermeneutics of Augustan art. There is no deny-
ing the value that poetic texts can offer the historian of art in reconstruct-
ing the ideology behind the monuments. Like the Greeks before them,
the Romans saw the visual arts as closely tied to literary modes like poetry
or rhetoric.[20] But it has now become something of a methodological com-
monplace to interpret Augustan works of art with a copy of Vergil or
Horace in one hand, and understandably so; their verses appear to corre-
spond to the visual works in such a profound and satisfying way. Yet it is
unwise to accord excessive authority to such poetry in attempting to re-
cover the sense and intent of Augustan art.[21] However indispensable
they may be as an interpretive guide to the Ara Pacis and related works,
these verses can never explain in and of themselves the process that gave
rise to the Roman monuments. However much they may tell us about
contemporary attitudes, and however much they may reflect the cultural
outlook that conditioned material artistic production, poems do not beget
monuments. The visual arts in antiquity also had their own inertia, and
one cannot hope to determine how the planners of the Ara Pacis formu-
lated their program of imagery without considering the existing prece-
dent of monumental decoration that necessarily informed their creative
endeavors.

It should be clear that the goal here is not to debunk the myth of the
masterpiece or to deprecate the use of poetic analogs as an interpretive
tool for the historian of art; the discussion that follows will also rely
heavily on literary evidence. The issue at stake is the relation between
tradition and intelligibility, and in this context tradition must be under-
stood in the most literal sense as something handed down over the
course of time—modes of artistic expression and modes of observing and
assimilating imagery on the basis of an acquired experience passed on as
cumulative cultural habit. The spectators of the Augustan monuments
responded to the recent events and to the new official ideology that was
endlessly promulgated all about them. But it is also crucial to consider
how the awareness of what has gone before may shape the expectations
and interpretive faculties of an intended audience, and ultimately how it
may shape the strategies that the designer formulates to exploit and ma-
nipulate such accumulated experience. This applies no less to Augustan
poetry, which evolved similarly through a studied and imaginative adap-
tation of inherited literary patterns, Latin as well as Greek. Regardless of
the medium, it is this process of selection and resynthesis that typifies the
development of all Augustan arts and institutions.

In what follows, the issue of audience response will therefore remain a

central and constant theme. Here, as the writer has argued elsewhere in the case of the public monuments of fifth-century B.C. Athens, it may be useful to conceive of the process on the model of recent literary theory, especially in terms of Stanley Fish's notion of "interpretive communities." Much like the author of a text, those who designed and executed the Augustan monuments were obliged to anticipate a larger audience invested in a common set of "strategies"—conceptual, analytical modes that would facilitate their ability to interpret what they perceive with relative uniformity, and hopefully in accord with the designer's intentions. And it may well be, as Fish also insists, that it is the "interpretive strategy" shared by author and audience alike, rather than the work itself, that generates much of its substance and impact.[22] It is essential to remain mindful of the ever present dynamic that existed among the monument, those who designed it, and the audience that it was meant to address. It is not simply the formal and semantic structure of a program of sculpture that concerns us here, but something more fluid and complex, a larger interpretive process whereby the works themselves mediated between the thinking of the artists or planners and that of the viewing public.

In fact, there is good evidence that those who designed such programmatic monuments were very much attuned to the critical faculties and responses of spectators. Here one need not rely only on contemporary theories of reception or audience competence; one may turn to those of antiquity as well. In *De Oratore* (III,1,195), Cicero asserts that everyone, even the unlearned crowd, *vulgus imperitorum*, is capable of making judgments about works of art like painting and sculpture by means of an innate sensibility, without necessarily having any technical skill or training of their own. A bit later (III,1,197), he emphasizes that while there may be considerable disparity between the learned and the unlearned as performers, there is remarkably little difference between them as a critical audience.[23] Thus, in *De Officiis* (I,lxi,147), he tells us that like poets, painters and sculptors have their work reviewed by the public, *a vulgo*, to improve or refine the finished product.

There can be little doubt that the planners of Roman monuments in the first century B.C. took the issue of audience response seriously. Of course, one ought not press this evidence too far. It is likely that in soliciting such response, ancient artists were not looking for audience approval; rather, they sought to insure that what they strove to express was having the desired impact. And since in these passages, Cicero is comparing works of visual art to the audial effects of oratory or poetry, it is likely that he is referring to aesthetic responses rather than to judgments over content or argumentation. Still, it would be unwarranted to assume that only the more learned spectators would have been deemed capable of judging or absorbing programmatic content. And here the issue of artistic expo-

sure is especially crucial, for planners of monuments could easily have anticipated that the spectator's experience with existing artworks or artistic traditions would channel into the innate sensibility or faculties described by Cicero. To be sure, the level of such exposure would have varied considerably among the Roman populace, depending on social and economic status, degree of leisure, and access to public and private collections or monuments. But all observers could be expected to bring to bear whatever experience they had along with the natural faculties believed to govern all audience response.

In this perspective the monuments commissioned by Augustus and his elite emerge as a visual interface intended to challenge the Roman public to rehearse or *re*-interpret the major ideological tenets and discourse of the new Principate—tenets shared, assimilated, and reinforced by various means—through public oratory and poetry, and through the constant reiteration of the daily civic discussion fueled by such media. Zanker's recent study has strongly emphasized the central role of Augustan visual arts in this process. But experience of tradition, especially visual artistic tradition, also played a vital part in forming the interpretive faculties of the communities for whom the monuments were originally made. Therefore, the application of such an approach to the study of the floral friezes of the Ara Pacis as visual imagery must begin by examining how tendril ornament had been applied as a symbolic statement of divinely appointed bounty and blessing in earlier monumental and decorative arts of the Greek and Roman world.

The first chapter examines the specific function of the floral imagery on the Altar of Peace and the insight that the evidence of earlier artistic precedent may offer as an interpretive guide, in addition to literary analogies. In doing so it is in fact possible to pinpoint the specific sources of the strategies used by the designers of the altar, and to some extent the degree to which such imagery was already familiar to the Italian population by Augustan times. But the second chapter looks more broadly at the symbolic use of floral ornament in Greek and earlier Italian culture, in order to reconstitute the inherited tradition or "interpretive strategy" that the wider Augustan audience would have brought to bear in responding to the Ara Pacis. This approach leads to some conclusions that depart substantially from prevailing opinion; hence the third chapter addresses the results of chapters one and two against the existing view of Augustan art generally. The last chapter deals with the floral imagery in more abstract terms as a vehicle for the Augustan mythology of renewal. Here the goal is above all to examine how borrowed Greek artistic and literary conceptions were adapted in the service of a new, nationally charged ideology of prosperity linked to moral excellence.

In general, the present study inverts the customary approach to this

monument, attempting to understand the Ara Pacis from the bottom up. To some extent this analysis yields to the tectonic structure of the Ara Pacis, very likely in keeping with the way that the designers intended the monument to function. Thus we begin by examining those portions of the Ara Pacis that were closest and most readable or accessible to the viewer, proceeding then to a consideration of how the embracing network of tendrils may have conditioned the response to the rest of the work. Despite the extensive focus on the floral imagery, the latter portions of this study will also address the relation of the ornamental friezes to the reliefs of the figural zone, particularly the panels on the east and west facades. Because of the contextual, hermeneutic approach applied to this material, however, much of the discussion will depart from the immediate subject of the Ara Pacis in order to consider the role or impact of artistic comparanda, and in the last two chapters, the larger Greek and Roman ideological or religious background as well. What follows then is not only an investigation of the Ara Pacis in its Augustan setting, but, as the title indicates, a consideration of a larger phenomenon that has long eluded systematic, critical study—the significative function of floral decoration among the peoples of Greece and Italy, from the Classical period through early Roman imperial times.

This objective will not be an easy one. It involves looking beyond the immediate structure of the ornament to the various vegetal, animal, and anthropomorphic components contained within it, and in semantic terms, to the cultural or religious resonance that these components imparted to the larger decorative array. Toward this end it will be necessary to develop new, more effective modes of analysis or classification and descriptive terminology for the different types of floral or vegetal compositions that were applied as bearers of meaning. But given the larger objectives of this study, the Altar of the Augustan Peace remains an appropriate focus and point of departure; no other extant classical monument accorded so much of its programmatic imagery to complex vegetal or floral themes of this kind, and no other classical monument demonstrates so emphatically the level of importance that this type of decoration could assume. Here the Ara Pacis will emerge as a high watermark in the larger evolution, the savvy culmination of centuries of artistic experimentation and usage. In the end, the method here essentially recapitulates the genesis of the monument itself. However far it may be necessary to stray from the Ara Pacis, it should be worth the effort, since those who designed and viewed this work did so not in isolation, but from the perspective and vantage afforded by a wide range of artistic precedent and cultural experience.

 Chapter I

The Imagery of the Floral Friezes and Hellenistic Greek Precedent

The Vegetal Inclusions— Polycarpophoric Tendril Ornament

The floral friezes of the Ara Pacis do not consist solely of stylized acanthus tendrils and blossoms; in addition, the tendrils emit certain distinct, recognizable botanical species. A wreathlike spray of laurel appears on the right side of the north frieze (fig. 4, no. 1; fig. 10).[1] Ivy trails emerge at various points across both long friezes. They grow around the central stalk or "candelabrum" on the north (fig. 4, no. 2; fig. 11), from the large volutes to the left and right of the great calyx below the candelabrum (fig. 4, no. 3; fig. 12), and within two more volutes on each side of the frieze (fig. 4, no. 4).[2] Virtually all of the central portion of the south frieze has disappeared, but clusters of ivy fill four more volutes, two on each side (fig. 3, nos. 1 and 2; fig. 13).[3] Large leafy vines with grape clusters hang from the tendril volutes on either side of the central calyx of the north frieze (fig. 4, no. 5; figs. 14–15); traces of one more are preserved on the right extreme as well (fig. 4, no. 6).[4] Two more grapevines appear at the left and right extremes of the south frieze (fig. 3, no. 3; fig. 15).[5] In the middle of the lefthand portion on the north is a sprig with three oak leaves (fig. 4, no. 7; fig. 16).[6] There are flowers as well. A pair of large poppies with thick ragged corollas grows alongside the two main tendril stalks in the central calyx on the north frieze (fig. 4, no. 8; fig. 17),[7] while just to the right of the calyx is a large blooming rose (fig. 4, no. 9). An-

other rose appears in the fragmentary remains of the righthand south frieze (fig. 3, no. 4; fig. 18).[8] More roses appear in the smaller floral panels beneath the allegorical reliefs on the east, on either side of the central calyx in each case (fig. 6, no. 1; fig. 7, no. 1; fig. 20).[9] For comparative purposes, photographs of poppies, rose, laurel, and oak are illustrated in a botanical appendix (fig. 91 a–e).

With the exception of the oak, these plants and flowers have been identified or alluded to generally in discussions and descriptions of the Ara Pacis. Some have noted the laurel, ivy, and grapevines; others, the poppies and the laurel, and so forth. But this has been a piecemeal process; seldom if ever has the full range and prominence of these botanical inclusions been emphasized sufficiently. Even Moretti approached these details casually, noting them at times but often bypassing them in his description of the monument.[10] This is unfortunate for here we have one of the most distinctive and significant features of the entire ornamental scheme of the Ara Pacis, and one whose origins can throw considerable light upon the meaning of these friezes. The use of such an array of real plants amidst stylized acanthus patterns is sometimes taken to be an Augustan innovation without Greek precedent.[11] But it can be paralleled quite closely in a series of Hellenistic marble reliefs found at Pergamon, and indeed, among the very works that scholars have long emphasized as forerunners of the Ara Pacis, but, as indicated earlier, purely in formal or stylistic terms.[12] No one has ever considered their relation to the Roman monument from the perspective of iconography.

Among these Pergamene works, the most significant is a matched pair of marble slabs which the German excavators found immured in the Kursunly and Abadscilar mosques in modern Bergama.[13] Although about a third of one of the slabs is missing, it is clear that the main outlines of their floral ornament corresponded nearly exactly, and that they comprised a single program of imagery. Each consisted of a large central stalk growing from an acanthus calyx to emit three pairs of superimposed boughs or branches, all treated with leafy acanthus foliage in the manner typical of the later Classical and Hellenistic periods (figs. 47–48). While the underlying tendril matrix is relatively formalized or abstract, it burgeons forth with various plants and fruits that are rendered in strikingly naturalistic detail. Some of these emerge along the central stalk; a pair of wheat ears and poppy capsules at the top, a spray of laurel with bayberries just beneath them, and sprigs of oak with acorns further down near the acanthus calyx (fig. 48a). Other plants are distributed along the main branches; a pine cone and needles near the top followed by a quince at the end of the branch, while the middle and lower branches terminate respectively in a pomegranate and grape clusters with vine leaves (fig. 48 b–c). Each of these plants is repeated symmetrically in both halves of

the composition. The other slab seems to have eliminated the oak, while
the laurel has been transposed down a level (fig. 47). But since the pop-
pies, wheat, and traces of the laurel occur on both sides of the central
stalk, there is no reason not to assume that here too all the plants were
repeated symmetrically, as on the more well preserved slab.[14]

A similar array of real plants and fruit occurs on several other fragmen-
tary Pergamene reliefs. The lower portion of a marble pilaster is deco-
rated with a sinuous acanthus pattern whose tendrils terminate in barley
or wheat ears, pomegranate, and a grape cluster.[15] The large acanthus
volute on a fragmentary marble plaque from the Asklepeion sprouts a
branch of laurel and what appears to be the eroded remnant of poppy
capsules; further to the left are pine or spruce needles, and above them,
the remains of nuts or an olive branch (fig. 50).[16] One last marble relief
from the *Hallenstrasse* or Covered Street has spiraling acanthus tendrils
that blossom in quince at the upper left, a poppy capsule and vines with
grape clusters down below, and a badly eroded portion on the right
which could be pomegranate (fig. 51) (cf. the quince and pomegranate on
the slabs from the Kursunly and Abadscilar mosques, figs. 47–48).[17]

With the exception of the pilaster, these works fall into the well known
category of "peopled" or "inhabited vinescrolls," since they also include
mythological figures or divinities who sit or stand among the tendrils.[18]
The tendril-grasping Nike or winged Victory of the *Hallenstrasse* fragment
and the winged Eros astride the volutes of the Asklepeion relief have
numerous counterparts in later Roman sculpture and painting (figs. 50–
51). However, the group of figures who inhabit the areas beneath the
floral ornament on the slabs from the mosques is virtually unparalleled in
ornamental compositions of this kind, certainly in monumental relief
sculpture, and they are of far greater value in determining the sense of
the various naturalistic fruits and plants as appendages of stylized acan-
thus ornament.

The lefthand figure on the better-preserved slab is a female seated
astride a rampant lion; she wears a *polos* on her head and holds a scepter
in her right hand and a tympanon in her left (fig. 48b, bottom). These
details all indicate that she is Rhea-Kybele, the Great Mother, depicted in
much the same way as she appears in the south frieze of the Great Per-
gamene Altar.[19] The figure opposite her is badly effaced, but the silhou-
ette is still clearly defined, especially in the drawing of the slab originally
published by the excavators (fig. 48c, bottom). As in the left portion of the
composition, this figure also rides a rampant feline, whose claws and
ring-tail are still discernible like those of Kybele's lion. And like Kybele
the figure holds a scepter or staff, but one with a pointed, bulbous finial.
Despite the damage, the staff is clearly a thyrsos, and thus the figure may
be identified as Dionysos in his standard Hellenistic format, riding a pan-

ther or tiger (fig. 48c).[20] Only one of the figures on the other slab is pre-
served. Although the upper torso is badly eroded, the distinctive winged
vehicle with a snake entwined around the wheel demonstrates clearly
that he is Triptolemos, following the iconography long established in
vase painting and relief sculpture (fig. 47, lower left).[21]

The identity of the corresponding figure on the missing right portion of
the relief remains uncertain, but one can only approach this problem by
determining the particular relevance of the figures in the lower portion of
these slabs to the imagery of vegetal life that springs forth above and
around them. Since the first thorough publication of these slabs by Win-
ter in *Altertümer von Pergamon*, scholars have recognized that the various
plants and fruits are not simply collective images of earthly wealth, but
attributes popularly associated with specific divinities in keeping with a
long and well documented tradition in Classical art and Greek and Latin
literature.[22] The grapes and vine leaves are the gift or plant of Dionysos;
the pine was associated with Dionysos and with Kybele; the oak with
Kybele and Demeter, and also with Zeus. The poppies and wheat ears
were Demeter's symbols just as the pomegranate was sacred to her and
to her daughter Persephone. The quince and the closely related apple
were especially connected with Aphrodite, and the laurel above all with
Apollo. Clearly these associations were not always limited to one divin-
ity, as we can already see, and in the course of time most of these plants
came to be connected with the Great Mother or Kybele, and also with
Dionysos, who became a pre-eminent deity of vegetal renewal and
fruitfulness.

Thus the gods on the slab were shown directly beneath the gifts which
were particularly associated with their nature and powers. This is entirely
understandable since all of these divinities were widely venerated in an-
tiquity as the key forces in the cycle of agricultural renewal and prosper-
ity. Consequently, the identity of the fourth or missing figure may not be
beyond recovery. As a counterpart to the major agricultural divinity Trip-
tolemos, the possibility that comes to mind most immediately is Demeter
or maybe Persephone. In the initial publication, however, Winter dis-
counted this, suggesting Hermes instead because the kerykeion or her-
ald's staff is carved in relief on the rear of both slabs (fig. 49, right), and
because Hermes too was a deity associated with trade and prosperity.[23]
Yet the use of the kerykeion was not limited to Hermes; by the later Clas-
sical and Hellenistic periods it had also come to serve as the attribute of
fruitful Peace or Eirene, as the subsequent discussion will show. More-
over, the large torches on the narrow face of the slabs are unmistakable
symbols of Demeter; they allude to the myth of her nocturnal quest for
the lost Persephone, especially since they also sprout Demeter's plants—
young poppy flowers and capsules, and ears of wheat (fig. 49, left).[24]

In view of this, as well as the poppies, wheat, pomegranate, and figure of Triptolemos on the main face of the slabs, these works appear to have a particularly Eleusinian cast or emphasis, and although this need not exclude Hermes, it makes it far more likely that the missing figure was Demeter herself or her daughter. If this was in fact the case, then the assemblage of divinities on these sculptures would correspond rather closely to those on the well-known "Eleusinian Pelike" now in the Hermitage Museum (fig. 57).[25] There Demeter occupies the center of the composition with little Ploutos and Persephone at her side, the latter holding Demeter's torch, while Triptolemos hovers above in his winged car. Dionysos holding his thyrsos sits to the right of Triptolemos with Rhea/Kybele seated below him on a covered omphalos. The left side of the composition is filled by additional figures who do not recur on the slabs—a seated Aphrodite with a kneeling Eros, and Herakles and Eumolpos above or behind them.

Instead of depicting the divinely begotten prosperity with the tendrils and their many fruits that dominates and even overshadows the divinities on the Pergamon slabs, the vase suggests this notion in more anthropomorphic terms through the small figure of the child Ploutos, the personification or *daimon* of agricultural wealth, who stands with the horn of plenty at his mother's side. Yet it is also possible that even here, the elaborate tendril composition that encloses the scene to either side was already meant to evoke the notion of the vegetal bounty associated with these divinities. The sherd of an approximately contemporary Apulian vase shows the remains of a similar scene with Demeter or Persephone holding a torch as she stands beside the snaky car of Triptolemos, only there, the entire composition is set in the very midst of an elaborate acanthus tendril pattern in a manner anticipating the composition of the Pergamon slabs.[26]

What begins to emerge from this comparison between the Pelike and the Pergameme reliefs is the notion of the cooperative interaction or concord (*homonoia*) among the gods that was considered essential to earthly prosperity. In her recent study of the Eleusinian Pelike, Simon has stressed this idea of concord in more narrative terms, for she sees the whole scene as the resolution of Demeter's angry dispute with her fellow deities over the rape of Persephone. Her mother Rhea at the lower right has interceded to restore good relations with the other Olympians so that the earth may once again bear fruit and sustenance for mankind. The corresponding figure of Aphrodite over on the left probably served a similar purpose. As goddess of love and fertility (Eros appears right beside her) she alludes to Demeter's fruitful union with the Titan Iasion through which Ploutos or the wealth of the land came into being, and also to Persephone's union with Hades.[27] Here Demeter has acquiesced to this

"new order," thereby reinstating the harmonious interaction among the chief divinities of agricultural fertility, as Triptolemos in his cart is about to begin disseminating the gift-knowledge of cereal culture. But despite these narrative implications, the calm and stately bearing of the figures suggests that the composition is still essentially iconic or symbolic, a kind of *Daseinsbild* expressing the theology of agricultural bounty through mythopoeic allusion.[28] The Pergamon slabs confront us with an imagery that is much the same in purpose and implication, except that they are more ornamental and emphatic in their evocation of the earthly bounties themselves (cf. figs. 47–48 and 57).

The specific role of Aphrodite on the vase may also shed some light on the inclusion of the quince in the upper branches on both slabs (figs. 47–48). Winter saw the quince, like the various other wild plants here, as an allusion to the powers of Rhea/Kybele, goddess of nature and the source of all life, cultivated as well as wild. Yet the quince is well documented as the fruit of Aphrodite, who did not appear on the slabs, so far as one can tell.[29] Thus it is possibile that these plants alluded not only to the power of deities who were explicitly depicted in these reliefs (there was in reality only room for four), but to others as well who were not actually shown. This certainly obtained either for Demeter or Persephone, depending upon which one may actually have appeared opposite Triptolemos on the slab. In this connection the depiction of Aphrodite on the Eleusinian Pelike as an ancillary but important factor in the balance of power among the leading fertility deities lends considerable support to the idea that her gifts too were meant to be evoked specifically on the Pergamene relief, especially since she also appears in an Eleusinian setting on several other Attic or Apulian vases.[30]

Perhaps one can explain the inclusion of Apollo's laurel on both slabs in the same way since he too had his place as a deity associated with agricultural fertility and the Eleusinian sphere. On a late Attic red-figure bell krater depicting Triptolemos between Demeter and Persephone, Apollo sits in the lower zone with a branch of laurel accompanied by Dionysos, Pan, and Hermes.[31] A somewhat later Apulian vase shows Apollo with his lyre and laurel along with Aphrodite and Eros, as Triptolemos departs in his car in the zone below.[32] At Delphi Apollo was honored with a statue bearing the epithet *Sitalkas*, "strong in grain," while on Rhodes he was propitiated as *Erythibios*, protector against grain blight.[33] Such epithets suggest that Apollo's role here was largely protective, and this would accord well with the more generally apotropaic or purifying quality associated with his sacred plant, the laurel.[34] Pliny (XVIII,45,161), moreover, specifically recommends placing laurel branches in grain fields as a preventative against crop mildew. Thus it is clear that Apollo also played his part in the divine interaction which guaranteed the success of

cereal agriculture, and on the evidence of Pliny his laurel appears espe-
cially appropriate among the other plants symbolic of god-given prosper-
ity on the reliefs (figs. 47–48).

However, the allusion to Apollo here may involve more than this, par-
ticularly in connection with Dionysos, who figures explicitly on the first
slab, for both gods were also closely associated with the Horai or Sea-
sons. Hesiod (*Theogony*, 900–903) identifies the Horai as the three daugh-
ters of Zeus and Themis—Eirene, "Peace," Dike or "Justice," and
Eunomia, "Good Order."[35] As sun god and lord of the solar year, Apollo
was intimately related to the Seasons in cosmic or cyclic terms. As a deity
of vegetation and earthly renewal, Dionysos too was closely associated
with the Seasons in Greek literature, art, and religious belief or ceremo-
nial. In the great processional pageant staged in Alexandria by Ptolemy II
Philadelphos, the Horai appeared as part of a larger series of figures in-
cluding the altar of Dionysos, silenes with emblems of peace and war,
and personifications of cyclical time.[36] On one late-fifth-century Attic
vase the inscribed figure of Eirene is shown wreathed in ivy and drinking
wine amidst the throng of Dionysos and his satyrs and maenads; on an-
other she participates in a *thiasos* as Dionysos embraces her. The latter
example closely recalls Euripides' *Bacchae*, 419–420, where Dionysos is
said to love the goddess Peace, giver of blessings and nourisher of the
young.[37] But the early-fifth-century poet Bakchylides also associates
Eirene with Apollo in his Fourth Paian. And on the remains of a late-fifth-
century round relief altar from the sanctuary of Artemis at Brauron in
Attika, she probably appears with Dionysos and Apollo together.[38] De-
spite the extensive mutilation, the inscriptions above the figures indicate
that the altar showed Hermes and Dionysos leading Eirene and the Char-
ites or Graces toward the Apolline Triad. Of the triad, only a fragment
with Leto's name and another with a female figure remain, but in view of
the site, Artemis must also have been included, and therefore Apollo as
well, as Simon has recently argued.[39]

At the same time, other evidence attests to the connection of the Horai
with Demeter and Triptolemos. The Homeric Hymn to Demeter already
addresses the goddess repeatedly with the epithet *Horephoros*, "leader of
the Horai" or "bringer of Seasons."[40] There are visual analogs to such
imagery as well; an Apulian volute krater in Leningrad depicts Demeter
and Triptolemos at the center of the composition flanked by Aphrodite
with Eros and Peitho on one side, and two Horai grasping ears of grain
on the other, all identified by inscriptions.[41] Similar examples from late
Hellenistic or early imperial times are the well-known Tazza Farnese and
the silver plate from Aquileia, where the Horai also accompany Demeter
and Triptolemos (figs. 58–59).[42] This association is readily intelligible
when one recalls that Demeter and her Eleusinian cohorts constituted a

virtual cornerstone of the myth and religious belief or speculation con-
cerning the natural cycle of seasonal renewal.

The particular and intimate relation between the Season Eirene and
Demeter or the Eleusinian sphere is enshrined in Kephisodotos's famous
statue of Eirene holding the child Ploutos which once stood in the Athe-
nian Agora (Pausanias, I,8,2 and IX,16,2). Here Peace literally becomes a
surrogate mother or *kourotrophos* to Demeter's son. Euripides (*Bacchae*,
420) had already called Eirene a *kourotrophos*, just as Pindar dubbs her
tamia ploutou or *ploutodoteira*, "protector" and "giver of Ploutos or agri-
cultural wealth."[43] But the strategy of artistic assimilation basic to the
statue, whereby Ploutos and his horn of plenty now became attributes of
or adjuncts to Eirene rather than Demeter herself, would not have made
sense unless the notion of Peace were already bound up in the larger
Eleusinian tradition.[44]

These multiple associations of the Horai are rather significant since
they provide an added context for appreciating the religious or theologi-
cal conceptions uniting Dionysos and Apollo with Demeter and Trip-
tolemos, and this in turn sheds some further light on the literal or allusive
depiction of all these deities on the Pergamene slabs. For we must in
some sense recognize that the collective image of divinely sanctioned ag-
ricultural bounty and renewal on these reliefs encompassed the notion of
the Seasons or Horai as well, especially since the symbol of one of them,
Eirene, appears on the reverse of both slabs (fig. 49, right). Previous com-
mentators on these reliefs have interpreted the kerykeion here in its pri-
mary function as the symbol of Hermes, god of commercial prosperity.
But by the early or mid fourth century B.C. the herald's staff had also
become an attribute of the fruitful prosperity associated with Peace or
Eirene, as the silver staters of Lokroi Epizephyrioi attest.[45] The recent
publication of the slightly earlier Brauron altar where Hermes appears as
the herald of Eirene discloses something of the process through which
she came to appropriate the symbol.[46]

In view of this, it seems that one can go a step further with the inter-
pretation of the Pergamene slabs as a decorative image of the manifold
gifts resulting from the unity of purpose or *homonoia* that existed among
the pre-eminent fertility deities. What we have here is an imagery of the
fruitful, abundant regeneration associated with yet another deity who
was very much a part of this divine circle—the Goddess Peace. But it is
not only the connection of Eirene with these deities, or the presence of
the kerykeion on the reliefs that impells us to this conclusion. There is
also the fundamental unity that the Greeks and Romans saw between the
personified concept of Peace and that of *homonoia* or Concord. Students of
late Republican coinage are familiar with the image of the kerykeion or
caduceus held between two clasped hands—the *"dextrarum iunctio"*—as

a symbol of pacific harmony and reconciliation associated with Pax and
Concordia by the Romans of the mid first century B.C.[47] This imagery,
however, alluded to more than earthly concord. Harmony and unanimity
of purpose had to obtain among the gods as well, and the clasping of
hands already signified concord between divinities by Classical times, as
a late-fifth-century Attic krater with Apollo and Dionysos in this pose
attests.[48] It is precisely such divine *homonoia*, not only between Apollo
and Dionysos, but among the various gods depicted or alluded to on the
Pergamon slabs, that these reliefs celebrated.

Moreover, by the Hellenistic period Homonoia was worshipped as a
personified goddess precisely like her Roman equivalent Concordia.[49]
And like Eirene, Homonoia already appears on the Italiote Greek coinage
of the late fifth or fourth century B.C., where, significantly, she is associ-
ated with agricultural wealth or prosperity through the symbol of the
grain ear on the reverse of the coins.[50] But the intimate relation of all
these concepts emerges most clearly in Kallimachos's Hymn to Demeter:

Hail, O goddess, and safeguard this city in Concord (Homonoia) and
 in prosperity,
and bring to the fields all things in abundant return.
Nourish the cattle, bring us sheep, bring us grain, bring us harvest,
and nourish Peace (Eirene), so that he who ploughs may also reap.[51]

Thus Homonoia was not simply related to prosperous Peace, but a re-
quirement for it, just as Peace was essential for the production and enjoy-
ment of earthly bounty under the benign care of the great life-giving
divinities like Demeter. It was this outlook that informed the religious
imagery on the Pergamene slabs. Even in the more prosaic terms of Greek
statecraft expressed by historical writers like Diodorus Siculus, *homonoia*
and *eirene* appear as reciprocal and inseparable concepts expressing the
unity of purpose essential to political and military tranquility.[52] The amal-
gamation of Peace with Concord was therefore not a Roman invention;
nor, it seems, was the idea of depicting the divinely engendered abun-
dance of such pacific concord in an ornamental format (figs. 47–48).

All this has enormous consequences for the interpretation of the floral
friezes on the Ara Pacis, for it shows that the depiction of various real
plants, flowers, and fruits growing amidst stylized acanthus ornament is
far more than a stylistic trait or peculiarity that can help to pinpoint the
particular sources of Augustan decorative arts. While the palmettes and
overall matrix of acanthus tendrils on the Roman monument may well
have an Apolline significance, as Pollini has argued, it should now be
clear that the highly naturalistic vegetal or floral additions were intended
to go well beyond a generalized evocation of efflorescent terrestrial life
and wealth. This usage was a distinct iconographic strategy that signified

not only earthly abundance, but even more importantly, the cooperative involvement and blessing of the specific divinities responsible for such prosperity, a cooperation, moreover, that was synonymous with the very concept of fruitful Peace. As such, the Pergamene reliefs of this kind appear to represent the germ or basic blueprint for the imagery of the floral friezes on the Ara Pacis, and consequently, it is well worth examining the relation between the Roman monument and these Hellenistic works more closely.

Of the six naturalistic plants that survive in the floral friezes of the Ara Pacis, four occur on the Pergamene slabs and the related fragments from the Asklepeion and *Hallenstrasse*: grapevine, laurel, poppy, and oak. The use of poppy and oak on the Roman monument departs somewhat from the Pergamene precedent; there are no acorns, and the poppies among the Ara Pacis tendrils are mature blossoms rather than capsules (cf. figs. 47–48 and 17). The quince, pine, pomegranate, and olive of the Pergamene reliefs have no counterpart on the extant remains of the Ara Pacis, but this may not hold true in the case of the wheat. Among the unpublished marble fragments in the Terme Museum recovered from Moretti's excavations of the Ara Pacis, there is in fact an ear of wheat.[53] The fragment is badly damaged; all that remains is the upper portion of the ear and the serrated contour of an adjacent leaf of some sort (fig. 22). The size of the ear (about 2 cm. wide) is commensurate with many of the smaller vegetal details like the laurel or ivy leaves on the Ara Pacis. Owing to its condition, there is no way of determining what portion of the floral friezes this may once have occupied. Still, this is possible, and there is in any case good external evidence that the floral friezes once included wheat.

Ears of bearded wheat appear several times amidst the acanthus ornament on a pair of Augustan silver relief cups now in the British Museum (fig. 90 a–b).[54] Indeed, the inclusions of this kind are rather extensive here, involving grapevine, ivy, apple or quince, poppy capsules, oak, pine, pomegranate, myrtle, fig, pear, and olive. Studies devoted to these vessels have stressed the extremely close stylistic relation between their decoration and the Ara Pacis, although they have noted that the cups contain many more such plants than the remaining portions of the floral friezes on the Ara Pacis. What has not been emphasized sufficiently, however, is that those plants on the cups that do not recur on the Ara Pacis, do appear on the various forerunners from Pergamon discussed above, especially the matched slabs.[55] Thus the cups provide good collateral evidence that the wheat ears from Moretti's excavation did once belong somewhere on the floral friezes, and they suggest furthermore that the Augustan monument may once have contained the full array of such plants, i.e., the pine, pomegranate, olive, and quince or apple. The well-known marble

chariot that gave its name to the Sala della Biga in the Vatican Museum furnishes yet another confirmation of this. There, among the elegant acanthus tendrils related so closely to the Ara Pacis, one finds not only roses about to bloom, but also several groups of poppy capsules juxtaposed with wheat ears, some even at the top of the central stalk, precisely as they appear on the Pergamene slabs (fig. 60 a–b; cf. figs. 47–48).[56]

In actuality, the drawings of Bonserini published in Moretti's monograph on the Ara Pacis show clearly that only a little over half of the north frieze survives, and only one third of the south (figs. 3–4). The confidence that is often placed in Moretti's detailed reconstruction of the missing portions may therefore be somewhat misplaced.[57] Enough remains to show that the main outline of the tendril volute matrix was bilaterally symmetrical, along with the more prominent features within the composition, like the swans. Many of the larger stylized blossoms and the more prominent floral inclusions like the grapevine or the ivy also repeat symmetrically on both sides of the composition. But in the limited number of instances where it is possible, direct comparison between the smaller details on both sides of each frieze and even between the larger features on both friezes demonstrates that the symmetrical uniformity only went so far. Although most of the left side of the north frieze is gone, on the large rectangular fragment that survives, three details depart noticeably from the righthand portion. The oak branch in the lower left of this fragment has no counterpart at the corresponding point on the right, only a stalk of more generic form (fig. 4, nos. 7 and 10).[58] There is a small blossom atop the volute to the right of the oak, but at the same point on the right the space is empty (fig. 4, nos. 11 and 12). At the left there is a helical tendril in the space down to the right from this volute, but at this point on the opposite end there is a blossomlike form (fig. 4, nos. 13 and 14). The large flower amidst the remaining fragments on the extreme left is also entirely different from its counterpart on the right (fig. 4, nos. 15 and 16).[59]

Similar discrepancies occur on the south frieze as well. Just below the cluster of ivy on the right side there is a large, well-defined rose, very similar to those at several other points in the friezes (fig. 3, no. 4; fig. 18). Yet the corresponding flower on the left differs markedly; it is five-petalled, but something other than a rose (cf. fig. 3, no. 5; fig. 19).[60] Further over on the lower right is a sinuous tendril terminating in a palmette-like, stylized blossom (fig. 3, no. 6); the corresponding space at the left is empty (fig. 3, no. 7).[61] The differences between both long friezes are even more striking. Compare the tendril just cited to its counterpart on right side in the north frieze (fig. 3, no. 6 and fig. 4, no. 17).[62] And on the north frieze, there is only one cluster of ivy on either extreme (fig. 4, no. 4, left and right). In the corresponding point on the south there are two on each side (fig. 3, nos. 1 and 2, left and right).[63] The rose cited just above on the

right of the south frieze has no counterpart in the same place on the north; there one finds a blossom of quite different type (cf. fig. 3, no. 4 and fig. 4, no. 18). Similarly, the oak branch on the north does not recur on the south at this point (fig. 4, no. 7 and fig. 3, no. 8).

Only one fragment of the large central acanthus calyx on the south frieze survives, a section of the right half, and significantly it shows no trace of the large ragged poppy occupying the same point on the north frieze (cf. fig. 3, no. 9 and fig. 4, no. 8). Another fragment from the area to the right of the central calyx clearly lacks the ivy of the corresponding point on the north (cf. fig. 3, no. 10 and fig. 4, no. 3).[64] Yet in the south calyx, Moretti nevertheless reconstructed both the poppy and the ivy on the left side only, purely on the basis of the north frieze, and in conflict with the absolute bilateral symmetry of the large calyx on the north (fig. 2, bottom center).[65]

Only one branch of laurel survives in the long friezes, on the right side on the north (fig. 4, no. 1; fig. 10). Moretti reconstructed its counterpart on the left side just below the remains of the ivy (fig. 4, left, no. 4), and another in the right portion of the south frieze (cf. fig. 3, no. 11 and fig. 2, right). There is evidence for the first reconstruction. Another of the unpublished Terme fragments from Moretti's excavation of the Ara Pacis consists of the edge of a spray of laurel with bayberries that corresponds closely in size to the one on the north frieze.[66] Though fragmentary, its configuration appears to be the reverse of this righthand laurel in the north frieze, curving downward from left to right, with the stem emerging from beneath a leaf to curve back upward (fig. 21). This then could be the lefthand counterpart of the laurel on the north flank. But no laurel actually remains in the south frieze. In the area on the left corresponding to Moretti's reconstructed laurel on the right, the branch is somewhat damaged or eroded, but it is clear that this plant is something other than laurel (cf. fig. 3, nos. 11 and 12; fig. 13, bottom).[67] Thus, if Moretti's reconstruction of the south frieze were correct, i.e., if originally there was a laurel branch on the right, then both halves of the frieze would be different at this point. If it were wrong (and this is certainly possible considering the disparities between the poppy and ivy in and around the central calyces on the north and south), then the north and south friezes would not correspond here.

To be fair, Moretti's reconstructions were never intended as a literal and absolute statement of what once existed throughout the floral friezes; they were conceived primarily along aesthetic lines to restore the rhythmic, decorative unity to the friezes which even today constitutes much of the visual coherence and appeal of the monument. But while this survey may have taxed the reader's attention, it is important to see that the Ara Pacis tendril compositions manifest considerable variations at the level of

detail of the floral inclusions, variation within *each* frieze and between *both* long friezes. To a great extent this appears to have been deliberate. While bowing to the Classical taste for symmetry, these lesser variations imparted a varied and dynamic or changeable naturalism to the overall compositon. But as a result, it is far from certain that what is missing corresponded precisely to what remains; it is entirely possible that additional plants, flowers, or fruits like those on the Pergamene reliefs once occupied the portions of the floral friezes that no longer survive. And since the British Museum cups and the marble chariot document the fuller impact of the Pergamene imagery in such Augustan tendril ornament, this possibility begins to approach a probability.

Moreover, the existing correspondences between the Ara Pacis and the Pergamene forerunners are by no means limited: grapevine, oak, laurel, poppy, and very likely wheat. Nor are the apparent distinctions as tangible as they might seem. On the Ara Pacis the substitution of poppy flowers for poppy capsules and the absence of acorns beside the oak leaves were formal alterations, but they did little to change the sense of the depiction or the strategy of the imagery; these were still the recognizable plants of Demeter or Ceres and the Great Mother. One may perhaps see the substitution of the roses for the quince or apple in the same way; the flower still alluded to Aphrodite or Venus. Nor is it certain that these other plants did not also appear. Yet the fundamental analogy in symbolic function transcends such differences in detail. What matters most is not the precise treatment or inclusion of this or that plant, but the larger purpose that they all served collectively as allusive expressions of divine power. For it was this aspect of the Pergamene floral reliefs that provided the real attraction to those who formulated the program of the Ara Pacis.

On the Altar of the Augustan Peace as well, one can scarcely doubt that all these plants were deliberately intended to evoke the specific power and blessing of the various divinities to whom they were sacred, even though the Roman monument no longer retained the actual figures of the gods themselves amidst the decorative foliage. In point of fact, these figures are probably more important for us today as a form of visual interpretive proof or documentation than they were in antiquity. For the original audience, their inclusion on the matched slabs was probably more emphatic than informative. To the ancient spectator familiar with the accepted lore and tradition of divine symbols and attributes, it was the various plants and other emblems like the torches and kerykeion that really disclosed the sense and nuance of the monument. It is only the modern archaeologist who requires the explicit presence of the gods themselves to read the floral imagery as an unambiguous statement of particular divine presences or forces.

This may help us to understand why the gods themselves on the slabs

are so small, why they are so apparently overshadowed by the burgeon-
ing vegetation that they engender (figs. 47–48). It also explains why some
of the vegetal references or attributes (the laurel and quince or apple) did
not even need to be accompanied by the figure of the associated god or
goddess, and why the ulterior conception of harmonious Peace central to
the monument was alluded to only by the kerykeion, and not by a figure
of Eirene herself. The figures of the divinities did not determine the
meaning of the floral ornament; they only made what would have been
apparent explicit. Thus one may interpret the remaining Pergamene dec-
orative reliefs that incorporated real plants among the tendrils as funda-
mentally the same in meaning even though they included only divinities
or *daimones* of intermediate status like Nike or Eros (figs. 50–51).[68] The
latter figures are paracletes, intercessors or agents of the superior deities
depicted on the matched slabs. Consequently, it would be implausible to
conclude that the various vegetal inclusions or attributes on these other
Pergamene works no longer alluded to the specific divine forces cele-
brated on the slabs; they simply utilized a less explicit mode of significa-
tion. And as such they stand midway between the slabs with the full
panoply of divinites and the friezes of the Ara Pacis, where even such
figures as victories and erotes were apparently deemed unnecessary.

This allusive mode of signification has a name, and it was in fact one of
the more widespread forms of imagery applied in the literary and visual
arts of antiquity. In the domain of literature or language, the Greeks and
Romans called such expression metonymy, a verbal form of representa-
tion in which an element, adjunct, or attribute closely associated with a
given entity or concept is allowed to stand for that entity symbolically.
Like metaphor, metonymy is predicated on the transference of descrip-
tive elements from one context to another. But metonymy presumes the
substantive relation between the various elements involved. The pre-
existing, established nature of the association between the metonym and
the entity that it represents constitutes the primary distinction between
metonymy and metaphor, where, in contrast, the equation or compari-
son between elements is more flexible or arbitrary.[69] Among the common
metonyms still current today, the use of the term "the Crown" to refer to
a king or monarchy, and "the White House" or "City Hall" to denote the
President of the United States or a mayor come to mind most imme-
diately. Among the ancients, metonymy often focused on exchanging the
gods with their attributes, and it is this which Quintilian, VII,6,23–26,
uses as the prime illustration of metonymy. The Romans called water
Neptune; wine was Bacchus or Liber; bread from grain was Ceres; and
erotic love was Venus (cf. Cicero, *De Oratore*, III,xlii,167).

The metonymic basis of many divine poetic and cultic epithets, how-
ever, is most immediately relevant in the present context. For example,

Dionysos was called *Kissos*, "ivy," and *Kallikarpos*, "beautiful fruit."[70] Of-
ten such epithets took an adjectival or attributive form instead of substi-
tuting the plant noun form as the god's name, but the associative
metonymic function of such cultic nomenclature was basically the same.
Thus Dionysos was *Ampeloeis*, "viney one"; *Euampelos*, "rich in vines";
Staphylites, "grapey one"; *Polystaphylos*, *Eristaphylos*, or *Eustaphylos*, "rich
in grapes"; *Botryokaites*, "wreathed in grapevine"; *Botryophoros*, and *Bot-
ryopais*, "bearer" and "child of the grapecluster"; *Kissophoros*, "bearer of
ivy"; and *Kissokomes* or *Kissostephanos*, "ivy-wreathed."[71]

Similarly, Apollo was *Daphnaios*, *Daphnites*, and *Daphnios*, "of or charac-
terized by laurel." He was *Daphnophoros* and *Daphnopoles*, "bearer" and
"dealer of laurel"; *Daphnokomes*, "wreathed in laurel"; and *Daphnogethes*,
"delighting in laurel."[72] Demeter was *Sito*, "grain or barley"; *Polykarpos*,
"rich in fruits"; *Chlookarpos*, "fruit of the new green grain"; *Polystachys*,
"rich in grain"; *Stachyostephanos*, "crowned in grain"; *Stachyoplokamos*,
"grain haired"; *Stachyotrophos*, "nourisher of grain"; *Anaxidora*, "mistress
of the gift of grain"; *Chloe*, "new green blades of grass or grain"; and
Euchloe, "rich in new grain."[73] Aphrodite also had such general vegetal
attributes: *Eukarpos*, "rich in fruits," and *Zeidoros*, "giver of grass or
wheat"; but her more specific epithets were *Rhododaktylos*, "rosy-
fingered," and *Rhodochroos*, "rosy-skinned."[74]

Although originally conceived as a literary technique, metonymy was
readily adapted to visual media throughout antiquity. In the visual arts of
classical cultures, the most common instance of metonymy was the use of
divine attributes to symbolize the associated gods. Such imagery is well
documented in Greek coinage where reverse emblems like the thunder-
bolt, owl, and swan evoked the powers of Zeus, Athena, and Apollo who
appeared on the obverse.[75] Such attributes were also used as metonyms
in more elaborate pictorial compositions; on an Apulian red-figure
lekythos of the fourth century B.C. by the Underworld Painter, the iso-
lated thunderbolt is used to signify the intercession of Zeus during the
battle between the Rival Twins, even though Zeus himself is not
shown.[76] But in either case, the sense of the symbol depended upon the
spectator's experience with the tradition of such attributes, or perhaps
upon other representations where the thunderbolt, owl, or swan actually
accompanied Zeus, Athena, and Apollo as a direct attribute.[77] Thus Peace
might be depicted holding the kerykeion or caduceus on Greek and Ro-
man coinage; yet when the staff itself appeared alone on such coins or on
the slabs from Pergamon (fig. 49, right), its established, traditional rela-
tion with Eirene or Pax empowered the form as a symbolic surrogate, a
visual metonym that vividly evoked the goddess even though she did not
actually appear.

The various vegetal or floral attributes of fertilty divinities can hardly

have functioned any differently than symbols like the thunderbolt or the kerykeion. They too became potent metonyms when transposed from the brow or hand of the divinity to the decorative format of ornamental foliage, especially against the background of the cultic and poetic nomenclature cited just above. Even amidst a painted still life, the image of such fruits could still move a thoughtful observer like Philostratos to think first and foremost of the deity who created such gifts:

> And if you behold the interlacing of the vine branches
> and the grapeclusters hanging from them, and the
> quality of the individual grapes, you will sing, I know, of
> Dionysos and proclaim the vine as grape-giving mistress.[78]

Consequently, the differences among the Pergamon slabs, the *Hallenstrasse* and Asklepeion reliefs, and the Ara Pacis friezes are really those of degree. On the slabs, most of the plants are barely metonyms; the direct contiguity of the gods comes close to reducing these vegetal forms to direct attributes rather than allusive symbols; only the laurel of Apollo and quince of Aphrodite function truly as metonyms (figs. 47–48). The *Hallenstrasse* and Asklepeion reliefs are more thoroughly metonymic; the presence of intermediate agents like Nike or Eros reinforces the notion that the pine, pomegranate, poppy, grapes, and laurel are symbols of divinity, but they ultimately serve and signify an absent presence—the greater gods who do not appear (figs. 50–51). The further restriction of such imagery on the floral friezes of the Ara Pacis to the plants themselves simply takes this imaginal construct a step further; its apparent elimination of divine figures of any sort imposes no fundamental change of meaning; it only constitutes a more strident and radical form of metonymy.

A highly educated observer in antiquity, one schooled in literary technique, would probably have understood the sort of imagery on the Ara Pacis or its Pergamene precedent as a visual artistic manifestation of metonymy, although, of course, there is no evidence that the ancients formally applied this concept as a critical term in discourse on the visual arts. It is therefore unlikely that there was any specific nomenclature for including an array of realistic plants in a decorative format as we see it on these Greek and Roman monuments. But the Greek term applied more generally to the collective use or display of plants and fruits in a religious context does survive in various literary sources; it was called *pankarpia* or *panspermia*, "a mixture of all fruits" or "all seeds."

From Hesychios and Suidas, we know that both terms were interchangeable. The majority of testimonia indicates that they described religious offerings, a collective mixture of first fruits, which probably originated in the rustic observances of ancient farmers.[79] Theophrastos

recounts the deposit of *pankarpia* as a propitiatory offering to Asklepeios for harvesting a medicinal herb sacred to him.[80] In the form of a many-fruited cake (a kind of ancient tutti frutti) or as a soupy ambrosia placed in a cuplike *kadiskos, pankarpia* was offered to Zeus Ktesios, Protector of Acquired Wealth and god of granaries.[81] *Panspermia* also figured in the rituals of the Athenian Anthesteria. On the third day of the festival or *Chytroi, panspermia*, a mixture of many grain seeds, was cooked in pots (*chytrai*, hence the name of the day) and given as an offering to Hermes of the Underworld (Chthonios). Although this was a propitiatory rite for the dead, it was intended ultimately to facilitate the process of earthly vegetal renewal in connection with the larger festival to which it belonged.[82] Thus, although Hermes was the immediate recipient of the offering in the *Chytroi*, the rite may also relate to the role of Dionysos, the main deity of the Anthesteria, as a god of vegetation and rebirth. In Sophokles' *Elektra* (634–637), Klytaimnestra offers *pankarpia* to Apollo as well, in this case as a purification rite in the aftermath of Agamemnon's murder.

This evidence shows once again that the notion of multiple fruits or plants connoted far more than abundance or prosperity to the ancient imagination; it was an imagery that impinged directly upon the religious beliefs and observances instituted to petition the gods for the cyclic renewal of earthly bounty. Thus one might be tempted to interpret the floral friezes of the Ara Pacis and their Pergamene forerunners along such religious lines as a decorative expression of *pankarpia* or *panspermia*. But the specifically ritual connection or function of these offerings seems to relate much more immediately to another, somewhat different format or class of vegetal ornament current in Augustan and earlier Hellenistic art—the many-fruited garland.

The garlands that decorate the upper section of the walls on the interior of the Ara Pacis enclosure are probably the most familiar example of this type of ornament (figs. 40–41), but it was already widespread in the Hellenistic Greek world, especially western Asia Minor and the Aegean Islands, as various studies have shown.[83] Research has also consistently indicated that richly fruited garland ornament of this kind originated in much the same context that it appears on the Ara Pacis, i.e., as the relief decoration of religious buildings—temples, monumental altars of various types, and sepulchral reliefs. This is hardly surprising since the use of such sculptural embellishment on Hellenistic monuments presumably replicated in a permanent form the real garlands which had been used as the decoration of altars and religious precincts or tombs for centuries.[84] The association of additional elements like *tainia* or liturgical fillets, the boukrania of sacrificial animals, and offering vessels only confirms such indications.[85] Because of their largely cultic and sacral usage or orientation, literally as depictions of religious offerings or ceremonial trappings,

garlands composed of multiple fruits provide the most palpable decorative artistic counterpart to the tradition of *pankarpia* preserved in the literary sources.

And in fact one such source actually describes a wreath as "pancarpous." In the opening section of *Oidipous Tyrannos* (82–83), Kreon returns from his inquiries on the king's behalf at Delphi bedecked in sprays of laurel; the precise phrase is *polystephes pankarpou daphnes*, "richly wreathed in many-fruited laurel." Here it is likely that this means a laurel wreath heavily laden with bayberries rather than one entwined with all sorts of other fruits; yet one cannot be certain since no other specialized term for garlands of the latter type, if the Greeks did have one, has come down to us. We only know of the generic expressions *stephos*, *stephanos*, *stemma*, which correspond to the Latin *corona*, *corolla*, and *sertum*. Vitruvius has a term for sculptured garlands comprised of fruits, *encarpa*. But although it is adapted from the Greek *enkarpa*, literally "things containing fruits," it is probably a Roman neologism rather than a loan word, since it is nowhere attested in Greek sources. And it may even have been coined as a technical term for the sculptural decoration of this type, rather than as a word applied to real garlands.[86]

In any case, Sophokles demonstrates that the concept of *pankarpia* could be applied to garlands or wreaths. So it is quite possible that ancient observers thought of such elaborate garlands as "pancarpous" offerings or trappings analogous to those in the rituals described above. This is all the more likely since *pankarpia* could evidently assume different forms. One source describes it as cakes, another as an ambrosial porridge. But still other texts neglect to specify how the *pankarpia* was prepared; perhaps it was also offered as simple assortments of different fruits such as those brought to the rustic altars in the Aeneas relief of the Ara Pacis (fig. 45, bottom center) or the Grimani relief in Vienna, where, significantly, the offerings are accompanied by lush garlands.[87]

The use of various naturalistically rendered fruits and plants amidst stylized acanthus tendrils, however, should be seen as a kindred but distinct artistic format, and one ultimately different in content or purpose. While informed by a similar mimetic impulse and technique, the use of these plants in such tendril ornament did not replicate the trappings of cult or ceremonial. Nor, conversely, is there any indication that the various plants in the garlands were intended automatically to operate as metonymic allusions to specific divinities, as they were in the Pergamene reliefs. The compendium of plants that made up the *pankarpia* or *panspermia* in the religious ceremonials discussed above were offered to various divinities—to Zeus, Hermes, Apollo, and Asklepeios—simply as a broad array of first fruits, a generic expression of the fertility and benefit sought by the worshipper.

And in this regard as well, the parallel of pancarpic offerings to many-fruited garlands is striking, for they too occur as the decoration of shrines and altars dedicated to various deities or purposes. Here again, there is no reason to think that the different plants which comprised the garlands were meant to evoke the powers of this or that deity as specific metonyms; they were all meant to propitiate the power of the particular deity whom the altar or building served. In the case of the round altar with such garlands in relief that Eumenes II commissioned at Pergamon, the inscription tells us that it was dedicated to all the gods and goddesses.[88] More specific intentions required the addition of more specific indices or visual metonyms. Thus garlands of this kind on monuments dedicated to Dionysos are suspended from masks, or they may incorporate a preponderance of ivy and grape vine; those dedicated to Artemis use stag skulls instead of boukrania, and so forth.[89]

These copious garlands also tend to contain a wider range of plants more in keeping with the sense of *pankarpia*; they are sooner understood as "pancarpous," or perhaps as "polycarpous," to coin a more precisely appropriate term. The array of vegetation in the garlands of the Ara Pacis is especially large; it comprises laurel, ivy, grapevine, oak, pine, pomegranate, poppies, figs, olive, myrtle, apples, pears, wheat or barley, and various nuts (fig. 41). Consequently, students of the monument have readily interpreted the garlands as additional symbols of the pacific bounty associated with the *Pax Augusta*, a fantastic mélange of fruits from different seasons blended in mystic harmony.[90]

In contrast, the multiplicity of naturalistic plants in the tendril ornament of the Ara Pacis and the earlier Pergamene reliefs is impressive, but it not as extensive as what we encounter in this garland decoration. To put it differently, it is more directed or focused, and primarily because it had a different and more specified meaning. The ornament did not consist entirely or substantially of the real plants themselves like garlands; it was not literally pan- or polycarpous, made of all or many fruits. The various plants, fruits, and flowers appeared at intervals amidst a larger matrix of ornamental fantasy, so they stood out from this matrix distinctively, retaining their capacity to impress and allude with specificity. Here the various plants were indeed metonyms; they were each intended to make the spectator mindful of the powers of particular deities, albeit as a collective and unified force, but with the individual resonance of the various divine participants still intact. Garlands could not do this; nor could a more naturalistic landscape interspersed with such plants like those in contemporary Augustan wall painting. Only the more abstract, systematic structure of ornament could provide the necessary foil for the mimetic plants and fruits so as to alert the viewer to their significative function.[91]

Thus, on the Ara Pacis, the contrast between the floral friezes and the interior ornament was profoundly deliberate. There, in proximity to the altar proper, the garlands were an eminently appropriate form of decoration, redolent as they were of the traditional ritual and offerings of religious cult. The various plants that comprised the image of "pancarpous" bounty in these garlands were dedicated collectively to Pax, or perhaps, like the Eumenes altar, to virtually all deities, those whose concord guaranteed the *Pax Augusta*. But the plants in the exterior friezes remained singular in their function as metonymic symbols and homages to certain of these deities each in their own right. As such, the floral friezes are not pan- or polycarpous; they are not comprised literally or entirely of many fruits, and thus they require a different and more suitable neologism. Like the divine power that they represent, the tendrils *bear* or *give rise* to the various fruits and plants; they are "carpophoric," or more appropriately, "polycarpophoric," in view of the large number of such fruits. Under such a rubric this visual imagery becomes intelligible as a collective ornamental avatar of metonymic epithets like *botryophoros, kissophoros, daphnophoros, stachyphoros,* etc., in a single unified composition. Today one can appreciate this function somewhat more clearly in its earlier and more explicit Greek form on the matched slabs, where the diminutive figures of the gods themselves are still there to make it emphatic (figs. 47–48).

On the basis of available evidence, metonymic, polycarpophoric tendril ornament appears to be a development of Hellenistic Pergamene art. Visual artistic metonymy itself was by no means restricted to this locale or even to the Hellenistic period, as the coins and vase paintings with this type of imagery demonstrate well enough. Even in the realm of floral ornament, the use of specific, vegetal forms or stylizations as metonymic symbols of fertility deities has a long history reaching back into the Ancient Near East.[92] And in later Hellenistic decorative art more generally, it was not unusual to depict the individual floral or vegetal attributes of divinities as the fruit or blossoms of stylized acanthus tendrils. Ornament of this kind with Dionysian plants, ivy and grapevines, is the most common instance of of such usage; one encounters it in metalwork as well as in Pergamene and Neo-Attic monumental decoration. Examples of this kind in metalwork are often wine-drinking vessels, while the monumental works may contain the figures of maenads and satyrs, so the specific, metonymic aspect of the imagery is clear enough. Some which combine either the ivy or the grapevine with poppy flowers would apparently allude to Demeter as well. But this sort of tendril ornament with only one or two naturalistic inclusions is simply "carpophoric."[93]

In the case of *poly*carpophoric acanthus compositions with a wider array of such plants sprouting from the tendrils, we are dealing with a

much more particular phenomenon that is literally restricted to the Pergamene works surveyed above. There is no evidence that such imagery reached the imperial capital from other centers of Hellenistic art since it is entirely unattested on the Greek mainland or in the regions once ruled by the Seleucids, or in Ptolemaic Egypt. Consequently, the connections between the Ara Pacis and the Pergamene material must be seen as rather substantive and direct. And concomitantly then, it is much more likely that the designers of the Ara Pacis knew and understood the imagery of divine cooperation and peaceful bounty central to these precedents, and that they sought to adapt it to their own artistic program in the cult of the goddess Pax. This is especially probable because the matched pair of marble slabs themselves can be shown to have once comprised the decorative components of a monumental altar.

The Ara Pacis and a New Altar from Pergamon

Fundamentally, the suggestion that the slabs from the Kursunly and Abadscilar mosques once belonged to an altar is not new. For some time now the slabs have been assumed to have served somehow as table supports, possibly as part of an altar table.[94] Generally though, scholars have been less interested in the function of these reliefs than in their decoration, as if the two were unrelated. To date, only the original report in *Altertümer von Pergamon* has provided any substantive attempt to determine the specific function of the slabs on material, archaeological grounds. Winter correctly rejected Kawerau's suggestion that they might have decorated the front of two projecting *antae* like those enclosing the steps of the Great Altar of Zeus. On the basis of one of the scenes in cubiculum M from the Villa of Fannius Synistor near Pompeii, he instead envisioned the slabs as the frontons of massive, tablelike parapets framing a separate, cylindrical altar (fig. 52a).[95] Yet all this seems unnecessarily roundabout, especially considering the evidence for Greek altar construction that has accumulated since Winter's day. Analysis of the reverse of the slabs suggests a much simpler and more compelling solution.

The rear of each slab has deep grooves or channels that were undoubtedly intended to receive additional slabs or braces, presumably also of marble (fig. 49, right). Since the channels on both slabs correspond closely, it appears that the elements which fitted into them ran directly from one slab to the other; thus the slabs were arranged parallel, back to back, not side by side as Winter and Kawerau thought, and the two kerykeia would have faced each other, just as the torches on the slender opposite edge would have faced forward as parallel emblems. Since the

outer edges of the channels on the reverse are mitered, particularly at the
moldings on the top and bottom of the slabs, the molding must have
continued onto the intervening portions between the slabs. Considering
the roughly dressed portion of the rear surface between the channels on
each slab and the evidence for the lower molding, it is clear that the trans-
verse connecting elements were also solid slabs without any apertures
(fig. 52b). One may envision an additional tablelike slab covering this
whole intervening section, although it evidently did not oversail the lat-
eral or end slabs; this can be deduced from the dressing of the top edge of
both end slabs, which have a smooth lower border that runs entirely
around a rougher, slightly elevated interior surface or plinth with dowel
holes distributed across it (fig. 52b). The table top itself would not have
required such dowels; nor would it have extended past the transverse
connecting sections to the front edges of the slabs. Thus the plinth was
meant to receive additional lateral mountings or crests of some kind
which enclosed or abutted the edges of the intervening table top (fig. 53).

The reconstruction thus far is essentially dictated by the evidence or
structure of the slabs themselves, although the proportions of the monu-
ment, i.e., the distance between the two parallel slabs with the decora-
tion, is only guesswork; it could well have been more elongated. But this
has no effect on the basic identification of the monument itself, whose
function can no longer be in any doubt. This was not simply a table, but a
tablelike altar, and more specifically, a variant or adaptation of the Greek
monumental altar *in antis*. The type takes its name from the lateral wings
or *antae* that project beyond the altar table to enclose the *prothysis* or area
just in front of it.[96] Typically, the *antae* of such altars also project above the
level of the table as barriers on the sides and rear of the altar. An out-
standing example is the large altar of this type dedicated to Poseidon and
Amphitrite on the island of Tenos, which has recently been reconstructed
by Etienne and Braun (fig. 55b).[97] The altar to which the Pergamene slabs
originally belonged departs from this format in that the *antae* do not rise
continuously above the level of the table at the sides or in back. Instead,
there is no rear barrier, and those at the sides appear to have been sepa-
rate pieces dowelled into place in the manner of other Greek monumental
altars without *antae* (cf. figs. 52b, 53, and 55b).[98] Another difference is that
there were also smaller *antae* projecting slightly behind the main body of
the altar (cf. figs. 52b, 54b, and 55b).

In these deviations from the standard structure of the Greek altar *in
antis*, the Pergamene altar really has only one close counterpart among
the monuments known today—the altar of the Ara Pacis itself (figs. 1 and
8). There too the *antae* project not only in the front but also just a bit
behind the body of the altar, without rising above the level of the
table, which is flanked instead by separate lateral barriers, and without

any rear barrier (cf. figs. 1 and 8 with fig. 53). There are, of course, differ-
ences in scale and proportion. The Ara Pacis altar is somewhat larger; the
table itself is 1.25 meters high while that of the Pergamene example
would have been about a meter tall including the table top.[99] The front
antae also project further on the Ara Pacis. But none of these disparities
affects the fundamental typological identity of both monuments.

Moreover, the barriers of the Pergamene altar may have related more
closely to the Roman counterpart. They have been reconstructed here as
the pedimental type with acroteria common in monumental altars of the
Archaic, Classical and earlier Hellenistic periods.[100] But this suggestion is
purely hypothetical in the absence of any direct evidence, and perhaps it
is conservative. By the later Hellenistic period such barriers may already
have been articulated with large volutes like those on the Ara Pacis.[101]
Similarly, the Pergamene altar may well have sat atop a stepped podium
with additional *antae* flanking the steps like those of the Ara Pacis. Greek
monumental altars were often mounted in this way,[102] and although al-
tars *in antis* did not always have such stepped podia, they naturally lent
themselves to this format, especially podia which also had flanking *antae*.
Thus the complete reconstruction of the Pergamene altar shows it situ-
ated on such a podium.[103] The final result is remarkably similar to the Ara
Pacis altar (cf. fig. 54a–b with figs. 1 and 8).

That the matched slabs were part of an altar, and particularly one that
provides the best extant parallel for the altar table of the Ara Pacis, lends a
renewed urgency to the goal of determining how extensively the de-
signers of the Ara Pacis relied upon the earlier tradition of Greek altar
complexes and their decoration. Some forty years have elapsed since
Thompson first drew attention to the connections between the Ara Pacis
and the late-fifth-century Altar of the Twelve Gods (Altar of Pity) in the
Athenian Agora.[104] He particularly emphasized the similar use of a lat-
ticed marble enclosure wall or parapet, square in plan and surrounding a
central altar. Like the Ara Pacis, the enclosure of the Athenian altar also
had two entrances. These analogies are indeed striking, and the likeli-
hood of a connection is strong in view of the Attic or classicistic orienta-
tion of Augustan art generally, and of Agrippa's building activity in the
Agora and elsewhere in Athens in the years just before the Ara Pacis was
erected, as Thompson made clear. But new excavation and research has
since brought to light other monuments whose relation to the Ara Pacis is
equally revealing.

A major addition of this kind, whose impact Thompson himself had
already begun to suspect, is the later fourth-century Altar Court at Sam-
othrace, and the detailed publication and reconstruction has amply borne
out his speculation.[105] Although it apparently lacked any major sculp-
tural embellishment and had no second, rear entrance, the Altar Court is

considerably closer to the Ara Pacis in plan and elevation than to the Athenian altar. The enclosure wall is more comparable in thickness and height, and the altar itself occupied more of the interior space, leaving only a narrow ambulatory around the sides and back, not a spacious, open interior like the Altar of the Twelve Gods. The altar itself in the Samothracian monument was also more monumental, like that of the Ara Pacis, on a raised podium with steps that even had flanking *antae*. Another closely related monument, and nearer in date to the Ara Pacis, is the late Hellenistic altar of Dionysos on the island of Kos. Here too the altar was narrowly enclosed by a surrounding wall, but one that had applied sculpture, as well as thick pilasters at the four corners of the enclosure, as on the Ara Pacis. The enclosure also had a second, rear entrance, apparently a later addition, although it is uncertain when this was done, and whether it imitated the structure of the Altar of the Twelve Gods or even the Ara Pacis.[106]

In his more recent survey of the Hellenistic traditions behind the Ara Pacis, Borbein has also stressed how even the decorative details depended most immediately upon Greek precedent. The lattice pattern on the lower interior wall of the enclosure is closely paralleled by the decoration of the dado zone on the enclosure around the altar of the later Artemision at Ephesos.[107] The garlands above the lattice on the Ara Pacis, as indicated earlier, also have numerous and precise forerunners on Hellenistic altars, and not only on those of the monolithic, cylindrical type, but also among altars of a more monumental scale. Borbein had briefly speculated on the analogy between the Ara Pacis and the garland decoration from the altar of Poseidon and Amphitrite at Tenos, but the evidence was still too fragmentary to deduce much.[108] Now that the Tenos altar has been thoroughly published and reconstructed, Borbein's intuition has been substantiated, like Thompson's suggestion on connections between the Ara Pacis and the Altar Court at Samothrace. On the Tenos altar, each facade of the altar table was decorated by reliefs of boukrania hung with rich polycarpous garlands brimming with pinecones, laurel, grain ears, flowers, and various fruits, precisely like those on the Ara Pacis enclosure (cf. fig. 40 and fig. 55a).[109]

Borbein is surely correct to argue that mimetic features like the lattice work or the garlands on the Ara Pacis do not simply replicate contemporary Roman cult equipment; they are not just imitations of a provisional wooden enclosure hung with real festoons and paterae, as scholars have argued and still do from time to time.[110] Even though such lattices or festoons may still have been in common use during the Augustan period, they had long been transposed into the ornament of Greek marble altars, and it was the mediating tradition of such established altar construction and decoration that provided the direct inspiration for the planners of the

Ara Pacis. The new reconstruction of the Pergamene altar slabs proposed here further confirms Borbein's argument. It demonstrates in the same way that the floral compositions and imagery on the exterior of the enclosure are not simply replicas of textiles with acanthus ornament hung over a putative wooden enclosure, and still less are they an ornamental transposition of the real vegetation that may originally have been planted all around this enclosure.[111] They too follow the paradigm and format of monumental altar decoration current among the Greeks in the preceding centuries.

Nevertheless, the evidence of the earlier Greek material is still too fragmentary and spotty to recover the process of adaptation in any definitive way. For example, it looks as if the designers of the Ara Pacis transposed to the altar enclosure modes or formats of garland and tendril decoration which were normally applied to the body of the altar itself (cf. figs. 40–41 and 55a). But forerunners with enclosure walls like the altar of Dionysos at Kos are rarely preserved, and even here the enclosure and its decoration barely survives, so one can deduce little about how these portions of Greek altar complexes might once have been embellished. Yet it would be surprising indeed if Hellenistic enclosures of this kind had not already come to be decorated in relief with garlands of some sort.

In the case of the polycarpophoric acanthus ornament, however, the evidence for such a transposition is more substantial. The identification of the Pergamene slabs as the lateral components of an altar certainly offers new evidence in support of Moretti's hypothesis that the sides of the Ara Pacis altar were originally decorated with elaborate acanthus tendrils, like the barriers above (cf. fig. 9 with fig. 53).[112] But the ornament of the Ara Pacis altar barriers is very different in style from that of the enclosure: it is heavier in proportion and more abstract or stylized in the treatment of acanthus detail, in the manner of Classical acanthus ornament or the classicizing derivatives of such ornament still current in Neo-Attic art. Nor do the altar barriers of the Ara Pacis display any naturalistic plants or flowers. Assuming that the ornament of the altar would have been uniform, it is therefore unlikely that the decoration on the *antae* beneath the barriers originally included the polycarpophoric format that we see on the Pergamene altar. Thus, although the planners of the Ara Pacis knew and used the polycarpophoric Pergamene tendril ornament, they applied it only to the enclosure, opting instead for an Atticizing approach on the altar itself. On the basis of surviving evidence, this seems a novel touch, but one cannot be absolutely certain that the Pergamenes had not already applied their distinctive ornament to the decoration of altar enclosures.

The planners of the Ara Pacis seem to have drawn eclectically upon a wide array of sources covering various regions and periods. The Athenian or Attic tradition is certainly clear, and hardly surprising, but the

evidence also points to substantial connections with the Aegean islands, and nearby western Asia Minor, above all in the configuration of the altar and its latticed articulation. For the form of the altar itself in the Roman monument, the new reconstruction by Etienne and Braun of the Altar of Poseidon and Amphitrite on the Cycladic island of Tenos furnishes a particularly instructive precedent. There we see a similar emphasis on an imposing stepped podium with flanking *antae*, and a similar massing, even though the Tenos altar is proportionally wider, with a more gradual ascent (cf. figs. 1 and 8 with fig. 55b). Nevertheless Etienne and Braun have stressed the details that distinguish the Ara Pacis altar from the canonic *in antis* type exemplifed by the one at Tenos—the lower *antae* with separate lateral barriers, and the lack of a parapet at the rear of the altar table, a structure which they see as exceptional or unique.[113]

But these features are not unique; they are, as indicated earlier, precisely those of the altar comprised by the matched slabs from Pergamon, whose structure thus emerges as highly distinctive and unparalleled, like its ornament (cf. figs. 1, 8, and 54). Here analysis of the architecture fully corroborates what can be deduced from the decoration of the slabs, underscoring the special role that Pergamene precedents played in the making of the Ara Pacis. In terms of the whole ensemble, Etienne and Braun see the Ara Pacis essentially as part of the western Asiatic tradition of monumental altar complexes, a circumstance that they too emphasize as entirely consonant with the Pergamene connections long attributed to its decoration.[114] Their observations find a striking confirmation in the new identification of the Pergamene slabs as literally the closest extant parallel for the architecture of the altar proper of the Ara Pacis.

The impact of these various precedents should also be seen in a larger context that transcends the Augustan period. The Roman assimilation of ornamental modes that evolved in Pergamon goes back well into the Late Republic, as the following section will demonstrate, and many of the Greek features or details of the Ara Pacis have analogies in earlier Etruscan or Roman art as well. The latticed treatment of the enclosure interior already appears on late Archaic stone *cippi*, as Borbein noted.[115] Moretti pointed to the analogies between the stepped altar podium with *antae* and the examples already attested in the Archaic sanctuary discovered at Sant'Omobono in Rome.[116] The two-zoned, superimposed arrangement of the outer friezes on the Ara Pacis enclosure also has good parallels in the painted terracotta plaques and wall paintings of Archaic Etruscan tombs.[117]

Yet the two-zoned structure also appears on the second-century Altar of Athena at Priene. There the upper storey utilized intercolumnar statues rather than reliefs, but the overall monument type and technology are much more immediately relevant to the Ara Pacis than the Etrus-

can works, and much closer in time. And the same applies to the various other Italic parallels for the Ara Pacis. What such local analogs indicate, rather, is an indigenous substratum that would have been favorable to the assimilation or perhaps the re-assimilation of such ideas under the stimulus of new, officially sponsored contacts with Greek monuments and strategies of imagery in the Augustan period. The analogy posed by the various precedents in Greek monumental altar construction and decoration must be considered collectively, for it cannot be fortuitous that so many salient features of the Ara Pacis are traceable to such a source.

In the case of the Pergamene altar reliefs, their original religious setting and function must have been an important factor in the impact that they exerted on the planners of the Roman monument. Thus it is essential to ask what cult or deity in Pergamon this altar served. There is, of course, no longer any conclusive way to determine the original context or site of the altar; the removal of the slabs to the mosques of Turkish Bergama eliminated all direct evidence of their ultimate provenance. Still, there are indications in their decoration: the metonymic imagery of divine concord or *homonoia* as an expression of the bounty associated with Eirene or Peace, an imagery that would have been ideally suited to the needs of those charged with designing the Ara Pacis Augustae.

But in spite of this, it is unlikely that these reliefs are the remains of an "Altar of Attalid Peace," a *Bomos Eirenes Attalides*, for there is no hard evidence that such a cult ever existed at Pergamon.[118] In Attic tradition Eirene was conceived as a subordinate or adjunct of Eleusinian cult, as we saw earlier, and there are clear indications that the Attalids followed Athenian precedent in their own attempts to project an image as the new guardians of Hellenism through public and religious monuments.[119] At this stage, therefore, Peace would still have been a conception tied closely to the cult of Demeter and the allied divinities; hence the Pergamene altar would have been most appropriate as a subordinate feature of the cult of the other, Eleusinian deities depicted on the slabs, whose worship at Pergamon is better attested.

Thus we come to the Sanctuary of Demeter. There the excavations revealed the remains of a series of five altars arranged symmetrically across the eastern courtyard and aligned with the central axis of the temple (fig. 56). Portions of the main altar itself (Altar A) survive, including the voluted crestings and an inscription which dates it to the reign of Philetairos (281–263 B.C). Only the tufa foundations of the other four altars (B–E) are extant today, and these appear to be even earlier. Since the axis that runs through the center of altars B–E diverges by about half a meter from the midpoint of the main altar or altar A, Bohtz has argued that the latter replaced an earlier altar contemporary with the other four, which would all then have belonged to a previous phase of the sanctuary (fig. 56).[120]

Yet amidst the destruction, altars B–D show evidence of later remodelling although virtually nothing of their superstructure survives.

It is tempting to think that the additional altars in the sanctuary were dedicated to other deities or concepts associated closely with the Eleusinian sphere. The remains of one of these, altar D, is about two-and-a-half meters square and would have served nicely as a tufa foundation or core for the stepped podium of the marble altar reconstructed here (fig. 56). In this connection, it is interesting to note that the marble altar podium of the Ara Pacis also had a tufa core.[121] A marble end block finished on three sides with upper and lower molding was found not far away from altar D and was tentatively attributed to the superstructure of these foundations by the excavator, Dörpfeld, but this is uncertain; its proportions also correspond to the foundations of altars B and C which were not far off.[122] Considering the extensive disruption that the ruins of this sanctuary later underwent, one ought not to place much stress on the precise find spot of any given fragment.[123] Thus the superstructure of altar D remains unknown, and perhaps it was here that the matched slabs once stood as part of a later remodelling of the altar. There was renewed building in the sanctuary in the reign of Attalos I or Eumenes II, when the surrounding colonnades with *oikoi* were added by Queen Apollonis. Such a date would not be out of keeping with that proposed for the matched slabs themselves.[124]

Later sculptural embellishments of the Demeter Sanctuary added in the Roman imperial period included friezes with the poppies and wheat ears traditionally associated with Demeter, along with motifs more appropriate to Dionysos—grapevines and clusters flanking wine kantharoi as well as cornucopiae brimming with grapes and vine leaves.[125] This mixed imagery may well be a continuation of an earlier decorative program emphasizing Demeter's ties to her male counterpart Dionysos, and maybe also to other deities associated with Eleusinian traditions. Ohlemutz repeatedly emphasized the "pantheistic" quality that the Demeter Sanctuary assumed in Roman times, through the addition of smaller altars at the periphery of the complex dedicated to other divinities.[126] If the altar to which the decorated slabs belonged also stood in this sanctuary in the Hellenistic period, it would have provided a striking precedent of this kind.

But wherever the altar stood originally, its cultic association of Peace with Concord or *homonoia* would have been particularly resonant during the reign of Eumenes II, in the earlier second century.[127] Eumenes had three able brothers, especially Attalos, who might all have attempted to seize power for themselves. Yet his regime was not marred by the internal dynastic strife that plagued the other Hellenistic kingdoms, even though foreign competitors like Rome deliberately atempted to foment

such disunity.[128] Polybios (XXXII,7,6–7) commented upon the extraordinary way in which Eumenes maintained the loyalty or obedience of his brothers. Similarly, their contemporary, Phillip of Macedon, in exhorting his sons to work together for the good of their kingdom, could do no better than to praise the relations between Eumenes and Attalos literally as a paradigm of *homonoia*.[129] In a very real sense such earthly political concord could be understood to mirror and respect the harmonious unanimity among the gods to explain and celebrate the prosperity of the Pergamene kingdom. In a climate such as this, the altar with its various divinities and the staff of Eirene herself would indeed have been the monumental, cultic Pergamene equivalent of the Roman coins and propaganda of the Late Republic that asserted peaceful Concord through the somewhat different image of the clasped hands with the caduceus. On this level, one can appreciate even more the enormous possibilities and advantages that an altar of this sort would have posed as a precedent to the planners of the Ara Pacis Augustae.

The Animal Inhabitants— Polytheriotrophic Tendril Ornament

The preceding discussion has concentrated on the polycarpophoric aspect of the imagery of divinely sponsored abundance central to the floral friezes of the Ara Pacis. But the designers of the monument also opted to include recognizable species of another kind amidst the undulating sprawl of tendril ornament—the tiny forms of animals who inhabit the lush, stylized vegetation. These are very different from the large swans that repeat symmetrically and prominently across the upper level of the composition; they represent instead a whole other order of natural life whose visual impact was less immediate and far more subtle. Like the various plants and flowers grafted onto the tendrils themselves, the presence of these little animals has been noted often in the literature on the monument, but here too, mostly in passing, without due emphasis on their scope and distribution within the floral friezes.

Probably the most familiar instance of these creatures on the Ara Pacis is the group or "scene" beneath the left side of the large acanthus calyx in the north frieze. There a snake is about to prey on a nest of baby birds, one of which is attempting to escape (fig. 4, A; fig. 23). On the opposite side under the calyx sits a frog (fig. 4, B; fig. 24). Slightly higher up two lizards scamper over the fronds of the calyx itself (fig. 4, C and D; fig. 25). The corresponding portion of the south frieze is missing, but in the well-preserved left end more of this imagery continues. Beneath the lowermost tendril volutes there is another lizard (fig. 3, A; fig. 26). Further up

to the left are two perching birds, and the one on the right is nibbling the cluster of grapes (fig. 3, B and C; fig. 15). Higher still, to the right, is a butterfly poised on a leaf of acanthus (fig. 3, D; fig. 27).[130]

Unlike all the vegetal inclusions except the rose, this array of tiny animals also extends to the rectangular panels of the east and west facades of the Ara Pacis. On the west, virtually nothing of the original lefthand panel beneath Mars remains; the panel beneath Aeneas, however, is almost entirely intact. There, at the top of the acanthus calyx, in the angles between the large leaves and first two volutes rising above them, are a snake on the left and a lizard on the right (fig. 5, A and B; figs. 28–29). In the upper right corner just below the swan is a small bird (fig. 5, C).[131] The panel beneath Roma is more richly outfitted. Near the bottom of the central calyx there is snake on the right and a lizard on the left (only the head is original) (fig. 6, A and B; figs. 30–31). At about the same level in the middle of the calyx there is a damaged figure of a bird who is just about to devour the tiny grasshopper directly below (Fig. 6, C and D; fig. 32). Just above the calyx more birds sit atop the thistles to either side of the central stalk. The two on the right thistle peck at the vegetation (fig. 6, F). The one on the left whose head is missing confronts another grasshopper, who, like the one below, is about to become a bird's dinner (fig. 6, E; fig. 33).[132]

However, the most extensive concentration of these animals occurs on the panel beneath the so-called "Tellus" relief, where nearly all the types attested in the rest of the friezes reappear.[133] At the bottom of the calyx on the left and right are a lizard and a snake, with a grasshopper down below in the center, as on the opposite panel beneath Roma (fig. 7, A–C; figs. 34, bottom center, and 36). But here there is also another frog like the one beneath the north calyx (fig. 7, D; figs. 36–37). Over on the right there is a scorpion, while further up on the left another snake slithers out of the foliage (fig. 7, E–F; figs. 35 and 38). A bit higher up, the grasshopper and pair of birds atop the thistles recall the panel beneath Roma, and on the right just below the main tendril there is a large snail (fig. 7, G–I; fig. 39, center and upper left).

Like the corresponding vegetal inclusions, these animals and insects are varied in number and placement. Even where they appear in compact distributions—around the central acanthus calyces—there is no strict symmetry. Lizards correspond to snakes, snakes and birds balance frogs, etc. (fig. 34), and when the animals are the same, like the two lizards on the north calyx, the precise placement and pose of each is very different (fig. 4, C and D). The damage within each long frieze is too extensive to determine whether there were any overriding repetitions in the choice and placement of the animals comparable to those between the two panels on the east facade. But even on the east, the differences between

the animals in the left and right panels are striking. Here as well, this variation was a deliberate attempt to impart a dynamic natural quality to the friezes, entirely comparable to the use of the real plants and flowers emphasized earlier, and it is therefore likely that the animals were just as important or significant as the vegetal inclusions.

Yet as iconographic components, scholars have taken the tiny animals even less seriously than the naturalistic plants. Even in his extensive monograph, Moretti did not address these details in more than the briefest terms, with little or no reference to the various illustrations in his text, where most of these details are visible.[134] And in the drawings by Bonserini and Paoloni which he reproduced in his figs. 119–122 and tav. X (here, figs. 3–4 and 5–7), few of these animals are indicated with any clarity. Elsewhere in the literature on the Ara Pacis, the animal inclusions have fared little better; scholars have cited them generally as components of the decoration, as they have the plants like the ivy, the grapevines or the laurel. Even Kraus's detailed study of the floral ornament could do no more than mention three such creatures amidst the whole ensemble. Nor has there as yet been any attempt to consider the artistic background or derivation of the animals in the floral friezes, or the evidence that this might provide toward their interpretation.[135]

Nevertheless these tiny denizens too follow Greek precedent, a tradition of "theriotrophic" floral ornament in which the tendril supports or nourishes animals. Birds were, certainly, a common feature of tendril compositions from the Archaic period onward, and at times other creatures like rabbits and grasshoppers or butterflies also appeared.[136] But larger arrays of such animals, and especially the reptiles, amphibians, and insects can be paralleled only in the later Hellenistic period, at Pergamon and the nearby regions of Asia Minor. It should not be surprising that the menagerie of the Ara Pacis friezes is traceable largely to the same artistic milieu which invented the use of realistic plants as components of acanthus decoration, but it is important to recognize from the outset that the Pergamene or western Asiatic monuments which utlize the animals in this way belong to different media than the examples with polycarpophoric ornament. Such animals are nowhere attested in the Pergamene reliefs discussed above, or, for that matter, in any Pergamene stone sculpture; they occur instead in Pergamene mosaics, and in the decorative silver and ceramic tableware of Asia Minor.

The most monumental example of this kind is the tendril border of the famous mosaic from Palace V signed by Hephaisteion.[137] The surviving portions include three grasshoppers and one butterfly (fig. 62a–b). The treatment of these details is very much like that in the Ara Pacis friezes, even allowing for the difference in medium, hardly surprising considering that tendril ornament in this mosaic has long been emphasized as one

of the closest stylistic parallels to the Ara Pacis.[138] The particular analogy between the tiny insect denizens in both works, however, has provoked no comment. The tendril in the mosaic border is carpophoric rather than *poly*carpophoric, so far as the extant portions indicate; the only recognizable vegetal inclusions are a large cluster of grapes just below one of the grasshoppers and round fruits which could be apples or pomegranates (fig. 62b).[139] The little animals do, nevertheless, occur in a polycarpous context at Pergamon, amidst garlands rather than tendrils. In another mosaic from Palace V in the so-called "Altargemach," the decoration consists of rich garlands filled with fruits and wrapped with tainia like those on the Ara Pacis interior. Here too much has been lost; less than three of the original six swags remain. But in the middle of one, a bird sits perched on a thin twig ready to devour a butterfly (fig. 63, lower right).[140]

The inclusion of small animals or insects in acanthus compositions was current in late Hellenistic metalwork as well. Among the lush leaves and tendrils worked in relief across a silver bowl of unknown provenance now in the Toledo Museum, there are bees along with birds and a butterfly like those in the Palace V mosaiacs.[141] Such imagery appears in even richer form on a splendid pair of silver bowls from the Civita Castellana hoard now in Naples.[142] Like the Toledo bowl, the ornament on the ones in Naples consists of a rosettelike arrangement of acanthus leaves alternating with rounded lotus or "nelumbo" petals containing additional acanthus tendril patterns. But the eight nelumbos on the two Naples bowls actually enclose little scenes in high relief against the chiselled tendril ornament. These include snakes, birds pecking at butterflies, lizards and bees, and lizards attacking frogs (fig. 64 a–c). Here the particular handling of the action—the coiling of the snakes, the momentary stasis of the frog, the sudden twists of the lizards—comes especially close to the dynamic naturalism of the corresponding imagery on the Ara Pacis friezes (cf. figs. 28–34 and 36–38).

Unlike the monumental remains of relief sculpture and mosaic pavements, however, the origin or attribution of this metalwork is uncertain, despite the evident ties to the Pergamene material. Pfrommer's new study has confirmed the Alexandrian background of the basic decorative format and typology of such bowls, since the radial arrangement of nelumbo petals goes back to Egyptian and Achaemenid Persian metal vessels whose ornamental traditions remained current under Ptolemaic rule.[143] Bowls of this kind were also produced in the faience and sandwich glass techniques which are most at home in Alexandria.[144] Cheaper ceramic versions, the so-called "Megarian bowls," were manufactured in great quantity at various centers throughout the Hellenistic Greek regions during the third and second centuries B.C.[145] But the more precious silver examples are rarer, and thus their distribution is too limited to deter-

mine centers of production securely as specialists have been able to do for the ceramic types.

In the case of the Civita Castellana bowls, clearly imported to Italy from the Greek East, Pfrommer has recently argued for a Seleucid origin, although scholars have tended to attribute them to Pergamon or Asia Minor.[146] In either instance these attributions have been based primarily on the stylistic affinities which the bowls and the accompanying finds from this hoard share with sculpture from Pergamon and other sites. But there is evidence of a more archaeological nature that can be brought to bear here—the ceramic analogs for such bowls found in Asia Minor and the nearby Greek islands. In his definitive treatment of such material recovered in the excavations at Delos, Laumonier has conclusively attributed the bowls of the so-called "Ionian" atelier to workshops established on the nearby Asiatic coast, at sites like Ephesos.[147] The bowls of this kind produced by the potter Menemachos are among the finest and earliest, probably of the mid second century B.C., and it is these that compare rather closely to the contemporary silver counterparts from Civita Castellana and the one in the Toldeo Museum. They share not only the rosettelike arrangement of acanthus and nelumbos common within the entire "Megarian" class, but also the distinctive treatment of the "historiated" nelumbo, i.e., as a frame for smaller patterns or scenes containing birds and frogs like those on the Civita Castellana bowls. Other examples of this kind have butterflies hovering above the acanthus leaves outside of the nelumbos, as on the Toldeo silver bowl.[148]

It is clear that Menemachos imitated metalwork originals precisely like the Civita Castellana and Toldeo bowls; other metal vessels of this type from Egypt, the Seleucid regions, South Russia, Thrace, and Greece lack the distinctive scenes of frogs, birds, lizards, and snakes within the nelumbos.[149] And so the connection between the Ionian ceramic adaptations and the bowls in Naples and Toledo should be recognized as quite specific and therefore meaningful. It is of course possible that the potter had access to exotic Seleucid or Alexandrian prototypes, or perhaps to plaster casts of such prototypes like those found at Mit Rahine near Memphis.[150] But it is also significant that only the western Asiatic Megarian bowls utilized this animal imagery, not those of other Hellenistic centers. It therefore seems likley that in this regard Menemachos emulated the more immediately accessible toreutic art of his own western Asiatic surroundings, and thus the Civita Castellana and Toledo bowls would appear then as local prototypes of just this sort. This is all the more probable in view of the analogous use of insects in the tendril ornament of mosaics attested archaeologically at Pergamon.

Taken together, the cumulative evidence of the mosaics, the metal bowls, and the derivative ceramic vessels demonstrates that yet another

major element of the Ara Pacis friezes originated ultimately in Hellenistic Asia Minor, if not in Pergamon itself. Like the polycarpophoric elaboration of the acanthus tendril, Greek works utilizing the decorative format of the tendrils nourishing and sheltering an array of birds, insects, amphibians, and reptiles appear only among the monuments of Pergamon and as portable objects whose origin in nearby Ionia is demonstrable or likely. Such "polytheriotrophic" floral ornament, as it may be termed— that which nourishes all sorts of animals—was a very special case of the inhabited vinescroll with a distinct geographic currency, one that largely overlapped or coincided with the distribution of the corresponding polycarpophoric tendrils bearing many fruits. Even though they do not occur simultaneously on any of the Pergamene monuments that have come down to us, both modes originated together in the same locale or region.

Yet despite this common origin, only the polytheriotrophic variant of Pergamene tendril ornament seems to have had an immediate effect upon the decorative arts in late Hellenistic Italy. Although the Pergamene tradition of polycarpophoric tendril ornament was of seminal importance to the program of the Ara Pacis, it does not at present appear to have made any impact in Italy before the Augustan period, at least not in the medium of sculpture. Among the corpus of Late Republican reliefs with vegetal decoration assembled by Kraus and Börker, there are "carpophoric" examples which include real plants or fruits, but they are limited to grapevine, ivy, and poppy, and never more than two such plants at any one time.[151] As indicated earlier, there is nothing particularly Pergamene about the more limited inclusions of this sort; they are common enough in Neo-Attic works from mainland Greece, Italy, and Pergamon itself.[152]

The situation is radically different, however, if one turns to Late Republican pavement mosaics and wall painting, and to the polytheriotrophic mode of tendril and garland ornament; in this case the material from the First and Second Style domestic decorations at Pompeii alone is impressive. The acanthus tendril border of the Fish Mosaic from the early Second Style tablinum in the House of the Faun is inhabited by the winged erotes, a butterfly, and a grasshopper precisely like those of the Hephaisteion mosaic; at one point an eros grabbing the wings of a butterfly precisely replicates the treatment of this theme in the Pergamene work, as Pappalardo has observed (cf. figs. 62a and 65a). There are also birds, a grasshopper, a snail, a running dog, a rabbit, and even a tiny mouse (fig. 65 a–c).[153] The approximately contemporary border around the Mosaic of the Doves from the house of the same name has a similar array of creatures, but inhabiting a garland wrapped with a helical tainia instead of a running tendril. There are grasshoppers, a mouse, a butterfly, and snails; at one point a bird is about to nibble at a snail (fig. 66 a–c).[154]

Such imagery appears even earlier in painting, like the First Style frieze in Oecus 44 at the House of the Faun.[155] Unfortunately the little of this frieze that survives is badly faded, and it has deteriorated since the published photographs were made. But one can still discern the form of an undulating tendril so richly laden with flowers, fruit, and foliage, that it looks more like a garland. Beneath the lush vegetation a lizard scampers along the ground with a grasshopper behind to the right (fig. 67); further up to the left is large peacock. In the area above the tendril to the right a butterfly hovers above the flowers followed by a flying bird. And though only a short interval of the frieze remains, it includes several recognizable fruits or plants; grape clusters hanging above the peacock and lizard, a pomegranate below the flying bird, and ivy just above its wings (fig. 67).[156]

Closely related but better preserved is the extensive painted tendril decoration in the well-known Room of the Mysteries at the Villa Item, which constitutes the focus of Pappalardo's recent study. This frieze ran above the Second Style *megalographia* for which the Room is named, and it is perhaps the most elaborate inhabited acanthus tendril that has survived from before the Roman imperial period. In addition to the veritable army of little erotes carrying torches, tympana, wine vessels, cistae mysticae, or playing flutes, the frieze contains rabbits and dogs running about, birds, butterflies, grasshoppers, and lizards (fig. 68 a–b).[157] In addition to these plants, the main acanthus calyx of the frieze also emits sprays of ivy (fig. 68a, top left). Although a generation or more later than the other Pompeian works of this kind, it includes most of the same animals all together in one continuous composition.

Collectively these mosaics and paintings document the clear impact in late-second- to mid-first-century B.C. Italy of the distinctive modes of floral decoration current somewhat earlier in Pergamon and the nearby regions. Indeed, Deubner long ago emphasized that the imagery of the Palace V mosaics was reflected directly in the high quality First and early Second Style pavements at Pompeii, particularly those in the House of the Faun, and more recently his opinion has been confirmed by the careful studies of Börker and Pappalardo.[158] Pappalardo has especially stressed the close and specific analogies between the borders of the Pompeian Fish Mosaic and the Hephaisteion pavement. In the case of the Dove Mosaic at Pompeii, the main scene itself is assumed to be one of a number of such that replicate a renowned prototype at Pergamon (cf. Pliny, *Natural History*, XXXVI,184).[159] All these analogies are in fact too specific and unusual to be fortuitous; Pappalardo was therefore justified in seeing the border of the Fish Mosaic from the House of the Faun and the tendril frieze from the Villa Item as reflections of a single Pergamene

artistic conception, perhaps not traceable to the workshop of the mosai-
cist Hephaisteion himself, but certainly to the highly specified genre of
floral ornament of which Hephaisteion was a major exponent.[160]

Yet this network of relationships should be expanded to include the
painted frieze from Oecus 44 in the House of the Faun, which Pappalardo
unfortunately neglected; and it is finally time to consider the evidence
that all these Pompeian works can bring to bear on the later use of such
imagery in the Ara Pacis friezes. Stylistically, Kraus considered the frieze
in Oecus 44 to be entirely within a peninsular Italian tradition going back
to the delicate Greek floral ornament typical of Apulian vase painting,
architectual reliefs, and later Hellenistic Etruscan terracotta revet-
ments.[161] But his judgment ignored the inclusion of the various animals
and plants, for with the exception of the butterfly, these have no prece-
dent in the Italiote Greek and related Etruscan material.[162] Like the ani-
mals in the various other Pompeian works, their presence points instead
to Pergamon or western Asia Minor.

The combination of the animals in this painted frieze with grapevine,
ivy, and pomegranate is also rather significant. So far as we know, this is
unparalleled in the Hellenistic Greek forerunners of such decoration; in
this mixture of multiple fruits and animals, the tendril freize in Oecus 44
is the only known precedent for the Ara Pacis. A similar anomaly obtains
in the case of the snails, dogs, mice, rabbits, and the peacock that inhabit
the flora in the Pompeian mosaics and paintings; they too have no precise
analogy in the available material from Pergamon or the related Asiatic
metalwork. Here, however, this might appear less relevant since the snail
is the only one of the latter features that recurs in the Ara Pacis friezes, in
the panel below Tellus (fig. 39).

Yet the problem assumes a different dimension when one considers
another work closely related to the tendril friezes of the Ara Pacis, the
sculptured door frame of the Eumachia building in Pompeii, which
Zanker has tentatively associated with the very workshop that produced
the Altar of the Augustan Peace.[163] For there, in addition to the various
birds, reptiles, insects, and snail encountered on the Ara Pacis, one also
finds the mice, rabbits, and even the peacock of the Pompeian mosaics
and paintings (fig. 61a–b). Parts of another similar marble door frame,
unfortunately unprovenanced and now in the Metropolitan Museum of
Art, include the lizard and birds of the Ara Pacis, and also a winged eros
like those in the Hephaisteion mosaic and the Pompeian pavements and
paintings.[164]

There are basically two explanations for this chain of relationships. It is
possible that the more extensive array of animals in the Italian material
represents a Roman elaboration of Pergamene or western Asiatic prece-
dent, one which occurred initially in the media of mosaic and painting

towards 100 B.C. and the following decades, and then spread to relief sculpture during the Augustan period. The other possibility is that the Italian works all reflect a Hellenistic tradition that was more varied and complex than what we see in the few surviving monuments of this kind on Greek soil, however high their quality. The former explanation would portray the Italian development more as an imaginative, synthetic adaptation of inherited ideas, a model certainly plausible for the Augustan period. Yet this apparent process of elaboration did not begin then, but as much as a century earlier, for it is in late Hellenistic Pompeii that we first encounter such imagery in Italy. Thus the question turns more on the nature of Italian art at this earlier stage, and there, the evidence for a highly free and innovative use of these Greek modes of ornament is less compelling.

The First and early Second Style decorations in the House of the Faun betray the taste of a sophisticated, Hellenized elite with an avid appetite for the kind of art cultivated in the Hellenistic courts. Nor was such taste at all local to Campania; the entry point for artistic ideas from the Greek East was Rome itself, as von Hesberg has argued in the case of the round altars with polycarpous garlands that became current across Late Republican Italy.[165] The Pergamene impact at Pompeii should be seen in the same terms, as the reflex of a larger process reaching back a generation or more to the time when, in the wake of the Attalid bequest, quantities of Pergamene art were transported to Rome and auctioned off in the Forum. This, along with the booty taken by the Romans in Asiatic campaigns, literally flooded Italy with the sort of metalwork discussed just above; the bowls in the Civita Castellana hoard are a case in point.[166] This process included sculpture, paintings, and mosaics, not to mention the Greek artists themselves who flocked to the new imperial capital as the old networks of Greek patronage in the East gradually collapsed. Where the supply of earlier Greek originals could not meet the Roman demand, Greek artists were more than willing to fill the gap.[167]

Certainly none of this precludes the opportunity for innovation as these artists came to adapt their traditions to the interior decor of a wealthy Roman clientele; but at this stage we should expect such changes to have been more in the way of new contexts or uses for certain categories of imagery, shifts of themes from one medium to another, etc., rather than fundamental alterations in the nature of the imagery itself. Here one must also bear in mind that this interior decor was not only derivative or retrospective, but also overtly replicative. Thus a painting of Alexander's victory at Issos could become a pavement mosaic, and thereby a work of Roman rather than Greek art. Yet the immediate composition and content of the painting itself did not presumably alter, and in cases like the name piece from the House of the Doves, one is dealing with an outright copy

or a close transcription that did not even involve a shift in medium or context. From this perspective, it does not seem likely that works such as the border of the Fish Mosaic and the painted frieze in Oecus 44 in the House of the Faun or the tendril frieze in the Room of the Mysteries were new elaborations of the artistic repertory that had been available to artists like Hephaisteion in Pergamon; it seems rather that they were simply adaptations of a wider array of such Greek precedent produced to satisfy the needs and tastes of Hellenophile Italian patrons.

The conclusion that follows from this should by now be apparent. The polytheriotrophic mode of tendril ornament originally current in second-century Pergamon was far richer or more varied than the surviving representatives of this genre in the Palace V mosaics or the Civita Castellana bowls. It encompassed the entire range of what we see in the Pompeian pavements and wall paintings. And it was this fuller Pergamene or western Asiatic tradition that informed the designers of the Ara Pacis and the somewhat later sculptured doorways. In the light of this, even the relation between the Ara Pacis friezes and the sculptured doorways assumes a new importance since the latter clearly reflect the whole array of imagery that was available to the designers of the altar. Together with the earlier Pompeian material, the door frames offer the same sort of evidence for the animals that the British Museum silver cups and the Vatican marble chariot provide for the use of additional plants or fruits on the Ara Pacis, suggesting that there may even have been more such creatures in the parts of the friezes that are missing today.

One need not push this evidence to the limits; there may not once have been running dogs, or peacocks among the Ara Pacis tendrils. Nor is it likely that there were erotes like the one on the Metropolitan door frame. Had such anthropomorphic inhabitants appeared, there would have been more of them scattered about in repetition as they are on the Pergamene and Pompeian forerunners, and some should then have turned up in the extant parts of the floral friezes. Clearly the designers of the altar approached this tradition selectively and judiciously. But there could easily have been mice or small rabbits, just as there were probably more realistic plants—grain ears, pomegranates or pine—growing from the tendrils themselves.

In much the same way the combination of the polytheriotrophic and polycarpophoric modes of tendril ornament in the frieze from Oecus 44 at the House of the Faun may also constitute precious and unique evidence that both types of decoration had not remained entirely distinct in Pergamene art. The Oecus frieze certainly shows that the planners of the Ara Pacis were not the first to combine both these modes. Yet is it likely that these painters were responsible for this innovation, or is it possible that the Asiatic Greek artists whose work they imitated had already fused

both modes? If the frieze of Oecus 44 is indeed the product of a direct assimilation of Asiatic Greek precedent in late-second-century B.C. Italy, then it could be that tendrils bearing multiple fruits or plants existed not only in Pergamene relief sculpture, but also in mosaic or painting, or perhaps conversely, that some Pergamene reliefs included the various tiny animals along with the plants. And if the rich array of animals and plants had already been combined in Pergamene sculpture, then the designers on the Ara Pacis might not even have been the first to do this in marble or stone.

In sum then, the Pompeian monuments discussed above are absolutely crucial in appreciating the artistic factors that conditioned the design or formulation of the program of imagery on the Ara Pacis. But their value is not limited to clarifying the extent of the Hellenistic Greek background here; they are also indispensible to our understanding of the meaning or sense of polytheriotrophic floral decoration. Onians has attempted to explain the use of various distinct animals and plants in floral ornament as a particular manifestation of a larger trend in Hellenistic art and literature which began to accord new importance to themes and subjects previously regarded as inconsequential, a kind of cult or fascination with the small or trivial.[168] His theory is attractive in the case of works like the *asaroton* or "Unswept Floor," or the marine potpourri of the Fish Mosaic, but does such an assessment apply to the flora and fauna of the tendril compositions as well? We have already seen the evidence for interpreting the vegetal inclusions of this kind as metonymic symbols capable of evoking the benefits and pacific blessings of the leading fertility deities. Yet once we see the animal inclusions or inhabitants in such decoration as an integral part of the very same artistic development, the possibility then arises that they too functioned in such metonymic terms. Just as the various vegetal inclusions of Pergamene tendril decoration were specialized emblems alluding to the gods who controlled earthly wealth and renewal, the animals too may have served to signify the manifold powers of specific life-sustaining divinities.

To some extent the context or function of the Greek precedents themselves supports such an interpetation. In the case of the bird and the butterfly on the swag in the mosaic from the "Altargemach" in Palace V, the garland decoration functioned within a larger ensemble that was entirely Dionysian. At the top of the mosaic were two splendid dramatic masks (unfortunately no longer preserved). And as its name suggests, this room served as a cult space, where the altar proper projected into the center of the chamber, flanked on either side by the panels with the masks (fig. 63).[169] The particular cult here is likely to have been that of Dionysos Kathegemon, or "the Guide," as he was worshipped at Pergamon. In this aspect, Dionysos was revered as the special progenitor

and guardian of the Attalid dynasty, and so his cult within the palace itself seems highly appropriate.[170]

The grasshoppers in the nearby Hephaisteion mosaic may be interpreted along the same lines on the evidence of an earlier parallel in metalwork, the gold diadem from the region of the Hellespont in the Metropolitan Museum. There, to either side of the central acanthus calyx that supports figures of Dionysos and Ariadne holding thyrsoi, two grasshoppers perch with birds along the tendrils that also include maenads playing lyres and flutes (fig. 69). In view of the origin and date of this work, the use of the grasshopper as a Dionysian symbol in tendril ornament appears to go back to the very beginning of the Hellenistic period.[171] The Hephaisteion mosaic also provides internal evidence for a Dionysian interpretation of the grasshopper and perhaps for the butterfly as well, since the tendril sprouts a large, leafy grapevine with succulent grape clusters on the bottom border (fig. 62b). Even on its own, the inclusion of the grapevine here was a powerful Dionysian metonym; a somewhat later Neo-Attic relief from Pergamon similarly spews forth vines and grape clusters, but in this instance playful satyrs and a sleeping maenad or perhaps Ariadne herself inhabit the tendrils as well, verifying the symbolic function of the grapevines above.[172] Grape and/or ivy vines also appear in the acanthus tendril ornament on a number of Hellenistic silver drinking vessels, where such imagery should allude most immediately to Dionysos.[173] The Civita Castellana bowls with their lizards, frogs, snakes, and butterflies among the tendrils were also wine vessels, along with the derivative ceramic examples manufactured by the potter Menemachos.

Collectively at least, the original Hellenistic forerunners of polytheriotrophic tendril and garland ornament provide a reasonable indication that such imagery was often associated with Dionysos, a life-giving fertility deity *par excellence*; moreover, the specifically cultic application of this imagery in the "Altargemach" mosaic underscores its religious connotations. Thus it is not surprising that the Italian monuments which first assimilated the innovations of this Pergamene or western Asiatic floral ornament fully corroborate this interpretation. At the House of the Faun, the lizard, grasshopper, and butterfly in the Oecus 44 frieze occur in tandem with both of Dionysos's plants, the grapevine and the ivy (fig. 67). In the Fish Mosaic the grasshoppers, rabbit, mouse, snail, and butterfly all move across tendrils that originate from the symbolic Dionysian kraters; for added emphasis, the red interiors of these vessels clearly indicate wine, and one of the erotes plays the *diaulos* or double flute characteristic of the Bacchic *thiasos* (fig. 65). The garland in the border of the Dove Mosaic that nourishes the snail, grasshoppers, and butterfly is puncuated at the four corners and in the center of each side by eight Dionysian masks (fig. 66). In the Room of the Mysteries, the Bacchic significance of all these

animals along with the ivy clusters and erotes holding wine vessels, tympana, and *diauloi* in the tendril frieze hardly requires comment, especially after Pappalardo's meticulous analysis of these elements.

All the same, it would be premature to conclude that the allusive potential of this array of animals in such a decorative format was limited to Dionysos alone. In the case of the frieze at the Villa Item, Pappalardo has also stressed the inclusion of elements symbolic of Aphrodite—the small templelike incense burner or *thymiaterion* carried by one of the erotes, and the rabbits that symbolized sexual arousal and procreation (fig. 68a, section A 13). He suggests further that in the *megalographia* below, the female figure across whose lap Dionysos reclines is not Ariadne, but Aphrodite or Venus, who was worshipped closely in connection with Dionysos in Campania.[174] The shoulder ornament on an Apulian lekythos tends to corroborate this reading of the rabbits; there two hares chase after birds beneath a tendril composition that sprouts a winged adolescent Eros.[175] Thus it is worth considering that the various other animals of this kind alluded not only to the life-engendering powers of the pre-eminent male fertility divinity, but also perhaps to a major female goddess (or goddesses) of this kind as well.

There is in fact more evidence to support this interpretation, but here one must leave the realm of floral ornament in the strict sense and extend the discussion to decorative allegorical landscape, another genre that depicted animals in their natural habitat, and often with a greater emphasis on the predatory element. Imagery of this kind is well represented in early Roman imperial silver and ceramic imitations. A pair of cups in the Pierpont Morgan Library is among the finest of examples. There large cranes feed on snakes and butterflies. On several analogous cups from the Boscoreale treasure, the cranes feed on grasshoppers as well as snakes, while various other insects and rodents cavort across the ground. The cylindrical cup (no. 13) from the House of Menander at Pompeii is a cruder but related example.[176] Here again the function of such vessels as drinking equipment suggests the Dionysian connection of such imagery, but the specific plants included in the scenes on the silver indicate something more. On the House of Menander cup the marshy setting also sprouts wheat ears and poppy, species hardly appropriate to a swamp. The Morgan cups do away entirely with the reeds; there the wheat and poppies alone comprise the vegetal setting. On the Boscoreale cups there are some poppy capsules, but most of the plants in the background there seem to be blooming roses. A roughly contemporary marble relief from Falerii Novi depicts the same imagery in monumental form.[177] There, too, cranes and other birds feed on insects in a lush, marshy setting that sprouts poppies and wheat ears like the Menander cup, and roses at the center like those on the cups from Boscoreale. The choice of plants in all

these works is fairly consistent and does not appear to be casual. The
wheat and poppy are allusions to the bounties of Demeter or Ceres just as
the roses allude to life-giving Aphrodite or Venus. And thus the animals
in these depictions were meant to be understood in similar terms as the
products and beneficiaries of the great fertility godesses.

But perhaps the association of the animals with the vegetal attributes of
more than one goddess was meant to suggest an even larger construct,
one that encompassed yet another female divinity closely associated with
fertility and renewal—Mother Earth herself, Gaia/Terra Mater or Tellus.
A more overtly allegorical work which supports this interpretation is the
silver plate from Parabiago near Milan.[178] At the bottom of the plate Terra
Mater reclines on sloping terrain embracing a cornucopia filled with
grapes while infant children play around her. Other infants, personifica-
tions of the seasons, approach laden with fruits and grain, while personi-
fications of the sea look up beneath them. Significantly though, a serpent
winds its way around the cornucopia as a lizard and grasshopper scam-
per above the gesturing infants. Although the plate is late antique, many
of these elements derive from a longstanding tradition of allegorical im-
agery going back to Hellenistic times, as the particular analogy of Terra
Mater with her counterpart on the breastplate of the Primaporta Au-
gustus demonstrates. Thus it is tempting to see the association of the
animal symbols with Mother Earth here as an ancient heritage of this
sort. Indeed a literary work many centuries earlier, the Homeric Hymn to
Mother Earth, provides a fully analogous image of the divine power be-
lieved to keep all creatures alive:

> I will sing of Gaia, mother of all, the good foundation,
> the eldest one, who nourishes all things that are upon the
> earth, all that go upon the land and move through the sea,
> and those that fly; these are nourished from your wealth.
> From you, O Mistress, come the blessings of children and
> abundant fruits; yours the power to give life or take it
> from mortal men.[179]

Consequently, the depiction of animals feeding on plants or on one
another in these landscape scenes was more than a generic evocation of
burgeoning life; it alluded more specifically to the divinities who sus-
tained the whole chain of existence, to Dionysos, to Demeter and Aphro-
dite, and also to Gaia. Final confirmation of this can be found on the Ara
Pacis itself, in the so-called "Tellus" relief, and in the artistic precedent
that may lie behind it. In this panel, a nurturing goddess actually appears
within the marshy landscape sprouting the poppies and grain ears amidst
the reeds (figs. 43). But here it is suprising to find no evidence of the birds
and insects or reptiles in predatory interaction. Only a crane stands idly

atop a fallen pitcher at the lower left corner (fig. 44). But is possible that such animal imagery was included in the sort of Hellenistic prototype that may have inspired the planners of the Ara Pacis; these creatures *do* in fact appear in another closely related work which scholars have often held to be more faithful in some regards to the original Hellenistic conception—the "Tellus" relief from Carthage. There the crane in the lower left is not isolated; instead it confronts a coiling snake as on the various silver cups, and even a bullfrog like those in the floral friezes just below Tellus (fig. 70).[180]

It is difficult to be certain why the designers of the Ara Pacis who adapted the putative Hellenistic model behind the Carthage relief did not include the snake and the frog at this point. But they may simply have decided to transpose this imagery away from the landscape itself and down into the more ornamental format of the floral friezes or panels where the little animals are of course quite prevalent. This would then explain the particular concentration of snakes, frogs, lizards, snails, grasshoppers, etc. in the floral panel directly beneath the "Tellus" relief (fig. 34); such placement may well have been a deliberate strategy that served to emphasize the "Tellurian" dimension of the animal imagery. But this logic would then bring us full circle to the male deity who was so closely associated with the decorative imagery of animal-nurturing vegetation in the Hellenistic East and Pompeii. For a similar concentration of animals appears in the central calyx of the north frieze, where they are juxtaposed not only with the poppies of Demeter, but with the profusion of lush grapevines and ivy tendrils sacred to Dionysos (fig.4, A–D).

In recognizing the dual association of this animal imagery with Dionysos as well as the goddesses, it is also important to distinguish the very different usage of the animals in either case, so far as the extant Hellenistic material enables us to judge. On the surviving monuments, the depiction of the animals as Dionysian symbols seems to have been restricted mostly to ornamental settings, i.e., they were used strictly as polytheriotrophic floral decoration, as the inhabitants of stylized tendrils. And as such they occur only in the Hellenistic art of western Asia Minor and the derivative works in Hellenistic Pompeii. In contrast, the "Tellurian" application of this imagery is documented mainly in landscape depictions. While the latter are actually works of Roman imperial date, specialists have repeatedly pointed to Hellenistic Alexandria as ultimate source of this vegetal scenery replete with animal life.[181] If this is at all correct, then in this regard alone, one must recognize the synthetic aspect of the imagery on the Ara Pacis, however clear the background and sense of the individual sources may appear.

At the outset, the introduction to this study argued in principle that the consideration of sources was vital to any real understanding of a monu-

ment like the Ara Pacis, and this extended look at the Greek artistic precedent should already have begun to substantiate such a claim. The Altar of the Augustan Peace was not simply a new beginning for Roman art; it was the summation of centuries of Greek efforts to formulate an imagery of pacific, divinely sanctioned abundance in all media of visual artistic expression—in painting, in sculpture, in metalwork, and even in the decoration of earlier monumental altars. As such, the Altar of the Augustan Peace was almost inevitably an eclectic work of art, drawing, as it were, upon any precedents that seemed to have potential for the creation of an imagery specifically suited to Augustan ideology. And so despite the dominant classicistic or Attic orientation of Augustan art more generally, the designers of this monument were more or less obliged to depend heavily upon themes, concepts, and artistic formats that had been current in the Greek monarchies during the Hellenistic period, especially in western Asia Minor and the neighboring islands, and to some extent in Ptolemaic Egypt. In a very real sense, therefore, the classicism of the Ara Pacis is really only a veneer that masks a more extensive and knowledgeable aquaintance with various Greek artistic traditions.[182]

This all certainly has a bearing upon the intelligibility of the monument. Considering the direct assimilation of Pergamene prototypes at Pompeii, and how the Pompeian works consistently retained the Dionysian sense or context of the originals right into the middle of the first century B.C., it is plausible that the artistic experience of at least some of those who viewed the Ara Pacis would have encouraged them to understand the imagery of the animals amidst the tendrils as expressions of Dionysos's power. But on the evidence of works like the Nile mosaic at Praeneste and the related nilotic pavements from the House of the Faun,[183] one must assume too that spectators of the Augustan period also knew something about the sort of "Alexandrian" Hellenistic landscape depictions ancestral to the silver cups and the Falerii or Carthage reliefs, a factor that would similarly have enabled them to discern the Tellurian connections of the animal imagery as well. Thus the synthetic range of traditions that informed the monument would hardly have made an ambiguous or muddled impression upon the knowing spectator. Instead one begins to see the richy nuanced quality that an imagery with such varied origins could convey.

But important questions remain. For even if segments of the Roman public were familiar with such Hellenistic artistic precedents because these had been adapted in the domestic decoration of the wealthy and elite, or through access to the originals displayed in private and public collections of Greek art, the planners of the Ara Pacis cannot have depended entirely upon such artistic experience to make their work intelligible to the large and varied audience for whom it was intended.[184] Nor is

it likely that many Romans of the Augustan period were directly familiar with the Greek or Pergamene architectural reliefs and monumental altar decoration known to those who designed and executed the Ara Pacis. Yet would such familiarity have even been necessary for the average spectator to have understood grapevines, ivy, and laurel as allusions to Dionysos/ Liber and Apollo, or roses and poppies as symbols of Aphrodite/Venus and Demeter/Ceres? And would an Augustan audience really need to have seen Pergamene works like the altar slabs in order to appreciate the theme of concord among such deities as a fundamental requisite of peace and prosperity? Or had these notions already been assimilated in a more cumulative and longstanding process of artistic and religious or ideological acculturation that would readily have equipped the people of Augustus's day to decode the manifold components of the floral friezes?

Consequently, it is still necessary to look more broadly at the imagery of abundance and fertility that had become widely current in Italy during the period before and after the establishment of the Principate in order to test how legible or self-sufficient the metonymic mode of signification advanced above for the floral friezes would have been to the Roman public at this time. Here it will again be necessary to turn to the evidence of earlier art and to the parallels offered by Greek and Roman literature. And in the course of this investigation, it will eventually prove possible to answer the ultimate question posed by the altar's complex imagery: how were the various borrowed Greek notions and artistic strategies assimilated to a more properly Roman or Augustan outlook and system of expression?

Chapter II

The Theonomous Tendril—Divinely Inhabited Floral Ornament in Late Classical and Hellenistic Art

The Tendril and the Goddess

The variants of floral ornament discussed so far, those that have been distinguished here as polycarpophoric and polytheriotrophic, were undoubtedly highly expressive modes of artistic signification. They were far more than pure decoration; to ancient observers they would have appeared no less meaningful than fully anthropomorphic sculptures or paintings of divinities accompanied by their vegetal and animal attributes.[1] Nor is their symbolic function even likely to have been exceptional within the larger sphere of classical floral ornament, for from the very earliest times the decorative tendril in Greek art was closely associated with divine power. This was expressed in several formats: through the figures of gods who sometimes brandished stylized vegetal motifs, through gods whose bodies fused with the tendrils in some way, or by means of deities who inhabited larger vegetal compositions of this kind.[2] The various Pergamene works with supernatural inhabitants examined above, especially the altar slabs, were the lineal descendants of this longstanding tradition, whose origins go back ultimately to the ancient Near Eastern prototypes that inspired Orientalizing and Archaic Greek floral ornament.[3]

For the purposes of the present study, however, we need not follow the

evolution of such imagery back to these beginnings, but only to Attic decorative arts of the fifth and fourth centuries B.C., and especially to the rich development that followed in Italiote Greek art during the late Classical and Hellenistic periods. The recent work of Pfrommer has thrown new light on the seminal role that the Greek regions of Italy came to play in this process as a major locus of artistic innovation whose impact was felt in floral ornament throughout the Greek world in the course of the Hellenistic period.[4] Although his studies have concentrated exclusively on the formal structure of the tendrils and their blossoms, it is nevertheless instructive to see how Pfrommer's findings are confirmed in iconographic terms as well. In the case of the Pergamene altar slabs, for example, the inclusion of Triptolemos has a striking precedent in an earlier Apulian vase fragment where enough remains to see that there too the youthful disseminator of agriculture was shown in his snake chariot in the midst of stylized acanthus ornament.[5] Thus only the polycarpophoric aspect of the tendrils on the slabs was a Pergamene innovation or elaboration; the more basic function of acanthus tendrils as symbols of the fertilizing power and blessing of Triptolemos and other divinities was an older and more widespread artistic phenomenon, and one that had long been known among the Greeks and their indigenous neighbors across the Italian penninsula.

As a result, one begins to see how readily such local artistic tradition or experience would have enabled the original audience of the Ara Pacis to make sense of the more specified floral or vegetal imagery adapted from Pergamene art. This becomes even clearer against the rather extensive background of such divine inhabitants in Italiote Greek floral ornament, especially in Apulian vase painting.[6] The range and format of these figures varies considerably. They may be male or female, and to a great extent they consist only of heads or busts emerging from the tendrils and blossoms themselves, but entire figures are not uncommon.[7] In the case of the heads, only one is identified specifically by an accompanying inscription; she is *Aura*, personification of the fertilizing breezes (fig. 74).[8] The identity of the full figures is easier to determine at times; Aphrodite's son Eros appears prominently.[9] And since the seated or flying female figures are accompanied by pairs of erotes, they have been plausibly identified as Eros's mother, Aphrodite.[10] Cases where erotes flank the female heads that emerge from the tendrils may also be Aphrodite.[11]

It was clearly this tradition of inhabited tendrils that informed the imagery on the Pergamene altar slabs, as well as other Hellenistic works in which the deity literally spews forth the stylized vegetation from its lower extremities—the so-called "grotesque." In the frieze from the Temple of Artemis Leukophryene at Magnesia on the Maeander, a goddess, apparently Artemis herself, is shown winged and crowned in a *polos* with the

lower part of her chiton transforming into acanthus leaves and tendril volutes.[12] Although there are close parallels in Greek mosaic and metal-work, especially in the later Scythian tombs, these are probably no earlier than the very end of the fourth century or perhaps somewhat later; the oldest extant examples of female figures or goddesses whose lower portions metamorphose into tendrils appear on Italiote Greek vase painting of the later fourth century B.C.[13]

Among works of the Neo-Attic sphere, there is also the remarkable architectural relief now immured in the upper right facade of the Little Metropolis in Athens.[14] Amidst a lush undulating acanthus tendril blooming with roses and other stylized blossoms, a female figure sits astride a flying swan (fig. 71). The roses immediately above her might already suggest that she is Aphrodite, but this is confirmed by an earlier Attic white-ground dish of the Pistoxenos Painter where Aphrodite, identified by an inscription, also rides a flying swan or goose, and by various other scenes of this type in Greek vase painting and metalwork.[15] On the Attic dish, the emphasis is on the goddess herself while the stylized tendril with its rose is no more than an attribute that she holds in her hand. In contrast, the Little Metropolis relief is more akin to the format on the Pergamene altar slabs or the Apulian vase paintings, where the decorative vegetation dominates the composition as a symbol of the goddess's life-engendering power (cf. figs. 71 and 47–48). In the specific case of Aphrodite, one is reminded of the terms in which the goddess portrays herself in Aischylos's *Danaides*:

> Holy heaven yearns to sting the ground
> and in passion takes hold of earth to make their wedding.
> Falling from the eager heaven, the heavy rains kiss the earth.
> And thus is born for mortal men the food of flocks
> and the livelihood given by Demeter.
> From this wetted marriage the forest attains its proper
> season. In these things, I have played my part.[16]

Here Aphrodite emerges as the force of sexual arousal basic to all pro-creation and renewal. Without her Zeus would not visit Gaia with his fertilizing showers, and Demeter then could not yield her rich grain har-vests. She is a causal factor in the larger interaction of the gods essential to all earthly renewal, and in this sense we can better appreciate how she came to acquire agrarian cultic epithets like *Eukarpos* and *Zeidoros*, "rich in fruits" and "giver of grass or wheat." Thus it is clear why she is pre-eminent among goddesses as the mistress of the stylized vegetation in the Little Metropolis relief and the related imagery of Italiote Greek art, and perhaps why her son Eros, the personification of arousal itself, ap-

pears so commonly in Greek tendril ornament from the late Archaic period onward (figs. 51, 62, 65, 68, 73).[17]

The old catchalls—"inhabited vinescroll," "peopled scrolls," or "grotesques"—customarily applied to ornament of this kind appear entirely inadequate as a descriptive terminology or means of classification. Just as it was necessary to formulate the terms "polycarpophoric" and "polytheriotrophic" in order to distinguish or characterize the supportive and nourishing function of the tendril with regard to the various plants and little animals, something more is needed to describe the inclusion of divinities or their lesser agents as the controlling power behind the surrounding stylized vegetation so redolent of life and prosperity. The tendril compositions containing such deities may most appropriately be termed "theonomous," since it is the authority or power of the accompanying gods that they truly symbolize and celebrate. Like the other terms developed here, this one is not mutually exclusive. Works like the frieze from Oecus 44 in the House of the Faun could be simultaneously polycarpophoric and polytheriotrophic. And in the same way, either type of tendril ornament could be "theonomous" as well, if it also included figures of the gods or their paracletes, such as Nike and Eros (cf. figs. 47–48 and 50–51).

Considering the rather extensive currency of theonomous tendril ornament in Italiote Greek art, it is not surprising that this class of decoration penetrated Etrusco-Latin arts to the north and remained current in central Italy down through Late Republican and early Augustan times. Terracotta temple revetments or friezes like those from Arezzo, Falerii and Cerveteri with heads blossoming forth from the tendrils are directly descended from the earlier Italiote Greek traditions, as various scholars have noted.[18] Indeed the period of transition from the Late Republic into the Principate witnessed a virtual explosion in the popularity of such "grotesque" decoration in public and private arts. The marble reliefs from the Temple of the Divine Julius in the Roman Forum with Nikai or victories whose lower portions turn leafy and spew tendrils document the continuation of this format into the Second Triumvirate, although here the Neo-Attic qualities of the style may indicate the admixture of other non-local models. In this case recent scholarship has emphasized the specific significative function of this decoration on the temple; the divinely inspired abundance expressed the connection of Caesar and his heir with their divine ancestress, Venus.[19]

A similar blending of artistic traditions is still discernible in the floral terracotta or "Campana" reliefs of the early imperial period. On one in the Louvre, Eros stands in an acanthus calyx flanked by spiraling tendril volutes (fig. 73).[20] The more abstract geometry and heavier proportions of

the tendril itself betray the taste for classicizing Neo-Attic floral orna-
ment, yet the overall composition and the more mature or pubescent type
of Eros directly recall the format and Aphrodisian preoccupation of
Apulian tendril compositions in vase painting and architectural reliefs.[21]
On another relief of this kind, a winged female deity, perhaps Artemis or
Diana in archaistic dress, similarly occupies a pattern of stylized tendrils
which are actually close in style to those on the Ara Pacis; yet another
shows multiple winged deities or victories standing atop a longer repeat-
ing tendril pattern analogous to the Divine Julius reliefs.[22] Pairs of such
figures appear seated on the tendrils in the paintings of the lefthand *ala* in
the House of Livia on the Palatine; in the paintings from cubiculum B in
the Augustan villa found beneath the Farnesina Gardens, this concept is
Egyptianized, with the goddess Isis as mistress of the tendrils.[23] But how-
ever receptive they may have been to exotic artistic ideas, first-century
B.C. Italians seem to have clung to a local tradition of theonomous tendril
iconography that literally went back centuries; at times the derivative
Campana plaques reproduced exactly the head-in-tendril format of
Apulian vase painting.[24]

Against this background, there can be little doubt that spectators of the
Augustan period were still very much conditioned to think of floral or
vegetal ornament as a manifestation of divine power, and especially that
of female fertility deities. This is critically important considering that the
planners of the Ara Pacis broke decisively with the overtly theonomous
format of earlier floral ornament. As indicated earlier, there is no reason
to believe that the floral friezes ever included victories, erotes, or the like,
even though these were common enough in the floral decoration of Late
Republican Italy and earlier Augustan art, and even in the very Per-
gamene works that inspired the polycarpophoric and polytheriotrophic
imagery on the Ara Pacis.[25] What we have instead on this monument is a
more radical form of metonymic allusion that relied on the popular reli-
gious or folkloric association of various plants and flowers, and probably
the animals as well, in order to attune the spectator to the profound con-
tent or associations of the floral friezes.

However, the lower friezes and panels of the enclosure exterior may
not really be devoid of theonomous components, for in addition to the
plants and tiny creatures dispersed across the tendrils, there is another
order of inclusion that has so far not been discussed—the twenty swans
that originally perched at intervals atop the tendril friezes all around the
monument (figs. 2–7). Unlike the other animals treated in the preceding
chapter, the swans were not incidental to the formal structure of the ten-
dril composition. They were much larger, more readily visible, and corre-
sponded fully to all the dominant symmetries and rhythms of the
undulating vegetal matrix that supported them. Nor were they a feature

of the Pergamane or western Asiatic forerunners of the Ara Pacis; they had a different source, and concomitantly, a different meaning or function.

The work to which scholars have always turned as an analog for the swans on the Ara Pacis is the famous gilt silver relief amphora from the rich Scythian burial at Chertomlyk (fig. 88c).[26] There too a number of birds occupy a larger matrix of undulating tendrils generally similar to those of the floral friezes. But there is another work related in style and perhaps in origin to the amphora that provides a much more immediate comparison for the swans of the Ara Pacis, and a key to their iconography as well. This is a Hellenistic decorated bronze mirror frame in the Metropolitan Museum said to come from Bulgaria (fig. 72). The main pattern consists of classicizing acanthus tendrils sprouting flowers and palmettes much like those on the Chertomlyk amphora, but arranged as a running circular frieze. Among the birds in the tendrils are the prominent figures of four swans or geese, and, as on the Ara Pacis, their poses and placement are closely integrated with the rhythmic symmetry of the supporting tendril.[27]

Fortunately, the very function of this object indicates why the birds were included on it. As a mirror, an implement for personal adornment or beautification, this work relates directly to the sphere of Aphrodite, especially since this goddess figured prominently, maybe even dominantly, as a theme in the decoration of late Classical Greek bronze mirror cases.[28] And as we have seen in the relief on the Little Metropolis and the related imagery in Attic and Apulian vase painting, the swan or goose was closely associated with Aphrodite, and with Eros. Here it is particularly significant that Aphrodite is even shown riding the swan on some Greek bronze mirror cases.[29] Thus the use of the swan or goose on the Metropolitan piece within a tendril composition was essentially a metonymic variation or abbreviation of the more standard type of Greek mirror decoration, and also of the type of floral imagery in the Little Metropolis relief where Aphrodite herself accompanies her swans and rides one of them (cf. figs. 71–72).

The evidence of the Metropolitan mirror affords a new perspective on the Ara Pacis swans, which, to some extent, may also have served as attributes or symbols of Aphrodite/Venus. It is important to remember the longstanding role of Aphrodite in Italiote Greek floral ornament, where at times the goddess and Eros even appear riding or accompanying the swan surrounded by tendril ornament.[30] The swan-riding Aphrodite or Turan was also known in Etruscan art.[31] Neo-Attic sculpture of the late second and first centuries B.C. like the Little Metropolis relief provides another avenue through which the Romans of this period would have become familiar with this kind of imagery. Nor is the Metropolitan

mirror a piece of Greek exotica remote in time from the experience and
sensibilities of the Augustan Rome. In their careful study of this piece,
Richter and Alexander were able to determine that it was a mechanical
copy (a lost wax casting) of an earlier work made originally in repoussé
technique. Like the Mit Rahine casts, the actual piece could date from late
Hellenistic or Roman times.[32] It may well have been antiquarian replicas
of this type that also helped to familiarize first-century B.C. Romans with
the late Classical or Hellenistic imagery of Aphrodite and/or her swans
amidst tendril ornament.

The conception of Aphrodite that informed the verses of Aischylos's
Danaides cited above was also adapted or elaborated for Roman consump-
tion toward the middle of the first century B.C. in the opening of Lu-
cretius's *De Rerum Natura*:

Mother of Aeneas and his line, beloved of men and gods,
nourishing Venus, who, beneath the orbiting signs of heaven,
makes the seas full with ships and the lands full with fruits,
since through you every kind of living thing is conceived
to rise up and look upon the light of the sun,
it is you, you, O goddess, whom the winds flee, the clouds
of heaven run from you and your advent, for you Tellus (Earth)
with wonderous skill sends up sweet flowers. For you the broad
seas laugh, and a pacified heaven beams with light diffuse.
For as soon as the Springlike aspect of the day is disclosed,
and the Aura (Breeze) of fruitful Favonius (the West Wind)
blows in thriving freedom, the creatures of the air first signify you
and your coming, divine one, their inner spirits awed by your power.
Then the wild beasts dance through the fertile pastures
and swim across swift-running waters. Held captive by your charm,
each follows wherever you may lead.
Indeed, throughout the seas and mountains and rapacious rivers,
through the leafy dwellings of the birds and green fields,
Inspiring the breasts of all with enticing Amor (Love),
with desire you cause them to propagate their race in kind.
And therefore, since you alone govern the nature of things
since without you nothing arises into the shining regions of light,
without you nothing fertile and lovely is made,
I am eager to have you as my ally in writing these verses
which I endeavor to compose upon the nature of things.[33]

Here too Venus is the force that inspires and incites all procreation and
renewal, especially the flora and vegetation put forth by the Earth or
Tellus. Just as Aischylos enables us to grasp the sense of the life-inspiring
power celebrated in the Little Metropolis relief or in the Metropolitan

mirror, Lucretius similarly provides a glimpse of how the Romans of Late
Republican and early imperial times would have perceived the swans of
Venus in the friezes of the Ara Pacis, especially since he tells us that the
creatures of the air heralded the fertilizing advent of the goddess.[34] This
is all the more likely since the conception of Venus as cosmic genetrix
continued in Augustan times, as Ovid demonstrates in the *Fasti*:

> She indeed sways, and well deserves to sway the world entire;
> she owns a kingdom second to that of no god;
> she gives laws to heaven and earth, and to her native sea,
> and by her inspiration she keeps every species in being.
> She created all the gods—'twere long to number them;
> she bestowed on the seeds and trees their origin.[35]

Venus also figured as a major component in Augustan religious and
dynastic propaganda, where she was not only the progenitress of all life,
but specifically the genetrix of Aeneas and the Julian line, a theme very
much in evidence in the figural reliefs of the Ara Pacis.[36] More recently,
the importance of this Augustan dynastic genealogical lore alone has
prompted Büsing to explain the swans on the Ara Pacis in connection
with Venus.[37]

Most scholars, however, interpret the swans as prophetic symbols of
Augustus's patron deity Apollo and the coming Golden Age.[38] There is
indeed ample literary and artistic evidence to demonstrate that the swan
was also the sacred bird of Apollo, and perhaps that it was assimilated to
Aphrodite from the Apolline sphere, as Simon suggested.[39] Because of
this, and because of Augustus's ceaseless efforts to associate himself with
the protection and blessing of both these deities, the swans in the Ara
Pacis tendrils may well have been intended to do double duty as symbols
of Venus *and* Apollo. But the specific evidence of earlier floral ornament,
as we have seen, suggests that Roman spectators of this period would
most readily have associated the swans of the floral friezes with Aphro-
dite/Venus, for in the context of decorative tendrils, the swan appears
exclusively as her bird, not Apollo's. And even on an Attic vase of the
early fourth century B.C. where both deities appear together at Delphi, it
is Aphrodite rather than Apollo who rides the swan.[40] In Latin literature,
too, the swan was well known as an attribute of Venus.[41] So even if the
swans on the Ara Pacis functioned as Apolline symbols, they must have
alluded at least as much to the goddess of life and procreation.

In either case, however, the functional difference between the swans
and the various plants, flowers, or tiny animals in the lower portions of
the tendrils begins to emerge more clearly. Even as allusive metonyms
which stand by themselves for either Venus or Apollo, the swans are still
fundamentally distinct from the roses and laurel that bloom along the

north and south friezes or the panels of the west facacde. They are not simply products or attributes of the sort that a deity might hold or hover over. In contexts where Aphrodite and Apollo ride the swan, these animals have agency. They aid, accompany, and support the god or goddess like Eros or Nike; indeed, in one Pompeian painting from the House of the Ship, Venus flies astride the winged shoulders of Eros precisely as she would the swan.[42] Thus the swans are really most comparable to the anthropomorphic paracletes or intercessors who served the greater gods, and in this sense they function in the floral ornament on the Metropolitan mirror and the Ara Pacis precisely like the erotes or victories who inhabit the stylized vegetation of earlier Greek and contemporary Roman art. Consequently, the tendril compositions of the Ara Pacis are indeed "theonomous." They signify the power of specific divinities not only through their metonymic vegetal and animal attributes, but through the immediate presence of the *daimones* who implement the will and authority of the gods—the swans of Venus and Apollo.

The specifically paracletic function of the swans in the tendril compositions actually seems to be underscored by the appearance of this creature, or possibly a goose, in the upper zone of the altar enclosure, on the left side of the so-called "Tellus" panel (fig. 43).[43] Here again the bird is an overt servant or agent of divinity, supporting a goddess in flight, but its precise relation to the earlier Greek iconographic tradition discussed above is complicated enormously by the interpretive problems that have long surrounded this relief. The motherly central figure or *kourotrophos* has been identified with various leading Greco-Roman fertility goddesses —Tellus, Venus, or Ceres—and more recently with Eirene or Pax herself, and now even the identity of the lateral figures on the swan and sea-serpent is disputed.[44] *Communis opinio* has tended to see them as *aurae velificantes*, divine personifications of breezes, which, along with the standard identification of the central figure as Tellus, seems to have a very neat parallel in Horace's *Carmen Saeculare*:

> May Tellus, burgeoning with fruits and cattle
> crown Ceres with a wreath of wheat.
> May the healthful waters and Aurae of Jove
> nourish our crops.[45]

Nevertheless, the history of Aura's iconography in earlier Greek and Roman art is a rather brief subject. Nor, within the rather limited material that remains, does there seem to have been a fixed conception or format used to represent the goddess of the breeze; only two securely identified examples of Aura have survived, and these are both quite different. One, mentioned earlier, on the neck of a mid-fourth-century Apulian krater, shows Aura's head, crowned in a polos, emerging from the central blos-

som of an acanthus tendril pattern (fig. 74). However, on a Lucanian sky-
phos of the late fifth century B.C., the goddess sits on a rock overlooking
the sea, with her name inscribed in a billowing veil behind her.[46] This
may perhaps have been the more customary way of representing Aura
since Pliny (XXXVI,4,29) mentions a pair of statues in the Hall of Octavia
at Rome, presumably Greek, which depicted two Aurae as *velificantes*,
i.e., with billowing cloaks.[47] This latter format is more immediately rele-
vant to the lateral figures of the Tellus relief, but it can hardly explain the
rest of their iconography. There is no solid evidence that Aura had previ-
ously been shown riding a swan, sea-serpent, or any other creature, or,
for that matter, hovering in flight.

Scholars have by now come to appreciate the highly synthetic or com-
posite aspect of the entire Tellus panel, but it is important to recognize
that even the individual elements of the relief like the "Aurae" are them-
selves deliberate amalgamations of different earlier iconographic types.
In the case of the flying swan or goose that supports the lefthand figure,
there can be little doubt that this was derived from the long-established
imagery of Aphrodite examined above. Aphrodite was the goddess tradi-
tionally depicted astride the swan, and at times even bare-breasted like
the figures on the Ara Pacis panel.[48] The format of the one at the right,
seated atop a sea-monster or *ketos*, is typical of Nereids or sea-nymphs,
but it too points to Aphrodite. As a sea-born goddess Aphrodite also
appeared riding marine monsters on Greek gems and in derivative Ro-
man wall painting.[49] Here it is interesting to note how often the swan-
riding Aphrodite in Greek vase painting and metalwork coasts over
marine environments or leaping dolphins.[50] The *velificans* motif is less
of an indicator since it was used for a wide range of figures, including
Dionysos and his maenads, Selene, Nereids, and fleeing or panic-stricken
women.[51] But it too is rather common in representations of Aphrodite,
especially where she appears riding her swan or *ketos*.[52]

La Rocca, who favored an Alexandrian origin for the iconography be-
hind the Tellus panel, has suggested that the flanking figures of the pro-
totype may originally have been Horai or Seasons, and that these were
adapted as Aurae on the Ara Pacis.[53] More specifically, one thinks of
Ptolemaic allegorical works like the Tazza Farnese or derivative Roman
counterparts like the silver plate from Aquileia, where the figures of De-
meter/Isis and Mother Earth are surrounded or accompanied by the
seated, standing, or reclining Horai (figs. 58–59). Here it is tempting to
see the "Aurae" of the "Tellus" panel in part as fusions of the male *velifi-
cantes* or wind gods and the reclining, partially draped Horai on the Tazza
(figs. 43 and 58).

Consequently, whatever the specific identity of the lateral figures on
the Tellus panel, it appears that their iconography or formal morphology

was reconfigured to put the spectator in mind of Aphrodite or Venus. Rizzo, and Moretti with him, believed that the swan-riding format had already been adapted to the representation of Aura by the late fifth century, citing the didrachms of Kamarina as proof. Accordingly, Rizzo interpreted the swan-riding *velificantes* who appear in the Augustan or early imperial "Campana plaques" as Aurae too (fig. 75), an identification that is still sometimes accepted.[54] But Von Rohden and Winnefeld identified the figures on the Campana plaques generically as a goddess, and the identification of the figure on the Kamarina coinage is hypothetical at best. Recently Delivorrias has suggested that these coins may depict Aphrodite herself, and this is certainly more probable in the case of the Campana plaques as well.[55]

Generally speaking, such terracotta reliefs were a replicative medium; they consisted largely of copies or free adaptations of contemporary or earlier works in other media, and often marble reliefs.[56] But considering the clothed upper torso with the "slipping garment," and also the cloth-bound coiffure, the Campana plaques with the swan-riders do not appear to depend on the Ara Pacis panel itself. In these details they correspond more directly and specifically to earlier Greek representations of Aphrodite (figs. 75 and 71). Moreover, even in their fragmentary state, the Campana plaques indicate that decorative tendrils also figured within the composition. On the one from the Esquiline Hill, the blossom even appears to be a stylized rose, recalling the accompanying tendrils and flowers on the Pistoxenos Painter's dish or the Little Metropolis relief (cf. figs. 71 and 75). This is all to be expected. Given the eclectic, retrospective nature of this Roman terracotta industry, it seems more likely that the plaques would draw upon the varied and well-established tradition depicting Aphrodite in this way, rather than that of Aura, whose earlier iconography, as a swan-rider at least, cannot even be securely attested.

Nor is Rizzo's interpretation of the Kamarina coins or Campana plaques as Aura crucial for the identification of the lateral figures in the "Tellus" panel. The evidence of the skyphos and the statues mentioned by Pliny is sufficient to show that seated *velificantes* of this sort could in some sense be understood as personifications of breezes.[57] But if the Campana plaques do indeed represent Aphrodite or Venus, then they demonstrate something far more important—that the swan-riding imagery of this goddess formulated in earlier Greek art was familiar to Romans of the first century B.C. in an accessible, mass-produced or popular form. It is possible that the type of bronze mirror cases depicting Aphrodite in this way were still known to Roman metalwork collectors, and if not as originals then through the medium of mechanical copies of the sort described earlier. One may also speculate about the extent to which monumental Greek paintings showing Aphrodite on the swan or marine

creatures would have been accessible to Romans of this period in private
or public art collections. The Campana plaques, however, when seen as
depictions of Aphrodite, provide tangible evidence that spectators of the
Ara Pacis would undoubtedly have understood the apparently novel Ve-
nusian aspect of the figures at the sides of the "Tellus" panel, and that the
planners of the monument could have anticipated such experience.

Thus it seems that Simon was long ago correct to interpret the compos-
ite imagery of the "Tellus" panel as a conscious attempt on the part of the
designers to instill the depiction of the Aurae with the qualities of Aphro-
dite or Venus.[58] This is especially likely because the connection between
Aphrodite or Venus and Aura is also well attested in Greek and Latin
literature. In Euripides' *Bacchae*, 837–839, it is Aphrodite who fertilizes the
land of Attika with *metrias anemon auras*, "the gentle breezes of the
winds." In the poetry of Hellenistic Alexandria, Aphrodite was even
given the epithet *Zephyritis*, "of the West Wind."[59] The passage from Lu-
cretius quoted just above demonstrates how thoroughly the Romans as-
similated this tradition, for there too Venus has power over the *Aura
Favoni*, "the Breeze of the West Wind." For Ovid as well, it is Venus who
sends the *faciles auras ventosque secundos*, "the gentle breezes and favorable
winds."[60]

However, it is Pliny who provides the real key to the Greek and Roman
lore associating Venus with the winds and breezes. Twice he tells us that
the West Wind (Zephyros/Favonius) was believed to inaugurate the
spring and open the soil for planting.[61] Yet ultimately, the power to open
up and initiate new life in the spring belonged to Venus, as Ovid, *Fasti*,
IV,85–90, notes, and spring was, of course, traditionally the season of
Aphrodite or Venus.[62] Pliny therefore helps to correlate the evidence of
Ovid and the other literary sources attesting to the goddess's power over
the winds. But there is even more, for Pliny goes on to explain how Fa-
vonius was the fecundating, generative breath of the universe, essential
to the process of animal and vegetal procreation, a characterization that
directly mirrors the cosmic, generative conception or function of Aphro-
dite/Venus so dominant in the passages from Aischylos and Lucretius
already cited.[63]

At another point Pliny goes into greater detail regarding just how the
terrestrial air currents were believed to have such an effect, in the case of
plants, at least. In describing the activity of the *ceriales auras*, the "fertiliz-
ing breezes," he explains that the gnawing of tiny insects helps to open
up apertures in plants, thereby allowing the Aurae to enter more easily.[64]
Perhaps this offers some added insight toward the specific inclusion of
insects on the tendril friezes of the Ara Pacis and their Greek forerunners.
But most of all, it renders the apparently anomalous image of Aura
amidst the tendrils on the Apulian krater perfectly intelligible. For there

we see literally the process that Pliny describes, with Aura penetrating the aperture of the plant or blossom as a life-engendering force (fig. 74). Since this particular depiction of Aura was a variant of a more wide-spread Italiote Greek decorative format often used to depict Aphrodite, it is likely that here too the penetrating power of the breeze was meant to be seen as an adjunct to the superior cosmic force stemming from the goddess of love and procreation.[65] Thus it was this generative, initiatory aspect of the winds and breezes that caused them to be seen as a function of the greatest genetrix, Aphrodite/Venus. In view of this goddess's privileged position within the ideologoical framework of Augustan religious propaganda, it therefore becomes clear why the designers of the Ara Pacis amplified the established tradition of Aura as a *velificans* with additional elements drawn from the Aphrodisian iconographic repertoire.

This does not, however, oblige us to see the central *kourotrophos* of the "Tellus" relief as Venus herself, as some scholars have insisted, for there are too many features of the composition that relate to other goddesses as well. The lapful of fruits and nurturing attitude toward the playful infants correspond to the iconography of Terra Mater or Tellus such as we see it on the breastplate of the Primaporta Augustus. And although students of the Ara Pacis have noted that the seated pose of this *kourotrophos* does not agree with the reclining posture established for Terra Mater, we know little of the Hellenistic background of such imagery. If the "Tellus" relief on the Ara Pacis and the closely related Carthage example do indeed depend on a Greek prototype depicting a seated Gaia or personification of the region of Alexandria, as Torelli and Stucchi have recently argued, then these objections would be groundless. Other Tellurian elements are the sheep and cow seated at the figure's feet. On the plate from Aquileia, which has repeatedly been claimed to reflect Ptolemaic precedent, a similar reclining cow appears next to Gaia or Tellus. The remainder of the composition here is unfortunately lost (fig. 59); perhaps it once contained the sheep.[66]

Nevertheless, there are features of the "Tellus" panel that point in still another direction. The rather prominent poppy capsules and ears of grain that spring up just to the left of the *kourotrophos* are primarily symbols of Demeter or Ceres, especially when shown together as they are here (fig. 43). And once again terracotta plaques of the "Campana" type enable us to gauge how readily an audience of the early imperial period would have understood these plants as attributes of Ceres, for they depict a bust of Demeter springing up from the earth with serpents coiling round her arms as she brandishes the emblems of her power—bunches of poppies and ears of wheat.[67] Indeed the plaque shows the goddess much as Theokritos centuries earlier imagined her amidst the threshing floor, "holding wheat sheaves and poppies in either hand."[68] Ceres also appeared on Late Republican coins grasping wheat ears.[69]

The vegetal crown with wheat ears that appears on the *kourotrophos* of the Ara Pacis is yet another characteristic attribute of Demeter or Ceres (fig. 43). Around the late second century or early first century B.C. this format appears on the well-known bust of Ceres from Ariccia where the overall classicizing treatment provides a rather striking analogy to the head of Tellus on the Ara Pacis panel.[70] In addition, the wheat crown occurs repeatedly for busts of Ceres on Late Republican coinage from the end of the second century right into Augustan times, following Greek numismatic precedent. Ceres also appears crowned in wheat on the early Augustan marble Urna Lovatelli and on a derivative Campana plaque of Julio-Claudian date.[71] In connection with such usage, Augustan poets like Tibullus, II,1,4, portrayed her with a crown of wheat; in Tibullus, I,1,15, she bears the title *Flava Ceres*, "golden- or grain-haired Ceres," recalling Demeter's Greek epithets, *Stachyostephanos* and *Stachyoplokamos*. To the extent that the lateral figures may incorporate something of the iconography and semantic charge of Horai, they too impart a Cerean or Eleusinian quality to the depiction, for Demeter was well established as a *horephoros* in earlier literature and art.[72] Here it is also worth noting that the imagery of one of the Horai, Peace, had progressively assimilated various attributes of Demeter/Ceres.[73]

The eclectic range and nature of iconographic components incorporated in the "Tellus" relief are undoubtedly responsible for the diverse identifications of the central goddess and her flanking acolytes as Tellus, Ceres, or Venus, accompanied by Aurae, Horae, or nymphs, etc. Yet in its very essence this eclecticism tends to preclude any one identification, and more recently attention has focused on the highly fluid, multivalent or polysemantic aspect of this imagery.[74] Here the mixed iconography could reflect the religious syncretism that brought about close connections between the cults of Tellus, Ceres, and Venus among the Romans; indeed literary sources often assert the equivalence or identity of these goddesses.[75] But the motives of the planners and such religious belief may have addressed a further connection among these deities, one that was central to the conception of Peace.

For, unlike the identifications specifically as Venus, Ceres, or Tellus, the attempt to see the central goddess of the Ara Pacis panel in some sense as Pax herself does not really require us to impose a single identity upon this complex and synthetic depiction. It is perhaps disturbing to suggest that the planners of a carefully worked-out monument like the Ara Pacis would confront the viewer with an imagery of female divinity that lacked sufficient closure. In reality, however, the use of a multivalent or polysemantic iconography may have been the most effective way to evoke the divine concord synonymous with Peace in the Greek and Roman view. It may therefore be pointless to dispute whether the goddess is Peace herself, or an amalgam of elements that constituted Peace. And here again,

the planners of the Ara Pacis seem to have taken their inspiration from the sort of Greek precedent embodied in the Eleusinian Pelike and the altar slabs from Pergamon (figs. 47–48, 57).

The goddesses whose iconography had been collectively resynthesized in the "Tellus" relief were identical or closely related to those depicted or alluded to on the Pelike or the slabs—Demeter, Aphrodite, and Rhea/Kybele or Gaia. On the Ara Pacis as well, the overriding issue would have been the *homonoia* or *concordia* among these deities that was essential to pacific bounty and abundance. As an allegory of cooperative interaction or Concord among the great goddesses, the "Tellus" panel conveyed the religious construct that had been fundamental to the concept and visual expression of Peace for centuries. The planners of the Ara Pacis worked on a larger scale; they separated the actual figures of the divinities emphatically from the tendril composition, and in the "Tellus" panel they attempted to fuse them in a way that expressed the highly integrated conception popularly accorded to these goddesses as a group. But the emphasis on divine cooperation was the same, and it was this that was so essential in depicting the concept of Peace.

On the Pergamene altar, where Peace was as yet an adjunct of Eleusinian religious veneration, there had been no need to show Eirene herself; it required no more than the kerykeion to signify the pacific condition that resulted from *homonoia* among the gods of abundance, or conversely, the abundance that the gods could effect when Peace existed (fig. 49). To the designers of a Roman monument in the first century B.C., and one now dedicated specifically to a cult of Pax Augusta, however, Peace had to be something more than an absent, metonymic presence. At the very least she had to be personified somewhat more corporeally in the form of the divine cooperation expressed in the "Tellus" panel, and for the ancient observer, there may well have been little or no effective difference between such collective allusion and the actual depiction of Pax herself. From this perspective, Pax would not have required a fixed or established iconography for the Augustan public to take the meaning of the panel with the benign *kourotrophos*; even as a relatively novel visual construct, the pacific presence or identity of the panel would have been readily intelligible.[76]

Nor must we assume that Roman spectators, like the planners, should have been familiar with the Pergamene altar or something like it in order to have perceived how the message of the panel would have resounded through the tendril friezes below. At the very least, the use of some of the same plant and animal attributes or metonyms in both zones would have provided an effective cue, and in any case an Augustan audience would have been highly capable of assimilating such imagery on their own terms. They had long become used to tendril ornament as an emblem of

divine power; they had adopted the Greek lore of divine floral and animal attributes; and they were well accustomed to the idea that terrestrial blessing depended not on any one deity, but on a number of gods whose relation or interaction was as crucial as their favor individually. Like the Greeks before them, the Romans of Augustan and later times also understood Concord as a basic adjunct or prerequisite of Peace; they too would have understood bountiful Peace in terms of the harmonious cooperation of the gods who supported the prosperity and stabilty of the Augustan regime (see Chapter I, pp. 17–22). For any spectator of the period attuned to the notion of a bountiful new order, this long-accumulated religious and artistic experience would have been ample preparation for absorbing the imagery of divinely sanctioned Peace that unfolded ornamentally across the looming expanse of stalks and volutes brimming with the gifts of Rome's heavenly protectors.

Theonomous Tendril Ornament and Dionysos/Liber

The imagery of goddesses loomed large on the Ara Pacis, not only in the allegorical scenes of the east facade, but amidst the floral friezes as well, in the form of the roses throughout the south, east, and north facades, the poppies and oak on the north, and perhaps the wheat at some point, too. Yet what of the male divinities? There are of course the swans so often associated with Apollo, although, as indicated earlier, they must also have functioned as Venusian symbols. In addition, there are very likely two branches of laurel in the north frieze (certainly one), and these are readily intelligible as Apolline references. Still, if this were all, it would hardly compete with the collective attributes of the fertility goddesses. There is, however, considerably more, for the plants of Dionysos/Liber also appear. This is to be expected, considering the many parallels between the Ara Pacis friezes and the Pergamene altar slabs, since there too Dionysos and his grapevines figured prominently as a pendant to Kybele and her oak on the opposite side (fig. 48 a–c).

Indeed, on the Ara Pacis, the plants of Dionysos are everywhere to be seen. Ivy sprouts from the central stalk on the north, and above the lowermost volutes to either side of the main acanthus calyx (fig. 4, nos. 2–3; figs. 11–12). Two more clusters of ivy fill the volutes further out to the left and right (fig. 4, no. 4). At the corresponding point in the south frieze there are two clusters of ivy on either side (fig. 3, nos. 1–2; fig. 13). Perhaps the most visible vegetal inclusions of this kind are the large grapevines and clusters above the central calyx on the north frieze, and two more which appear at the left and right extremes on the south (fig. 3, no.

3; fig. 4, no. 5; figs. 14–15). Part of a similar grape cluster and tendrils still remains at the right end of the north frieze (fig. 4, no. 6). Considering that all the other grape and ivy inclusions are repeated symmetrically in both halves of each long frieze, Moretti's reconstruction of the grapevines at the left end on the north is probably justified.

The preceding discussion has stressed the uncertainty concerning what appeared in the missing portions of the floral friezes, but even so, it is difficult not to recognize the enormous emphasis placed upon Dionysian elements within the metonymic system of vegetal inclusions on the Ara Pacis. They are large and prominent; they repeat symmetrically on both halves of each long frieze, and between both long frizes as well, in a manner that cannot be paralleled for any other of the recognizable plants and flowers incorporated on the monument in this way, except to some extent the roses in the south and east panels. The concentration of the ivy and grapevine around the main stalk and calyx on the north frieze is especially striking, not only for the cumulative, multiple effect of these plants in one area, but because they are placed centrally, at the very focus and origin of the entire composition (fig. 4). None of this can be accidental, and it needs to be explained, particularly because even the Pergamene altar reliefs do not weight or underscore the Dionysian element in this way (figs. 47–48).

The reason for this emphasis transcends the immediate prototypes of the Ara Pacis; it pertains to a more fundamental and widespread conception of Dionysos that had been current among Greek and Italian peoples for centuries. Perhaps more than any other Greco-Roman deity, Dionysos/Liber was associated with the vine and even more generally with the eternal renewal of vegetal life. In Greek usage he acquired the cultic epithet of *Phloios*, the moist flowing essence that makes all plant life swell to ripe, succulent maturity.[77] Nor was this aspect unknown in Italy. Augustine (*City of God*, VII,21), paraphrasing a lost work of Varro, describes more generally how Liber was believed to have power over moist male seeds, literally as the seminal fertility behind earthly regeneration.[78] To the Greeks he was also *Auxites*, "the Augmenter," or more specifically *Aëxiphytos*, "Augmenter of plants."[79] This helps to explain another of his more overtly metonymic epithets referred to earlier, *Kallikarpos*, "beautiful or rich in fruit," or *Karpios*, "fruity." Dionysos was sometimes even regarded as the discoverer or inventor of all fruits (Athenaeus, *Deipnosophists*, III,82d).

However, Dionysos is best known for his connection or identity with vines, especially ivy and grapevine. He was, as we have seen, *Kissos*, "ivy," *Ampeloeis*, "Viney One," or *Euampelos*, "rich in vines." Sometimes his epithets focused more on the fruit than the vine itself: *Staphylites*, "Grapey One"; *Polystaphylos*, *Eristaphylos*, or *Eustaphylos*, "rich in grapes";

Botryokaites, "wreathed in grapevine"; or *Botryophoros* and *Botryopais*, "bearer" and "child of the grapecluster."[80] But all these epithets were more detailed manifestations of a larger, arboreal identity popularly attributed to Dionysos. He was widely known as *Dendrites*, "of the tree," or *Endendros*, "he who is or works within the tree."[81] Nonnos (*Dionysiaca*, XXXVI,291–312) is, of course, a rather late source, but he preserves a more spectacular narrative variant of the tradition behind these epithets in which Dionysos metamorphoses at will into vines and trees.

Greek and Roman visual arts fully complemented the literary and cultic tradition of Dionysos as a vine- or tree-god. He appears often in Archaic Attic vase painting carrying branches of ivy or grapevine.[82] Of particular relevance here are the cultic representations on fifth-century vases where Dionysos is worshipped in the form of a trunk or pillar bedecked with garments, a mask, and ivy branches.[83] While the precise ritual depicted in these scenes is unclear, the effigy itself was undoubtedly meant to fuse the vegetal or arboreal and anthropomorphic aspects of the god.

But perhaps the most stunning imagery of this kind appears on a series of Campana plaques. The finest and best preserved example, of the Augustan period, shows the infant Dionysos at the center of the composition flanked by adoring satyrs, his hair and garment dripping with ivy and fruits (fig. 78).[84] Below a fawn skin or *nebris*, the archaistic folds of his chiton gradually metamorphose into rippled acanthus sheaths or bracts which then become the trunks of undulating vines with clusters of grapes. As the kneeling satyrs honor him appropriately with the music of the tympanon and timbrels, the infant god grasps the branches that he emits, underscoring his eternally youthful power over this and all vegetation. The plaque perfectly embodies the shape-shifting qualities recounted by Nonnos, or the epithets *Dendrites* and *Endendros* celebrating Dionysos as the immanent power within trees and plants. But here we also sense the resonance of more specific appellations like *Ampeloeis*, *Euampelos*, *Kallikarpos*, and most of all, *Botryopais*, "child of the grapecluster".

Properly speaking, this Campana plaque is not really an ornamental composition of the theonomous type; despite the conventional treatment of the vine and the overall symmetry, it is essentially an allegorical scene, however, decorative. But it was no doubt designed under the influence of more overtly ornamental works, for Dionysos and his mythological acolytes also appeared as inhabitants of theonomous tendril patterns, a circumstance that is certainly understandable given the association or indeed the unity of Dionysos with the vine. On the early Hellenistic gold diadems from the Hellespontine region discussed earlier, Dionysos and his consort Ariadne sit enthroned with their thyrsoi above the central calyx of an acanthus tendril surrounded by attendant female musicians (fig. 69). The point of the composition is clearly to express how the god

holds sway over the vegetal domain, much as Aphrodite and Eros had appeared in the tendril ornament of somewhat earlier Apulian vase painting.[85]

The male heads emerging from the blossoms of Italiote Greek ornament of this kind are more difficult to identify; they vary widely in type, and, like the female heads in this format, they surely do not all represent the same character. Some have been identified as Adonis, but others could be Dionysos.[86] This is particularly likely since the derivative second-century B.C. Etruscan terracotta frieze of this kind from Cerveteri clearly does depict the god, Fufluns as he was known in Etruria, or perhaps Liber by this time. Some of the heads are clearly male, and crowned with ivy or grapevine, corresponding to the Greek cultic epithets *Kissokomes*, *Kissostephanos*, and *Botryokaites*, with winged erotes hovering to either side who offer the god drinking horns.[87] Some of the heads here are female and crowned in grapevine, also flanked by erotes. These are most likely the god's consort, Ariadne, or Libera as the central Italians called her.[88] Iconographically at least, this work simply substitutes the "head-in-tendril" format for the full figures on the diadem (fig. 69).

The Dionysian aspects of the theonomous tendril decoration on the Pergamene altar slabs require no further comment here, nor for the most part do the counterparts in mosaic like the Hephaisteion pavement or the related mosaics and paintings in Pompeii, except perhaps with regard to the erotes. While Eros connects most immediately to the sphere of Aphrodite, smaller infant erotes seem to have functioned as Dionysian acolytes as well. We see this most clearly in the tendril frieze in the Room of the Mysteries. Only one of the erotes carries the domed *thymiaterion* symbolic of Aphrodite or Venus (fig. 68a, section A 13); most of them carry Dionysian paraphernalia—wine vessels, tympana, and double flutes (fig. 68a, section A 6–7, 9–12). Similarly, the erotes of the Fish Mosaic are part of a tendril composition that grows from large, wine-filled vessels (fig. 65c). In the Cerveteri relief as well, the erotes offer wine vessels to the god whom they serve, although here too a double function is possible. The erotes also flank Ariadne or Libera, who was sometimes equated with Venus.[89]

In Campania, moreover, Venus replaced Ariadne and Libera as the divine consort of Liber, and it is Venus whom Pappalardo has identified as the goddess supporting Dionysos in the *megalographia* at the Room of the Mysteries.[90] It may well have been this association that facilitated the assimilation of Eros to the Dionysian sphere, especially in theonomous tendril ornament. Here it is also worth noting that the Augustan Campana plaque with Eros included vines with grape leaves, grape clusters and helical tendrils growing from the larger acanthus pattern (fig. 73).[91] In approximately contemporary poetry, Propertius, III,17,1–4, praises

Bacchus or Liber for his power to quell the erotic impulse of Venus, again stressing the interactive relation between the spheres of both deities.

In Neo-Attic art, too, Dionysos and his mythic entourage figured prominently as divine inhabitants of decorative vegetal compositions. The elegant marble relief of this kind found at Pergamon included satyrs and the sleeping Ariadne or a maenad amidst the interlacing acanthus tendrils, a format that remained current in the Neo-Attic marble vessels of imperial Roman times.[92] In the relief on the reverse of the Pergamene piece, the tendrils enclose a heraldic scene—a large wine vessel flanked by rampant goats, the sacrificial animal of Dionysos.[93] However, the most familiar imagery of this kind in Neo-Attic art appears on the large marble thrones found in Rome and in the Theater of Dionysos in Athens itself. These depicted the god Sabazios, an Asiatic variant of Dionysos, with the lower part of his body transforming into acanthus tendrils which he grasps in either hand.[94]

The basic conception in these Neo-Attic reliefs is identical to the Augustan Campana plaque with the infant Dionysos discussed just above. There too the archaistic folds of the chiton function as a kind of visual pun on rippled acanthus leaves emitting tendrils. It was clearly Neo-Attic theonomous tendril ornament of this kind that inspired the less stylized depiction on the Campana plaque. According to Richter, all four thrones of this type are precise Roman copies of a Hellenistic original, now lost. Three were presumably made in Rome although their date is uncertain.[95] But Neo-Attic reliefs with Sabazios/Dionysos as lord of vegetation must have been known at Rome by early imperial times since he too appears in this way on the Campana plaques (fig. 77). On these works Sabazios does not spew tendrils; instead he stands in their midst clutching two griffins somewhat like the Campana plaque with Eros (cf. figs. 73 and 77).[96] Indeed, apart from the central figures, both plaques are remarkably similar in the classicizing emphasis on large, fluted tendril volutes and the spare, less naturalistic, serrated articulation of the acanthus leaves. Both may well have come from the same workshop specializing in such theonomous floral or vegetal compositions. In view of their style and high quality, they are very likely Augustan.

Borbein has already noted how acanthus compositions of this sort soon became a particular specialty of the ateliers that manufactured the Campana reliefs. Here these craftsmen seem to have been extremely adroit at blending and adapting the wide-ranging precedents at their disposal, some local, others more exotic.[97] The example with the infant Dionysos represents one such case, and thus it is worth examining this process further in another series that is related, yet different (fig. 79). On these plaques the satyrs do not flank the image of the god himself, but one of his attributes, a large wine vessel or krater.[98] The pedestal of the ves-

sel, however, corresponds fully to the lower portions of the infant Dionysos on the Campana plaques and Sabazios on the marble thrones—i.e., it consists of overlapping layers of acanthus leaves that emit a larger tendril pattern (fig. 79). On the plaques with the krater, there is of course no immediate ambiguity between the leaves and drapery, but anyone familiar with the fuller range of types, i.e., the craftsmen and their clientele, would scarcely have missed the connection (figs. 78–79). Thus the vegetalized krater is essentially a more radical transformation of the vine-spewing god himself, one that combines his vegetal and symposiastic attributes as a larger, composite visual metonym. This is further underscored by the grape cluster hanging from the tendrils above the kantharos (fig. 79).[99]

One other Campana plaque type may develop this symbolism even more radically. There, at the center, only the acanthus tendril itself remains, its branches rising from a large, leafy calyx (fig. 80).[100] Yet the adoring posture and gesture of the female attendants who kneel beside or amidst it indicate that this is no simple vinescroll. The poppy capsule surmounting the central stalk suggests a connection with Demeter or Ceres, but the lower border provides the real key here with its row of *aigokrania*, the skulls of goats. The goat was traditionally associated with Dionysos, especially as his sacrificial animal.[101] Since the horns of the skulls are decorated with taeniae or fillets and because they alternate with rosette-shaped offering vessels, *phialai* or *paterae*, the ritual sacrificial sense of these symbols is manifestly clear; they denote the Dionysian function of the attendants to the tree or tendril above, who may then be maenads. Thus the stylized plant is the ultimate Dionysian metonym—the tree-god himself, *Dendrites*, now fully divested of any human or nonvegetal elements. The presence of poppy here should occasion no surprise in view of the longstanding and intimate association between Dionysos and Demeter. Poppy capsules also decorate the handles of the sardonyx "Cup of the Ptolemies," which depicts a rustic shrine with the cult trappings of both deities, although there the Dionysian element predominates.[102]

This last Campana plaque takes us back to the Ara Pacis itself, since it is analogous in scheme and detail to the central portions of the north frieze and the four panels on the east and west facades (cf. figs. 4–7 and 80). The poppies appear on the north frieze as well, but in the form of large pendulous flowers rather than capsules, surrounded by the profusion of ivy and grapevine (fig. 4, center, and fig. 17). Is this portion of the long frieze then a metonymic evocation of Dionysos or Liber, like the Campana plaque? Perhaps such an interpretation seems extreme. Yet in view of the longstanding religious and artistic traditions outlined above, it is difficult to see how the average Greek or Roman spectator could have

responded to this part of the Ara Pacis much differently. No other deity was so intimately identified with the vine in earlier or contemporary art, and here the Campana plaques are particularly illuminating. As works produced for private as well as public or official consumption, these decorative terracottas help us to gauge how extensively the tradition of theonomous tendril ornament celebrating Dionysos or Liber had been assimilated and diffused across Rome and the surrounding region at about the same time that the altar was erected. And they also demonstrate that there was considerable lattitude as to how or how much the god might appear. He might stand amidst the tendrils, or he might shift his shape to denote his identity with the vine more overtly. Then again, the vine might replace him entirely, leaving only his satyrs and maenads behind to indicate his immanent presence.

However, contemporary Augustan marble furniture indicates that even the prominence of the ivy and grapevine in the long friezes would have been sufficient to evoke the powers associated with Dionysos/Liber. A prime example is a monumental candelabrum in the Conservatori Museum.[103] All the panels of the three-sided base depict figures from a Bacchic *thiasos*—dancing maenads, one with a thyrsos, and Pan holding the shepherd's crook and feline skin as he prances with a playful panther. In the relief decoration above, a composite vine sprouting ivy and grape leaves with corymbs and grape clusters winds around the main shaft of the candelabrum, with small birds feeding off the fruit. The elegant naturalism of the vegetal detail comes especially close to the Ara Pacis, as Cain has emphasized.[104] Here, the fusion of the plants most closely associated with Dionysos would in and of itself suggest the powers of this god, but the juxtaposition of the imagery on the base makes this meaning absolutely clear. After exposure to monuments like this one, those who observed the repeating sprays of ivy and grapevine on the Ara Pacis would not have needed satyrs and maenads among the tendrils to see these vegetal details as allusions to Liber.[105]

Whether in the form of costly marble fittings or the cheaper medium of terracotta, the widespread currency of all this Dionysian imagery shaped the experience and interpretive capacity of the Roman audience in Augustus's day. Such works provided a familiar background against which the viewer could map and absorb the programmatic complexity and detail of monuments like the Ara Pacis. And the sense of the imagery on these works could not be switched off or ignored. Even if the planners had intended otherwise, it is doubtful that an audience used to the imagery outlined above would have come away without a profound sense of the benign and mystic power popularly attributed to the god who controlled the vines and all vegetal renewal. But the planners did not intend otherwise, for we have seen that they drew consciously on the Per-

gamene or Asiatic Greek traditions of altar decoration in which Dionysos figured as a major participant in the floral or vegetal imagery of the divine concord underlying fruitful Peace. Thus the evidence converges from all sides. Among the deities whose blessing and support the altar celebrated, Dionysos or Liber assumed his full share.

A similar kind of evidence and a similar logic also apply to the interpretation of the polytheriotrophic imagery—the many small animals that populate the tendril friezes. Allegorical or landscape scenes in Roman relief and metalwork suggest that the theme of animals feeding upon plants or on one another figured as part of the imagery of fertility goddesses that had developed earlier in Hellenistic art. But we have also seen how the inclusion of such animal imagery in the more stylized format of floral ornament had Dionysian connotations. This is documented not only in the Hellenistic Greek precedents themselves, but in the derivative mosaics and paintings produced in Italy during the Late Republic. Consequently, it is significant that early imperial metalwork, ceramic relief ware, and marble sculpture from the private sphere provide strong evidence for the continued association of this animal imagery largely with the powers of Dionysos or Liber.

The British Museum cups are, as indicated above, the examples of Augustan silverware most closely related to the Ara Pacis, especially with regard to their polycarpophoric imagery. Thus it is extremely important that they also contain at least some of the small animals that turn up in the floral friezes—birds, three butterflies, two grasshoppers, and another insect, perhaps a cicada (fig. 90 a–b). Here a Dionysian connection is only implicit in the function of the cups as wine-drinking equipment, as it was for the reptiles, birds, and insects of the Civita Castellana bowls. Other early imperial silver vessels, however, were less subtle, like the footed goblets from the Hildesheim Treasure.[106] The main decoration around the side of the vessels depicts a Dionysian shrine or precinct liberally outfitted with the cult trappings typical of this god—masks, *liknon*, *thyrsoi*, *cistae*, timbrels, as well as the goat and panther. But in the lower zone around the belly is a lush ornamental habitat of acanthus tendrils containing birds, beetles, butterflies, and cranes grappling with snakes. So that there would not be any doubt that this zone related to the imagery above, some of the acanthus tendrils sprout ivy leaves. This tends to support the Dionysian interpretation for the animals on the British Museum cups, and for another wine bowl with tendril ornament from the Hildesheim Treasure, where butterflies appear too.[107]

Animal themes of this sort were also current in decorative marble work of this period. One of the most striking examples is a small votive sculpture in the Vatican, dedicated by Sextus Scutarius and his family (fig. 81 a–c).[108] The basic form of the monument is a tree stump carved in the

round, which provides the armature for the detail in relief. A large sinuous grapevine wraps itself around the stump with a grape cluster on the rear; on the left are the damaged remains of a figure. A hand and forearm are visible above while the entire lower portion of the body is goatlike, but standing erect, apparently Pan (fig. 81b). Snakes coil at the two front corners of the base; further up on the trunk a lizard catches a butterfly or moth while a bird pecks at another insect (fig. 81 a–c). There is a notch on the top of the stump, presumably for the attachment of an additional section or element of some sort. All the animals recall those in the Ara Pacis friezes (cf. figs. 27, 29–33, 36 and 38). But here, they are immediately juxtaposed to the vine and Pan, whose combined sense is clearly Dionysian.

Similar scenes with animals amidst ivy and grapevines also appear in the relief decoration on a series of marble pilasters or piers in the Vatican Museum.[109] On these reliefs, birds peck at butterflies, grasshoppers, and cicadas; cranes and even small birds bite at snakes (fig. 82). On some, lizards climb across leaves, or birds and mice nibble on grapes. As on the Scutarius votive, the life-supporting image of the vine is paramount here, and it is tempting to see these decorative scenes of animal interaction as an expression of Dionysos or Liber and his power, especially since another pier or pilaster of the very same type at the Villa Adriana in Tivoli contains clear evidence to this effect.[110] There too an undulating grapevine supports birds, snakes, a lizard, a cicada, a grasshopper, a mouse, and even a snail. But in addition there are also Dionysian cult trappings or fetishes suspended from its branches—timbrels, a Pan mask, and a cista (fig. 83 a–b). A series of altars to Dionysos or Liber from Otricoli and now in the Vatican Museum provide further evidence of this kind. The corners of the altars are decorated appropriately with the heads of goats, the special offering to Dionysos. Ivy garlands decorated with taeniae hang between the heads, while snakes, grasshoppers, and lizards catching butterfies occupy the space below. On the rear, a snake menaces a nest of birds, as on the north frieze of the Ara Pacis.[111]

However, the Dionysian resonance of these little inhabitants emerges most extensively in a series of marble reliefs in the Museo Gregoriano Profano in the Vatican. Although these were reportedly found with the reliefs from the Tomb of the Haterii, they belonged to another, early imperial tomb, possibly nearby on the Via Labicana.[112] One panel consists of a moderately stylized amalgam of ivy and grapevine arising from a central acanthus calyx. There, a bird and mouse nibble at grapes to the left and right amidst the vines, while to the right of the calyx a lizard scurries along the ground with an insect in its mouth (fig. 84 a–c). Another panel of this type is only partly preserved, but to the left of the calyx sits a frog (fig. 84d). The largest relief from this ensemble is the most well

known: two treelike grapevines sprout up and intertwine to form a sort of
arbor, while beneath them the little figure of Priapos tends or harvests
grapes with a pruning hook (fig. 84e). A snake coils about the trunk of the
lefthand vine with a small cicada just above it; beyond the right trunk a
scorpion moves along the ground (fig. 84f). Although the combination of
ivy and grapevine and the figure of Dionysos's son Priapos already set
the tone for this imagery, additional figural panels make the Dionysian
emphasis explicit. These include old Papposilenos on a donkey, the infant
Dionysos on his goat, and another scene with Lykourgos and the nymph
Ambrosia.[113]

Moreover, the probable function of these reliefs as the decoration of a
funerary monument also helps to demonstrate that the interaction of the
little creatures was not simply a decorative evocation of blissful abun-
dance, but a profoundly religious imagery expressing the belief in mystic
regeneration that was central to expectation beyond the grave, belief in
which the powers of Dionysos or Liber played a large part. Still, this
belief and the use of such imagery in sepulchral art only adapted or ex-
tended the concepts and modes of representation pertaining to benefits
that Dionysos conferred in the here-and-now, and in this sense the Gre-
goriano Profano reliefs are fully relevant to the corresponding imagery on
the Ara Pacis. This is all the more likely considering the Augustan or
Julio-Claudian date that various scholars have proposed for them.[114] The
treatment of the ivy and grapevine comes rather close to the counterparts
in the floral friezes of the altar enclosure, and this applies to the grape-
vine on the Scutarius votive as well (cf. figs. 10–15 with 81 a–c, 84 a–d).
But the animal imagery on these works is equally related; indeed the scor-
pion in its vegetal setting on the Ara Pacis is paralleled only by the Geg-
oriano Profano relief (figs. 35 and 84f). The Dionysian altars with such
animals are also Augustan in date.

If all these marble reliefs and metalwork with polytheriotrophic detail
were actually a reflex of or response to the official imagery of the Altar
of Peace, like the Eumachia doorway at Pompeii, what then does their
overtly Dionysian cast imply for the interpretation of animals on the Ara
Pacis itself, where the additional elements like silenes, Pans, or masks do
not appear? Does the absence of these indicators in the Ara Pacis floral
friezes suggest a different, more neutral meaning or function for the ani-
mals there that was then adapted to Dionysian usage in later monuments
erected under private patronage? Probably not, because the larger context
of such imagery is uniformly Dionysian. Whether one traces it to the ten-
dril frieze in the Room of the Mysteries and the Fish Mosaic from the
House of the Faun, or further back to the "Altargemach" mosaic and the
Civita Castellana bowls, the answer is the same; when the animals ap-
pear in floral ornament, there are additional elements or functions which

underscore the Dionysian sense of the entire composition. Only in land-
scape depictions does it seem that the animals were associated with the
powers or attributes of fertility goddesses (see Chapter I, pp. 53–55). Kel-
lum's more generalized interpretation of the little creatures of the tendril
friezes is certainly plausible, and one cannot overlook the textual evi-
dence that she musters for connecting the frogs, lizards, and snakes with
Apollo.[115] Yet the evidence of later Hellenistic and early Roman imperial
decorative arts also has much to tell us about how an Augustan audience
would or could have responded to the polytheriotrophic imagery on the
Altar of Peace.

Thus one should conclude that the planners of the Ara Pacis did not
break with the sense or meaning attested by virtually all the other com-
paranda for this imagery in the periods leading up to and immediately
following the erection of the monument. Had they done so it would
hardly have accorded with the way in which most spectators had come to
understand the motif of animals inhabiting tendril decoration. It is far
more likely that the altar's designers sought to work within this tradition
of decorative animal inhabitants by adapting it to the particular task at
hand. The absence of other, overtly Dionysian trappings or characters on
the Ara Pacis resulted from the larger objective—the need to integrate the
Dionysian allusions more subtly within the collective imagery of divine
power that the altar celebrated. Despite his strong presence as god of the
vine, and despite the apparent preponderance of Dionysian plants in the
overall ensemble of the floral friezes, Liber had to coexist and cooperate
with the powers and attributes of other divinities—the roses and pop-
pies, the laurel, the oak, etc.—for this was the essence of the Pax Au-
gusta, as it had been the essence of Eirene on the Pergamene altar. In
supporting the rich array of animal life, Dionysos/Liber pooled his power
with that of the goddesses, and so the tiny creatures appeared not only in
proximity to his ivy and grapevine (fig. 4, center), but especially in the
panel below the multivalenced image of the seated *kourotrophos* (figs. 7
and 34). In striving for this imagery of divine concord and blessing, per-
haps we see now why the designers transposed the little animals from
the landscape of the allegorical panel to the ornamental friezes below (cf.
fig. 44 with figs. 23–26 and 34–39).

Nor was this close working relationship between Liber and the great
fertility goddesses a specialized theme of the Ara Pacis or Greek prece-
dents like the Pergamene altar reliefs. Divine cooperation of this kind is
throughly attested in Greek art, literature, and religious practice, as it was
in Italy too from a relatively early period. In connection with the Per-
gamene altar reliefs, the preceding chapter has already discussed the role
of Dionysos within the Eleusinian sphere, but this was part of a larger
connection with Demeter. In Athens the festival of Haloa was celebrated

in honor of both deities together.[116] In *Isthmian Ode*, VII,3–5, Pindar calls Dionysos the *paredros* or "thronemate" of Demeter; Pausanias (II,37,1–2) mentions paired images of Dionysos and Demeter in the the sacred grove at Lerna, and a cult of Dionysos with Demeter and Kore at Thelpousa in Arkadia, complete with statues of all three (VIII,25,3). In his hymn to Demeter (VI,70–71), Kallimachos too emphasizes this solidarity, saying that what is of concern to Demeter is of concern to Dionysos, for he shares her anger. In Roman times as well, their mysteries continued to be celebrated jointly at Ephesos.[117]

In Magna Graecia the close connection between Demeter and Dionysos is attested in the early Classical votive reliefs at Lokroi Epizephyrioi; there the goddess sits enthroned holding ears of wheat while the god confronts her carrying his grapevine and a wine cup.[118] From the Greek south the joint worship of this kind spread to central Italy, where it contributed to the formation of a new cultic triad in 493 B.C. when the Romans built a temple on the Aventine dedicated to Ceres, Liber, and Libera.[119] In this cult, Libera appears to have corresponded to Kore or Persephone rather than Ariadne, although Le Bonniec has argued strenuously against any direct derivation of the Aventine triad from Eleusinian usage. Initially the Aventine cult evolved as an elaboration of the more widespread pairing of Demeter with Dionysos on the one hand, and of Dionysos/Liber with Ariadne/Libera on the other, probably under the influence of the Capitoline Triad. Only in the course of time did this cult assume a more Hellenized, Eleusinian aspect.[120]

Against the established background of such cult practice, Liber and Ceres continued to be understood as a closely connected pair in Roman religious belief down through the Late Republic. At the opening of his treatise on agriculture, Varro invokes Ceres and Liber as a couple, analogous to Jupiter and Tellus or Sol and Luna (*Res Rusticae*, I,1,5). For Varro the wine god and the grain goddess were essential components of the traditional religion of the Italian farmers.[121] It is probably Varro's views that are transmitted in greater detail by Augustine in *City of God* (VII,21). There Ceres and Liber are the chief deities of seminal regeneration, of dry and liquid seeds respectively, as well as protectors of the fertility of the fields, "*pro eventibus seminum sic ab agris fascinatio repellenda.*"[122] Such belief was also enshrined in the religious festivals celebrated in common for Ceres and Liber or for the whole Aventine Triad, the Ludi Scaenici, the Cerealia, and the Ambarvalia.[123] And all during the first half of the first century B.C., Roman moneyers repeatedly associated Ceres and Liber on coinage. Obverses with the head of Liber or a bearded silene had reverses with Ceres holding torches, often in the snake chariot.[124] It is also significant that most of the issues with Ceres or Liber alone were struck by the same moneyers.

The pairing of Ceres and Liber as pre-eminent deities of agriculture remained an important theme of Augustan bucolic poetry or pastoral. In the *Fasti* (III,785–786), Ovid stresses the shared festivities held in honor of both, and when in Book I (349–361), he tells how the goat came to be the sacrificial animal of Liber, he prefaces his aetiology with the origin of the sow as Ceres' offering. In the Fifth Eclogue (79–80) and at the opening of the *Georgics*, Vergil too singles out Ceres and Liber as the special gods of the rustic farmer much as Varro had done a generation earlier.[125] Tibullus devoted an entire elegy to a country festival devoted simultaneously to Liber and Ceres as protectors and purifiers of the fields and crops.[126]

Dionysos/Liber was also closely associated with Cybele or the Great Mother in Greek and Roman tradition. Euripides (*Bacchae*, 77 and 125) already describes bacchantes participating in the orgiastic rites of the Great Mother, and centuries later Catullus (LXIII,21–26) still includes ivy-wreathed maenads shaking their holy emblems as part of the mysteries for Cybele. In the *Library* (III,5,1), Apollodoros recounts how Rhea or Kybele was supposed to have admitted Dionysos into her orgiastic rites or mysteries. Strabo (X,1,13), too, emphasized the close connection between the cults of Dionysos and the Great Mother. Perhaps the best evidence of this apears in the careful supervision or regulation that the Roman leadership simultaneously imposed on the orgiastic cults of Cybele and Liber.[127]

The ties between Liber and Venus, particularly in Campania, where Venus sometimes replaced Ariadne or Libera as the god's consort or female counterpart, have already been discussed above. It should by now be clear that Liber's connection to all these fertility goddesses was a larger, collective phenomenon, and one that probably had to do with the identity or equivalence among the goddesses themselves. As variable aspects or facets of the female divinity essential to earthly renewal, each in her way came naturally to acquire an affiliation with the major male deity of this type. This is probably the outlook that informed the well-known saying attributed to Terence: Without Ceres and Liber, Venus grows cold.[128] Generally this line is interpreted as a humorous piece of metonymy: without bread and wine, erotic desire wanes; sustenance and a bit of intoxicating release help to fan the flames of desire.[129] But there is probably a good deal more implicit here that has to do with the role or power of these gods generally, and how their powers or spheres of influence interacted. No one deity was the sole source of blessing or abundance. Here too, Ceres and Liber are paired; in tandem they bring their powers into play with Venus, and Venus needs their cooperation. Even as the inspiring genetrix celebrated by Aischylos, Lucretius, or Ovid, she must work her wonders through or amidst the domain of the other deities who engender life and prosperity. Each divinity complemented and

augmented the power of the others within this system, and the whole was much greater than the sum of the parts.

So it was on the Ara Pacis, where the beneficial concord of all such gods unfolded symbolically across the floral friezes in the pacific coexistence of vegetal attributes like vine, poppy, roses, laurel, and oak. It had been much the same on works like the Pergamene altar reliefs as well. But spectators of the Ara Pacis would not have depended upon a familiarity with such Greek precedent to understand the floral friezes; they would not have needed to see the figures of Dionysos accompanied by Kybele, Triptolemos, and Demeter or Kore as they appeared on the Pergamene reliefs, for the traditions associating Dionysos/Liber and the goddesses in Greek and Roman belief transcended the specific kinds of monument that inspired the designers of the Ara Pacis.

To the Roman audience, the longstanding usage of religious cult, coinage, poetry, and popular belief would have enabled them almost instinctively to grasp the meaning of the harmonious assemblage of visual metonyms distributed through the lower zone of the enclosure, and to sense not only the analogy that these interrelated multiple gifts or attributes provided for the multivalenced image of the goddess or goddesses in the "Tellus" panel, but also the relation of Liber to the various deities that this panel may have depicted. Thus the panel would have made eminently good sense above the lush stylized foliage where all their fruits or plants grew in such happy proximity. And so in following and adapting the various Pergamene prototypes for the floral friezes, the designers of the Ara Pacis could anticipate that much of this imagery and what it signified was familiar to their viewing public—the many plants, the many animals, and the theonomous function of floral ornament generally. But they could also count on the intelligibility of the concept that was fundamental to this program, since the notion of peaceful and abundant cooperation among Dionysos and the goddesses was no novelty to the people of Late Republican and Augustan Rome.

Chapter III

Dionysos, Apollo, and Augustus

Liber in Augustan Art and Literature

The interpretation of the floral and animal imagery on the Ara Pacis set out in the preceding chapters has been based primarily on the detailed analysis of the friezes themselves, and on the comparative evidence of related works in earlier Greek and contemporary or slightly later Roman art. For the most part, this evidence shows that the imagery on the Ara Pacis retained the fundamental sense and metonymic strategy of the underlying Hellenistic precedents—an array of plants and animals serving as allusive expressions of the protection and blessing of the leading fertility deities. However, no Augustan monument existed in isolation; they were all part of a larger program or network whose collective meaning and purpose were carefully calculated and coordinated. At this point, therefore, it is necessary to consider how the imagery of the floral friezes corresponded to or fit within the larger setting of Augustan art, literature, and ideology. In some cases, the results are to be expected, but in others, they are surprising.

As symbols of Venus, genetrix of the Julian line, the swans and roses celebrated the protection of a powerful fertility goddess who was widely venerated and closely tied to Augustus and his dynastic mythological propaganda. Cybele and her oak were also well integrated within the Trojan-Aeneadic cycle of propaganda celebrated in Augustan poetry, as indicated earlier. Ceres too had an honored place within the Augustan religious structure as we see it in Ovid's *Fasti*, and in the rustic poetic genre shaped by Vergil and Tibullus. But in the case of Apollo, the divine patron and protector of Augustus, the impression is far less than we might expect. The swans, as we have seen, may be Apolline symbols, but

only to an extent, for these birds operated at least as much as Venusian emblems. We are left with only one or maybe two sprays of laurel on the north as evident tokens of Apollo's power or favor.

This in itself might not be too disturbing, except that the laurel is far outnumbered by the six or seven roses of Venus, and by the overwhelming dominance of the Dionysian plants—ten branches of ivy and six large grapevines. Nor can we attribute this imbalance to the state of preservation, unless one is prepared to assume that multiple branches of laurel were once packed into the missing portions on the left of the north frieze, or in the missing center and right of the south frieze. Yet there is little evidence for this, especially on the south, where the extant remains contain no laurel at all. On the basis of Greek and Augustan comparanda, the tiny animals also appear to have been largely Dionysian symbols. Against the background of earlier and contemporary Greek and Italian decorative arts and religious belief examined in the preceding chapter, the Dionysian emphasis in the floral friezes of the Ara Pacis is not at all surprising. But against the background of the Augustan scholarship that has emerged in the last several decades, this apparent preponderance of Dionysian elements over those of Apollo is nothing less than shocking.

Here it is not even that the Apolline component somehow seems insufficient, but rather that the Dionysian element should appear at all, let alone in such quantity. Within the accepted, highly polarized view of Augustan ideology and religious propaganda, there should effectively have been no place for Dionysos or Liber. In accordance with a longstanding tradition of divine affiliation and tutelage current among the Hellenistic monarchies, Antony had adopted Dionysos as his special protector, patron, and model.[1] Amidst the rivalries and tensions of the Second Triumvirate, Augustus (then still Octavian) had responded by claiming Apollo as his divine inspiration and guardian. When Octavian triumphed at Actium, ostensibly through the aid and providence of "Actian" Apollo and the other gods of Rome, Apollo's pre-eminent position as the special prophet and guarantor of the new regime or Principate was secure. More than any single deity, he symbolized the heavenly, cosmic sanction for the new era of peace, stability, and rectitude now synonymous with the Principate. And Dionysos? Well, Antony lost.[2]

However, the implications of this opposition are assumed to go far beyond the issue of one divine patron versus another. In either case the choice embodied the deeper affinity between the nature of the protegé and that of the divine patron. As an unabashed inebriate and devotee of the good life, Antony was naturally drawn to the god of wine and ecstatic release, just as the temperate young Octavian found a natural exemplar in the god of moderation.[3] On a deeper cultural or geo-political level, Antony's choice of Dionysos reflected his eastern proclivities. The guise

of *Neos Dionysos* followed the usage of the monarchs who had ruled the Hellenistic East; it corresponded to his union with Cleopatra, the last of these monarchs, from whose capital, Alexandria, Antony had opted to govern the eastern half of the Roman Empire in accordance with the Pact of Brundisium.[4] Octavian ruled Italy and the West from Rome, just as he wrapped himself in the protection of Apollo, the prophetic deity so long associated with Rome's fate and imperial destiny.[5] In this way Actium became much more than the last battle in the Roman civil wars; it was meant to be understood as a moral and cultural victory in which a new order founded on Western, Italian excellence triumphed over the decadence of the Hellenistic East.

These are the basic facts, or at least the facts as they appear to many scholars today. But the actual circumstances may have seemed a good deal more complex to Italians living in the aftermath of Actium. There is certainly no doubt that in the period leading up to and following the battle Augustus and his partisans did all they could to develop the image of Antony as foreign, un-Roman, and morally corrupt, the absolute antithesis of Octavian and the Roman conception of order. But it remains unclear how this polarity continued to involve Dionysos once Augustus had triumphed; nor is it apparent that the Augustan response to a Hellenistic, Greek-inspired Antonian program of ruler glorification automatically precluded the assimilation of concepts and themes from the very same source. What matters here is whether modern scholars take the Augustan counter-propaganda or ideology at face value, or whether they are willing to probe more deeply for the underlying realities that shaped the way this ideology evolved and functioned. On the surface, all propaganda—imagery that seeks to convince or compel opinion—is by nature seamless and unequivocal. But beneath the surface is a patchwork comprised of the very contradictions and alternatives that propaganda strives to contain or suppress. Augustan propaganda was no exception, particularly with respect to Apollo and Dionysos or Liber.

The choice of Apollo as patron deity by Octavian or Augustus may itself provide the best illustration of this. Most immediately, it was indeed a response and a retort to the royal Hellenistic theme of the "New Dionysos" promulgated by Antony. Yet one fights fire with fire. Octavian's decision may have been intended to appear as a rejection of a foreign Greek strain of imagery, but in reality he simply utilized a different Greek alternative. In adopting Apollo in this way, Octavian followed what had long been the cornerstone of royal Seleucid propaganda. Already by the reign of Antiochos I, Apollo was claimed as the *Archegetos*, protective founder or progenitor of the Seleucid dynasty.[6] In accordance with this, the royal portraits on the obverse of Seleucid coins were routinely accompanied by reverse images of Apollo seated on a bejewelled *omphalos* with

his bow, surrounded by the king's name.[7] An unstratified painting from
the House of Augustus on the Palatine indicates, moreover, that the
Princeps was well aware of this Seleucid precedent. It shows Apollo with
his bow case and cithara astride the *omphalos*, precisely as the god ap-
peared on coins of Antiochos I.[8] Moreover, when the Senate awarded
Augustus the *corona civica*, it was for perennially "saving the citizens and
conquering enemies," phraseology that directly recalls the title *soter tou
demou*, "savior of the people," used by Antiochos I, and *nikator*, "con-
queror," used by Demetrios II and Seleukos VI.[9]

The entire Augustan complex on the Palatine is also rooted in such
ambiguities. The Palatine was traditionally associated with Romulus and
the foundation of Rome; indeed the *Ficus Ruminalis*, the grotto of the
Lupercal, and the "hut of Romulus" were not far from Augustus's own
residence, and in the period just after he moved onto the Palatine, Octa-
vian even entertained the idea of adopting the name of Romulus, later
choosing Augustus instead.[10] But despite this traditional Italic resonance,
there were other, less local precedents that conditioned the plan and pur-
pose of the Palatine complex. As Zanker has observed, the deliberate
proximity of Augustus's own residence to the temples of Apollo and the
Great Mother followed the established Hellenistic practice of juxtaposing
the palace with the shrines of the chief tutelary deities of the kingdom in a
lofty, highly visible setting.[11] The only extant parallel is of course the
acropolis at Pergamon; elevated above the surrounding Roman land-
scape, the Palatine complex would similarly have underscored the inti-
mate relation between the ruler and the gods. The Mausoleum of
Augustus embodied a similar duality. It clearly recalled the old Italian or
Etruscan stone and earthen tumuli of the Archaic period, again possibly
as an allusion to Romulus or his era. But here too, scholars have empha-
sized the royal Hellenistic inspiration—the large, centrally planned
tombs of eastern Greek dynasts.[12]

In Zanker's view, however, these ambiguities represent the denoue-
ment of the ideological and artistic contradictions that had typified the
end of the Republic and the Second Triumvirate. Under the Principate
these inconsistencies were finally resolved and supplanted by a new pro-
gram of imagery articulating the harmony of a different, new Roman or-
der established or consolidated by Augustus.[13] But how and in what
sense were the contradictions between eastern Hellenism and western or
Italian *Romanitas* resolved? Is it simply that the Hellenistic Greek artistic
formulae and themes current in the Late Republic were jettisoned whole-
sale and replaced by a distinctively Roman program expressed through
the stylistic alternative of classicism?[14] Or is it not also possible that Helle-
nistic themes and formulae were reintegrated and redirected within a
highly synthetic Augustan artistic program that had the classicistic gloss

of unity and distinctiveness appropriate to a new regime, but whose core and substance continued to rely on the long-established Hellenistic imagery of power and authority? For there was much in the Hellenistic artistic tradition that was potentially useful if it could be reworked to serve an Augustan purpose. And it was after all a Hellenistic tradition that had shaped the artistic experience and faculties of first-century B.C. Romans.[15]

There is no better illustration of this than the Ara Pacis itself, whose floral or vegetal ornament derives almost entirely from the forerunners of Pergamon, Asia Minor, and the Greek Islands, and where even the surface classicism of the mythic, allegorical, and processional reliefs cloaks a pictorial-spatial structure, stylistic detail, and iconography that were unknown before the Hellenistic period.[16] The same applies to the Dionysian imagery in the floral friezes, which may not be so out of place after all. Are we really to conclude that the vines and tiny animals were not intended as allusions to Liber and the powers popularly attributed to him, because of his association with Antony? Can it really be that these elements were not meant to celebrate his capacity as chief lord of vegetal abundance? The larger history or fortunes of Liber's worship in Italy suggests otherwise. From the perspective of the Roman religious and political establishment, Liber certainly had a habit of getting into trouble; he repeatedly became associated with individuals and groups whose activities and objectives might appear less than beneficial to the Roman state. But these difficulties never had any lasting effect on his popularity or place within the Roman pantheon.

After centuries as a revered member of the Aventine Triad, Liber became the focus of nocturnal orgiastic rites that eventually provoked the suppressive measures of the Senate in 186 B.C. Here, too, there has been a tendency among scholars to explain this development as the result of a larger cultural confrontation or polarity whereby the native worship of Liber became infected by decadent Bacchanalian rites of foreign, Asiatic origin.[17] However, the recent and thorough monograph by Pailler has shown that the orgiastic worship of Dionysos was long established in South Italy and Etruria, and that even Livy's account indicates more local, Italian sources for the Roman Bacchanalia.[18] And what the Senate suppressed in their edict was not the worship of Liber per se, but a powerful new organization that was getting beyond the control of the Roman government, and one whose interests or concerns transcended the familiar, public, state-oriented structure and practice of Roman religion.[19] Thus the Senate proscribed the nocturnal orgies and uncontrolled assemblies of initiates, while under official supervision, the traditional, official public cult of Liber continued to exist at Rome and elsewhere in Italy.[20] Dionysian themes remained current in Roman theater of the early second cen-

tury as attested by Ennius's *Athamas*. They continued to occur often in architectual terracottas in second- and first-century Rome. In the late second century and early first century B.C. Liber still appeared on Roman coinage, and his popularity is attested in Campania at this time in the First and early Second Style decorations at Pompeii discussed above.[21]

Less than a century after the Bacchanalia Affair, however, Liber once again became associated with a threat to Roman stability—Mithridates VI Eupator, the ruler of Pontos who attempted to break Roman power in Asia Minor and the Greek East. Mithridates too was a New Dionysos; by 102–101 B.C., he had already assumed Dionysos as a surname and was issuing coins with wreaths of ivy and grapevine on the reverse. By 89/88 B.C., when hostilities against Rome commenced in Asia Minor, Mithridates adopted a more supple portrait type intended to liken him to the Hellenistic image of the youthful Dionysos.[22] At about the same time, during the Social War, the confederation of anti-Roman states in Italy adopted the Dionysian numismatic propaganda of Mithridates. Here, too, contemporary Roman issues with the head of Apollo have been interpreted as a response to this Dionysian imagery.[23]

But the situation is more complex, since the head of Liber also appeared repeatedly on Roman issues in 90, 89, and again in 78 B.C. The issue of 89 even included Victoria on the reverse. As Bruhl and Crawford have noted, some of these Liber coins were struck by the Cassii, a family traditionally connected with the plebeian cult of the Aventine Triad.[24] Consequently, this numismatic imagery on both sides may well have been a function of the class conflict basic to this period. Günther has stressed the soterial, utopian overtones of the Dionysian propaganda used by Mithridates and the Italian confederation in the hope of fomenting insurrection among the urban and rural poor against Roman domination.[25] The Roman Liber issues would then have met this challenge. Commissioned for the kind of interests that the Cassii represented, these coins directly addressed the loyalty of the popular classes in Rome and Italy. Liber was especially their god, above all the protector of their liberty (Liber/*libertas*), as Bruhl has emphasized.[26] And here Liber was advertised overtly as a supporter of the Roman state, the propagandistic claims of Mithridates notwithstanding. Coins with Liber or Dionysian imagery continued to be struck into the early forties, and toward the middle of the first century and in the succeeding decades, Dionysian themes attained a new prominence in Roman wall painting.[27]

Thus Liber had more than once come to be associated with enemies of the Roman state, but it appears more significant that in spite of this, the Romans were never inclined to give him up. After the affair of the Bacchanalia, the Senate punished the licentious rites and the underground power structure that appeared to threaten the fabric of Roman society, but

the edict itself protected the ancient shrines, images, and rites accorded to the god. When Mithridates and his allies attempted to use Dionysos to undermine Roman authority in Asia and Italy itself, the Romans responded not only with Apollo, but by reclaiming Liber as their very own. The reason for this is not far to seek. To the Italians, Liber remained the primary male deity of earthly prosperity and regeneration despite the complications that arose periodically from his assimilation to the Greek Dionysos. When Antony too assumed the guise of New Dionysos and then allied himself with Cleopatra, he clearly left himself open to being branded as another overblown, anti-Roman eastern potentate like Mithridates, especially when he also failed in his efforts. But here again, Liber does not seem to have been much the worse for this, since the Augustan response was not to stigmatize the god for his affiliation with Antony, but rather to divest the god of that affiliation.

Consider the well-known episode recounted by Plutarch in his biography of Antony (75,3–4). On the night before Octavian arrived at Alexandria in his final pursuit of Antony and Cleopatra, the prodigious din of a Dionysian *thiasos* was said to have been heard making its way out of the city. Plutarch adds that this omen was immediately interpreted as a sign that Dionysos had abandoned Antony. Rose plausibly suggested that this story was put about by Octavian as a deliberate attempt to separate the memory of Antony from any residual association with the power and inspiration of Dionysos.[28] Indeed it was probably only one of many such stories that Octavian and his supporters circulated before and after Actium to undermine Antony and his legacy. Others may be preserved in Plutarch's *Antony* (60,2–3). These tell how just before the war, a marble statue of Antony at Alba oozed sweat for days, while on the Athenian Acropolis the statues of the Pergamene kings Attalos and Eumenes that had been reinscribed with Antony's name were struck down in a tempest. During the same storm, the nearby statue of Dionysos was even blown into the theater below. Here, too, Dionysos had abandoned Antony; returning to his theater, he left behind the fallen reinscribed statues of the Attalids which symbolized Antony's doomed attempt to appropriate the legacy and prestige of the great Greek rulers of the past.

But perhaps the Augustan strategy of divestment was articulated most effectively in the more grandiose terms of epic poetry like Vergil's portrayal of Actium in Book VIII of the *Aeneid*. There the outcome of the battle is clearly predicated on the basis of divine backing, with all the gods of Rome fighting on the side of Augustus, while the monstrous, foreign deities like Anubis aid Antony and Cleopatra. Here a civil war becomes a kind of new Gigantomachy, replete with all the overtones of the mythic theme—the preservation of the cosmic moral order ordained by superior divinity.[29] Foremost among the Roman gods is the shining

Actian Apollo with his bow, but significantly, Dionysos is nowhere to be seen among those who support Antony and his "Egyptian wife." True enough, the god does not appear on the Roman side either, but there was nothing to be gained by confirming the Antonian claim to Dionysos's protection and inspiration. Perhaps this is why even the imagery of the Campana plaques on the Palatine Temple of Apollo avoided the confrontation between Apollo and Dionysos. There, in the plaque depicting the struggle for the Delphic tripod, the clash between Augustus and Antony was symbolized not by pitting Apollo against Dionysos, but against Herakles, with whom Antony had also tried to affiliate himself.[30]

Thus it is surpising that scholars have tended so readily to see Actium as a struggle between Apollo and Dionysos, for no evidence suggests that Dionysos was believed to have participated in the battle in any sense. At the conclusion of his poem on Actium, Propertius (IV,6,76–86) actually stresses the love and inspiration of Liber or Bacchus for Apollo, while invoking Bacchus's aid in the poetic praises of Augustus's victories (see p. 102 below). And even earlier, Horace had celebrated Actium by toasting Augustus's success through a metonymic reference to the wine god in his role as "the releaser":

> Pour us out the Caecuban wine;
> It is sweet to escape care and worry
> Over Caesar's welfare with pleasant Lyaeus.[31]

This clear and consistent strategy of dissociating Dionysos or Liber from the taint of Antony also corresponds to the evidence afforded by the whole range of Augustan art and literature, for at no time did the god weather the vagaries of political propaganda better than in the period after Actium. Whether we turn to decorative sculpture, painting, metalwork, or Arretine reliefware, Liber had never been more popular in Italy than he was in the Augustan period. This should already be clear from the material discussed in the last chapter. Cain's survey has shown that Dionysian themes constituted a sizeable portion of the imagery applied to the monumental marble candelabra of Augustan date.[32] Moreover, the representation of the god relied primarily on the mature, bearded, heavily draped type of Archaic and Early Classical Attic art; the more youthful, effeminate Hellenistic type is rare, and even when it is used, Dionysos is heavily draped, not naked.[33] Here one senses how the god was accommodated to the values and ideals of the new Augustan order, no longer the languid and ecstatic deity associated with Antony, but now a dignified Pater Liber instead. Things must have been very much the same in the period after 186 B.C.

The less costly medium of the Campana plaques seems to have followed a similar pattern. Von Rohden and Winnefeld's survey showed

that Dionysian themes constituted the largest single class of imagery applied to these decorative terracottas. The plaques discussed above depicting the vegetal nature of the god were only some of the many types that also included mythic narratives, *thiasoi*, rituals, vintaging scenes, masks or theatrical imagery, etc., expressing the wide spectrum of concepts associated with this popular deity.[34] Like the marble candelabra, the original setting of these Campana plaques included not only public or religious buildings, but private use or patronage as well, suggesting the broad appeal and currency of such imagery. Sinn's study of marble ash urns discloses the importance of Dionysian themes in another private sphere of patronage, the funerary art of the Augustan and Julio-Claudian periods.[35] The sepulchral reliefs in the Museo Gregoriano Profano discussed earlier provide a more costly and monumental example of this kind (fig. 84 a–f).

Dionysian imagery also remained dominant in the decoration of Augustan silver, particularly scenes depicting Bacchic cult trappings in a rural or rustic shrine. In keeping with the bucolic *topos* adapted from Hellenistic sources by contemporary Augustan poets, metal relief decoration of this sort was heavily laden not only with the usual paraphernalia— wine vessels, masks, tympana, *thyrsoi*, etc.—but also with various rustic or bucolic accoutrements also associated with the Dionysian acolytes Pan and the satyrs: the *syrinx* or panpipes, the *lagobolon* or *pedum* (shepherd's crook), and the *pera* or shepherd's sack.[36] Although later Julio-Claudian silverware with this imagery sometimes included the mythic acolytes of Dionysos themselves, Augustan examples generally focused on the setting of the shrine and its trappings as a kind of religious still life. Alternatively the trappings were arranged more abstractly or regularly, as an emblematic pattern.[37] On the Arretine reliefware counterparts of such silver, Dionysian themes also remained extremely popular.[38]

In the public, monumental sphere we have the exquisite Augustan reliefs that once decorated a fountain at Praeneste.[39] Near a rustic shrine of Dionysos or Liber, there is a small, rocky altar decked with offerings, along with a votive monument decorated in relief with a silene mask, a *syrinx*, and the *liknon* or winnowing basket, while a torch and Dionysian wand or thyrsos lie across the top of the monument.[40] The theme of Dionysian worship amidst a rustic natural setting appears even more extensively in the vault stuccoes of cubicula B and D from the Augustan villa excavated beneath the Farnesina Gardens in Rome. The various panels include scenes of initiation and sacrifice, some with herms of Priapos, satyrs, silenes with thyrsoi, female attendants with the *liknon*, busts of the bearded mature Dionysos, and possibly the infant Dionysos as well. In cubiculum B the paintings of the lower zone also depicted the myth of the nymphs of Nysa with the infant Dionysos.[41]

To some extent the currency of Dionysian imagery in these various media may be due to the retrospective or replicative nature of Roman decorative arts at this time. Dionysian subjects had been immensely popular in the derivative repertory of Neo-Attic sculpture like the marble candelabra. The extension of this process of replication or adaptation in less costly media would explain the currency of the Dionysian repertory on the terracotta Campana plaques or in stuccoes, just as Augustan silver and Arretine ware continued the Dionysian imagery established in earlier Greek metalwork. In the case of the tableware, the function as drinking equipment would also have provided an added incentive for retaining Dionysian themes. Yet the Roman market did not consist of passive, undiscriminating gluttons. The popularity of Dionysian imagery in all these media would hardly have continued unless it had been amenable to the buyers. Thus if official Augustan art imposed any sort of rejection of Dionysian imagery, it apparently had no effect on the private artistic sphere or the artists who met this demand.

But it does not appear that any such official rejection ever occurred, for Dionysos or Liber even figured in the decoration of the imperial residences on the Palatine. The imagery of the rustic shrine outfitted with the *pedum, syrinx,* and the *pera* appears prominently in the wall paintings of Room 5 in the House of Augustus, although there the Dionysian masks and tympana have been transferred from the shrine itself to the enclosing architectural settings (fig. 85b), where the masks are so prominent that they have given this room its name.[42] In the adjacent "House of Livia," the paintings of the righthand *ala* feature large, polycarpous garlands very close to those on the Ara Pacis, only here the swags are outfitted additionally with satyr masks and one of the most sacred Dionysian symbols, the *cista mystica,* along with the *pedum,* and a lyre wrapped in ivy (fig. 86).[43]

If we turn to the public sphere of Roman religion, the situation is much the same, for Augustus himself initiated the rebuilding of the temple of Ceres, Liber, and Libera, which had been damaged by fire in 31 B.C. To judge by the treatment that he received in Ovid's *Fasti* (713–790), there is no indication that Liber had lost any of the major status within the Roman pantheon accorded to him somewhat earlier by Varro. Ovid rehearses the Greek Dionysian traditions of his birth and his exploits as conqueror of the East. But here again the god emerges as the dignified Pater Liber, closely bound to the most sacred Roman traditions. Ovid particularly emphasizes his role as the protector of Roman freedom, on whose feast day young men received the *toga libera* (or *toga virilis*), the manly toga, symbolic of the free Roman who has come of age. Liber or elements from the Dionysian sphere even figured in the worship of the Augustan family gods or Lares. On the Augustan round altar from Ostia dedicated to this

cult, Pans are shown escorting the Lares to a centrally located altar flanked by Hercules on one side and Liber's thyrsos or staff on the other.[44]

The Varronian image of Liber as a leading deity of the old Roman farmers, a *deus rusticorum*, was extensively elaborated in Augustan poetry.[45] The preceding discussion has already stressed the role that Liber and Ceres played jointly in such poetry as chief gods of agriculture, but here the god of wine also figured prominently in his own right. For Tibullus (II,1,17 and 39), Liber is one of the *di patrii*, the ancestral gods handed down by native tradition, who both taught and guaranteed the living of the farmers and rustic shepherds, in the spirit of the fountain relief from Praeneste and the Roman silverware discussed above (p. 95). Vergil essentially dedicated the entire second book of the *Georgics* to viticulture and the time-honored veneration of Liber amidst the ancient, rustic or agrarian life-style that had shaped and strengthened the Roman character. For Vergil, it was Liber who had been a primary focus of the old Roman piety, and it is in this connection that Ovid stresses the ancient, rustic origins of the toga ritual on Liber's feast day. The association of Liber with traditional Roman ways is critically important in appreciating how this god too figured within the Augustan campaign to restore the ancient religious practices and moral standards that were believed to have made Rome great.

Thus one should expect that Liber would also appear prominently in the poetry of Horace, an ardent supporter of the Augustan moral *renovatio* and the foremost exponent of the Augustan theme of *moderatio* or temperance. Here, however, Liber does not appear so much as the *deus rusticorum*, but in more elevated terms as the creative force behind the poet and his art. Liber was in fact the special patron god of the Augustan poets. Like Propertius and Ovid, Horace (*Odes* III,25) calls directly upon Liber for the poetic inspiration that is achieved through wine.[46] But there is nothing wild or frenetic in this, for although Horace stresses the "liberating" or inspiring effect of Liber's wine (cf. *Odes* I,18 and I,27), he clearly opposes such usage to the drunken excesses of barbarians or Centaurs, whose intemperance is odious to the god. No one is to pass the bounds of moderation in enjoying Liber's gifts: "away with the ways of barbarians, / protect modest Bacchus from bloody brawls."[47] Similarly, in Ode II,19, Horace depicts Bacchus as a defender of Olympian authority against the impious barbarity of the Giants. Here the image of Liber is a world apart from the notions of immoderation and indulgence associated with Antony.

Yet Horace's interest in Liber involved more than personal creativity. In Ode III,25, Horace seeks Bacchic inspiration in order to glorify Augustus in verse, a desire that relates more broadly to the affinity or analogy be-

tween the god and the Princeps, a recurrent theme in the Odes and Epis-
tles. There, Horace directly compares Augustus to Liber and the other
worthies of myth who attained immortality for their excellence and bene-
faction to mankind, and it is in this encomiastic, paradigmatic, ethical
context that the highly moralized image of Liber proved to be most use-
ful.[48] Basically these poems all utilize the analogic structure inherited from
Pindar: they celebrate the exploits of contemporary figures obliquely
by digressing upon the heroic deeds of the past. In Epistle II,1, the anal-
ogy is rather direct:

> Romulus, Father Liber, and Castor and Pollux
> were received into the temples of the gods
> after achieving great things,
> while they yet cared for the earth and
> the race of men,
> deciding harsh wars, assigning lands,
> and founding towns,
> they lamented that they did not
> find the recognition they hoped for . . .
> But upon you (Augustus) while still at hand
> we bestow timely honors.[49]

Ode I,12 is less obvious; it begins with the praises of a number of gods
and heroes, including the same ones cited above, but only at the end of
the poem does their analogic function become clear:

> O Father and guardian of the human race,
> seed of Saturn, to you entrusted by fate
> with the care of great Caesar,
> may you rule with Caesar next in power.
> Whether he lead in well-deserved triumph
> the vanquished Parthians, hostile to Latium,
> or the Chinese and the Indians who
> lie along the borders of the Orient.[50]

In Ode III,3, Augustus is inserted or nested more emphatically within the
very midst of the deified heroes:

> By such skill did Pollux and wide-ranging
> Hercules strive to attain the fiery heights
> among whom Augustus reclining
> will drink nectar with purple lip.
>
> For this achievement, Father Bacchus,
> did your tigers draw your car,
> pulling the yoke on unaccustomed neck;

> For this did Quirinus (Romulus) escape
> from Acheron on the steeds of Mars.[51]

In Ode IV,8 the heroes only serve more generally as symbols of the achievement that the poet should strive to immortalize in verse, but the connection with Augustus had become so familiar in Horace's earlier work that it hardly required explicit emphasis:

> What would the son of Mars and Ilia be
> had envious silence obstructed Romulus' fame?
> . . . Thus did laboring Hercules make good his hope
> to feast with Jove.
> Thus did the radiant, starry sons of Tyndareus
> rescue shattered vessels from the deepest seas,
> and Liber, his brows bedecked with vines of green,
> brings happy issue to our prayers.[52]

Collectively the *Odes* and *Epistles* demonstrate not only that Liber was an honored deity within the Augustan pantheon, but that he had an established, recurrent function as a mythic analog for Augustus himself; Liber was a paradigm for the achievement and benefaction that was eventually to earn a place among the gods for the Princeps as well. Nor can there be any doubt as to the specifically moral, ethical quality of the analogy that Liber and the other deified heroes projected. This exemplary catalogue of mythic achievement was already current in the Late Republic, where it is attested in Cicero's *Laws* (II,8,19). And somewhat later in his commentary (II,11,28), Cicero explains further that these heroes had earned the divine honors accorded to them because of their outstanding moral qualities—their *pietas*, *virtus*, *mens*, and *fides*.[53] Thus it appears that the Augustan Liber was nothing like the dissolute, effeminate Dionysos who had supposedly been the patron of Antony and his royal predecessors in the Hellenistic East. Instead the god was entirely acclimatized to the highly moral, traditionalist orientation of the Principate.

Nor does it seem that the Antonian connection posed any impediment to the strategy of comparing Augustus directly to Liber. This identification was certainly not as all-encompassing as Antony's association with Dionysos; Augustus had Apollo. But the catalogue of deified heroes in Horace and Cicero nevertheless drew directly on the Hellenistic traditions of ruler glorification that had so attracted Antony. Indeed, the use of the hero catalogue as a precedent for according divine honors to a ruler goes back to the very inception of this Hellenistic tradition. On the evidence of Quintus Curtius and Arrian, Bellinger convincingly demonstrated that the systematic comparison to Dionysos, Herakles, and the Dioskouroi originated in the encomiastic poetry and adulation directed

toward Alexander in the period immediately following the conquest of
the Persian empire. Curtius portrays this development negatively, as the
brainchild of mediocre court poets and flatterers, but Bellinger is correct
to insist that Horace could still have recognized the positive advantages of
applying such glorification to Augustus, especially since it had appar-
ently been accommodated to Roman tradition for some time. According
to Cicero (*Tusculan Disputations*, I,12,28), Ennius had already begun to
include Romulus in the catalogue of heroic benefactors who deservedly
attained their godhead.[54]

The evidence for the origin or background of this imagery in the lore of
Alexander is certainly important, but even without it the Alexandrian res-
onance would also have been clear enough to Horace's audience. By the
first century B.C. the exploits of the Macedonian king had become inex-
tricably tied to the mythic traditions of Dionysos and Herakles as world
conquerors.[55] As the consort of the last of the Hellenistic monarchs, An-
tony campaigned against the Parthians, attempting to make himself a
new Alexander as well as Dionysos and Herakles reincarnate, partic-
ularly because all three had become so thoroughly conflated. In the role
of the final successor to this tradition and victor of Actium, Augustus and
his supporters could hardly have ignored the legacy of Alexander either,
as various recent studies have shown so clearly. Indeed, in the period
following Actium, Augustus used a seal of Alexander on his official and
private correspondence. The precedent of Dionysos and Alexander
would only have increased in relevance after the "diplomatic victory"
over the Parthians.[56]

Thus, the Augustan poets continued to exploit the reciprocal allusive-
ness that had come to attach to the theme of Oriental conquest in order to
praise the new world order established by the Princeps.[57] The treatment
of the power and extent of Rome under the Principate in the *Carmen
Saeculare* is certainly reminiscent of Alexander:

> Now the Mede fears the Alban Axes
> and their armies powerful on land and sea,
> now the once-proud Scythians and Indians
> seek the responses of Rome.[58]

But it is no less redolent of Liber as Ovid describes him in the *Fasti*:

> It would be long to recount his triumphs
> over Sithonians and Scythians,
> and to tell of your conquered people
> O incense-bearing Indus.[59]

Against this background, it is also clear why the *Res Gestae* (26–33)
dwells at length upon Augustus's successes in the East, emphasizing the
extraordinary nature of the embassy from India.

Yet it is perhaps most interesting to see how Actium itself was transformed from an internecine Roman conflict into a grandiose struggle of West versus East worthy of Alexander. The preceding discussion has already noted the gigantomachic dimension accorded by Vergil to the battle in Book VIII of the *Aeneid*, where the gods of Rome supporting Augustus confront the monstrous, composite deities aiding Antony and Cleopatra. But the foreign, Egyptian or Oriental quality of these deities was also intended as a significant aspect of their baleful and inimical nature, and one that they shared fully with the army that they protected. Antony's forces certainly included troops levied from the eastern provinces under his control, but Vergil is not content to speak only of Arabians, Sabaeans, or Egyptians on the enemy side. Instead Antony is said to command an army drawn from the length and breadth of deepest Asia as well, and the poet has chosen his vocabulary very carefully:

Here is Antony with barbaric (i.e., Oriental) might and varied arms,
a victor from the peoples of the Dawn (the East) and the shores of the
 Red Sea (the Indian Ocean),
he brings with him Egypt and the power of the Orient
to utmost Bactria, and there follows, O abomination, his Egyptian
 wife.[60]

Even the Parthian king might have found it difficult to muster such a force, and this is the point. The xenophobic, anti-Asiatic rhetoric and tone of this passage and the whole Vergilian account of Actium is manifestly clear. What was primarily a civil conflict has turned into a Roman war against an external, Oriental foe. It is not a Roman, or even a Hellenistic monarch who challenges Octavian here, but another Xerxes or Dareios. Consequently, the victory at Actium was meant to be seen as another Issos or Gaugamela, or, as Hölscher has recently argued, as another Salamis.[61]

Despite Antony's ambitions against Parthia, the Princeps was now effectively what Antony had failed to become, a new Alexander, and ironically it was Antony who was now cast in the role of the defeated, decadent Oriental monarch. Indeed Book VIII concludes with a direct allusion to Alexander's conquests. There the description of the triumphal procession for Actium elides into an image of the pacified peoples and rivers from the four quarters of the world; the Euphrates moves with humbler waves, and the Araxes remains indignant at its bridge. This last image is a reference to the bridge built by Alexander across the Araxes, although not the Araxes in Armenia, as Servius and later commentators have assumed, but the River Araxes in Persis.[62] Although Tiberius campaigned for Augustus in Armenia, no Roman army ever set foot in interior Iran. Here, in keeping with the rest of the Actian account, the implication of Augustus's victory was made to extend deep into Asia, as a

new triumph over the Persians. Vergil's pairing of the Araxes and the Euphrates here ultimately alluded to Dionysos, who is supposed to have bridged the Euphrates during his eastern campaigns (Pausanias, X,29,4).

The Alexandrian/Dionysian resonance of the imagery at the end of Book VIII also helps to explain why Vergil's Actian account adroitly by-passed Dionysos as a patron or inspiration for Antony. Dionysos was the divine paradigm of the oriental conqueror, the prototype for Alexander himself and all who emulated the Macedonian king. Thus the decision to portray Antony as a new Dareios or Xerxes, an overblown Eastern poten-tate, was a major transformation that effectively erased and precluded any affiliation with Dionysos or Alexander. It was Augustus who now became the heir to the tradition of eastern conquest, and as the new world order began to take shape, it became ever more necessary that Dionysos abandon Antony, for there was certainly room for the god in the new imagery of the Principate. When Propertius lauded the global conquests of Augustus, and especially those against Africa and the Ori-ent which recalled Alexander and his mythic predecessors, it was natu-rally Dionysos's inspiration that the poet invoked, like Horace before him:

> O Bacchus, you are accustomed to
> inspiring your Phoebus,
> So let one recount how the Sycambri
> are servile in their marshes,
> Let another sing of the dark kingdoms
> of Cephean Meroë (Nubia),
> Let another record how lately the Parthian
> makes treaty and confesses his defeat:
> "Let him give back the standards of Remus,
> and soon he shall give up his own:
> Or if Augustus should spare for a time
> the quivers of the East,
> Let him defer these trophies for his boys.
> Rejoice, O Crassus, if you know anything as you
> lie amidst the black sands:
> Now we may cross the Euphrates to your grave."
> Thus will I spend the night with cup
> and with song,
> until the day casts its rays upon my wine.[63]

In 19 or 18 B.C., Augustus even began to issue coins from the mint at Rome through the moneyer Petronius Turpilianus, with the ivy-wreathed head of Liber on the obverse (fig. 87 a–b).[64] The reverse of these issues varied—sometimes a kneeling Parthian holding a military standard, or a suppliant Armenian (fig. 87 a–b). Like the breastplate of the statue from

Primaporta, these coins commemorated Augustus's diplomatic triumphs in the East shortly before 20 B.C., when he recovered the standards and spoils lost by Crassus to the Parthians over three decades earlier at Carrhae, and crowned Tigranes as king of Armenia and vassal of Rome. The ones with the standards on the reverse are explicitly labeled "signis receptis" (fig. 87a). It is extremely significant that so central an event as the return of the standards from Parthia was directly associated on this coinage with the head of Liber on the obverse, which added an unmistakable reference to Dionysos as the paradigmatic conqueror of the Orient. This is substantiated by other coins of this series with Augustus on the reverse as victor, standing in an elephant biga and holding a laurel branch (fig. 87b).[65] As Matz pointed out, these Roman issues were not meant to portray Augustus as a New Dionysos like Antony, but the Liber obverses and the emblem of the elephant biga both played directly upon the imagery of Dionysos as vanquisher of the East, following a format that had already been used on the coinage of the Hellenistic kings.[66] Apollo was the special protector of Augustus, but there were times and circumstances when only Dionysos or Liber could supply the necessary effect.

Vergil also exploited the encomiastic technique of comparison to Liber and Hercules that Horace had utilized so well and so extensively in praise of Augustus. This appears in Book VI of the *Aeneid*, at the close of the long prophetic vision of Rome's future which Anchises unfolds to Aeneas in the Underworld, culminating in the achievements of Augustus:

> And he shall spread his empire beyond
> the Garamantes and Indians
> to a land that lies beyond the constellations,
> beyond the paths of the year and sun,
> where heaven-bearing Atlas turns upon his shoulders
> the firmament studded with glowing stars
> in truth, Alcides (Hercules) did not range over
> so great a stretch of Earth,
> though it fell to him to pierce the brazen-footed
> deer,
> or pacify the forests of Erymanthus,
> and though he made Lerna tremble with his bow:
> nor victorious Liber who guides his chariot
> with reins of ivy,
> driving with his tigers down from Nysa's lofty
> crest.[67]

The references here allude to the Indian embassy of 20 B.C., to the recent campaigns of Balbus against the Libyan Garamantes, and to Ethiopia (the land of Atlas), which submitted as a vassal state to Augustus after

the successful expedition of 24–22 B.C.[68] For Horace, Augustus exceeded those who were deified in times remote because he gained the love and recognition of mankind while he yet lived among them. But for Vergil, Augustus exceeds these predecessors as a cosmocrator, in the sheer scope of his conquest and power. Here again, Vergil's use of Liber and Hercules as precedents for Augustus probably alluded to Alexander too, especially because of the emphasis on the imagery of world rule, and Norden argued that this passage may actually have been adapted from a royal encomium of Hellenistic date.[69] It is in fact likely that such expressions were widespread in the Hellenistic period, and not only in literature. During the second half of the second century B.C., the Greek cities of Maronea and Thasos issued coins with heads of Dionysos on the obverse and standing figures of Dionysos or Herakles on the reverse. The pairing of both here is significant, but so are the inscriptions, which call Dionysos and Herakles *soteres*, "saviors," undoubtedly alluding to the benefaction which had earned them their divinity.[70]

The catalogue of deified heroes also appears on silver wine cups of late Hellenistic or early Roman imperial date. On one example from Stevensweert in Holland, the main frieze consists of heads or masks of Dionysos and Pan with Herakles and the Dioskouroi, too; the intervening spaces were filled with their trappings or attributes—the rustic fetishes associated with Dionysos and Herakles' bow and club. A second cup of this kind from the Hildesheim Treasure includes masks of Herakles with his bow and quiver amidst a larger array of Dionysian masks and fetishes. The precise date for these works or the imagery applied to them is uncertain. The Stevensweert kantharos has been dated as early as the second century B.C., or perhaps a bit later; the Hildesheim cup should be early imperial.[71] But even if these are both Augustan or Julio-Claudian works, they probably replicate or adapt the format and imagery of Hellenistic prototypes. Since both cups utilize the Greek catalogue of heroes in its original form, without the interpolation of Romulus, it is unlikely that they represent some new Roman application of this kind of imagery in metalwork. If these cups are indeed Hellenistic, or even if they depend on Hellenistic exemplars, such Greek originals may well have been produced in court workshops, which adapted the imagery of royal glorification from contemporary encomiastic poetry to the decorative arts. One can only imagine the effect that these cups would have had at Roman banquets where the poetry of Horace and Vergil with this type of heroic comparison was recited.

Although these cups feature the basic Greek hero catalogue, or at the very least Dionysos and Herakles, it is noteworthy that the Dionysian element predominates. Even on the Stevensweert cup where the Dioskouroi appear as well, the various Dionysian trappings and the rich

spray of ivy executed in high relief around the bottom clearly take pride of place. To some extent this may be due to the function of the vessel as a wine cup, but it probably also reflects the pre-eminent role of Dionysos as conqueror of the East. In his discussion of mythic precedents for the exploits of Alexander, even Arrian (*Indica*, V,7–10) stresses that the tradition of Dionysos's conquests was far more extensive or well known than that of Herakles. And ultimately it was Dionysos who appeared as the paradigmatic cosmocrator because he not only achieved wide-ranging conquests, but also spread the civilizing arts of agriculture in the aftermath of his victories. Diodorus Siculus (II,38,5, and III,63,1–III, 64,7) stresses how Dionysos justly deserved immortality for disseminating the knowledge of all things useful for life—the cultivation of the vine and the storage of fruits, and many other agricultural skills. According to Diodorus, Dionysos was also a law-giver who taught humanity to be pious and dutiful to the gods, and just to one another. But most of all, Dionysos put an end to strife; he established *homonoia* or concord among the nations and instituted *polla eirene*, "abundant peace" (III,64,7).

Concord and Peace return us back to the Ara Pacis and its Pergamene forerunners, and one now begins to appreciate the true scope and resonance of the Dionysian imagery on these monuments. Dionysos or Liber was not only a procreative life-force essential to the agricultural cycle; he was a symbol of the universal harmony and order essential to prosperity. This is why Euripides says that "Dionysos loves Eirene," and this was the sense of the contemporary Attic vase paintings where the two were shown embracing. And it was this Dionysian connection with Concord and Peace, accumulated through centuries of poetry, art, and religious belief that informed the overwhelming efflorescence of ivy and grapevine on the Ara Pacis. Here was the true paradigm of the cosmocrator who could guarantee abundant Peace to a grateful humanity.

This was potent imagery, far too potent to allow Antony's connection with Dionysos to remain a stumbling block, and that is why Liber eventually found his proper place within the Augustan strategy of divine affiliation, just as Cleopatra's association with Aphrodite (Plutarch, *Antony*, 26,2–3) did little to restrict the use of Venus in the Augustan program. Zanker has provided a vivid picture of the "rival imagery" or invective that typified the propaganda on both sides once the Pact of Brundisium had lost its force.[72] But with Actium behind him, there was no longer any practical advantage for Augustus to prolong the antagonistic dialectic with Antony's Dionysian affiliation; Augustus's real objective would have been to eradicate the Dionysian associations that Antony had promulgated in order to adapt and incorporate the traditions of this god to the new imagery of the Principate. And virtually all the literary and artistic evidence considered so far indicates that this is precisely what he did.

In the light of all this, Sauron's recent attempt to explain the floral friezes of the Ara Pacis as a vegetal allegory of Actium—laurel versus ivy, Apollo versus Dionysos, Octavian versus Antony—has little plausibility, even in the most general terms.[73] The basic premise of his arguments, the antagonistic image of Dionysos as patron of Antony, had long since evaporated or reverted to the traditional conception of Liber as a benign deity of peace and regeneration thoroughly at home within the public and private arts and literature of the Augustan period, and, indeed, thoroughly tied to Augustus himself. And Dionysos was in any case missing from the glorified accounts of the battle. Nor do the extant remains of the Altar substantiate Sauron's argument that the "confrontation" of the ivy and the laurel on the right side of the south frieze was aligned with the point of the division between the Julio-Claudians and the descendants of Antony in the procession above. The laurel at this point of the south frieze is a reconstruction by Moretti based on the laurel of the north frieze. The corresponding area on the left side of the south frieze has a different plant, as indicated earlier, so there is no evidence for any laurel on the right, even on the basis of symmetry.[74]

Moreover, as allegorical symbols of conflict or confrontation, the one or two branches of laurel that do appear hardly have the upper hand; they are far outnumbered by the ten sprays of ivy that still exist in the north and south friezes, not to mention the six large vines and grape clusters. Nor does the juxtaposition of the laurel with the ivy on the north in any way suggest conflict or discord; their proximity is balanced and felicitous, expressing the harmony and concord that inform the entire monument. The laurel and ivy at this point actually emanate from the same acanthus husk or bract; they are literally two shoots or branches of the same tendril (fig. 10). Visually the message here seems to be one of unity or even identity, and there is in fact good reason for this.

Dionysos and Apollo—
The *Numen Mixtum*

So far, the modern conception of an anti-Dionysian invective or dialectic within the post-Actian Augustan program of imagery has not sustained close scrutiny. Dionysos was carefully divested of Antonian or Oriental associations and reintegrated as Pater Liber alongside Apollo and the array of other gods and heroes whose precedent and protection collectively asserted the divine underpinnings of the Principate. Up to this point the reason for the reintegration has appeared largely practical; the longstanding conception of Dionysos as deity of abundant life and founder of pacific world order was too useful to abandon, and too widely established

to suppress. But there was another, more complex and profound factor that more or less obliged the inclusion of Liber within the structure of Augustan religious ideology, one that absolutely required a harmonious relationship between Liber and Apollo, and one that may also help to explain why Octavian originally chose Apollo as his patron in response to Antony's Dionysos. For both deities were generally perceived as different aspects of a single, unified divine power or *numen*. And it is probably along these lines that one may begin to understand why both their plants were shown bifurcating from a common source in the north frieze of the Ara Pacis.

The evidence for the close connection or identity of Apollo with Dionysos reaches back at least to the Classical period and is attested in literary sources as well as in the visual arts. The nature of this connection is no longer fully clear, but it appears to have focused on a polar relation that was complementary or reciprocal rather than inimical, as various scholars have demonstrated.[75] One of the best sources here is Macrobius (*Saturnalia*, I,18,1–6), who plainly asserts that Apollo and Dionysos or Liber are one and the same god. Although his evidence is late and undoubtedly reflects the obsessive syncretism of Late Antiquity, Macrobius carefully cites a range of literary precedents to substantiate the great age and truth of this belief, including Varro, Aristotle's *Inquiries into the Nature of the Divine*, and lines from Aischylos and Euripides that are otherwise unknown. In the Aischylos fragment both gods are invoked as a unity: "The ivy-like Apollo, the Bakchic One, the Seer."[76] The Euripides fragment reverses the order of the invocation, but it is conceived in precisely the same terms: "Lord Bakchos, lover of laurel, Paian Apollo skillful with the lyre."[77]

In both cases the reciprocity between these deities involves the interchange of their vegetal attributes. This probably explains why in the twenty-sixth Homeric Hymn Dionysos is described as "thickly-wreathed in ivy and laurel." Such poetic imagery corresponds to cult usage as well; Pausanias (VIII, 39,6) tells of a statue of Dionysos at Phigalia whose lower portions were also covered by both plants. Even the tree-idols of Dionysos in fifth-century Attic vase painting sometimes included sprays of laurel at the base.[78] The frieze from the choregic monument of Thrasyllos erected in 320 B.C on the slope of the Acropolis above the Theater of Dionysos in Athens also probably relates to these practices; there the relief decoration includes laurel and ivy wreaths side by side.[79]

Plutarch too asserts the unity or identity of Apollo and Dionysos. In the *Moralia*, 388 E (The E at Delphi, 9), he tells us that Dionysos's share is no less than that of Apollo at Delphi, nicely paralleling Macrobius's report of the joint worship of both gods at Delphi and Parnassos as well.[80] As proof of the authenticity and age of these traditions, we also have the

Paian to Dionysos which the Delphians commissioned from the poet Phi-
lodamos of Skarphea about 340 B.C. There Dionysos is repeatedly in-
voked with the paired epithets Bakchos and Paian, as he is welcomed in
worship at Delphi, Parnassos, and other sanctuaries, until ivy-wreathed
Muses hymn the god with song while Apollo himself leads the dance in
his honor. Stewart has demonstrated how the unified and harmonious
conception of both gods exemplified in this poem also found expression
in the pediments made for the rebuilding of Apollo's temple at Delphi in
the later fourth century B.C.[81]

Thus the unity between Dionysos and Apollo at Delphi that Plutarch
described in the *Moralia* was quite venerable, and it was only one aspect
of a larger and more profound connection, as Plutarch goes on to show in
a fairly detailed theological discussion explaining Apollo and Dionysos as
different aspects or manifestations of the same deity:

> But indeed, because of some pre-ordained purpose,
> he (the god) experiences changes, sometimes kindling
> his nature into fire entirely comparable to all other
> things, at other times assuming manifold variations in
> form, feeling, and powers, even as the cosmos now does.
> He is called by the most familiar of his names. Those who
> are more knowledgeable, however, conceal from the majority
> the transformation into fire and call him Apollo on account
> of his solitariness (A-pollo, i. e., "without the many"), and
> Phoibos (brilliant) because of his spotless and undefiled
> nature. With regard to his turning and reconstituting
> himself into winds, water, earth, stars, and the genesis of
> plants and animals, they only hint at what he endures and
> the transformation, as a kind of tearing apart and
> dismemberment. Him they call Dionysos, Zagreus, Nyktelios,
> and Isodaites. . . . To him they sing dithyrambic songs full
> of emotion, with a transformation having a certain wandering
> and dispersion. . . . But to him (i.e., Apollo) they sing the
> Paian, orderly and moderate music.[82]

In this passage, Plutarch, who was himself a priest and presumably
quite knowledgeable in such matters, provides a valuable insight con-
cerning the complex relation between Dionysos and Apollo. However
different in their outward aspect or character, they were nevertheless sub-
sumed within a larger, unified concept of divinity. The *homonoia* or con-
cord of both divinities, especially at Delphi, was also widely celebrated in
Greek vase painting; the best example is the Kertch Style Attic krater
where a laureate Apollo extends the handshake of harmony and soli-
darity to an ivy-wreathed Dionysos above the *omphalos*, surrounded by

satyrs and maenads.[83] Here Dionysos partakes of his proper share at Delphi much as Philodamos and Plutarch described it. Another Kertch Style hydria effectively reverses this setting; there Apollo is seated on his swan, holding a branch of laurel as he is received within the domain of Dionysos. Maenads and satyrs with thyrsoi beckon toward the god as a kneeling satyr averts his eyes in reverence, dazzled by Apollo's brilliance.[84] Stewart has also emphasized the fusion or conflation of Dionysian and Apolline traits in the statuary types used for both deities in the later Classical and Hellenistic periods.[85]

Nor was the unity of Apollo and Dionysos limited to Greek belief and religious practice; Simon has demonstrated the close and longstanding connection between these deities in Italy. She has focused especially on the interchange or conflation of their symbolic attributes, the laurel and the ivy, in Etruscan tomb painting and minor arts, providing a clear parallel for the similar exchanges in Greek literature and the Thrasyllos monument.[86] Etruscan vase painting and metalwork also followed Greek precedent in depicting both gods as a harmonious pair, or as part of a triad with Dionysos's mother Semele.[87] The intermingling of Apollo and Dionysos apparently remained current down through the Late Republic, since Macrobius (I,18,4) included Varro among the earlier authorities who attested to such belief. By early imperial times laurel was still depicted in Roman painting as part of the cult trappings of Dionysian shrines.[88] Moreover, the poet Lucan could effectively refer to both gods as a *numen mixtum*, a mixed or united divinity, in describing the joint celebrations for these gods on Mount Parnassos:

> Parnassos seeks the heavens, a mountain with double
> peaks sacred to Phoebus and to Bromios (Dionysos),
> where in honor of a *numen mixtum*
> Theban Bacchantes offer triennial Delphic feasts.[89]

Joint rituals or observances of this type did not, however, take place in Republican Rome, where the worship of Apollo and Liber was to some extent divided along class lines. But Simon has indicated that the old Patrician priesthoods which favored the service of Apollo nevertheless assimilated aspects of Liber's cult, particularly the dramatic liturgy, in order to compete with or co-opt the Dionysian religious proclivities of the population at large.[90] Here again this borrowing or transfer of religious practices is most intelligible in the context of the underlying reciprocal or complementary relation between both divinities. Thus by the time of the early empire, the syncretism of Apollo and Dionysos had already made itself felt in official Roman cult, and it found ample expression in Roman imperial painting and sculpture.[91] Consequently, it is not surprising to encounter this phenomenon on the Augustan monuments like the Ara

Pacis, where the "mixed" aspect of Apollo and Dionysos or Liber emerges tangibly in the intermingled branches of their sacred plants (fig. 10). But even so, this was no innovation or modification of advanced Augustan art; the blending of the Apolline and Dionysian is already discernible in the monuments produced just before or after Actium.

An impressive example of this phenomenon is the painted decoration of the so-called "Room of the Masks" (Room 5) from the House of Augustus on the Palatine.[92] The Apolline character or aspect of these paintings is well known from the various studies published by the excavator, Carettoni. It emerges most clearly in the scenery within the architectural setting of the south wall, which depicts a tapered conical monument known by various terms—the *konoeides kion*, "Agyieus pillar" or "Baitylos"—with a large curving exedra as a backdrop (fig. 85a). Literary sources, coins, and archaeological remains all indicate that this was an aniconic form of monument associated with the worship of Dionysos, Artemis, and especially Apollo, in his aspect as Agyieus, "god of the wayfares."[93] The placement of the pillar before an exedra in the painting closely approximates a real monument, the hemicyle built by Pratomedes for the Apollo sanctuary at Cyrene in Libya during the Hellenistic period.[94] The covered quiver that leans against the base of the pillar seems to be an added Apolline allusion (fig. 85a). An Agyieus pillar outfitted with a similar quiver and a cithara also appears among the terracotta "Campana" plaques that once decorated the Palatine temple of Apollo right next door to Augustus's residence.[95] The swans in the friezes of the architectural framework on the west wall of the Room of the Masks provide one last allusion of this sort (fig. 85e). They are very reminiscent of the swans in the Ara Pacis friezes, but here, where there are no tendrils or additional elements symbolic of Aphrodite/Venus, they seem to function primarily or solely as Apolline symbols.[96]

The rest of the scenery of the west wall, however, points in another, different direction. In place of the conical Agyieus pillar there is a columnar stele surmounted by a vessel or urn, and enveloped by a nearby tree (fig. 85b). Monuments of this type are fairly common as features of the rustic shrines depicted in the sacral-idyllic landscape of Roman wall painting and stucco reliefs.[97] But they were also used more specifically as components of rustic Dionysian shrines. The shrine of this sort on the late Republican silver cup in Toldeo includes such a stele with an urn amidst the various trappings of Dionysos, and it also appears among the Dionysian trappings depicted in the panel on the votive monument with the thyrsos in the fountain relief from Praeneste.[98] Since the very same array of Dionysian fetishes is also displayed on or around the stele in the Palatine painting—the *syrinx*, or panpipes, the *lagobolon* or *pedum*, (shepherd's crook), and the shepherd's sack or *pera*—here too the Dionysian

emphasis of the stele or the shrine as a whole is clear (fig. 85b). Moreover, just as the Agyieus pillar was complemented by the added symbol of the swans over on the west wall, the column with its urn corresponded to additional tympana which were suspended from the architectural framework on the south (fig. 85, d and e).[99]

Thus the paintings of this room would seem to have functioned as a kind of counterpoint, opposing or juxtaposing a sacral-idyllic scenery redolent of Apollo on the one hand with that of Dionysos or Liber on the other. But it is not so cut and dry. To begin with, there is a reciprocal displacement or exchange between the Apolline swans and the Dionysian tympana; the swans appear on the architecture enclosing the stele with the Dionysian bucolic trappings, while the tympana hang from the architectural framework around the Agyieus pillar. Nor is the divine association or significance of the central monuments on the west and south walls really so distinct. The tree that lovingly embraces the columnar stele with the Dionysian fetishes is a laurel, Apollo's laurel. And while actual examples and artistic representations suggest the Agyieus or *konoeides kion* was primarily an Apolline form of monument, the lexical evidence of Harpokration and Suidas nevertheless states plainly that it was also a symbol of Dionysos, or of Apollo and Dionysos simultaneously.[100] There is visual artistic evidence of this kind as well.

A conical pillar like that on the south wall in the Room of the Masks is depicted on the fragment of a late Hellenistic Pergamene relief skyphos, but there it is outfitted with Dionysian imagery like the columnar stele on the west wall. A *lagobolon* with a *pera* lie against the base, along with a torch, and in addition, a lyre-playng Pan leans back against the upper part of the pillar.[101] The well-known Munich relief of the farmer leading a cow past a rustic sanctuary also includes such a conical pillar. There the Dionysian character of the shrine is evident from the *liknon* filled with fruits and a phallus that sits atop the pillar itself, and from the thyrsos, torches, and tympana beside and above the precinct walls.[102] Still another example appears in the Dionysian shrine on a pair of silver cups from Pompeii.[103] In a more mixed vein, an actual marble Agyieus pillar of Late Republican date in the Villa Albani has a frieze along its base that includes not only Apollo and nymphs or Horai, but also a dancing satyr holding the *lagobolon* or shepherd's crook.[104] Because of the ambiguous associations of the central, columnar monuments or pillars on both walls, as well as the transposition of the swans and the tympana, the use of Apolline and Dionysian elements in the Room of the Masks effectively visualizes the concept of *numen mixtum*.

This blending of both deities in a rustic or idyllic setting also occurs in the poetry of the Augustan period. As Simon has observed, a similar mixture of Apolline and Dionysian imagery is central to Vergil's Fifth

Eclogue.[105] There, as in Theokritan verse, the main character, the shep-
herd Daphnis, is a devotee of Dionysos:

> Daphnis showed how to yoke Armenian
> tigers to the chariot,
> Daphnis showed how to perform the
> sacred dances (thiasoi) of Bacchus
> and how to wind soft leaves around the
> harsh lance (e.g., thyrsoi).[106]

But though clearly a founder and promoter of Dionysos's worship,
Daphnis is tied to Apollo as well, and not only because his name derives
from *daphne*, Apollo's sacred laurel. Later in the Fifth Eclogue (65–73), the
other shepherds pay honor to Daphnis jointly with Apollo, with two al-
tars for each, with libations of wine (referred to metonymically as Bac-
chus), and with satyr dances. As the poem closes, the shepherd Menalcas
vows that Daphnis will customarily receive these rites from rustic wor-
shippers, even as they propitiate Bacchus and Ceres.

Propertius conjures up a more overtly syncretistic scene in Elegy III,3.
Although he often implores Dionysos or Liber to inspire his verse, here it
is Apollo who speaks to the poet from his tree in the Castalian grove,
revealing a vision of an idyllic green cave. With the exception of the
Muses who are within, however, the cave is anything but Apolline, and
we revert to the more usual source of Propertius's inspiration. The walls
are hung with clay images or masks of silenes, with panpipes (the *syrinx*),
and with tympana—the standard array of Dionysian trappings. One of
the Muses even gathers ivy vines to wrap around thyrsoi. Grimal has
stressed the general similarity between this poetic scenery and the sacral-
idyllic landscape of contemporary Roman relief and wall painting.[107] But
the poem's specific blend of Apolline and Dionysian imagery in a rustic,
pastoral setting is particularly analogous to the paintings in the Room of
the Masks, and not only with regard to the shepherd's pipes and tym-
pana, but also in the prominent display of the particular trappings for
which this room is named.

Despite the eponymic distinction accorded to them here, the paired
placement of dramatic masks in the architectural scenery or framework
on each of the walls in this room is not at all unusual within the larger
context of Second Style painting. A similar arrangement appears in the
paintings of the Villa at Boscoreale, and in the House of the Labyrinth
and the "Villa of Julia Felix" at Pompeii.[108] The wide diffusion or currency
of this format tends to support the idea that it originated from a common,
readily accessible background, the scenographic embellishment of the
stage or theater, as Beyen and others after him have argued. In the case of
the paintings in the Room of the Masks this thesis has been further sub-

stantiated by the close analysis of Richardson and Cerutti, using the evidence of Vitruvius for such stage scenery.[109]

Yet the implications of such an origin for the significance of the masks remains open to question. It would be simplistic to assume that the masks here were essentially excess baggage, part and parcel of the theatrical paraphernalia that went along with the architecture. The mask was a potent Dionysian attribute or cult object long before it acquired a theatrical meaning because of Dionysos's association with the theater or drama.[110] Thus theatrical masks of various types appeared regularly as an element in depictions of Dionysian shrines. Consequently, some scholars have insisted that the mask continued to function as a religious symbol in Roman wall painting, and not simply as a more neutral allusion to the theater.[111] Engemann has even argued that the masks depicted on architectural ledges or cornices in such paintings replicate actual religious objects or trappings displayed on the walls of Roman houses, a usage that has no substantive connection with the theater.[112]

In the case of masks suspended from filleted polycarpous garlands with other cult trappings like the *cista mystica*, as they appear in the Villa at Boscoreale or the House of Livia (fig. 86), the religious, cultic resonance is even clearer. And as Lehmann observed, this format recalls the trappings of an actual religous ceremonial—the great Dionysian procession of Ptolemy Philadelphos, where a statue of Dionysos was covered by a canopy consisting of garlands with vines, ivy, and other fruits, embellished further with dramatic masks, fillets, tympana, etc.[113] The masks and garlands of these wall paintings also recall another royal Hellenistic Greek religious precedent, the floor mosaic of the "Altargemach" in Palace V at Pergamon, which served as the cult chamber where the Attalids privately venerated Dionysos Kathegemon as protector and progenitor of the dynasty (fig. 63).

Thus, in addition to theatrical usage, there was a much broader range of traditions and associations that informed the decoration of the Room of the Masks. And here, one should see the masks not only as Dionysian symbols, but as emblems specifically appropriate for decorating the residence of a ruler. The same may be true of the Agyieus pillar as well, for like the mask, it too turns up within the context of religious cult associated with Hellenistic kings. The Agyieus pillar appears prominently on the series of Ptolemaic faience oinochoai which commemorated the ruler cult in Egypt.[114] The pillar stands behind the queen who holds a cornucopia and offers a libation to the altar of Agathe Tyche, "Good Fortune." Although the pillar was, as we have seen, primarily an Apolline cult object, nothing else about these vessels seems at all Apolline, and this is not surprising since the Ptolemies apparently did not encourage his cult as they did those of Aphrodite, Demeter, and Dionysos.[115] However, these

vessels are consistently outfitted with satyr or silene masks at the top of the handle, and on one fragmentary example, the Dionysian element penetrates the cult scene itself, since a shaggy he-goat, the sacrificial animal of Dionysos, appears right next to the altar.[116]

Consequently, these faience oinochoai present a mixture of Dionysian and Apolline features; perhaps the Agyieus pillar on these vessels is the type that was simultaneously dedicated to Apollo and Dionysos, as attested by Suidas and Harpokration. But in any case, the combination of the satyric masks and the pillar on these vessels nicely parallels the paintings in the House of Augustus. It is tempting to think that this is somehow not fortuitous, especially since certain of the faience oinochoai show the queen holding a double cornucopia or *dikeras*, a Ptolemaic symbol of superabundant prosperity, which also appears in the Room of the Masks, crowning the apex of the architecture on the south wall above the Agyieus pillar (fig. 85a, top).[117] The mechanics of this connection remain elusive. It is unlikely that the wall paintings depended directly on the faience vessels of the third century B.C.; instead the paintings probably reflect the actual monuments or ceremonial shown on the vessels. One wonders whether pillars of this sort were set up within the palace precincts, or whether they were depicted on a grander scale in the decorations of the palaces, just as the masks were monumentalized in the mosaics of the "Altergemach" at Pergamon. Fittschen has emphasized the role that Hellenistic palace architecture may have played in the origin of the Second Style generally.[118] This may apply as well to the details or objects included within the architectural settings of the Second Style, especially for paintings in the House of Augustus, which was a direct, albeit more modest, analog of the royal Hellenistic residences.

In the end, we are left with isolated and fragmentary remains, like the faience oinochoai, the description of Ptolemy's grand procession, and the Pergamene mosaic, that provide only fleeting glimpses of the cultic monuments, regalia, and architectural decoration utilized by the Hellenistic kings to affiliate themselves and their dynasties with divine protectors. But even this limited evidence should be enough to suggest that the decoration of the Room of the Masks was more than a mélange of current theatrical scenery and sacral-idyllic landscape. Instead its imagery may derive as well from the usage of the Hellenistic courts, perhaps even from Hellenistic palace architecture and decoration. And if the commemorative faience vessels are any indication, even the mixing of Apollo and Dionysos or their attributes in the Augustan paintings may reflect not only the syncretism customary for both gods, but also the precedent of Hellenistic ruler glorification.

However, nowhere in the art of the early Principate was the complex and multifaceted interaction between Apollo and Dionysos or Liber more

forcefully addressed than in the cistophoric and related quinarial coinage issued by Augustus in the years just after Actium, approximately contemporary with the Palatine paintings.[119] And nowhere has the sense of the interaction or relation between both gods been so oversimplified or distorted.[120] The Augustan cistophori take their name from the *cista mystica* depicted on the reverse, where it appears behind the standing figure of the goddess Pax with the caduceus, and surrounded by a large wreath of laurel (fig. 87c). Made primarily for circulation in the eastern provinces, these coins have long been recognized as a direct response to the cistophori issued a decade earlier by Antony, following Pergamene or Asiatic precedent of the second century B.C. (fig. 87d and f).[121] Like the Greek forerunners, the Antonian cistophori focused on the imagery of Dionysos as prototype and protector of the ruler or dynasty, and undoubtedly as an expression of Antony's stance as "New Dionysos." On the obverses, Antony appeared crowned in ivy and corymbs, with yet another, larger ivy wreath as an enclosing border. The reverses contained Dionysos's *cista mystica* flanked heraldically by a pair of snakes. On some issues Dionysos himself stands atop the *cista* holding his thyrsos and a wine vessel.[122]

Despite a certain measure of transposition and substitution, there can be no doubt that the Augustan cistophori deliberately corresponded to those of Antony. In addition to the *cista mystica*, the laurel wreath on the reverse provided an obvious counterpart to the ivy wreath on the obverses of the Antonian issues, just as the laureate head of Augustus answered the ivy-wreathed Antony. The silver quinars issued by Augustus at about the same time (29–28 B.C.) constituted an even more direct response of this kind; there, the reverse showed the *cista* flanked by snakes precisely like the Antonian cistophori, except that the mystic basket now supported a Victoria instead of Dionysos.[123] Nor is the polemic nature of this response at all ambiguous; the Augustan coinage of this kind was clearly a numismatic extension of the anti-Antonian propaganda that circulated widely in the aftermath of Actium. Indeed the legend on the quinar, "Asia recepta," makes the reference to Actium itself explicit.

But how this polemic functioned is another matter; for it is highly questionable that the carefully orchestrated counterpoint between the imagery of Apollo and Dionysos on these coins was itself inimical. The aggressive interpretation of "Apollo versus Dionysos," elaborated in recent scholarship on the Augustan cistophori essentially misreads the whole sense and intent of the Apolline transformation that was imposed upon Antony's Dionysian cistophori or their Asiatic prototypes.[124] This transformation aimed instead at subsuming and reassimilating the Antonian imagery within the construct of the new Augustan religious ideology, although so far, only Simon appears to have recognized this. As she

has astutely observed, the formal structure of the coins themselves is visually expressive of inclusion and harmony rather than conflict or opposition. The laurel wreath encloses the *cista mystica* the way that Dionysos was integrated within the Apollo cult at Delphi.[125] The objective here was not to discredit or suppress the deity that Antony had claimed as his patron, but simply to discredit the claim itself, and to articulate the ineffable connection of Dionysos and his mystic attribute with Apollo, and through him with Augustus as well. The Augustan cistophori were perhaps the most public and enduring expression of the strategy of divestment traced above in literary and verbal media.

Alpert has stressed the broader historical context in which this development unfolded. To some extent the Antonian cistophori and the Augustan counter-issues recapitulated the numismatic exchanges of an earlier generation, when Mithridates of Pontos issued "Dionysian" tetradrachms with ivy wreaths imitating Pergamene cistophori, and Rome responded with Apolline coinage.[126] But there too the Roman strategy had been one of reclamation that included issues with Liber and Victoria, as we saw above. And Liber coinage continued to be issued around the middle of the century, just as Dionysian subjects remained popular in Roman art more generally right into the Principate. The Romans of Mithridates' time had been no more inclined to surrender the powerful imagery of Dionysos to their enemies than Augustus was some fifty years later. Consequently, there is little basis for Alpert's argument that during the first century B.C. this deity had come to be understood as *romfeindlich*, "hostile to Rome."[127]

This argument becomes even more untenable in the light of the fundamental religious connection or unity between Apollo and Dionysos. Even during the period of conflict with Mithridates, the Romans had responded not only with Apollo and Liber on distinct, simultaneous coin issues, but also with others that combined the imagery of both gods. The denarii of M. Fonteius struck in 85 B.C. have the laureate head of Apollo on the obverse, with a Dionysian scene on the reverse—a Bacchic Eros riding a billy goat.[128] Toward the middle of the century, the blending of Apollo and Dionysos had already begun to penetrate the cistophoric format as well. The proconsular cistophori issued at Ephesos in 58–57 B.C. have the traditional Pergamene obverse with the *cista mystica* surrounded by an ivy wreath; but on the reverse the coiling snakes enclose Apollo standing atop his tripod (fig. 87e).[129] Thus by the Late Republic the precedent for an Apolline cistophorus had already been established, and not in Rome or Italy, but in the provincial coinage of Asia Minor.

All this muddies the waters considerably for the view that post-Actian Augustan art asserted a clear-cut polarity between a benign, Western or Italian, Apollo and an inimical, Eastern, Hellenistic Dionysos.[130] Nor

does this view hold up against the background of Augustan propaganda or the Greek precedent that it followed. We have seen how the conception of Apollo as protector and progenitor of the ruler was just as eastern or Hellenistic in origin as the use of Dionysos in such a capacity, and how Dionysos was neatly excluded from the anti-Oriental dialectic of Actium preserved in Augustan poetry. Here it is especially worth recalling the intimate and harmonious relation between Apollo and Liber at the close of the Actian elegy of Propertius (IV,6,76–86) discussed earlier. "O Bacchus, you are accustomed to inspiring your Phoebus." Perhaps this notion of divine interaction also informs the very last two lines, where the poet vows to spend the night toasting the eastern conquests of Augustus with verse until the rays of daylight break upon his wine—the rays of Phoebus himself mingling with Liber's intoxicating juices of poetic inspiration (see p. 102).

Augustus's choice of Apollo as his patron and protector was conditioned by a range of precedents and considerations, and not only in the traditions of the Hellenistic East but also in Italy. Delphic Apollo had come increasingly to acquire a protective association with the *fata romana*, the destiny of the Roman state, a process that accelerated in connection with the official use of the Sibylline prophecies.[131] The related traditions that tied Apollo to the Julian house and to other prominent aristocratic Roman families would have factored into his choice, as did Apollo's protective relation to the Trojans, mythical ancestors of the Romans.[132] But Augustus's use of Apollo specifically as a countermeasure to the Dionysian propaganda of Antony must also have been based in the reciprocal relation that had united these deities for centuries in the beliefs and practices of Greek and Italian peoples.

Thus the cistophori issued by Augustus were not simply a counterblast against the imagery that had been promulgated by his defeated opponent. On one level, they represented a fusion of the two currents of ruler glorification that had dominated the religious propaganda of the Hellenistic kings—the Apolline tradition of the Seleucids and the Dionysian tradition of the Ptolemies and Attalids. But in more specific terms, the cistophoric issues of 28 B.C. were the culmination of an objective that had preoccupied the Romans throughout the final century of the Republic, the need to resolve the competing claims of these traditions after decades of propagandistic usage on both sides by Greek and Roman alike. There can be little doubt that this resolution was facilitated by the longstanding syncretism or reciprocity between both gods. It was this complex relation that made the *cista mystica* appropriate and intelligible within the laurel wreath of Apollo for the population of Augustan times, as it had justified the mixed Dionysian and Apolline aspect of the Ephesian cistophori several decades earlier. The legend of the Augustan cistophori—*vindex populi*

romani libertatis—was equally a manifestation of this process. On the surface it celebrated Antony's defeat as the destruction of a threat to Roman liberty.[133] But this nomenclature too had a syncretistic dimension, for it now assimilated to Apollo and to Augustus yet another of Liber's features, his role as guardian of the freedom of the Roman people.[134]

If the new imagery of the Principate was indeed meant to supplant and resolve the contradictions of the dying Republic, as Zanker argues, then the Augustan cistophori constituted a major facet of this agenda. The notion of conflict or opposition between Apollo and Dionysos has more to do with Nietzsche than it does with the religious beliefs of classical antiquity, which stressed the complementary relation between these deities. Those who designed the Augustan cistophori had no stake in prolonging conflict; if Plutarch is reliable, popular opinion had already begun to separate Antony from Dionysos directly after the defeat at Actium, and these coins were intended to finish the job. Here the attributes of Apollo and Dionysos were commingled in a manner entirely appropriate to mixed divinity. Instead of conflict the cistophori exuded *homonoia* or *concordia*, as in fact they should, for along with the laurel and the *cista*, they included Pax as well (fig. 87c). This was yet another factor that more or less obliged the incorporation of Dionysos/Liber within the religious political ideology of Augustus.

In Classical Athens, as we have seen, Dionysos was said to love Peace. In vase painting he embraced her and entertained her in the company of his maenads and satyrs. In the procession of Ptolemy Philadelphos, Dionysian figures accompany the Horai. By the time of Diodorus Siculus, this had not changed, for the historian tells us that in the aftermath of Dionysos's global conquests the god had established *homonoia* and abundant Peace.[135] But in this as well, he worked in harmony with Apollo. Already by the late fifth century, both were closely associated with the Seasons or Horai, especially Eirene, as we saw on the round marble altar from the sanctuary at Brauron. These Greek traditions were, moreover, known in Augustan Rome since Dionysos appears as leader or guide of the Horai on the marble candelabra bases of this period, just as processions of the Horai on Augustan relief ware were liberally outfitted with baskets of Dionysian plants, masks, and bucolic fetishes.[136]

Thus the mutual relation to Eirene or Pax must also have been a significant aspect of the *numen mixtum* that united Apollo and Dionysos. And it was this very special connection among all three that the cistophori of 28 B.C. celebrated and advertised as the final outcome of the victory at Actium. Moreover, the association with Peace may already have been a factor on the original Dionysian cistophori of Pergamon, since individual issues included the kerykeion or caduceus on the reverse.[137] Consequently, it cannot be accidental that the interior decorations of the temple

to Concordia Augusta overlooking the Roman Forum included not only images of Apollo, but also a depiction of Dionysos or Liber by the fourth-century Greek painter Nikias.[138]

The harmonious connection of Apollo and Dionysos or Liber with Pax finally brings us back to the Ara Pacis, and to the common or unified source of the laurel and ivy in the floral friezes (fig. 10). From the evidence of earlier Augustan art and literature assembled above, it should be clear that the plants of Apollo and Dionysos here can hardly be symbolic of conflict between these gods, as Sauron argued. Like the cistophori, they represent a mixed conception of the two male divinities most closely related to Peace. This suggests a special status or emphasis for Apollo and Dionysos within the program of the Ara Pacis that may even transcend the overall theme of concord including the other, female deities whose plants also appear amidst the acanthus tendrils. And there are, in fact, additional indications of this on the interior of the Ara Pacis, in the ornament of the lateral barriers of the altar proper.

In addition to elaborate spiral volutes and tendrils, these barriers are decorated at either end by the imposing figures of leonine griffins (figs. 8–9, 40, and 42). As Simon indicated in a thorough study of the meaning of the griffin in Greek and Roman Art, the basic function of these composite creatures on the altar was apotropaic; they served as the flanking guardian figures of a sacred precinct like their forerunners in ancient Near Eastern art.[139] But the griffin also had a more specific association in Greek and Roman art as a symbol of Apollo and Dionysos, providing yet another instance of the attributes shared or exchanged by both deities.[140] Nevertheless the association with the griffin was predicated differently in either case. Its function as an attribute of Apollo had essentially solar connotations, suggesting his equivalence with Sol, and based ultimately on the earlier connection between the griffin and solar deities in the ancient Near East.[141] It is in this capacity that Apollo rides the griffin on the breastplate of the Primaporta Augustus, where he is compared or identified with the figure of Sol above.[142]

However, the overtly celestial or cosmic setting of the breastplate is very different from the vegetal context of the Ara Pacis altar. There, instead, the griffins are embedded against massive volutes with acanthus leaves which almost seem to grow from behind their manes, while more acanthus forms a leafy bed or calyx beneath the creatures (fig. 42). If the suggested reconstruction of an elaborate acanthus composition on the lateral altar walls below the griffins is at least only generally correct, then their association with lush, ornamental foliage would originally have been even more striking (fig. 9). This pronounced floral or vegetal context links the griffins of the Ara Pacis more specifically to Dionysos, whose connection with these creatures centered on his role as lord of plant and

animal life, again following earlier Near Eastern tradition where the griffin was also associated with vegetal renewal.[143] The Augustan Campana plaques with Dionysos-Sabazios discussed above in Chapter II celebrated the god in this dual capacity, for he controls not only the enclosing mesh of stylized tendrils, but also pairs of rampant lion griffins, which recall those on the Ara Pacis (fig. 77).[144] Another Campana plaque has a pair of griffins flanking a fruit-filled krater with crossed thyrsoi behind it, a composition based on Hellenistic Greek models.[145] For spectators familiar with such plaques or other works with similar imagery, the griffins of the Ara Pacis in their vegetal setting would have readily evoked Dionysos's powers.

From Greek literary sources, we also know that the griffin was a symbol of the East and its wealth. Thus it is easy to understand, as Simon further demonstrates, how the griffin came to be associated with Dionysos in his role as conqueror of the Orient.[146] This is certainly the sense of the relief decoration on the Hellenistic marble throne of the priest of Dionysos Eleutherios in the Theater of Dionysos at Athens. There the front edge depicts addorsed griffins confronting kneeling Persians or eastern barbarians, while the back rest shows vintaging satyrs.[147] In time the added association of the griffin with Nemesis eventually merged with the Dionysian theme of eastern conquest in order to represent the rightful supremacy of Rome over Orientals and other barbarians. On the breastplate of a Julio-Claudian armored statue in the Lateran Museum, griffins attack kneeling eastern barbarians supported by tendrils.[148]

In the case of the Ara Pacis, Simon preferred to interpret the griffins as emblems of a *numen mixtum*, simultaneously expressing the power of Apollo and Dionysos.[149] In support of this mixed identification, one may cite as a parallel another, somewhat later altar of early Roman imperial date in Providence. There, griffins appear together with Apolline and Dionysian elements—a laurel tree with bow and quiver, and satyrs with a *cista mystica*.[150] On a more abstract level, it is also useful to recall the testimony of Plutarch's *Moralia*, 388 F, cited above, where the syncretistic unity of Apollo and Dionysos is said to manifest itself respectively in solar form (fire and light) and as the regeneration of plants and animals. Since the griffin actually embodied these solar and vegetal or animal aspects, they would have been rather effective not only as symbols of Apollo and Dionysos individually or alternatively, but also together, as a mixed divinity.

The complex array of associations involved in such a double resonance for the griffins would in fact have been ideally suited to the overall program of the Ara Pacis. Here, the overtones of just world conquest or dominion would have complemented the military basis of the *Pax Augusta* expressed more overtly in the relief of Roma on the altar enclosure. But

the concepts associated with the respective components of the *numen mixtum* developed this theme in more specific terms. The solar, Apolline connection of the griffin would have reinforced the notion of justice and rectitude that legitimized and guaranteed the power of Rome and the Princeps, just as it would have suggested the prophetic destiny that had established this power. The vegetal, Dionysian aspect of the griffins was most immediately relevant to the prosperity and abundant life of world peace that followed in the aftermath of civilizing global conquest. Individually these associations offered a potent and compelling rationale for the *Pax Augusta*; but together, as a unified conception, their impact was overwhelming.

On the outside of the altar enclosure, then, the plants of Apollo and Dionysos or Liber must also have been redolent of the theme of harmonious, burgeoning world Peace associated with both gods. And here, to an extent, this followed the precedent of the Pergamene altar slabs, which had already associated their plants (laurel and grapevine) on a monument dedicated to fruitful Peace and Concord. But on the Pergamene altar, there was no special juxtaposition of the Apolline and Dionysian plants, which took their place beside the various other divine vegetal attributes. The particular emphasis there was on the plants and other symbols of Demeter. The relation between Dionysos and Apollo on the Pergameme monument was part of a larger conception in which both gods, and Demeter as well, were understood together as *horephorai*, leaders of Eirene and the other Seasons. Considering the "Tellus" relief with its multifaceted *kourotrophos* flanked by Aurae/Horai, it is clear that the Ara Pacis was still invested in this female theology of abundance, yet there are fundamental changes. While still important, Demeter and the Great Mother no longer predominate, but give way to the imagery of Aphrodite/Venus, and not only in the "Tellus" relief but also in what remains of the floral friezes, where roses now outnumber the poppies and oak.

At the same time, the Apolline and Dionysian plants on the Ara Pacis have achieved a new quality of integration reflecting a conception of mixed divinity that is not evident on the Pergamene reliefs. In view of this, and also considering the mixed aspect or function of the altar griffins, it may be that the relation of the various tiny animals in the friezes to Dionysos and the goddesses now came to extend to Apollo too. While, as we have seen, the significance of such animals related uniformly to Dionysos in earlier Greek and contemporary or later Roman floral ornament, and to fertility goddesses in allegorical landscape, Pollini has pointed to literary evidence that also associates the frog, snake, and lizard with Apollo and his prophetic powers. Similarly Pollini has connected the snake and the bird's nest of the north frieze with the well-

known omen on the fall of Troy and and the birth of the new Rome.[151] Thus, like the polycarpophoric imagery on the Ara Pacis, the inherited polytheriotrophic function of the floral friezes may too have come to provide a locus for the operation of the *numen mixtum*.

Indeed, this may help to explain the new dominance of the Dionysian elements throughout the long friezes. Once we are prepared to recognize the ivy and laurel as harmonious and complementary emblems of a *numen mixtum*, rather than as symbols of opposition, the apparent disparity in their frequency becomes a moot issue. As in the case of the altar griffins in their leafy setting, the Dionysian association or side of the *numen* was far more relevant to the notion of efflorescent plant and animal life; hence the preponderance of ivy and grapevine, and also the enormous emphasis on the largely Dionysian artistic tradition of tiny animals as inhabitants of ornamental tendrils. None of this really competed with or diminished the status and presence of Apollo. One or two branches of laurel were sufficient to express his blessing and protection, especially considering the apotropaic associations of the plant, and especially if Pollini is also correct in interpreting the overall acanthus network itself as Apolline.[152] Moreover, the Dionysian side of the *numen*, the capacity to regenerate, was in any case at Apollo's disposal, as one last look at Propertius's Actian elegy makes clear. There it is only in a figure of speech that Bacchus "inspires" Apollo; the line literally says, "O Bacchus, you are accustomed to be *fertile* for your Phoebus."[153] We could ask for no better evidence of the specific function of the unified, cooperative interaction of these two gods.

The all-encompassing power of this divine unity and its special relation to the goddess or theme of Peace, then, explains the overwhelming presence of the Dionysian attributes or metonyms in the floral friezes of the Ara Pacis. They symbolized not only the god himself, but also his function within the larger concept of divinity that supported the Roman state, its leader, and the *Pax Augusta*. Precisely how ancient observers would have understood this complexity and who or what they would have called it at a given moment is difficult to say; and the problem is perhaps analogous to how spectators would have understood the multivalent *kourotrophos* of the "Tellus" relief. In cases such as these, our modern need to categorize and delimit phenomena in neat, clear terms may well be at odds with the nature of the evidence and ancient usage. To us it may seem disturbing that the laurel could be seen as a Dionysian plant, or that the ivy and vine could become Apolline symbols. But in the context of ancient religious belief this posed no contradictions; it symbolized or embodied a mystic and complex notion of unified but composite divinity whose closest analog is perhaps the doctrine of the Trinity in Christian theology.

There is, of course, no doubt that Augustus strove primarily to advertise himself as a protegé and replica of Apollo; symbolizing as he did all that was pure and shining, regulated, and controlled, Apollo's divine guardianship was ideally suited to the Augustan politics of imperial reconsolidation and restored stability based on religious reform. Yet Augustus could not, as we have seen, overlook or ignore the tradition of Liber, so widely venerated by Italians as giver and renewer of life, and especially not if he was understood as an adjunct or extension of the same godhead as Apollo. This is already evident in the Room of the Masks and the cistophori. In the course of time Augustus came to explore the Dionysian side of *numen mixtum* more fully. As he received the submission or friendship of Iranians, Indians, and Africans, Augustus and his supporters could scarcely have avoided the traditional precedent of Dionysos/Liber as pacifier of such widely dispersed regions in their efforts to assert his own claims as cosmocrator in official art and poetry. The longstanding syncretism between Apollo and Dionysos provided the obvious solution, one in which Augustus ultimately did not have to choose, but got it all. Like Augustus we may prefer to call the god who supported him Apollo. But we need only scan the tendril friezes and the altar barriers of the Ara Pacis Augustae to see that this divinity was more complex or synthetic than students of the Augustan period have generally been willing to allow, and that his powers and blessings incorporated significant aspects of the god we call Dionysos, Bacchus, or Liber. In considering the nature and import of the floral imagery on the Altar of the Augustan Peace, we must, like the ancient observer, keep this in mind.

Chapter IV

Degenerare and Renovare

The Ara Pacis and
the Return of the Golden Age

Like the *Pax Augusta*, the notion of the Golden Age, the *aurea aetas* or *aurea saecula*, was a major theme or *topos* of Augustan literature. For poets like Horace and especially Vergil, who sought to idealize the stable and ordered Peace of the Augustan regime in the comparative terms of mythic precedent, the analogy of a pristine era of blissful abundance and moral virtue must have seemed irresistible. Here was a tradition enshrining an age that knew no war or faction, a time when humans lived in tranquil harmony with themselves and the gods, while the Earth, in satisfaction, was fruitful of her own accord. In the myth of the Golden Age, the conceptions of peace and abundance converged with glaring clarity and effectiveness, and as such it became an essential component in the Augustan program of imagery. Yet if this theme was appropriate anywhere in Augustan literature and art, it must have appeared indispensable to those who planned the Altar of the Augustan Peace.

Thus, when L'Orange undertook his systematic exploration of the imagery of abundance on the Ara Pacis, he naturally felt compelled to relate the burgeoning life and prosperity evoked in the floral friezes to the theme of the *aurea saecula*.[1] As his chief interpretive guide or analog, L'Orange used the literary work in which the bounties of the Golden Age were most fully and explicitly articulated, Vergil's Fourth Eclogue. There the subject is treated in prophetic terms, the coming of a new age of terrestrial abundance foretold and sanctioned by Apollo and the Sibyl, and ushered in by the birth of a new savior or messianic child.[2] The poem itself predates the emergence of Augustus as the ruler of the Roman world, and the precise identity of the child as Vergil originally conceived him is still a matter of dispute. But eventually it was Augustus whom Vergil lauded as the long-awaited monarch of the Golden Age, so the poem is relevant to the Ara Pacis in hindsight at least.[3] Nowadays, it has

become accepted opinion that the floral friezes were meant to symbolize the return of this lost era of bounty and goodness.[4]

Yet important questions remain with regard to the intelligibility and specific function of this theme on the Ara Pacis. It is of course easy to assume that spectators familar with Augustan poetry could have correlated in a general way the decorative image of efflorescent vegetal and animal life with the analogous literary imagery. Nor is the currency or availability of such poetry really an issue here since it is likely to have been disseminated widely through public readings or performances.[5] But did the public awareness of the *aurea saecula* really depend primarily on the work of the Augustan poets, or was the theme of a new, expected age already part of the common lore of the Late Republic? And were there already works of art that expressed or depicted this theme? These are questions that students of the Ara Pacis have largely left unposed, let alone unanswered.

So far, only Alföldi has methodically pursued the problem of the Golden Age in Rome during the second and earlier first centuries B.C. In his view, this theme had already come to serve as a symbol of hope or expectation for an end to the war, social unrest, and astrological fatalism that plagued the Late Republic.[6] To some extent this opinion is supported by the Fourth Eclogue itself, which originated against the immediate background of the turbulent and violent years following the assassination of Caesar. Moreover, the poem appears to address an expectation that is familiar and potentially resonant for its audience. All the same, the numismatic evidence assembled by Alföldi is, on its own, less than compelling. The issues featuring Apollo and/or the Sibyl do seem to parallel the prophetic sources invoked in the Eclogue, but this numismatic imagery may only refer more generally to the destiny of Rome. The *fata romana* had long been tied to Delphic oracular tradition, just as copies of the Sibylline prophecies had been kept in Rome for official consultation since the time of the last Tarquin.[7] The fruit-filled cornucopiae on the reverses of late second-century Roman Apollo coins certainly suggest the general theme of prosperity, in keeping with the Ptolemaic issues that they imitated. But like the Sibylline coinage of the succeeding century, there is no internal evidence that conclusively documents their connection with a tradition of the Golden Age or its return.

Here, too, the solution to the problem lies in determinimg what, if any, Hellenistic Greek precedent there may have been for such imagery in all media of expression. But first, it is essential to look more closely at the structure and content of this theme in Augustan or Vergilian poetry. The notion of a long-awaited Golden Age may seem familiar enough in traditional classical terms, but in reality it was a complex package whose origins went well beyond Greek mythology. This is not the place to resume

the longstanding debate about Vergil's sources, but the conception of the Golden Age in the Fourth Eclogue departs considerably from the familiar version of the theme inherited from Hesiod's *Works and Days* (106–201) and the *Phainomena* of Aratos (96–136). Vergil of course borrowed the grand cosmic conception of a sequence of metallic generations or ages, as well as the bucolic imagery of primitive bliss and the association of this unspoiled human condition with the Virgin or Justice personified. But the Hesiodic tradition is purely a tale of degeneration, a cosmogonic aetiology designed to explain the corruption and suffering of the human condition as the poet himself had experienced it. Within the downward cyclical structure of Hesiod's myth, there is no hint of the grand periodic return or regeneration that constitutes the very essence of Vergil's poem.[8]

The conception of cyclical renewal and the prophecy of a *new* age of blessing and abundance is a distinct strain with different sources. Here we enter upon a realm determined by the complex interaction of Greek mathematics and philosophical or astrological speculation, involving the theories of *metakosmesis* and *anakyklosis* or the eternal return, and concepts like the Great Year.[9] The extent to which such theories depended on Near Eastern astrology and mathematics and when such borrowings may have occurred are also still debated. But the Hellenistic East was certainly familiar with the principles of long-term periodic recurrence. It is also to the Seleucid and Ptolemaic domains that one must turn in tracing the background of a related phenomenon, the adaptation of these abstract periodic theories to ruler glorification, where the arrival of a new age or cycle was associated in prophetic oracular tradition with the soterial power of the king.

Here the crucial issue is to determine how much Vergil and other Romans of the later Republic were familiar with precedents of this kind, and recent studies have already gone far in answering such questions.[10] But in evaluating and understanding the Roman contribution, it is perhaps even more crucial to establish how much these various themes and concepts had already become interrelated in the usage of the Hellenistic Greek world. To what extent, if any, had the Hesiodic aetiology of degeneration and the lore of the Golden Age already been assimilated in the Greek East to the theory of eternal return in order to produce the notion of the recurrent Golden Age? Did the efforts of Hellenistic monarchs to equate their reigns with new cosmic periods or cycles also include the tradition of a Golden Age? Did the revolution of the ages involve moral regeneration as a condition of the new era, and was the soterial image of the ruler in such cyclic glorification a paradigm or exemplum for the larger ethical regeneration of the age? And finally, were these ideas in any way expressed in the visual arts of the Hellenistic monarchies?

The answers to these questions are neither simple nor clear; they emerge something like an edifice built up one brick at at time, and here

the foundation is the evidence connecting the propaganda of the Helle-
nistic dynasts with the doctrine of the Great Year, the period required for
the sun, moon, and planets to complete their courses and return to their
starting point.[11] As Van den Broek has demonstrated, it seems likely that
the Seleucids attempted to synchronize the inception of their dynasty
with the beginning of a new Great Year cycle. According to Pliny, the
treatise of the Roman Senator Manilius, composed in 97 B.C., maintained
that the mythic bird, the Phoenix, was a symbol of the Great Year, the
lifespan of the bird and the duration of this time period being equal. Since
Manilius also stated that when he wrote, some two hundred fifteen ordi-
nary years of the current Great Year had already elapsed, the beginning
of this cycle would then have coincided with the final foundation of Se-
leucid power in Mesopotamia in 312 B.C. This correspondence is hardly
fortuitous, especially considering that the Mesopotamian priest and
scholar Berossos produced a treatise, the *Babyloniaca*, which discussed,
inter alia, the doctrine of the Great Year, and which was dedicated to the
reigning Seleucid, Antiochos I.[12]

A little over a half-century later the Greek dynasts of Egypt apparently
followed suit. Tacitus (*Annals*, VI,28) mentions that the Phoenix was sup-
posed to have appeared in the reign of Ptolemy III. Since this king was
also responsible for the priestly convention and decree at Canopus in 238
B.C. which instituted new extensions of the ruler cult and sweeping cal-
endrical reforms, Van den Broek has made a good case that Ptolemy III
also attempted to synchronize his reign with the inception of a new era,
in this instance, the Egyptian Sothic period, which was also identified
with the Great Year and with the Phoenix.[13]

A little more than thirty years earlier, close in date to Berossos, the
imagery of cyclical time had also figured prominently in the grand pro-
cessional pageant of Ptolemy Philadelphos, witnessed by Kallixeinos of
Rhodes and preserved in Athenaeus's *Deipnosophists* (197C–203B). Imme-
diately following the beginning section with the altar of Dionysos, came a
group of figures surrounding the central character of Eniautos, personi-
fication of the Cyclic Year. He represented more than the normal concep-
tion of the year as a twelve-month duration; instead he embodied the
larger notion of recurrent periodic time. In keeping with this, he was
followed by the figure of Penteteris, personifying a five-year span, and by
the Horai, the cyclic, recurring seasons. On either side of Eniautos were
silenes holding the kerykeion and the *salpinx* or battle trumpet, here,
clearly antithetic symbols of peace and war, as Simon has indicated.[14]
Since Eniautos himself held a cornucopia, this group of figures collec-
tively seems to have symbolized the notion of prosperity in the context of
larger cyclic renewal, to glorify the felicitous and abundant age or reign of
the Ptolemies.

Together these various precedents manifest a conception fundamen-

tally similar to the idea of cyclic return in the Fourth Eclogue, where a new age of pacific bounty is at hand with the birth of the mystic soterial child. In the Eclogue, however, the child is as close as we get to a king; given the uncertain political background of the Second Triumvirate, the poem does not overtly associate this new age with a ruler or dynasty. But two decades later in the *Aeneid*, Vergil had no qualms about equating Augustus and the Julian line with the coming of the new era:

> here is Caesar and all of Iulus'
> progeny, coming beneath the revolving heaven.
> This man, this is he, whom you often hear
> promised to you,
> Augustus Caesar, son of a god, who will establish
> once more in Latium the Golden Age in the fields
> once ruled by Saturn.[15]

Still, despite the analogy that they pose, the Seleucid and Ptolemaic examples of propaganda considered so far cannot parallel the Vergilian equation of the new era specifically with a renewed Golden Age. Nor does this material in itself indicate that the Hellenistic precedents asserted the arrival of this era as the outcome of prophecy, but only as the result of an established chronic cycle. Yet, there is other evidence which suggests that such Hesiodic and prophetic features had indeed been part of the "new age" propaganda of the Hellenistic monarchs, although it does not appear in sources that are strictly Greek, but rather in the oracular literary tradition of the Hellenized Jews of Alexandria. The material in question comprises the third book of the rather heterogeneous corpus known as the *Oracula Sibyllina*, or the *Jewish Sibyl*. The third book is itself something of a mélange culled from different sources, but the material incorporated in it is to a great extent datable to the second century B.C.[16]

Book III (743–761 and 785–795) is perhaps best known for the analogy or precedent that it offers to Vergil's Fourth Eclogue, as the recent studies of Nisbet and Du Quesnay have once again emphasized.[17] There we encounter a remarkably similar prophetic imagery which foretells a divinely appointed era of peaceful bliss and prosperity, a new righteous order without fear or malice among man and beast alike. Du Quesnay's careful analysis of the *Oracula Sibyllina* and the Eclogue has even disclosed distinctive phonic and rhythmic similarities of language, including alliteration and repetitions, suggesting that Vergil's explicit invocation of a Sibylline source or authority in the poem is entirely credible. Students of the *Oracula Sibyllina* have also noted the almost rambling obsession with recurrent cycles, cataclysmic disaster, and chronic innovation that typifies this work and such oracular literature more generally, features also significant in relation to the imagery of the Eclogue.[18] There can in fact be no

doubt that Book III was circulating in Rome by the mid first century B.C., since a portion of it, along with Berossos, was paraphrased by Alexander Polyhistor, who was active in Rome at this time.[19]

But the analogies that Book III poses to Hesiod are also striking. The future age of goodness and blessing in lines 743 ff. is strongly reminiscent of *Works and Days*, 227–237. Both stress how cities will thrive, how existence will be full of good things, how the Earth and fields will yield abundantly in crops and rich flocks of animals, free from the affliction of war and famine. What Hesiod describes is not, however, prophetic; it is the bliss experienced by those of his own time whenever they manage to preserve the piety and justice of the Golden Race of times past, in contrast to the evil and suffering around them.[20] Yet it is precisely this that parallels the *Oracula Sibyllina* (III, 702–704), where those who obey God's laws will dwell in peace and divine protection, while the evildoers around them are destroyed. Book III even contains direct quotations or close paraphrases of *Works and Days*.[21] It is true that the *Oracula Sibyllina* nowhere utilize the specific metallic terminology of Hesiod's generations, but the various other connections nevertheless attest that the author of these portions of Book III was familiar with Hesiod, and therefore with the theme of the Golden Age. By implication at least, the new era prophesied by the Sibyl of Book III is formulated in terms of the ancient time of goodness and blessing celebrated in the *Works and Days*.

Because of this it would appear that the transformation of the Hesiodic myth of descent or degeneration into a recurrent pattern involving a new Golden Age was not a Vergilian or Roman innovation, but very likely a development of oracular traditions current in Ptolemaic Alexandria. It is more difficult to be sure whether the Hellenized Jewish milieu that produced the *Oracula Sibyllina* was responsible for this, or whether they adapted it from Greek or Greco-Egyptian precedent. Another passage from Book III indicates that the latter possibility is more likely. Amidst the apocalyptic turbulence to come there will also be a divinely appointed monarch to usher in the goodness at hand:

> And then shall God send a king from the sun
> who shall make the Earth desist from evil war,
> destroying some, but upon others imposing oaths or trust.[22]

On the surface, this divine emissary appears Jewish or messianic, but Collins has shown that the expectation of a king from the sun was a thoroughly Egyptian mode of royal glorification that had been assimilated by the Ptolemies. In the old pharaonic tradition, the king's function was to establish Ma'at, equity and justice, principles associated with the sun or sun-god, which concomitantly ensured the prosperity of the realm. The Greek dynasts of Egypt readily adapted this ideology in their

court ceremonial and titulature; they too were chosen or begotten by the sun-god.[23] And in turn, it seems that the messianic imagery of the *Oracula Sibyllina* here adapted the solar, soterial ideology of Ptolemaic ruler glorification. The new epoch awaited by the Jewish sibyllist was to be inaugurated by a Ptolemaic monarch.[24] Nor is this surprising given the specific background that has been advanced for Book III. It most likely dates from the time of Ptolemy Philometor, a great benefactor of the Jews in his kingdom.[25] As such, this portion of the *Oracula Sibyllina* was part of the same development that produced the so-called letter of Aristeas, a work of Jewish apologetic designed specifically to demonstrate the harmony of the Ptolemaic ideals of kingship with Jewish teaching.[26]

The "king from the sun" was also an *eirenopoios*, a peacemaker, and this too was an established feature of Greek royal ideology or political principle. The encomiastic poems that Theokritos composed for Ptolemy Philadelphos and Hieron of Syracuse both utilize the condition of peaceful prosperity as an indicator of the glorious rule and order achieved by the monarch.[27] Similarly, official decrees like the Rosetta stone and the decree of Canopus praise the peace achieved by the ruler. In the more abstract context of political theory, the letter of Aristeas stresses the capacity to maintain peace within the realm as a prime responsibility of kingship, along with a devotion to justice, goodness, and the salvation of the people.[28]

Thus the messianic emphasis and Jewish background of the *Oracula Sibyllina* may be somewhat misleading, since this prophetic speculation drew deliberately upon notions of salvation or benefit and solar, cosmic justice and peace that had long been associated with the function of kingship in Egypt. And one must consider this together with Ptolemaic events like the convention and decree of Canopus or the procession of Philadelphos, and the similar attempts of their Seleucid competitors, which were all designed to legitimize the ruling dynasty through the association with cycles of chronic recurrence. Collectively, this evidence indicates that the prophetic imagery or theme of a new age of prosperity, peace, and justice was the creation of the Hellenistic royal courts, an integral component of the ideology of ruler glorification elaborated under Alexander's successors.

The similar preoccupations of the Fourth Eclogue then do not seem to represent an independent Roman creation, but rather a masterful poetic adaptation of oracular traditions in Alexandra that had served to propagandize the Ptolemaic dynasty. If the *Oracula Sibyllina* are any indication, even the use of the Hesiodic tradition within this construct was not a new interpolation. It may only be that Vergil made the specific metallic nomenclature of the age sequence more explicit, but this too could already have been a feature of the Greco-Egyptian oracles or propaganda that

informed the Jewish sibyllists. The key transformation in the Eclogue is the suppression of the overtly royal function of this imagery; now it is a mystic child or *puer* rather than a "king from the sun" who will usher in the new age. Yet even so, the royal, solar quality of this age is still dominant, only it has been transposed to the sun-god proper who already reigns: "tuus iam regnat Apollo." Nor would this suppression last, for as indicated earlier, it too gave way with the establishment of the Principate, when Augustus himself eventually became the expected monarch sent from god, "divi genus," to inaugurate the new golden era (*Aeneid*, VI, 789–794).

On the Ara Pacis, the immediate relevance of this royal solar theology becomes apparent only in the context of the great Solarium Augusti, the enormous astrological timepiece or horologium that provided the wider setting for the Altar of Peace within the Campus Martius. Buchner's studies suggest that the precise placement, orientation, and internal proportions of the Ara Pacis were all arranged to coincide with various axes and points of intersection comprising the trapezoidal and parabolic grid of the Solarium. These axes and the zones that they defined corresponded in turn to planetary or astrological periods, especially the winter solstice and autumnal equinox, the days of Augustus's conception and birth respectively. The main equinoctial axis ran right through the center point of the altar proper, which defined an equilateral triangle along with upper end point of the line of months and the outer limit of the zone of Capricorn, the sign of Augustus. Perhaps best of all, on September 23, the birthday of the Princeps, the shadow of the gnomon of the sundial, an enormous obelisk imported from Heliopolis in Egypt, pointed directly at the Ara Pacis. The gnomon was also oriented slightly to the west of due north, so that it pointed at the Mausoleum of Augustus across the Campus Martius.[29]

If Buchner's reconstruction is accurate, one could ask for no clearer indication of the saecular, cosmic implication of the *Pax Augusta* and its cult, or of the epochal importance attached to the existence of the Princeps as the special prerequisite of the new age of peace, much like the *puer* of the Fourth Eclogue. Buchner has rightly stressed the solar connections of Augustus's divine protector Apollo within this whole conception, not to mention the solar associations that had always attached to obelisks, and especially one imported from the Egyptian "City of the Sun." The obelisk was crowned by a gilt bronze globe surmounted in turn by a miniature obelisk, a symbol of world rule, which corresponded to the inscription on the obelisk base celebrating the conquest of Egypt. Thus Actium appears as the event ushering in the new era of peace.

But one may speculate whether it was simply the obelisk that was imported from Egypt, for the whole conception of the Solarium as Buchner

explains it also demonstrates how thoroughly familiar Augustus and those around him must have been with the new age imagery of the Hellenistic courts, particularly in Egypt. When we bear in mind that Berossos's *Babyloniaca* and the *Oracula Sibyllina* were already known in first-century B.C. Rome, the placement of the Ara Pacis within a complex asserting the cyclic, solar origins of Augustus and his rule cannot be unrelated to the analogous usage of the Greek monarchs who preceded him; it was the Hellenistic or Ptolemaic notion of a prophetic "king from the sun" who would usher in an era of abundant peace and justice that inspired the soterial expectation of the Romans and the imagery that Augustus presented to satisfy their hopes. Perhaps the mathematician, Novius Facundus, whom Pliny (*Natural History*, XXXVI,72) credits as the designer of the Solarium, also drew upon the Ptolemaic or pharaonic monumental traditions that had long been used to celebrate an eternal solar conception of divinely sanctioned monarchy.

Against the backdrop of the dynastic Hellenistic imagery of recurrent age cycles that had penetrated Rome by the last century of the Republic, Vergil appears to represent the culmination of a larger process of assimilation, particularly if the Romans of this period were obsessed with *anakyklosis* or *metakosmesis* and the implications of such theories for the *fata romana*.[30] So Alföldi may have been correct after all to interpret in this way the Roman adaptations of Ptolemaic coinage advertising prosperity, or Roman issues with the image of Apollo and his Sibyl. Still, such numismatic material was a far cry from the extensive imagery of abundance on the Ara Pacis. For this, the only real precedent that we have is the related vegetal imagery of Pergamon or Asia Minor, and especially the Pergamene altar reliefs. But how far then, if at all, might this altar or other, similar monuments have inspired the designers of the Ara Pacis as a guide for expressing the bounties dispensed through the inception of a new age or era?

In the absence of any clear indications, one can only speculate. The Pergamene reliefs may have had some connection with the celebratory language used in the official inscriptions of the Attalids. One from Elaia honoring Attalos III asks that his kingship endure *kata ton hapanta aiona*, "down through the entire aion," but the precise sense of the word *aion* here is uncertain.[31] Like the Latin equivalent *saeculum*, it has varied meanings: a great age or epoch, a generation, a lifetime, or eternity. In the context of a royal encomium it should be more than a generation or lifetime, since any ruler would be expected to rule that long. Moreover, the close similarity with the honorific language of the somewhat earlier Rosetta stone suggests a grander connotation, for there the related or analogous terms *aionobios* and *eis ton hapanta chronon* are used overtly to acclaim

the king or his rule as eternal.[32] Perhaps in the Pergamene kingdom as well, this usage was intended to laud the kingship of the Attalids as "saecular" and enduring, especially in connection with the ruler cult.

There may be some further indication of this. On the Pergamene altar slabs, the kerykeion appears prominently as a symbol of prosperity and peace (fig. 49, right). But the association of this symbol with Eirene, one of the Horai or Seasons, may also have implied the notion of cyclic bounty or renewal, especially in conjunction with the Eleusinian imagery that also functioned prominently on these altar reliefs (fig. 47–49, left). Here it is helpful to recall that the kerykeion as an emblem of peace was held by one of the figures who accompanied the personification of Eniautos or the Cyclic Year in the procession of Ptolemy Philadelphos, and that Eniautos was followed by the Horai.

Is it too much to suppose that the cyclic connotations of this sort which may have been implicit on the altar slabs somehow related to the cyclic or epochal associations of the Pergamene king and the peaceful prosperity that he too was expected to insure for his land and people? The role of the king or ruler as mystic bringer of peace or *eirenopoios* was not only a Ptolemaic theme in the Hellenistic period; it is attested in the propaganda or flattery that was accorded to Demetrios Poliorketes in 290 B.C. in Athens. Athenaeus (*Deipnosophists*, 253E), quoting Douris of Samos, says that the Athenians prayed to Demetrios in song that he bring peace upon them, for it was within his power to do so. Perhaps the Pergameme altar too was meant to celebrate an era of peace and prosperity that was believed to have been inaugurated and guaranteed by the reigning dynasty.[33]

If this were in fact the case, it would have provided a further impetus for the planners of the Ara Pacis to emulate and adapt the kind of imagery on the Pergamene altar reliefs. Yet on both monuments, it still remains unclear as to how the imagery of cyclic peace and renewal associated with the ruler or dynasty would have been expressed through the specific form and detail of the vegetal decoration. In this regard as well, the answer probably resides in the essential strategy that the designers of the Roman altar adapted from the Pergamene prototype—the use of vegetal attributes as allusions to the collective power of various divinities. For just as the notion of Peace was expressed or evoked in terms of the *homonoia* or concord of various divinities, so too did the conception of an age of bliss achieved through the long cycle of time involve the participation and support of the gods in different capacities. To spectators who were familiar with the lore of the recurrent Golden Age elaborated in Augustan poetry and probably in popular tradition as well, the various symbolic plants on the Ara Pacis would also have functioned on this additional

level, not just as tokens of different divine powers, but as references to the role that these divinities played in the mystic, cosmic process of saecular renewal.

Apollo and his laurel provide the appropriate point of departure. On this level, the laurel would clearly have expressed Apollo's role as a prophetic deity, and not only as guarantor of the *fata romana*, but especially as the harbinger of the recurring Golden Age. In the Fourth Eclogue, Vergil had already invoked Apollo and the "song of Cumae," the prophecy of the Cumaean Sibyl to signal the arrival of the long-awaited era of rebirth and renewal. Throughout Book VI of the *Aeneid*, the Sibyl herself appears directly as the agent of Apollo and guide of Aeneas through the Underworld, where she aids the shade of Anchises in unfolding the entire fabric and pattern of Rome's destiny to the Trojan forebear, culminating in the prophecy of Augustus and the new *aurea saecula*. Considering that laurel wreaths also figured prominently with the tripod on Late Republican coinage depicting Apollo's Sibyl, the laurel of the Ara Pacis friezes may also have had a specifically Sibylline connotation.[34]

The Apolline aspect of the swans must also have fit into this pattern, as various scholars have indicated. Petersen long ago suggested that these birds functioned here as prophetic Apolline symbols, and more recently, Pollini has shown that the swan had a particularly oracular or prophetic connotation. Against the background of Vergil such a connotation must have included not only the more general conception of Apollo as prophet of Rome's destiny, but also as herald of the returning Golden Age.[35] Pollini would argue further that the entire acanthus matrix of the friezes was redolent of Apollo's role in this regard, and that even the split palmettes atop the tendrils were understood as an ornamental avatar of Apollo's sacred tree, the palm. Here Pollini has particularly stressed the connotation of immortality and renewal, because the Greek word for palm, *phoinix*, denoted the Phoenix, the mythic bird of regeneration.[36] To the extent that the Augustan audience was sensitive to this semantic and imaginal confluence, the added association of the Phoenix with the doctrine of eternal return may also have empowered the palmettes as signifiers of the new age imagery taken over from the Hellenistic monarchs.

All the same, Apollo's divinity was inextricably tied to that of Dionysos or Liber, as we have seen in the preceding chapter, and significantly, this unity also operated in the mantic sphere. Dionysos had an important part in the oracular shrine at Delphi, as Plutarch and others attest, but Plutarch (*Moralia*, 716 B) also stresses the vital role that Dionysos played more generally in prophecy.[37] Plato offers a special insight into the Dionysian connection here. In the *Phaidros* (244 B–C), he explains that prophecy, *mantike*, is the same as *manike*, madness (the additional "t" being a modern and corrupt insertion in Plato's view), for the gift of true prophecy

requires a state of frenzied madness. This equation of mantic power, so thoroughly Apolline, with the divine *mania* commonly associated with Dionysos or his followers is revealing, and thus one perceives more fully what kind of share it was that Dionysos had in Delphi.[38] This oracular, Apolline *mania* had its counterpart in the Hellenistic conception of *mania sophron*, that oxymoronic blend of madness and control—moderated frenzy—that was believed essential to true artistic or poetic inspiration.[39]

Nor was this reciprocity between Apolline madness and Dionysian moderation arcane to the Augustans. Horace and Tibullus, we have seen, called repeatedly upon the divine inspiration of Bacchus and the liberating influence of his wine. But Horace especially asserts the temperance required to enjoy such inspiration, just as Propertius asks Bacchus to "pacify" him with inspiration.[40] And conversely, it is Apollo who teasingly calls Propertius *demens*, "madman," in his quest for poetic inspiration (*Elegy*, III,3,15). Vergil, however, comes closest to Plato's unity of the manic and mantic, in the frenzied raging of Apollo's Cumaean Sibyl as she nevertheless guides Aeneas on a well-ordered prophetic journey through the Underworld in Book VI of the *Aeneid* (esp. lines 77–83 and 98–101). Perhaps it is no accident that while the Sibyl on the denarii issued in Rome in 65 B.C. was accompanied by the Apolline tripod and laurel wreath on the reverse, she herself was shown *kissokome*, wreathed in ivy, like Dionysos.[41]

It is difficult to be certain whether the ivy and grapevine in the floral friezes were meant to be understood in simliar terms as pendants to the laurel, i.e., as allusions to the Dionysian share in the prophetic function of Apollo. Nothing specifically precludes such an interpretation, but then again, no literary treatment of the Golden Age theme addresses Bacchus or Liber in a direct oracular capacity. The closest we get to this is the Fourth Eclogue, where the vision of the teaming earth includes the plants ivy and grapevine, along with baccar, which is cognate to Bacchus.[42] But the prophetic emphasis at the beginning of the poem is purely Apolline. The Eclogue actually suggests that the Dionysian side or aspect of the *numen mixtum* would have been more appropriate for evoking the vegetal bounties of the Golden Age as opposed to the prophetic emphasis of the Apolline side. Here the construct may have been analogous to the mixed imagery of the griffins on the altar itself, where their Apolline connotations revolved around the connection of these composite creatures with solar justice, while their Dionysian quality emerged more in the vegetal setting in which they appeared. Such a division for the role of these gods in the *aurea saecula* is in fact corroborated by the *Georgics*, where Vergil produced his fullest treatment of the relation of Dionysos/Liber to the Golden Age theme. There, predictably, he appears above all as a god of earthly blessing and abundance.

The locus of this treatment is Book II, which was devoted to the god of wine and viticulture, and opens appropriately with a direct invocation:

> Now I will sing of you, O Bacchus, and with you
> also of the young boughs of the forest
> and the offspring of the slow-growing olive.
> Come hither O father of the wine-vat (Lenaeus)
> all is full with your gifts,
> for you the field blossoms heavy with the
> autumn vines,
> and the vintage froths in the full-laden vats.[43]

Further along in lines 136–176, Vergil begins to celebrate the gifts of Bacchus in a more auspicious and resonant setting—the boundless wealth of the land of Italy, Terra or Tellus Italiae. Instead of the monstrous, warlike progeny emitted by regions of fable like Colchis, Italia is a land of abundance, an abundance engendered by the god of wine, trees, and plants: "The copious fruits and Massic juice of Bacchus / fill her (i.e., Italia)."[44] However, the end of this passage shows that Vergil is really alluding to the abundance of the Golden Age. After recounting the prowess of the Italian people from remote times down to Augustus himself, the poet closes in praise of the land who gave them all birth: "Hail Saturnia Tellus, Great Mother of fruits, and / Great Mother of men."[45]

This conception of a "Saturnian" Tellus or Earth is profoundly significant. Saturn was the Italian equivalent of the Greek Kronos; Tellus is thereby made into his consort Rhea/Cybele or Magna Mater. Vergil in fact underscores this with the added epithet *magna parens*, a variant of Cybele's title, the Great Mother. But this reflects more than the syncretism between the Earth and the Great Mother discussed earlier, since Kronos/Saturn had been the divine ruler or overseer of the lost Golden Age. Thus Vergil's application of the Saturnian epithet to Tellus means that she is not just the Earth or even Italy, but the land of Italy under the reign of Saturn, i.e., the Italy of the *aurea saecula*. Yet why does Vergil combine the images of the wine god and Saturnian Italy to frame this encomium on the bounties of his native land? What then does Bacchus or Liber have to do with the bygone era of goodness and abundant blessing?

The answer appears as the narrative of Book II gradually merges the tradition of this remote Golden Age with the rustic existence of Italy's past and the veneration of Bacchus in the ancestral religion of the simple, pious farmers of old. For Vergil, the ancient Trojan colonists of Italy had already instituted the joyous Dionysian rituals and sacrifices (lines 385–396). It was for rustic Italians such as these that the Earth had voluntarily yielded an easy sustenance; and it was among these simple, pious people that Justice, the Virgin, had taken her last footsteps before she left the

terrestrial regions for the celestial domain (lines 458–474). The images of the spontaneous earthly abundance and departing Justice finally demonstrate that the blessed *vita rustica* which Vergil has been describing here is indeed that of the Golden Age or Race recounted by Hesiod and Aratos (cf. *Phainomena* 115–136). Vergil drives the point home at the very end of Book II as he finishes praising the unspoiled goodness and harmony of these folk in the midst of their worship of Bacchus:

> This was the life cultivated by the Sabines of old
> Thus lived Remus and his brother, thus surely did
> Etruria grow strong, and Rome become the fairest of things,
> girding her seven citadels within one wall.
> Even before the rule of the Dictaean king (Jove) and
> before an impious humanity feasted on the slaughter of cattle,
> This was the life that golden Saturn lived on earth;
> when none had yet heard the war trumpet blow, or
> the ringing of the sword against the hard anvil.[46]

As he would soon do with the Trojan Epic, here Vergil has fully transformed the borrowed Greek matter of the Golden Age into a national, Italian myth. Kronos becomes Saturn, and the god-fearing primitive Golden Race becomes the people of primitive Italy. The pristine piety and excellence of the first golden generation in the *Works and Days* and Aratos's *Phainomena* become synonymous with the *mos maiorum*, the ancient, ancestral rites and customs of the rustic forebears of the Romans, the "sacra deum sancti patres." It is now these Italians whose simple virtue had induced Justice to live among them. Yet the truly striking innovation here is the image of Bacchus as the focus of the ancestral piety that originated among the Golden Race in olden Italy. The reasons for this are anything but obscure. Bacchus or Liber was the pre-eminent rustic deity; as such, he was ideally suited to this role as the god of the primitive Italians. And as the divine lord of copious earthly abundance, his powers and gifts corresponded best to the concept of limitless bounty central to the Golden Age:

> And thus the colonists of Ausonia, a race sent from Troy,
> led dances with rough verses and unfettered laughter,
> and donning frightful masks of hollowed cork,
> did call upon you O Bacchus in joyful song, and for you
> hung pleasant masks from the tall pine trees.
> Thus every vineyard matures with ample increase,
> and the hollow valleys and deep mountain glades
> attain fullness, wherever the god turns his lovely visage.
> Thus in the established manner we pay Bacchus the honors due him

with the songs of our forefathers and bring him plates and cakes, and the consecrated he-goat, led by the horn, shall stand by the altar, and we shall roast the fatty entrails on hazelwood spits.[47]

Thus, it was indeed the vegetal, fertility aspect of Bacchus or Liber that Vergil utilized to integrate this god within the new Roman conception or adaptation of the Golden Age myth, in contrast to the oracular connection of Apollo with this theme as we see it in the Fourth Eclogue and later in Book VI of the *Aeneid*. Yet the absence of such a prophetic, recurrent emphasis for the *aurea saecula* did not in any way diminish the immediacy of the theme in the *Georgics*; for here Vergil opted to assert its relevance by other means. The passage cited just above epitomizes a more widespread strategy in Book II whereby the boundaries between the past and present repeatedly shift or dissolve; there is an almost constant elision between the blessings of the simple rustic life of then and now, and it is as if in a sense the Golden Age had never ended for the simple and innocent Italian farmer.

In this regard as well, Vergil, like the Jewish sibyllist, followed Hesiod. For in lines 227–237 of the *Works and Days*, the poet explains that those who adhere to divinely appointed law and justice may in a way sustain or recapture the blessing formerly enjoyed by the Golden Race.[48] The hallmarks of this condition—the absence of war, the spontaneous earthly bounty, the rich flocks, the ease of existence, the abandonment of seatravel—all recur in Book II of the *Georgics* (458 ff., 490 ff., 513 ff.), and in a context that seems to be contemporary rather than remote in time. It was thus that the rustic devotees of Bacchus, respectful of divinity, untainted by greed and aggression, could at any time restore through their own moral purity the *aurea saecula*. As Latinus would later say to the Trojans in the *Aeneid*:

> and do not ignore the fact that
> the Latins, Saturn's people, are fair and just not
> by the imposition of bond or laws,
> but of their own free will and in keeping
> with the custom of their ancient god.[49]

Consequently, it becomes clear how Vergil could close Book II of the *Georgics* by comparing the ways of rustic, contemporary worshippers of Bacchus to the mode of life and character of Romulus and Remus, the ancient Sabines and Etruscans, and old Saturn himself. For the abundant, "golden life" of Saturn and Bacchus could be understood as the patrimony of Italians or Romans who adhered to the ancient standards and customs—the *mos maiorum*. That this patrimony was understood to extend right into the Augustan present we can scarcely doubt, for the imag-

ery at the end of Book II essentially reiterated the earlier laudatory invocation of "Saturnia Tellus" and the great line of Italian peoples from the Sabines down through Augustus (lines 167–174). Here we have a conception of the Golden Age that is perhaps complementary to the more mystic and prophetic treatment of this theme in the Fourth Eclogue and the *Aeneid*, one that relies less on the central figure of the messianic ruler who is to usher in the new era. Yet even the more soterial rationale for the returning Golden Age in the Eclogue still required the child to assert the ancient Italian ways: "And with ancestral virtues will he rule a world in peace."[50]

The notion of the Golden Age in the *Georgics*, however, would have had a greater immediacy for the Roman public because it related more directly and substantively to the issue of collective moral regeneration and return to traditional values that was so central to the ideology of the Principate.

This was a conception that would have worked well within the imagery of the floral friezes on the Ara Pacis, and again in terms complementary to the prophetic allusions imparted by Apollo's swans and laurel. The sprawling decorative imagery of ebullient, spontaneous growth would readily have evoked the time of blessed prosperity that could be regained not only through the divinely appointed rule of Augustus, but also through a larger return of the Roman people themselves to the simple, uncorrupted values and traditions of old-time Italy. The floral friezes with their multiple sprays of ivy and grapevine, and the many tiny animals, provided an effective decorative, visual counterpart for the recurrent imagery of Bacchus or Liber in Book II of the *Georgics* (figs. 2–4). On the Ara Pacis, these attributes embodied the powers of the *deus rusticorum*, the great giver of abundance who had been the primary object of that traditional Italian piety in the days when Justice still abided among the humble farmers and herders of Ausonia. If the Golden Age was to return, this would surely depend in good measure upon the renewal of the pristine Roman values and religious tradition that Bacchus stood for. One may also gauge how closely Bacchus or Liber was tied to the themes of traditional religion and to the Trojan origin of the Roman people and their Princeps from another of Horace's odes (IV,16). After praising Augustus for reviving the ancient ways, he closes the poem by invoking the god of wine in the very midst of the *mos maiorum*:

> On common and on sacred days
> amidst the gifts of jocose Liber,
> with our wives and children
> we shall first pray to the gods
> in the established manner,

> and according to ancestral custom we shall
> > hymn the virtues of the heroic dead
> in song mixed with Lydian flute,
> > Troy and Anchises and the offspring
> > of life-giving Venus.[51]

These lines, written around the time that the Ara Pacis was begun, almost seem to describe the procession of pious, traditional Romans and their familes in the friezes of the altar enclosure, standing above the lush array of tendrils filled with the grapevine and other tokens of Liber's generosity (fig. 2).

Among the various deities whose allusive vegetal emblems appeared in the floral friezes of the Ara Pacis, Apollo and Liber were not, however, the only ones associated with the theme of the Golden Age and its restoration under Augustus. In the case of Venus and Cybele, the Great Mother, we encounter two female divinities who were well suited to combine the notions of prophetic destiny and earthly abundance. As the mother of Aeneas, Venus had a special interest in the fate of her son and his progeny, and so in the very first book of the *Aeneid* Vergil depicts her imploring Jove to vouchsafe the greatness in store for the Trojan colonists of Italy. In lines 257–296, Jove responds with a prophetic covenant in which he unfolds the illustrious future appointed for the Julian line, from Iulus himself and Romulus down to Augustus. Here, the deeds foretold for the Princeps—the end of war and the softening of the "harsh or bitter ages," the *aspera saecula*—inversely signify his restoration of the *aurea saecula* in place of the suffering endemic to the Hesiodic Age of Iron.

In essence this entire passage is a somewhat elliptic prefiguration or foretaste of the prophecy disclosed more fully by Anchises in Book VI, where Augustus will plainly reestablish the Golden reign of Saturn. The Apolline context of the prophecy in Book VI is clear; it occurs as Apollo's Cumaean Sibyl guides Aeneas on his Underworld journey. Yet it is spoken by the husband of Venus, just as Jove's prophecy in Book I is given to Venus herself, and this is quite deliberate on Vergil's part. For the basis of this prophetic destiny is dynastic, and therefore a function of Venus's role as genetrix of the Julian line. From this point of view, it becomes clear that the soterial role of Augustus as appointed restorer of the Golden Age thoroughly involved the intercession and providence of his divine ancestress Venus.

The *Aeneid* shows that Vergil conceived the Great Mother or Cybele in very similar terms. In this case the genetic affiliation was not as direct, but as the Idaean Mother of all the Trojans, Cybele was no less a partisan of Aeneas and his destiny than Venus. And so in Book IX, 80–92, the Great Mother too implores Jove to protect and aid Aeneas and his comrades as

they prepare to set out on the journey that will shape Rome's future, just as she oversees their progress in the settlement of Italy later in Books IX (107–122), and X (215–257).[52] But on various levels, the protective intercession of Cybele here also bears upon the eventual restoration of the Golden Age by Aeneas's descendant. As the consort of Kronos/Saturn who had originally reigned over the *aurea saecula*, Cybele was intrinsically associated with the theme of the Golden Age.[53] It was in this sense that Vergil produced his syncretistic fusion of Terra Mater and Magna Mater when he hailed Italia as "Magna Parens Frugum, Saturnia Tellus," in the *Georgics* (II,173). Yet the specifically oracular relevance of Cybele's association with the golden reign of Saturn emerges only in Anchises' prophecy in Book VI of the *Aeneid* (784–794), where the image of the Great "Berecyntian" Mother in her turreted crown elides directly into the promised restoration of the *aurea saecula* under Augustus (see p. 142 below). It is difficult to understand why Vergil effected this juxtaposition here unless he deliberately wished to emphasize the prophetic, Saturnian dimension of Cybele.

The prophetic function of Cybele in this context is actually not at all surprising, for her worship at Rome had been tied to the *fata romana* from its very inception. Livy (XXIX,10,4) tells us that the cult of Cybele had originally been introduced to Rome from Pessinos in Asia Minor on the advice of the Sibylline Books in 205 B.C., to insure the defeat of Carthage.[54] As late as 43 B.C. the coins of Norbanus still celebrated this event and the close ties between the prophetess and Cybele; there the obverse showed a bust of the Sibyl while the Great Mother in her lion car appeared on the reverse.[55] By the Augustan period, then, when the triumphant destiny of Rome had come to be equated with the Golden Age of Sibylline prophecy, it seems almost inevitable that the providential image of Cybele would also have been incorporated in this theme by virtue of her connection with Kronos/Saturn.

The decorations of the Ara Pacis must also have been meant to stress in some way the special protective role of Venus and Cybele as guarantors of the line that was to restore the Golden Age, and one might perhaps expect this to emerge most readily in the relief of the *kourotrophos* on the east facade of the altar enclosure (fig. 43). Students of the Ara Pacis have long suggested that this maternal allegory of divinely inspired natural bounty was meant to evoke the blessings of the *aurea saecula* that had once again descended upon Rome and Italy; thus the Tellurian aspect of the composition would have embodied Vergil's more specific conception of a "Saturnia Tellus," the land of Saturn's Golden Age reborn.[56] Yet the multivalenced imagery of divine female power and abundance in this relief would also have been ideally suited to express the dynastic notions that Vergil portrayed as central to the restoration of the Golden Age—the

parallel intercession of the Great Mother and the genetrix of the Julian family. If the Venusian elements of the iconography were indeed meant to connote the role and powers of this goddess as she figured within the Augustan religious ideology, then it must surely have been Venus as *Aeneadum Genetrix* that the relief celebrated.[57]

Against the background of the syncretism uniting the major fertility goddesses at this time, it is possible that the maternal *kourotrophos* herself could have alluded to Cybele as well. Although the poppies and wheat ears in the background were primarily the attributes of Demeter/Ceres, they were also appropriated by the Great Mother, and even at times by Venus, so perhaps they functioned here in this capacity too.[58] If the *kourotrophos* was to some extent a depiction of Cybele and her powers, then the pairing of this panel on the east facade with the seated figure of Roma opposite would have a close parallel in Anchises' dynastic prophecy in the *Aeneid*:

> Lo my son, under his auspices (i.e., Romulus)
> that glorious one, Roma . . . shall encircle
> her seven citadels within one wall,
> blessed in her progeny of men, just as
> the Berecyntian Mother turreted by her crown
> rides her car through Phrygia's cities
> delighting in her divine offspring,
> embracing a hundred grandchildren,
> all dwellers of the heavens, all tenants
> of the heights above.
> Turn both your eyes this way, behold this race,
> your Romans. Here is Caesar and all of Iulus'
> progeny, coming beneath the revolving heaven.
> This man, this is he, whom you often hear
> promised to you,
> Augustus Caesar, son of a god, who will
> establish once more in Latium the Golden Age
> amidst the fields once ruled by Saturn.[59]

Here the interplay between the imagery of Roma's walls and the turrets of the Great Mother as she encircles her progeny is rather elegant, providing a subtle yet effective parallel between Rome and the "global" associations of Cybele.[60] On the evidence of this passage, then, the Roma on the Ara Pacis corresponded not only to the opposing figure of "Tellus," or even to a "Saturnia Tellus," but to Cybele herself as guardian of the line that was destined to revive the abundant golden blessings that had existed under her consort's reign. A connection between the monument and the poem is all the more likely considering that Romulus, who appears in the prophecy, and Aeneas, to whom it is spoken, both occur as

paired counterparts on the west facade of the Ara Pacis (figs. 45–46). At the same time, however, the Roma of the Ara Pacis corresponded as well to Venus in this dynastic tutelary capacity, insofar as the multifaceted *kourotrophos* panel symbolized this goddess too.[61] These associations would also have been amplified by the more general function of Venus and Cybele as equivalent and pre-eminent deities of the kind of pro-creative abundance basic to the *aurea saecula*.

Yet however the "Tellus" relief may have expressed the role of Venus and Cybele as dynastic guarantors of the promised new Golden Age, this conception would have emerged most extensively in the lower zone amidst the blossoming network of stylized vegetation that bore their sa-cred plants. Here again the poppies and wheat ear of Ceres may also have done double duty for the Great Mother. But Cybele had her own emblem, the oak, which also had a special resonance with regard to the *aurea saecula* (fig. 16). For the oak and its fruit, the acorn, were symbolic of the primitive sustenance that the earth had given spontaneously before hu-manity labored to feed itself with the aid of Ceres' agriculture.[62] To Tibullus, the oak was a source of magical bounty in the Golden Age: "So well did men live under Saturn's rule . . . / the oaks themselves gave forth honey."[63]

But as the sacred plant of Saturn's consort, the oak was particularly well suited to symbolize the *aurea saecula*, and perhaps even the promised *new* Golden Age, since Vergil (*Georgics*, II,16) says that the oak was considered oracular. Since the oak was commonly associated with Jove, here it may have alluded even more specifically to his prophecy to Venus (*Aeneid*, I, 257–296) that Augustus would eventually restore a Golden Age of peace. Accordingly, the same should be true for the Venusian components of the floral friezes. In their capacity as floral emblems or metonyms of the *Ae-neadum Genetrix*, the roses of the Ara Pacis alluded in turn to the provi-dential intercession of Venus essential in fulfilling the dynastic destiny that would culminate in the restoration of the Golden Age (figs. 18 and 20). And insofar as they were Venusian symbols, the swans too would have functioned in this way, while simultaneously evoking the power of Apollo as the prophet of the *aurea saecula* (figs. 2–7).

Here the ambivalent or shared function of the swans is particularly instructive, since it closely paralleled the attribute of the griffins which Apollo held in common with Liber on the altar itself, as well as the unity or integration of the laurel and ivy that expressed the complementary roles of each as divine prophet and nourisher of the Golden Age respec-tively (figs. 10, 42). The emphasis placed upon harmony or concord among all these deities has appeared repeatedly as a major facet of the use of the symbolic plants and animals on the Ara Pacis, especially in connection with the central theme of the *Pax Augusta*, with which such divine cooperation was essentially synonymous. But the ultimate sense

of these attributes and their capacity to express a unity of spirit and purpose among the gods, especially among Apollo, Liber, Venus and Cybele, seems to have pertained to a still grander theme, one in which Peace itself was only a component or consequence—the cosmic return of the piety, justice, and prosperity of Saturn's golden reign.

Mos Maiorum—The Ara Pacis and the Return of the Italian Good Old Days

Who controls the past controls the future:
who controls the present controls the past.[64]

For the Romans of the Augustan period, the conception of the Golden Age embodied on the Ara Pacis was essentially one of renewal—the renewal of time and the renewal of bounteous life. But despite the soterial dynastic rationale that was central to this ideology, the *Georgics* afford an added perspective disclosing still another basis for the era of tranquil abundance achieved under the Principate—the renewal of traditional religious practices and moral values, *mos maiorum* and *priscae virtutes*, which were associated with the character and fate of an entire people. Worship of the gods in the time-honored fashion amidst the *vita rustica*, an existence of robust, edifying labor and simple, uncorrupted pleasures:

> Thus lived Remus and his brother. . . .
> This was the life that golden Saturn lived on earth.

These ancestral ways had earned the felicitous state enjoyed by Romans in the remote past, and if retained, they would do so again. This, as we have seen, was not so much an innovation but rather an adaptation of the ethical basis already central to the theme of the Golden Age developed in Hesiod and Aratos. But Vergil's treatment of the theme in this way, his emphatic wedding of the *aurea saecula* not only to the retention but also to the *revival* of Italy's national values, transcends the Hesiodic conception of degeneration; it betrays instead the impact of another distinct *topos* which was thoroughly familiar to Romans of the Late Republic—the struggle to forestall or reverse a degeneration of the *mos maiorum*.[65]

For Cato, during the first half of the second century B.C., this theme of decline centered on the increasing confrontation or interaction of Italian culture with that of the Greeks. In his view, the ancient Romans had been a simple, agricultural people, unspoiled by wealth and dedicated to their country and the solid values on which it stood.[66] As indicated in the introduction to this study, Cato especially focused on the visual arts as a tangible manifestation of a rising tide of foreign luxury, citing the proges-

sive abandonment of "traditional" terracotta architectural sculptures in favor of Greek marble types as an example of the erosion of the simpler ways and values that had sufficed for the Romans of old.[67] In his *De Agricultura* (I,1–2), Cato tells us that the *maiores* praised a man by calling him "good farmer." And so a century later the equally conservative Varro (*Res Rusticae*, I,2,10) complained how the praise and status traditionally accorded to Romans on the basis of their industry and success as agriculturalists had given way to a new measure of achievement based on the ability to acquire Greek art. Thus he extolled the virtue of the most eminent farmer of his day, G. Tremelius Scrofa, who amassed collections of crops, as opposed to Lucullus, who sought to impress contemporaries with collections of Greek paintings.

There are still echoes of Cato's attitude even later in Pliny's account of the influx of Asiatic Greek metalwork into Rome as booty during the early 180s, and again in 132 B.C. following the liquidation of the Attalid bequest on the Roman auction block, events that Pliny portrayed as nothing less than a severe blow to Roman morals.[68] In the same vein, Livy too wrote that the statues and paintings from Syracuse "were no doubt the spoils of the enemy and were no doubt taken by right of war: all the same it was from these that one can trace the beginning of the craze for works of Greek art and, arising from that, the licentiousness with which all places everywhere, be they sacred or profane, were despoiled."[69] In his life of Marcellus (XXI,5) and again, very much under the Catonian impress, Plutarch similarly asserted that after the taking of Syracuse, the Roman people who had previously been farmers and warriors now began to spend their time in idleness and discourse on the arts.[70]

As Pollitt has emphasized, this "Catonian" attitude toward the visual arts continued well into Roman imperial times.[71] But the underlying cultural attitude found its fullest expression in the Roman rhetoric current during the final decades of the Republic, especially in Cicero. There, in the domain of public and courtroom oratory, the loss of traditional Roman values became a highly effective charge to level at one's opponents, particularly in contrast to the traditional standards of the past. Thus the *luxuria, avaritia,* and *audacia* of defendants like Verres were contrasted to the *continentia* and *temperantia* of illustrious and moderate old Romans like Scipio Africanus Major. The greedy corruption of the magistrates of the Late Republic was portrayed as antithetical to the integrity of the Roman ancestors, just as the luxurious opulence that had come to infect the sophisticated Roman city life was opposed in every way to the *innocentia, parcimonia, diligentia,* and *iustitia* of the virtuous, rustic Romans of yore.[72]

The antithesis between decadent, "modern" urban avarice or luxury and the pristine Roman virtue of the countryside provided a major theme for the historians and poets of the very Late Republic and the Augustan period as well. Following the early Roman annalists like Cato, Sallust too

presented Rome's development as a process of moral degeneration, while Livy seems to have drawn more on Cicero in this regard.[73] Among the poets, there was no greater exponent of moderation and simplicity against urbane decadence and excess than Horace, espousing the virtues of the *vita rustica* on his Sabine farm.[74] But it was clearly this set of oppositions that also informed Vergil's *Georgics* with their romantic encomium on the rustic Italian or Roman laborers among whom Justice had dwelled in the age of Saturn, when the *mos maiorum* had originated.[75] Given the basic analogies with the Hesiodic tradition, it was nearly unavoidable that the mythic decline of the Golden Age would eventually merge in Roman circles with the view asserting the progressive erosion of the *mos maiorum* as a historical process. All the same, the latter theme was an independent phenomenon with its own motivations, and these did not necessarily originate in fact or reality.

It is true that the Late Republic was a period of violent upheaval and corruption which to some extent involved a loss of cultural identity in the face of advancing Hellenism. But this was primarily a failure in the Roman constitution, a gradually developing crisis in which an oligarchic state structure could not accommodate itself to the position of imperial authority that the Romans had already acquired by the second and earlier first centuries B.C. It was not an immediate result of some collapse in morals attendant upon exposure to Greek refinement or luxury. Despite the testimony of Plutarch, there is in fact little reason to believe that the Romans had been a race of simple farmers and fighters before they conquered Syracuse.

Archaeological discoveries in the city and its environs have come increasingly to demonstrate that Rome was entirely comparable to other major mid-Italic urban centers from Archaic times onward. The late Archaic form of the Regia in the Forum closely parallels an official Athenian structure of Archaic date, "Building F" that was later replaced by the Tholos in the southwest corner of the Agora.[76] The Archaic Temple of Jove on the Capitoline must have been the equal of any in Etruria at this time; the cult statue was commissioned from the famous Veiantine sculptor Vulca.[77] Similarly, when the Romans built a temple to Ceres, Liber, and Libera on the Aventine in 493 B.C., they secured the services of the eminent Greek artists Damophilos and Gorgasos to decorate it; soon after, the sanctuary was outfitted with a monumental bronze cult statue of Ceres.[78] The terracottas from the religious precinct at Sant'Omobono are comparable to those of the Apollo temple at Veii; the terracotta chariot friezes from the Esquiline and Palatine Hills are almost identical to those from Velletri, and all may reflect the impact of Veiantine precedent.[79] The inscription of the Cista Ficoroni shows that what is perhaps the finest extant example of the late Classical Praenestine bronze engraving industry was executed at Rome, where the artist may have secured access to the

Greek painting that served as his model.[80] Even if these works were pro-
duced by craftsmen brought in from outside, they nevertheless attest to a
sophisticated Roman clientele and a high standard of patronage.

The Rome of Archaic, Classical, and Hellenistic times was no backwa-
ter. As they accumulate, the fragmentary remains of these earlier periods
provide an emerging picture of a city whose level of Hellenism was on a
par with the Etruscan sites to the north or the Latin-speaking towns to
the south and east.[81] If we are looking for a time when the Romans were
primarily a simple race of soldier-farmers, the *rustici milites* of Horace
(*Odes*, III,6,37), then we must limit ourselves to the eighth or the seventh
century B.C., when the cultural level in many parts of Greece was not
appreciably higher. The Rome of Cato's day may not have been a Per-
gamon, an Antioch, or an Alexandria, but it was a city that had long
participated in the process of Hellenization endemic to Italian culture.
The contrast that Cato and his first-century successors drew between
Greek and Roman or Italian culture and values was exaggerated, to say
the least; it was an elaborate, polarized construction whose intent and
substance were really much more political than moral or historical.

This brings us finally to the party slogan from George Orwell's *1984*
cited at the beginning of this section. The analogy here is not meant sim-
ply to imply that the rhetoric of Cato, Cicero, and the Augustan poets
and historians was some ancient manifestation of Newspeak. But the Cat-
onian invective and the tradition that it spawned were very much about
creating or controlling an image of the past so as to alter or affect the
perception of events, and thereby the course of events as well. And one
may deduce this not only from the disparity between the idealized rustic
view of the early Romans and the archaeological record, but also from the
literary precedent that inspired this view.

The set of interrelated oppositions involved here—temperance versus
excess, frugal simplicity versus luxury and avarice, diligence and justice
versus arrogant corruption, city versus country, and the concomitant op-
position of strength versus decadent weakness—was in fact a well-
established *topos* of Greek literature and oratory. Like the basic strategy of
antithesis or binary opposition, the notion of moral and cultural confron-
tation promulgated by Cato and his successors, as well as their moralized
conception of statecraft, did not arise from the objective assessment of
Roman culture on its own or in relation to that of Greece, but rather from
the adaptation of models of cultural or political analysis inherited from
earlier Greek historical writing and rhetoric.[82] In the case of first-century
B.C. Romans like Cicero or Livy, the familiarity with such models has
never been in doubt, but it is now clear that even their predecessor old
Cato was already thoroughly acquainted with Greek modes of discourse,
despite the ostensibly anti-hellenic thrust of his political ideology.[83]

Thus it should be evident that the moralized, xenophobic, nationalist

stance of the Catonian invective was essentially a rhetorical ploy. It was an attempt to undercut any notion of Greek cultural superiority and to provide in its place a basis for national pride that was sorely needed as a *de facto* rationale for the rising power of Rome, and probably to discredit political opponents of a more Hellenized bent as well. But as the studies of Smethurst have demonstrated so effectively, the basic content and strategy of this ideology were essentially Greek. In its developed Ciceronian form, the traditionalist, reactionary goal of reforming or improving the present through recourse to the standards of a better or ideal past was an instrument of political discourse, and one of considerable power. But the Attic orators had long ago discovered this. The glorified image of early Rome in Book II of Cicero's *Republic* is entirely comparable to the way in which the Athens of Solon and Miltiades or Perikles provided the moral exempla for Isokrates, who similarly looked to an earlier time when men had served the state unselfishly, with moderation and restraint, dedicated only to justice and pious respect for law. At one point in the *Republic* (II,34,59), Cicero even compares his early Roman statesmen to the great Athenian Lawgiver.[84]

In much the same way the Catonian ideal of the *rustici milites* can be traced to Greek moralistic writing. In the opening section of *De Agricultura*, Cato claims to follow Roman tradition by praising farming as the best of occupations; farmers are the most respected of men, and their training makes them brave and sturdy soldiers. Varro (*Res Rusticae*, III,1,4) also calls agriculture the oldest and noblest means of existence.[85] Yet these views were already well developed in Xenophon's *Oikonomikos*. There too the rigors of farming were supposed to cultivate not only crops, but manly fortitude, strength, and courage. The Greek forerunner of the *vita rustica* as Xenophon conceived it was also the nurse of *arete* or excellence of character; farming taught justice and righteousness. These ideas recur in Aristotle's *Oikonomikos* (1343a–b), where again farming is a just occupation, and one that fosters the manliness and courage necessary for war.[86] And what is perhaps most striking in the parallel between the Roman and Greek conceptions of the farmer ideal is the fundamental emphasis on the rustic way of life as the source of virtue. Nor does this seem to be fortuitous since Cato certainly read Xenophon and quoted him in his own writings.[87]

The new aspect of the Roman farmer ideal, however, resided in the much broader currency and nationalistic emphasis now given to the theme. Yet even Xenophon and his predecessors already grasped the political implications of the simple rustic life as an explanation for the rise and fall of nations. The Greek view of Persian culture was largely predicated on the theme of moral degeneration. In the *Kyropaideia* (I,3,2–12 and VIII,8,1–2 and 15), Xenophon stresses the simple, frugal, and hardy

life as farmers and herders that had originally enabled Kyros and his people to acquire and hold an empire. But the seeds of eventual destruction were dormant in the Oriental (i.e., Mesopotamian) luxury that had already begun to infect the Persians' Median kinsmen under Kyros's grandfather Astyages (VIII,1–15). In time the disciplined old Persian *paideia* with its emphasis on the virtue of character, the physical labor of agriculture, and martial arts died out, and the Persians slid into the avarice, corruption, and physical decay that Xenophon attributed to them in his own day.[88] It is significant that Cicero already doubted the historicity of this account.[89] But that did not prevent him or his contemporaries and predecessors from adapting the political theory behind Xenophon's writings. The pattern here is remarkably similar to the threat to Rome envisioned by Cato, or to the luxurious decadence and corruption that Cicero and Varro excoriated as the antithesis of the disciplined, rustic lifestyle that had made Rome great.

Xenophon also suggested the antidote to this process of degeneration, a central figure or leader who could serve as a living exemplum of the ancient standards and virtues. In the *Kyropaideia*, it is the king who stands as a model of behavior for his people as a whole. In the *Oikonomikos* (IV,24), Xenophon even portrays Kyros the Younger as placing equal emphasis on husbandry and war as worthy enterprises. The toil of agriculture is good and ennobling discipline, worthy of a king or prince who would have his people do the same. Here, this theme of king as farmer may in fact preserve a very ancient tradition associated with kingship in the Near East.[90] The more extensive portrayal in the *Anabasis* of Xenophon's contemporary, the younger Kyros, was in fact a detailed argument for the king or leader as a model of regeneration. Xenophon asserted that had the younger Kyros succeeded in his bid for power, his commitment to the traditional Persian *paideia* would have transformed his people back into the nation of warriors who had followed Kyros the Great to victory.

Thus it is not surprising that traditionalists of the Late Republic like Cicero who advocated the revival of the *mos maiorum* also came increasingly to speculate upon the notion of a single figure or leader who could instill and safeguard old Roman values and constitutional principles for the good of the Roman people. There were various terms for this concept—the *rector*, *moderator*, *gubernator*, or *princeps*—which all seem to denote the first citizen of a free society, an ideal statesman who would regulate the state according to principle, and not as an absolute dictator.[91] It is uncertain how much this conception in Cicero depended on the "kingly man" of Plato's *Politikos*.[92] It is clear, however, that the Principate of Augustus with its image of moderate, virtuous leadership was meant to be understood as the practical response to the expectation of this sort which arose during the final decades of the Republic.[93]

Nevertheless, the image of the virtuous *princeps* envisioned by Cicero and supposedly realized under Augustus also finds a close parallel in the exemplary, highly moralized, and regenerative conception of monarchy articulated by Xenophon in the *Kyropaideia*, *Anabasis*, and other works, as well as in the larger body of Greek political theory dealing with the role of kingship in society. Early encomiastic applications of the *basilikos logos* or theory of kingship, like Isokrates' *Nikokles* and *Evagoras*, or Xenophon's *Agesilaos*, all stress the absolute necessity for moral strength and virtue on the part of the ruler. He must be moderate and control his passions and appetites; he cannot rule others if he cannot rule himself. He must be justice incarnate, the embodiment of the law that he administers. And he must be pious toward the gods. The king should also be of illustrious lineage so that he may inherit a nature inherently disposed to such excellence of character. All these qualities are essential, moreover, because the king is a paradigm of the virtues that his people are to follow or imitate.[94]

In the course of the Hellenistic and Roman imperial periods, this theory of kingship would be elaborated along more philosophical or theological lines. In Musonius and the Neo-Pythagorean tractates on kingship, for example, Xenophon's metaphor of the good ruler as "law with eyes" evolved into the more abstract doctrine of the king as "living or animate law."[95] Similarly, the king's function as a paradigm of virtue and piety attained a more mystical expression in the view that he was a heaven-sent replica of divinity who could be imitated by his subjects in turn.[96] Despite their date in the first or second century A.D., these texts very likely preserve the transformations of the Hellenistic period.[97] In the *Republic* (VI,13), for example, Cicero had already adapted such views to his concept of the *rector*, who is likewise conceived as a figure sent from heaven. There is also the evidence of the so-called *Letter of Aristeas*, a tract from the reign of Ptolemy Philometor. Although primarily an apologetic vehicle designed to demonstrate the concurrence of Greek conceptions of kingship with Jewish thought, the correspondence of this work to Xenophon and Isokrates shows that it was largely a variation on the *basilikos logos* as it continued to evolve in the Hellenistic period. The *Letter* too repeatedly asserts moderation or self-control, justice, piety, and dedication to law as the attributes of the ideal king.[98]

Collectively, these texts suggest that the notion of restrained and pious leadership advertised under the Principate was not only the outgrowth of Republican hopes or expectations, but also a product of the Greek political theory that had fueled such expectations. This Augustan image was largely a repackaging of the *topoi* associated with the benevolent conception of monarchy current in Greek thought from the fourth century onward, and especially in the royal propaganda of the Hellenstic courts. At the same time, the regeneration that Augustus and his supporters

claimed to have achieved for Rome and its people corresponded fully to the pattern that Xenophon had in mind for Kyros the Younger; the Principate too was founded on the restoration of an ancient *paideia* that exhorted a moral simplicity and discipline reaching back to a superior rustic, agricultural past. And in both instances, the exemplary piety, justice, and moderation of the leader corresponded fully to the qualities encouraged among the people by the traditional *paideia*, or, as the Romans preferred to call it, the *mos maiorum* and *priscae virtutes*.

Ultimately there is a sublime irony in the fact that Antony, who strove to become another Hellenistic monarch, has come down to posterity in the role of a decadent, excessive oriental despot, while the ideals of authority or kingship promulgated among his royal Hellenistic predecessors became the heritage of Augustus, now recast as native *Italian* values and traditions. But this strategy of reversal was well in place at the end of the Republic, as Cicero's *Philippics* demonstrate only too well. And here too, the Ciceronian precedent was ultimately traceable to Attic Greek inspiration, in this case the attacks that Demosthenes mounted against the Macedonian king.[99] Cicero had already portrayed Antony as susceptible to the lure of an exotic luxury and hedonism incompatible with the *priscae virtutes*; and there too, the "Roman" values scorned by Antony were none other than those which Greek orators, philosophers, and moralists had praised for centuries. Here again Orwell's party slogan has a striking immediacy. Those who control the present have enormous power to shape and define the sense of the past. In this, Augustus and his partisans had learned the lessons of Cato and Cicero well. But control of the past also shapes the future. The Augustan view of history would have long-term consequences for the Roman self-image, just as the views of Cato and the later Republican traditionalists had initially created the ideological context that Augustus sought to exploit and expand upon.

If the concepts of cultural antithesis and cultural or moral degeneration and regeneration originated primarily as models or strategies of Greek rhetoric and historical or moralistic writing (and these need not be distinct categories), and if their application among the Romans was due more to established practice or usage than observation of fact, then this would help to explain the underlying contradictions that naturally arose when such Greek modes of discourse were used to articulate a distinct Italian cultural identity in direct contrast to Greek values and practices. But the currency and diffusion of these modes among the Romans also helps to clarify the development of a more national and historicized mythology of decline and restoration parallel to the wholly imported theme of the Golden Age. Vergil, it is true, achieved a modicum of success in his attempt to fuse these two traditions in the *Georgics*, for this was essentially the point of transposing the *aurea saecula* to primitive Italy and iden-

tifying the goodness of the pristine golden race with the *priscae virtutes* of the rustic *maiores*.

Yet by the time of the Principate, the quest to regain the unspoiled excellence of the ancient Italian forefathers had already attained a momentum of its own, and it was this rather than the theme of the Golden Age that really offered elbowroom for elaborating a national Italian mythology of renewal. Thus, before returning to the Ara Pacis one last time, it is worth considering how, like the Golden Age, this specifically Italian mythology or early history also lent itself to the notion of cyclic moral regeneration, and how this involved traditions of Roman leadership that could serve as a precedent or analog for Augustus himself.

Just as Greek poets like Hesiod were not the only ones who treated the theme of civilization or humanity in decline, the sibylline oracles and the propagandists of the Hellenistic courts were not alone in their concern with the principle of cyclic return or renewal. Even historians like Polybios accepted the notion of recurrent cycles—patterns of degeneration and return—as a basic model of development, particularly in the evolution of governmental constitutions. In Book VI of his *Histories* Polybios expounded the theory of *anakyklosis*, whereby states pass through a series of *metabolai* or transformations beginning with just kingship decaying into autocratic tyranny, followed by beneficial aristocracy decaying again into greedy oligarchy, then becoming just democracy which erodes into mob rule, and finally coming full circle to kingship.[100] Thus it is worth considering whether such an "anacyclic" perspective would have enabled first-century B.C. Romans to see the transition from the chaotic circumstances of the Late Republic into the one-man rule of the Principate as something of a return to the just and moral kingship of Rome's early days.

Since some scholars have suggested that Cicero may have based his conception of the *rector* or *princeps* on the ancient king Numa, that paragon of virtue who also figures prominently in the *Republic* (V,2), the idea of a cyclic return to the blessings of this early Roman age does in fact begin to take on substance.[101] Unfortunately, we no longer possess the portions of Polybios's work that dealt with Rome's earlier history, where he presumably applied his theory of *anakyklosis* to the vicissitudes of the Roman constitution. But Trompf has plausibly reconstructed the broad outline of what this would have been, beginning with the just rule of the early Roman kings, degenerating into the tyranny of Tarquinius Superbus, and eventually ending in the prognostication of mob rule and the return to kingship.[102] It is tempting to speculate about the impression that such a model would have made on Cicero, although Trompf would minimize the impact of Polybios in the *Republic*.[103] A similar conception of large-scale cyclic decline certainly informed the earlier parts of Livy's *His-*

tory, especially the preface.[104] With the success of the Principate, however, it may well have seemed that the final part of the cycle had arrived, ushering in a time analogous to the circumstances of Rome's inception and early years.

Here it is important to remember how in 28 B.C., Augustus (then still Octavian) considered taking the name of Romulus, for although he did not finally do so, historical sources leave little doubt that his whole career emulated or competed with the qualities of leadership ascribed to Rome's glorious founder. And as indicated earlier in Chapter III, there may well have been strong Romulan overtones in Augustus's decision to establish his residence on the Palatine, not far from the sites of the Lupercal, the *Ficus Ruminalis*, and the "Hut of Romulus," as well as in his choice of the traditional Italian tumulus form for his Mausoleum. The established Late Republican tradition of Romulus as the originator of all that was virtuous in the Roman constitution had a considerable impact on Augustus. Indeed the description of Romulus as civic and religious organizer, legislator, builder, and warrior in sources of the Augustan period like Dionysius of Halicarnassus (*Roman Antiquities*, II,7,1–II,16,3) almost seems to describe the Princeps (cf. Suetonius, *Augustus*, 28,3, 29,1–30,1, 31,4).[105]

The analogies to Numa, particularly as he appears in Plutarch's biography (*Numa*, XX,2–3), are also significant. Like Augustus, Numa kept the doors to the Temple of Janus closed in his reign as a token of enduring peace. He was a beacon to his people, a source of honor and justice; under his leadership they wished only to worship the gods and till their land. Nor did he need to compel the multitude in any way, for they were swayed entirely by his shining example of righteousness and moderation (*Numa*, XX,8). While this corresponds to the general picture of ideal kingship from Xenophon onward, it comes especially close to the terms in which Horace repeatedly described Augustus and his impact on the people and destiny of Rome. Moreover, it seems that the notion of such a renewal of ancient Roman standards of kingship was also alluded to in the prophetic vision that Anchises imparted to Aeneas in the *Aeneid* (VI,777–812) as a parallel to the renewal of the Golden Age. There, the sequence of great Romans is interrupted parenthetically by the digressions on Roma and the Great Mother, and on Hercules and Liber; but it can hardly be accidental that among the Romans, Augustus (lines 789–790) is preceded by Romulus (lines 777–778) and followed by Numa (lines 808–812).[106] Nor can it be fortuitous that one Augustan moneyer struck an issue with Numa's head on one side and that of the Princeps on the other.[107]

Like the theme of the Golden Age, the parallel tradition of Roman renewal constituted a major component in the program of the Ara Pacis, for just as the panel with the *kourotrophos* on the east front provided a focus

or point of departure for the *aurea saecula*, the panels on the west depicted the ancestral kings of ancient Italy. The righthand panel showed Aeneas sacrificing the sow to his household gods beneath the oak tree at Lavinium (cf. Dionysius of Halicarnassus, *Roman Antiquities*, 57,1). Here he is attended by two young male sacrificial assistants or *camilli* and by his son Ascanius or Iulus, who stood directly behind him. The gods or *penates* probably occupy the small temple in the upper left corner (fig. 45).[108]

In contrast to the scene of Aeneas, the left panel of the west facade is very poorly preserved (fig. 46). At the left extreme stood a bearded figure in armor. He corresponds to the torso of another figure on the right side who leans on a staff, both facing the center. Between them is a tree with the remains (only the claws) of a large bird perched upon it. This scene has long been identified as Mars and the shepherd Faustulus overlooking the she-wolf as she suckles the twins Romulus and Remus in the grotto of the Lupercal. The bearded figure in armor can in fact only be the Roman god of war within whose field the Ara Pacis was situated. Although the wolf and twins have vanished entirely, the tree does seem to fit the accepted identification; it would be the *Ficus Ruminalis*, the fig tree, and the bird would be the woodpecker of Mars who helped the she-wolf to nourish the twins until the shepherd found them (cf. Plutarch, *Romulus*, 4).[109]

The figure at the right, however, does not at all conform to the iconography of Faustulus or even of shepherds more generally. He is not wearing a tunic or animal hide; enough remains of his upper torso to show that it was largely uncovered. But the mass of crescentic drapery folds gathered over the abdomen and curving upward toward the armpit is too thick and low to be part of a tunic or chiton exomis; they are much sooner intelligible as part of a larger draped garment, a toga or himation, as the outline reconstruction on the panel indicates today. Thus this figure was shown in the old-fashioned format without an undergarment, much like Aeneas in the righthand panel (cf. figs. 45 and 46). As Simon has noted, the righthand figure also does not respond with an animated gesture of amazement at the sight of the wolf and the infant twins, in the manner that later became customary for shepherds in this scene.[110] Instead the upper torso leans forward with the right arm extended over a staff. Nor is this staff a short shepherd's crook or *pedum*; it is long enough for the figure to rest upon it diagonally, like the "Eponymous Heroes" in the east frieze of the Parthenon, or like the draped figure of Aeneas in the scene of the Lavinian sow depicted on the Altar of the Augustan Lares, which may actually be modelled on the righthand figure of the Lupercal scene (cf. figs. 46 and 76).[111]

If this is in fact Mars and the shepherd gazing upon the twins in the

Lupercal, then one is obliged to conclude that Faustulus was shown re-
laxing in his Sunday-best, affecting the manners of a man of much less
humble station. Livy (I,4,7) and Dionysius of Halicarnassus (*Roman Antiq-
uities*, I,79,9) both note that Faustulus was the shepherd of the king, but
this position would hardly justify the formal dress that we see in the
relief. In attempting to deal with the problems posed by this panel,
Berczelly suggested that it depicted a related but different narrative from
the Romulan cycle; he identified the righthand figure as Pater Tiberinus
wearing a himation, while the intervening space would have shown a
sleeping Ilia or Rhea Silvia approached by Mars.[112] But considering the fig
tree and the woodpecker, this revision seems too extreme. Moreover, the
similarity of the righthand figure to Aeneas in the opposite panel or to the
Aeneas on the Altar of the Augustan Lares suggests rather that he was a
personage of comparable status or function, i.e., another king.

Still, what king would provide an appropriate counterpart to Mars as a
witness for the Lupercal? The only possible answer is the king of Alba
Longa, Numitor, the maternal grandfather of the twins who had been
driven from his throne by his evil brother, Amulius, the persecutor of
Rhea Sylvia and her sons. Dionysius (I,84,1–4) tells us that in some ac-
counts, Faustulus secretly acted as a foster-parent on behalf of the de-
posed king, and Dionysius (I,84,8) and Livy (I,5,6) both agree that it was
ultimately Numitor who recognized and verified the true identity of the
twins when they were grown.[113]

While the substitution of Numitor for Faustulus here would apparently
have departed from the specific detail of the story, it was entirely in keep-
ing with the overall approach and intent of the relief, which was not,
strictly speaking, narrative. The inclusion of the god Mars here was also
highly innovative; it does not correspond to literary accounts of the dis-
covery of the twins that have come down to us, or for that matter to the
surviving representations of the twins and the wolf in the visual arts.
Mars is unknown in depictions of the Lupercal that can be securely dated
to pre-Augustan times, and he remained rare in such scenes after the Ara
Pacis. The god's presence and even his pose with a billowing cloak is best
paralleled by visual depictions of Mars and Ilia (Rhea Silvia), which is
what prompted Berczelly to reidentify the subject of the Ara Pacis panel
as such.[114]

However, the presence of Mars in this scene does not require a rein-
terpretation; his interpolation was a form of artistic license intended to
stress the divine parentage and future destiny of Romulus, an expressive
technique, moreover, that has many counterparts in earlier Greek and
Italic art. The most common example is the inclusion of the goddess
Athena in depictions of the Archaic period as the guardian or inspiration
of various heroes, even though her specific participation in the events or

battles may be unattested in literary sources. The inclusion of Apollo amidst the Thessalian Centauromachy in the west pediment of the Temple of Zeus at Olympia also has no literary analogs and likewise served to reinforce the ethical overtones of the theme. In Etruscan art the best example of this kind is the painting depicting the sacrifice of the Trojan captives in the François Tomb at Vulci, where the local figures of Vanth and Charu were added to the composition of the putative Greek original to stress the funerary implications of the myth. On the Altar of the Augustan Lares the figure of a seated prophet was similarly inserted into the scene of the Lavinian sow to stress the providential nature of Aeneas's arrival in Italy (fig. 76).[115]

If the central portion of the relief did in fact depict the wolf and the twins, as the remains of the *Ficus Ruminalis* and the woodpecker clearly indicate, then this motif alone would have been sufficient to identify the subject for the viewer. Faustulus himself was not essential; he and the other shepherds were often deleted in the examples of this myth attested in Roman sculpture, mosaic, coinage, gems, and other minor arts.[116] Thus it is likely or highly plausible that the righthand figure corresponded to Mars in functional as well as visual terms—another interpolation intended to reinforce the larger relevance of Romulus within the program of the altar.

In this regard Numitor would have been a highly effective choice. His inclusion would have underscored the royal as well as the divine heritage of Romulus, while, at the same time it provided a useful visual avatar of the nearby infant Romulus, a genealogical prefiguration of the king that Romulus would become. As such, Numitor would also have functioned as a counterpart to the analogous togate figure of his royal ancestor Aeneas in the opposite panel, a vital link in the Alban lineage uniting the Trojan colonists and Rome's founder. This might also explain why an Augustan sculptor later adapted the leaning figure of the Lupercal scene to the depiction of Aeneas on the Altar of the Augustan Lares (fig. 46 and 76). On the Ara Pacis Numitor would have been a far more lofty and appropriate pendant to Mars than Faustulus, one that could stress the whole range of Romulus's parentage, in keeping with the generational emphasis of Aeneas and Iulus in the adjacent panel. And since it was Numitor who, according to Dionysius (I,85,1–2), inspired Romulus to found Rome, his inclusion would have infused the depiction with a providential quality that suitably expressed the role of the whole narrative in Rome's destiny. Because of this range of associations, the inclusion of Numitor would have been ideally suited to the more contemplative and "iconic" intention that Zanker has astutely discerned in the panels of the west front.[117]

At the very least, the reliefs of the west facade would have paired Aeneas and Romulus, paralleling the program of statuary in the Forum Au-

gustum, as Zanker has also indicated.[118] Indeed it rather striking how closely the whole array of divinities and mythic characters depicted or alluded to throughout the Ara Pacis corresponds to those shown in the statuary and pedimental reliefs of the Augustan Forum—Mars, Venus, Roma, Aeneas, and Romulus. It is clear that both monuments partook in the very same ideology of mythic prefiguration and divine providence. But here it is also worth noting that Numitor too would have appeared in the Forum, in the lefthand exedra, among the kings of Alba Longa, near the statues of Romulus and the Julian family.[119] And on both monuments the emphasis on the ancient Italian kings becomes clear only in the context of the ulterior analogy that they posed to the Princeps. In the Forum the statues of Aeneas and Romulus in the flanking exedrae corresponded to the name of Augustus inscribed on the facade of the temple to Mars Ultor at the center of the axis running between both statues, and to the statue of Augustus himself in a chariot which the Senate had placed in the very midst of the complex (*Res Gestae* 35). The inscription on the base which commemorated Augustus's new title as Pater Patriae also added immensely to the paternal overtones of the analogy to the ancestral founders, Aeneas and Romulus.[120]

On the Ara Pacis the analogy between these figures and Augustus was less symmetrically determined. As scholars have long noted, it is most apparent in the similarity of pose, costume, and bearing between Aeneas and what remains of the figure of Augustus around the corner in the south processional frieze (figs. 2, center left, and 45). Both were shown *capite velato*, with veiled head and wreathed in laurel, in the act of religious ceremonial, underscoring the specific quality or virtue of *pietas* that united Augustus with his forebear. Recently, Rose has elaborated on this interpretation by identifying the figure behind Aeneas as his trusted Trojan lieutenant Achates, and the young *camillus* or sacrificial attendant before him as Aeneas's son Iulus. Rose argues that the analogy with the processional figures extended beyond Augustus to include his colleague Agrippa and young Gaius, who also may appear as a *camillus* in the south frieze. But the juxtaposition of Aeneas and Romulus in the panels of the west front of the altar enclosure suggests that such comparisons went even further than the initial Trojan colonists; the larger west ensemble implicitly extended the analogy with Augustus to Rome's founder as well.[121]

Though informed by the same underlying ideology of mythic fulfillment or renewal that appeared in the Forum Augustum, the effect on the Ara Pacis would nevertheless have been quite different. The static and draped appearance of Augustus, Aeneas, and possibly old Numitor, was more appropriate to the ceremonial and pacific context of the Altar of Peace, in contrast to the dynamic pose and martial emphasis indicated for

the statues of Aeneas and Romulus in the Forum, and even for the statue of Augustus in the triumphal chariot.[122] This is all the more understandable considering how the paired analogy of Aeneas and Romulus to Augustus on the Ara Pacis also involved other implications or undercurrents that related more directly to the central theme of recurring abundance. For both these ancestral figures were not only prototypes of illustrious leadership in a pristine time of moral excellence, but also the progeny of deities closely associated with the prosperity of the Roman state. In the case of Aeneas this is obvious. His mother Venus was not only the Aeneadum Genetrix, divine source of the Julian line, but also a major divinity of procreative power, who inspired even the burgeoning gifts of the other fertility deities, as we saw earlier. The lineal connection with Venus in this capacity must have contributed substantially to the perception that the leadership of Augustus was intrinsically capable of securing the divine guarantee of prosperity for his people, especially if he retained the virtues of Aeneas, and if in turn the Roman people emulated such *priscae virtutes* on the part of their Princeps.

In the case of Romulus, there were similar associations as well, although they are no longer so readily apparent. Unlike Aeneas, he would have been shown directly with his divine parent Mars on the left side of the panel. Here Mars has sometimes been seen as corresponding to the concept of Venus implicit in the Aeneas panel; he was the lover of Venus, and as Lucretius indicated in the proem of *De Rerum Natura*, 39, the goddess has the capacity to quell the god of war, a theme appropriate to the Ara Pacis.[123] But Mars had originally been much more to the Romans than a war god. The evidence of old, traditional ritual shows that he was worshipped as protector of the crops and fields. The *Carmen Arvale*, a processional hymn in Archaic Latin which probably goes back to the sixth century B.C., invokes Mars (or Mamars), along with the Lares and the Semunis or gods of sowing, to ward off evil influence.[124] The apotropaic agricultural purpose of this hymn is clarified by the *lustratio agri*, a peripatetic ritual recommended by Cato (*De Agricultura*, CXLI) for purifying farmland. This included a *suovetaurilia*, the offering of a young sheep, pig, and cow, which are to be led around the land with a prayer that implores Mars to prevent infertility, sickness, and bad weather from harming the crops and livestock.[125]

There is no need to revive the old debate as to whether the Italic Mars was primarily a war god or originally an agricultural deity who took on an increasingly warlike aspect as the result of assimilation with the Greek Ares.[126] The more recent study by Scholz has shown conclusively that Mars was in origin a specifically tutelary divinity. He was in fact the chief protector of the Roman people worshipped originally in the Capitoline Triad, a role in which he was eventually supplanted by Jove.[127] It is this

protective aspect that is really central to the *Carmen Arvale* and the ritual recounted by Cato. In earlier, less aggressive times, the protective function operated most immediately in the context of the agriculture essential to the early Roman economy. Later, when Rome's military designs and power expanded, this function began to manifest itself more as protection in war, and as Mars developed in this way he also came increasingly to be understood as the Italian Ares. Yet the evidence of Cato in the second century B.C. demonstrates that throughout this process, Mars never did lose his identity as protector of the crops and farms.[128]

On the Ara Pacis Mars appears in what had by then become his familiar, Hellenized form—the armored god of war. Nevertheless, here too there are indications that he still incorporated his traditional function as guardian and guarantor of Rome's prosperity. Just to the right of Mars there are clearly discernible sprays of laurel (fig. 46).[129] The uppermost fragments of this laurel also include the remains of Mars's spear or *hasta*, but too little is left to be certain whether the god actually gripped this plant along with the spear, as the present reconstruction has it, or whether these branches were part of a second tree adjacent to Mars, as Moretti suggested. In either case, though, the laurel appears closely tied to the god in visual terms.[130] Nor does this seem to be coincidental, considering that the laurel was used at times as an attribute of Mars.[131] Again it is easy to dismiss this as a function of Mars's warlike aspect since the laurel also served commonly as a token of victory (Pliny, XV,40,133–134). But as noted above in the first chapter, Pliny tells us that the laurel was an apotropaic plant; if placed in the fields it was believed to ward off mildew from the grain crop (XVIII,45,161). Thus the connection of the laurel with Mars in the relief involved more than the notion of success in war since its apotropaic association fit perfectly with the longstanding tradition of Mars as protector of Roman agriculture.

The planting of laurel trees in front of the Regia in the Roman Forum provides additional evidence of this kind.[132] As its name indicates, this building had long been associated with the old Roman kings, although under the Republic, it became a kind of office or headquarters for the Rex Sacrorum, the priestly aspect of the king divested of political power. In religious terms, however, the Regia functioned mostly as a center for the cult trappings of Mars and the fertility goddess Ops, a local Italic equivalent of Cybele or Rhea, who was also understood as Saturn's consort.[133] At the Regia, then, the use of laurel as a vegetal attribute of Mars related specifically to his worship in connection with another deity who helped insure the success of Roman agriculture. Nor in this case were the additional royal overtones of the Regia insignificant, for by the Augustan period at least, Mars's role as guardian of Roman agriculture had come to be associated with the sacral duties of the old Roman kings.

The evidence for this is preserved in the cult of the *Fratres Arvales* or Arval Brethren, whose ancient hymn was mentioned just above, and in the mythic account of the origin of this priestly college. No less an authority than Varro (*De Lingua Latina*, V, 85) confirms that traditionally these Brethren were charged with the public rituals to insure the abundance of the *arva* or grain fields, in keeping with the apparent function of the *Carmen Arvale* itself. But the hymn is a precious testimony of the central role that Mars had played within such rituals from a very early period. The added role of the Roman king here is attested, however, by the story of the founding of the *Fratres Arvales*, ostensibly by Romulus himself.[134] The other original "Brethren," eleven in number, were supposedly the shepherd foster brothers of Romulus, the natural sons of Faustulus and Acca Larentia. Unlike the venerable hymn and Varro's definition of the group, no detail of this aetiological foundation myth can be attested before the reign of Tiberius.[135] The Arval cult as a functioning priestly college begins with Augustus, who apparently reconstituted or redefined the whole tradition of the group after it had fallen into obscurity.[136]

Thus the revival of the *Fratres Arvales* seems to have been part of the larger Augustan religious reform which claimed to bring back the most ancient rites and institutions, the *mos maiorum*, values and ways considered to have been the backbone of Roman existence.[137] Consequently, the recent study of Scheid has explained the Romulan aetiology of the group as a calculated elaboration of the Augustan period, and probably in the years just after Actium, when the Princeps was preoccupied with the idea of becoming a new Romulus.[138] By officiating over the Brethren in public ritual as the modern counterpart to Romulus and recruiting the rest of the group from the finest senatorial families who traced their lineage back to Rome's origins, Augustus portrayed this priestly college as the literal embodiment of the ancient time-honored ways that had insured Rome's prosperity from its very inception, a religious institution that would now restore and preserve that prosperity in the ancestral manner. And significantly, an inscription from the reign of Caligula records that the Arval Brethren also participated in the annual rites of the Ara Pacis.[139]

Since the Brethren were directly connected with the cult at the Altar of the Augustan Peace, the tradition of Mars and Romulus that this group enshrined must have informed the conception and sense of these figures in the lefthand relief on the west facade of the monument depicting Rome's founder. There, in the wild and rustic setting of primitive Italy, Mars with his laurel was meant to be understood as the appointed guardian of the agricultural bounty achieved by the Roman people, bounty achieved not only through labor and industry, but also through the proper rites that would be instituted by the god's own son to secure the beneficial intercession of his divine father (fig. 46). So it is unlikely that

the Ara Pacis portrayed Aeneas and Romulus as respective exempla of *pietas* and *virtus*, in the manner of the statues in the Forum Augustum.[140] On the Altar of Peace there is no contrast between Aeneas with old Anchises on his shoulders and Romulus holding the *spolia opima*, the standards of a victor. In *both* panels the key issue was the ancient brand of religious observance established by the founding fathers of the Latins or Romans. Here, no less than Aeneas, the conception of Romulus subsumed his role as a paradigm and originator of Rome's religious institutions.

Thus the immediate comparison between Augustus in the south procession and the mythic precedent of the reliefs on the west facade must indeed have involved Romulus as well as pious Aeneas (figs. 2, 45, and 46). And if Pollini is correct in suggesting that Augustus held a *lituus* as augur in the processional frieze, the analogy with Romulus would even have alluded to his founding role in this religious office.[141] Indeed, the theme of augury would have been highly appropriate to the notion of Augustan renewal as a function of promise or destiny. Yet this notion was not only prophetic or dynastic, but also ethical. By revivifying these *priscae virtutes* and *prisci mores* as his inherited family patrimony from Aeneas and Romulus, Augustus set himself up as an *exemplum* for the Roman people; collectively, such virtue on the part of the Princeps and those he led would restore the pristine life of bliss and bounty enjoyed by the *maiores*. In this way the ethical lapses of the Late Republic would fade away, and the gap that had separated the present from the good old days would effectively close.

Consequently, the imagery on the west facade of the Ara Pacis appears to have been thoroughly invested in the sort of anacyclic view of cultural degeneration and regeneration presented in Polybios's *Histories*. The new era of the Principate was not just the returning Golden Age of Vergilian poetry, but a more immediately historicized conception predicated on the cyclic return of an ideal period of ethical monarchy. To be sure, the Princeps was not a *rex*. Upon reflection Augustus declined to adopt the name of Romulus and with it the *overt* reinstatement of *regia*. Instead his chief claim was to have restored the Republic. But there is no denying the positive image of ancient kingship embodied in the bearded, barechested, togate figure of Aeneas performing the sacral obligations of the hereditary *rex*, and possibly in the corresponding draped figure of the left panel as well (figs. 45, 46). It was the degenerate tyranny of the last Roman king that the Romans abhorred. The early kings like Numa, Romulus, and their Alban or Trojan predecessors Numitor and Aeneas had all been models of virtue and restraint who were lauded or deified for their achievement and benefaction. They embodied the concept of the temperate and lawful early kingship praised by Polybios, and they may

well have helped inspire the idea of the *rector* or *princeps* that appeared in Cicero, which in turn provided the model for the Principate of Augustus. This was the conception of ancient leadership whose recurrence was celebrated across the figural reliefs of the west and south facades of the Ara Pacis.

Yet beneath this traditional Roman surface, there are still echoes of the pious, just, and virtuous standard of kingship advocated in the Greek *basilikos logos*, and perhaps even something of the highly moralized image of the king as farmer in Xenophon's *Kyropaideia*. Although neither Aeneas nor Romulus appears on the Ara Pacis specifically as husbandmen, the rustic, natural setting of both scenes nevertheless evoked the more humble, agararian circumstances of the ancient Italians. This ambience emerges with particular effectiveness in the primitive little altar of heaped up stones in the Aeneas panel (fig. 45, bottom center), as Hannestad has observed.[142] The added capacity of the Mars panel to subsume the notion of Romulus as founder of the Arval cult would also have stressed the responsibility of the king in this early period to insure successful agriculture.

Owing to the lack of preserved monuments, it is difficult to know how extensively the visual arts in the Hellenistic courts had already attempted to express the image of the king as farmer or guarantor of agricultural prosperity, but there is evidence of this kind in the silver plate from Aquileia. Though early imperial in date, the iconography of this work has generally been taken to reflect a Hellenistic or Ptolemaic tradition (fig. 59). There the great dispenser of agriculture, Triptolemos, is surrounded by female fertility divinities—Demeter, Mother Earth, and Seasons—who relate closely to the imagery of the "Tellus" panel on the east facade of the Ara Pacis, as indicated earlier. But the draped costume and location of Triptolemos standing beside a small altar in a rustic setting also links the composition to the Aeneas panel (cf. figs. 45 and 59). The analogy assumes greater significance when we recall that here Triptolemos, like Aeneas, is probably a guise for an emperor or, in the Greek prototype, a Ptolemaic king.[143] As such, the plate becomes intelligible as an emblematic image, an allegory on earthly prosperity and the special function of the king to insure this bounty through his connection with the divinities of life and regeneration.

On the Ara Pacis, this theme operated in more implicit terms; it resided, as indicated earlier, primarily in the descent of Aeneas and Romulus from Venus and Mars, and it receded somewhat into the immediate narrative circumstance or detail of the panels. But even this use of mythic narrative, in the lefthand panel at least, has an effective Hellenistic parallel—the Telephos frieze on the Great Altar at Pergamon, which similarly celebrated the achievements of the contemporary ruling

dynasty by tying the Attalid family to the theme of a mythic founder or ancestor. The central image that once occupied the Lupercal panel—the infant Romulus with the she-wolf overseen by his divine father in a landscape setting—would have been especially analogous to the portion of the Pergamene frieze where Herakles comes upon his son Telephos being suckled in the wild by a lioness. Not surprisingly, later Campana plaques eventually played upon this similarity by pairing the Romulus and Telephos myths.[144]

Yet the specifically moral or ethical dimension of the mythic royal prototypes in the Mars and Aeneas panels as paradigms of piety and religious observance has no precedent in the Aquileia plate or the Telephos frieze, so far as one can tell. Such programmatic comparison between the virtues of the present and the remote or mythic past appears to relate to a different type of Greek visual-artistic precedent: the victory monument. In the paintings of officially sponsored public works like the Stoa Poikile in Athens, for example, the struggle against the Persians at Marathon was juxtaposed with various battles against mythic Asiatic enemies in order to celebrate the character and achievement of the Greek victors as the outcome of ancient standards of piety, discipline, and moderation.[145] Following Athenian precedent, the "Lesser Attalid Group" commissioned by the Pergamene king for the Athenian Acropolis later celebrated his defeat of the Gauls as a moral victory, the defense of Hellenic order, by juxtaposing statues of these barbarians with those of other conquered enemies of Greece from earlier history and ancient myth—Persians, Amazons, and Giants.[146]

To judge by the evidence that survives, the designers of the Ara Pacis adopted a broad, synthetic approach in combining various Greek monumental traditions of mythic comparison to produce the revivalist imagery of virtuous leadership on the west front. Those who conceived the Altar of the Augustan Peace required a wider thematic construct that could celebrate Augustus not only as the descendant or elected protegé of the gods, like the Aquileia plate or the Telephos frieze, but also as the embodiment of moral strength or character, in the manner of Greek victory monuments that had enshrined contemporary achievement in the guise of mythic excellence. On the Ara Pacis, moreover, this synthetic approach was entirely nationalized within a distinctive, local mythic and cultural tradition. Perhaps this emerges most clearly in the specific, biographic emphasis on the Princeps himself in the south frieze as a distinct, actual entity, an approach that stemmed undoubtedly from the old Italic desire to commemorate individual service or achievement. Nowhere in the Hellenistic monuments cited above did the figure of the reigning monarch himself provide an immediate, historical presence as the unambiguous focus or object of the mythic comparison. Nor in such precedents did the

themes of lineage and character fuse so effectively as an explanation for the ruler's ability to secure abundance for his land and people.

But the ultimate question remains. How, in the end, did the floral friezes on the Ara Pacis express the concomitant theme of the blessings or bounties achieved through the recurrence of ancient Roman standards of leadership? To some extent, this may have operated on a general level, in terms of the rhythmic formal correspondences that Büsing carefully observed between the processional reliefs and the floral friezes beneath them. It can hardly be accidental that the ordered structure and harmony of Augustus, his colleagues, and his familiy in the upper zone so closely parallels the vital yet controlled movement of the efflorescent life below (fig. 2). Whether we see the floral friezes as the embodiment of a recurrent Golden Age or as a renewal of the virtuous and blessed life under Italy's early kings, the visual analogy or congruence between the foliage and the procession was meant to express their substantive and causal relation. The new age had ostensibly arrived because of the resurgence of traditional moral excellence that the Princeps and his elite had instilled among the whole Roman people.

At first glance, it would appear that this particular connotation of the floral friezes did not arise from any internal quality or character immediately discernible to the viewer, but primarily from the ideology that the viewer brought to bear in interpreting them. There is, however, one indication that the tendril pattern itself could have been designed to attune spectators to its function as an emblem of *renovatio*, i.e., to the traditionalist rationale of the renewed era of abundance. This was the very structure of the long friezes, for the overall scheme or arrangement of the undulating volutes had no immediate precedent. It was typical instead of the floral ornament of the fifth and fourth centuries B.C.

Scholarship has tended to emphasize the relatively direct, Hellenistic sources of the long floral friezes as well as the smaller panels on the east and west facades of the enclosure. This is certainly true with regard to the naturalistic treatment of the leafy vegetal detail of the acanthus (Kraus's *Pflanzlichkeit*).[147] Similarly, the use of blossoms enclosed within the various spiral volutes of the larger main tendril is a Hellenistic trait, in contrast to the more geometricized plain spiral tendrils of the Classical period and later classicizing works, e.g., the acroteria of Attic grave stelai, the Metropolitan mirror frame and gold diadem, or the decoration of the well-known gilt-silver amphora from Chertomlyk (cf. figs. 2 and 5–7 with 69, 71, and 88c). And we have already seen that the inclusion of distinct, recognizable plants and fruits was also traceable to Pergamene or western Asiatic Greek developments of the mid to late Hellenistic periods. Perhaps even the basic scheme of the four smaller panels derives from Hellenistic prototypes; it comes rather close to the gypsum casting found in the

metalwork atelier at Mit Rahine near Memphis datable to the late second century B.C. (cf. figs. 5–7 with 89a).[148]

In contrast, the expansive structure or matrix of the main tendril on the two long friezes has no parallel among extant Hellenistic monuments, in any medium (fig. 2). Viewed head-on, the Chertomlyk amphora (later fourth or early third century B.C.) seems generally comparable as an all-over tendril composition, but the pattern is not really longitudinal like the Ara Pacis friezes. It is an approximately radial arrangement of two roughly triangular tendril arrays corresponding to the conical surface of the vessel (fig. 88 b–c).[149] Elaborate tendril compositions adapted to a long horizontal space or field were not unknown in Hellenistic times, particularly in the medium of decorated textile like the embroidered hanging from the Pavlovsky Kurgan in the Crimea, the sort of pattern that later inspired the designers of certain Campana plaques (fig. 88a).[150] But even these longitudinal tendril compositions turn out to be quite different from the long friezes on the Ara Pacis. They are, to be sure, made up of multiple vertical stalks with pairs of volutes which, individually, are comparable to those on the floral friezes. However, the overall structure is intermittent or discontinuous, consisting of serial but discrete tendril volutes and acanthus calyces. Unlike the Ara Pacis, the vertical stalks on the textile do not arise from two tendrils that emanate from one central calyx and run continuously along the baseline (Kraus's *Bodenranke*) (cf. fig. 2 or 89c with 88a).[151]

To the writer's knowledge, the only surviving works that display anything like the structure of the long friezes are Attic red figure vases of the late fifth century and the Italiote Greek vases of the succeeding decades where such patterns became even more elaborate (fig. 89b). The Apulian example illustrated here, one of two hydriae from the circle of the Lycurgus Painter,[152] offers an especially striking analogy to the underlying tendril matrix of the long friezes. On the vase too the pattern consists of a central pair of addorsed volutes that spew forth continuous, lower horizontal tendrils to provide a common source for multiple vertical offshoots (cf. figs. 2 and 89c with fig. 89b). Fig. 89c strips away part of the vegetal detail to expose the tendril matrix of the long friezes more clearly, but even on the actual monument, the spiral geometry of the old Classical scheme is still dominant despite the more naturalistic and three-dimensional overlay of blossoms, smaller tendrils, and leafy acanthus detail (cf. fig. 89c with 88c). The Ara Pacis also retained the classicizing two-dimensional or planimetric projection of the main tendril matrix against a uniform ground plane, relegating the more Hellenistic spatial projection of helical tendrils and blossoms to subordinate detail (contrast figs. 2–4 with figs. 62a and 74).[153]

It is difficult to assess the significance of these analogies. Students of

the floral friezes have tended to cast a narrow net by looking almost entirely to stone sculpture as precedents, although the impact of other decorative arts must also have come into play.[154] Still, one need not assume from the remaining evidence that the designers of the Ara Pacis adapted the basic structure of the long tendril composition from ceramic heirlooms that were still accessible in Roman art collections. Literary sources certainly attest to the collection of ancient Greek ceramics during the Late Republic (cf. Strabo, Geography, VIII,6,23). But these same sources also document the Roman taste for old Greek toreutic; the bronze mirror frame discused earlier even demonstrates that the Romans copied antique metalwork (fig. 72).[155] The extant archaeological record may also be skewed or misleading; it is possible that there were heirloom textiles with the type of pattern on the red-figure vases, or perhaps there were old metalwork vessels with tendril compositions laid out as strictly longitudinal friezes like those on the ceramic examples. The role of textile prototypes has long been adduced to explain the long floral friezes; scholars once argued that the marble enclosure replicated an earlier wooden one decorated with costly wall hangings.[156] While it now appears that the planners of the Ara Pacis drew most immediately on the design and decoration of earlier Greek monumental altars, it is still possible that they assimilated ornamental features from textiles or other media as well.

However, the crucial issue is not the particular medium or source of the tendril design basic to the long floral friezes, but the recognizably antique or Classical character of the design and the particular associations that resided in this character, for some spectators at least. Galinsky has emphasized the unusual structure of the schema utilized in the long friezes, suggesting that it may have been meant to express the abundant vegetal growth of the Pax Augusta; alternatively, Coarelli would associate the structure of the long friezes with the prodigious grapevine that grew from a single source at the Porticus of Livia in Rome.[157] But perhaps the semantic charge of this formal structure or schema was intended to function in more associative terms—a distinctively *old-fashioned* decorative image of plenty that could evoke a bygone time, the ancient days and values of Rome's blessed past. Still, the floral reliefs on the exterior are hardly rendered in a fifth- or fourth-century B.C. style; instead the designers chose to overlay the more antiquated tendril matrix with a surface treatment of naturalistic vegetal detail that reflected more recent stylistic trends or taste. This must have been deliberate, for the designers could easily have opted for the heavier, more geometricized classicism of the Campana plaque with Eros or the barriers of the Ara Pacis proper (figs. 8–9 and 73). Thus the more contemporary, Hellenistic aspect that they imposed upon the Classical schema of the outer enclosure must have been meant to suggest that the ancient abundance engendered by old-time

piety and modesty was renewed or reborn in a glorious new present (fig. 2).

Even in this more specific sense, the floral friezes may have been designed to parallel the figural zone just above them. The fifth- and fourth-century Greek sources of the processional reliefs have often been noted, and Zanker and Hölscher have stressed the strongly ethical overtones of such Classical references within the new visual artistic language of the Principate.[158] But as in the floral friezes, the classicism of the processions and the smaller figural panels has also been accommodated to a different conception of pictorial, spatial depth and landscape depiction that derive from more recent, Hellenistic relief sculpture, especially that of Asia Minor.[159] Here too the Classical core is overlaid by a later, Hellenistic veneer or surface, effectively fusing past and present. Thus the formal parallelism between the figural and floral friezes observed by Büsing would indeed have operated as a cue for a more profound relation between procession and vegetation. In their own way each portion of the monument adapted or repackaged in contemporary terms artistic formulae that carried the charge of tradition, and by such means each reinforced the other as a causal expression of *anakyklosis* or *renovatio*.

Nor should one doubt that this adaptation of borrowed Greek forms was capable of expressing a particularly Italian conception of revival. Koeppel has recently shown that the processional reliefs of the outer enclosure drew not only on Attic forerunners like the Parthenon frieze, but also on Etrusco-Italic monumental painting that had long since transformed such Greek precedent into a distinct, local idiom of civic, processional iconography, including women and children.[160] While these paintings come entirely from the private, funerary sphere, it is likely that they corresponded to a public, official medium of imagery in central Italy that has so far eluded the archaeological record. If this is indeed the case, spectators of the Augustan period would readily have associated the processional imagery on the Ara Pacis with a venerable local tradition of civic excellence and piety. Keeping in mind the longstanding absorption of Classical tendril ornament in mid-Italic decorative arts—architectural reliefs, wall painting, and engraved metalwork—it is clear that the antique aspect of the floral friezes on the Ara Pacis could also have functioned in these terms, paralleling the processions to evoke the blessings achieved in the good old days by the good old ways. And considering that the Hellenistic or Pergamene features of the floral friezes had been at home in Italy for several generations, it is doubtful that even the "modern" aspect of the tendril compositions would have appeared as anything but Roman to the Augustan audience. From this perspective, the blending of old and new on the Ara Pacis offered a highly effective vehicle for expressing a national *renovatio*.

Yet here again, the notion of revival would ultimately have focused on the more specific analogy between Augustus and his royal predecessors, and this in turn must also have involved not only the overall style but also the particular detail of the floral friezes—the vegetal and animal attributes, and above all those of the divine progenitors of the archetypal kings. In the case of Aeneas, it is the protection and providence of his mother Venus that guarantees the abundant life and prosperity of his people, or perhaps conversely it is his special relation to her, his inherited excellence, that lends efficacy to his kingship for the good of his subjects. Thus the various roses and swans of the goddess, especially the swans below Aeneas, would also have suggested the divine support for his blessed rule, and, by extension, support for its reincarnation in the form of the Principate.

In the case of the lefthand panel, the immediate presence of Mars directly expressed a similar notion of divine sanction and efficacy for the rule of Romulus. And since the god is closely associated there with laurel, it is possible, even likely, that the spray of this plant just around the corner in the north floral frieze alluded to Mars's powers as well as those of Apollo. Thus the apotropaic laurel amidst the stylized tendrils may also have symbolized the capacity or function of Mars to avert evil from the crops and to engender agricultural plenty, as he appears in the hymn of the Arval Brethren which, at times, may even have been sung in ceremonies at the Ara Pacis. In this context, however, the laurel could still have functioned as a symbol of Apollo, and in much the same way, for Apollo too was worshipped in Greece as guardian against grain blight, Erythibios, and as *Sitalkas* (see p. 18, above).

The laurel, in fact, had multiple associations, also serving as a victory token and even as a sign of suppliant status when grasped in the hand. It is in the latter capacity that Simon would interpret the sprays of laurel held by various figures in the processions on the north and south sides of the enclosure, a *supplicatio* adapted as a ceremonial of loyalty to the Julio-Claudian family.[161] But perhaps these figures also grasped the branches as symbols of the beneficial, saving power of laurel and the healing, apotropaic function of the gods to whom it was sacred, in keeping with the use of the laurel in the north floral frieze and the relief with Mars. Here it is useful to recall the double allusion of the poppies to Ceres and Cybele, the griffins on the altar as symbols of Apollo as well as Liber, or the swans which alluded simultaneously to Apollo and Venus. The specifically Italian and dynastic resonance of the floral imagery here was ultimately inseparable from the various other themes articulated in the tendril friezes.

Multiplicity of meaning, the potential of iconographic elements to shift, modify, or pool their significance from one level or context to another, was the very essence of the mercurial imagery on the Ara Pacis. This

metamorphic capacity was, as we have seen, the basis of the overall sys-
tem of allusive metonymic attributes within the tendril compositions
whose individual meanings also functioned collectively as an expression
of the concord equatable with Pax. But at the same time, the use of these
attributes could operate as a further allusion to the role of the gods in the
prophecy and fulfillment of the Golden Age and its return, or still more
specifically as symbols of the recurrence of a benign monarchic constitu-
tion as it had existed at Rome's foundation or among the ancestral Trojan
colonists. Each of these levels of meaning provided a somewhat different
rationale or basis for Augustan claims to universal peace and prosperity.
But all involved a relatively consistent strategy asserting the divine affilia-
tion, lineage, and tutelage of the Princeps, for ultimately, the themes of
Peace and cyclic renewal were meant to reflect directly on Augustus and
what he had achieved for the Roman people.

 Conclusion

Like the material remains themselves, the imagery of the Ara Pacis has a highly stratified archaeology, involving a nuance and complexity deposited by centuries of artistic experience and experimentation. And so it seems appropriate to conclude by drawing together some of the more important issues or results that have emerged here from the investigation of the varied traditions underlying the Altar of Peace, and by considering the relation between tradition and innovation as a fundamental dynamic of Augustan art. Initially it appeared likely that the Ara Pacis represented not only a new departure in the evolution of Roman imperial monuments, but also the culmination of artistic developments that preceded it, and this has been amply confirmed by the close study of the floral friezes. What we encounter in these tendril compositions is perhaps the most elaborate and sophisticated example of visual metonymy that had so far been produced in the arts of antiquity. In their quest for an imagery that could best express the new concept of the Pax Augusta, the designers of the altar enclosure managed to avail themselves of the most effective precedent in existence—the allusive, polycarpophoric imagery of Pergamene relief sculpture. It certainly comes as no surprise that they drew most immediately on a Pergamene forerunner that had already applied such imagery as the decoration of a monumental altar, and indeed, an altar that celebrated Peace. But ultimately, this choice reflected the designers' keen awareness of the potential of such decoration, whose multiple vegetal attributes could so effectively symbolize the collective support of the gods as a rationale for the theme of Augustan Peace and the stability of the Augustan regime itself.

Still, the polycarpophoric tradition comprised only one stratum in the iconographic archaeology of the Ara Pacis. The designers fused this approach with an apparently distinct mode of polytheriotrophic tendril ornament, although one also derived from Pergamon or Asia Minor. This added an array of tiny animal attributes which could bolster and expand the allusive potential of the tendril compositions, and concomitantly, their capacity to express the divinely sanctioned Pax Augusta. The swans constituted yet another tradition or stratum, that of theonomous tendril ornament, in which the birds functioned not as beneficiaries of the nourishing, divinely inspired vegetation, but as direct agents or paracletes of the gods who engendered the tendril.

All of these metonymic modes or strategies came directly from the long-evolving tradition of Greek floral ornament. All had become part of the cumulative deposit of artistic usage in late Hellenistic Italy, and we saw extensive evidence in the first two chapters of how familiar such imagery had become to the Italian public. But the very range of the strategies applied in the floral friezes should alert us to the Janus-like aspect of the Ara Pacis, for up to this point, these differing modes had remained largely distinct; no extant Greek work appears to have utilized the many plants, the many little animals, and the various swans within one unified tendril composition. What is most striking and effective in the Ara Pacis is not simply the profound familiarity of the planners with earlier Greek traditions, but their capacity to blend those traditions into a unified product that impresses the observer as something essentially new and distinctive, despite its traditional orientation or background. It was the crystallization of this synthetic creative faculty that constituted the decisive turning point of Augustan official art. It was this that enabled Augustan artists to develop a formal visual language capable of asserting a new vision of *Romanitas*, and nowhere do we see this more clearly than on the Ara Pacis.

No less important was the potential of this synthetic Augustan imagery to lend itself readily to new avenues of expression and interpretation. Thus the collective, allusive metonymy so effective in articulating the Pax Augusta could easily subsume the theme of *renovatio*, either in the sense of a returning Golden Age, or in the form of an anacyclic renewal of the pristine values and constitution of Rome's early days and rulers, as we saw at the end of the last chapter. When compared to the forerunners in Pergamene or Asiatic Greek art, the metonymic imagery of allusive plants and animals in the floral friezes appears at once the same and yet so different, and the change resided largely in the understanding that the spectator brought to the monument. For an Augustan audience accustomed to the various traditions of tendril ornament that went into the Ara Pacis, and for an audience that was also attuned to the theme of *renovatio* through various modes of public discourse, the metonymic plants, flowers, and animals would no longer have functioned as signifiers of an Attalid imagery of abundant Peace; instead they would have articulated the doctrine of renewed abundance achieved by the Principate.

None of this should occasion the least surprise or doubt, and here we return to the apparent paradox addressed at the beginning of the introduction. For the Augustans, there would have been nothing contradictory in the strategy of recasting the old as the new, or in claiming what had been Greek as something now distinctively Roman. It was perfectly natural that a royal Pergamene imagery of divinely engendered pacific bounty and renewal should suddenly acquire a national Italian resonance

and currency as a tool of official propaganda. For it has become increasingly clear that we have tended to take too polarized a view of this decisive period of Roman art and the changes that it brought about. On the analogy of trends in Roman rhetoric in the first century B.C., one may readily oppose the controlled classicism of Augustan official art with the "baroque asianism" or Hellenistic orientation of Late Republican monuments in the public and private spheres.[1] But Hölscher is surely correct in emphasizing that Roman art exploited the full range of Greek stylistic alternatives throughout its development, that a Hellenistic component is still discernible in Augustan art, just as later periods with a predominantly Hellenistic artistic orientation continued to utilize classicizing modes as well.[2]

As evidence of this one need look no further than the floral friezes themselves, but Hölscher has also shown, for example, how closely the landscape and sacrificial iconography of the Aeneas panel depended on Hellenistic Greek works like the Telephos frieze or the paintings at Delos, despite the Attic classicism of the central figure of Aeneas. Indeed, as indicated in the last chapter, it is well worth considering how extensively the whole Augustan strategy of affiliation with mythic ancestors or founders took its cue from Greek precedent like the tradition of Telephos among the Attalids in Pergamon. And we have certainly seen how even the Augustan use of Apollo as divine patron of the renewed virtue of the Roman Principate followed Seleucid practice; it did not represent a distinctively Italian counterblast to the Hellenistic, Dionysian imagery embraced by Antony. For Augustus, Apollo and Dionysos continued to function within a venerable tradition of religious harmony or unity that is no longer fully clear, and once again we have no better example of this ambiguous interrelation than the floral friezes of the Ara Pacis. The ideology of the Pax Augusta did not focus on polar exclusion and rejection; it strove for transformative inclusion and resolution.

Thus the complex synthetic, retrospection of the Ara Pacis is very much at the heart of the Augustan artistic development, and perhaps at the heart of a distinctive new Roman imperial art as well. The more recent theoretical discourse on the "problem" of Roman art is no longer grounded in the polar opposition of East and West, of Greek and Italic, as competing artistic alternatives or sensibilities.[3] *Romanitas* now appears to reside less in specific formal preoccupations or tastes, but more immediately in Roman attitudes regarding the range and particular usage or effectiveness of inherited Greek artistic alternatives. Hölscher has especially stressed the major break or innovation in the late Hellenistic period, when the "diachronic unfolding" of discrete, periodic styles in earlier Greek art gave way to a new "synchronic spectrum" in which the primary concern became the management of earlier artistic traditions as a set of

coexistant possibilities.[4] While the origins of this change are to be sought in the latest Greek art itself, it was the Romans as patrons who ultimately assumed the responsibility of Greek artistic tradition. There can be little doubt that Augustan art paved the way for the systematic application of Hölscher's "synchronic spectrum," and it was here that the Romans found a real opportunity to set their own distinctive stamp on the evolution of ancient Mediterranean art.

In many ways this conceptual model had already been anticipated in the final chapter of Otto Brendel's *Prolegomena to the Study of Roman Art*. Brendel had come to believe that in the making of the art we call Roman, the Roman factor or denominator, "far from excluding the Greek, includes and confirms it." Brendel suggested that in this process, the Roman denominator emerged as the higher order, absorbing and transmuting the Hellenizing detail. He concluded that if the absorption of Greek elements constituted the most widely attested characteristic of Roman art, then its history can only be "the history of that fusion itself in its varying forms, degrees, and successive stages."[5]

The Ara Pacis thoroughly attests to the validity of these views. In every sense the monument confirms and includes the Greek legacy, whether Pergamene Hellenistic or Classical Attic, and it bears eloquent witness to the simultaneously inclusive and transformative agenda of the Roman designers or patrons. The approach to tradition is eclectic in the most positive Greek sense of the word—not an arbitrary or incidental mélange, but a thoughtful selection of all that was deemed effective and appropriate to the task at hand. The altar provides impressive evidence of the Augustan capacity to manage the "synchronic spectrum" of Greek alternatives. And if we seek the Roman "denominator," it is everywhere to be seen. It is discernible in the adroit combination of previously distinct Hellenistic forms of floral symbolism as a new, more thorough and distinctive expression of a Roman Peace and moral-cultural regeneration. It is apparent in the decision to expand the conception of Augustan Peace beyond the largely Eleusinian parameters of the Pergamene prototype, and especially in the new emphasis on Apollo and Dionysos, and on Venus. It is likewise discernible in the decision to merge the inherited Pergamene artistic strategies celebrating abundant Peace with those celebrating mythic ancestral founders. It is evident in the decision to include the "Tellus" panel as a more immediate and concrete image of the maternal divinities whose interaction constituted Peace, and in the decision to juxtapose the ancient Italian kings on the west front with Augustus himself in the processional relief, in keeping with the longstanding biographical or historical, commemorative orientation of Italic art. And when viewed against Hellenistic precedent, we may encounter the Roman factor especially in the desire to assert a more overtly ethical aspect to the

mythic ancestors or founders on the enclosure and to the comparison that they offered to the Princeps.

But perhaps we see the guiding Roman denominator most effectively in the astute selection of the various alternatives underlying the altar's program, for the success of this assimilation and transformation depended largely on securing Greek precedent with the capacity to lend itself to new possibilities—to become a locus for the syncretism of Apollo and Liber, or to evoke an Italian-Saturnian Golden Age and the simple, prosperous time of Aeneas and Romulus reborn. The ingenuity and judgment of the Greek artists who originally created the expressive metonymic floral imagery of the altar from Pergamon are matched only by the skill and discernment of the Augustan designers who recognized and exploited the inherent potential of the Pergamene decoration in formulating the program of the Altar of Peace. The most effective works of Roman art were always those whose makers responded to existing artistic tradition actively, with intelligence and imagination. In this regard above all, the Ara Pacis Augustae remains a seminal and enduring expression of *Romanitas*.

Notes

Introduction

1. For the most recent and thorough discussion of this program of cultural or national renewal, see Zanker, *The Power of Images in the Age of Augustus*, esp. 5–25, and 101–66.

2. Cato's remarks here are recorded by Livy, XXXIV,4,3–4. See Pollitt, "The Impact of Greek Art on Rome," 158–59; and Zanker, *Power of Images*, 23–24.

3. On the East or Asiatic Greek derivation of Mid-Italic fictile architectural ornament, see A. Andrén, *Architectural Terracottas from Etrusco-Italic Temples*, Lund, 1940, cxxix–cxli; idem, "Osservazioni sulle terrecotte architettoniche etrusco-italiche," *Opuscula Romana*, 8, 1974, 1–2; and A. Akerström, *Die architektonischen Terrakotten Kleinasiens*, Acta Instituti Atheniensis Regni Sueciae, ser. 4, 11, Lund, 1966, 269. M. Cool Root, "An Etruscan Horse Race from Poggio Civitate," *AJA*, 77, 1973, 122–37, esp. 126 ff., has also pointed to the impact of Corinthian art in the style of such architectural decoration in Archaic Italy; cf. K. M. Phillips, Jr., "Poggio Civitate," *Archaeology*, 21, 4, 1968, 255; A. Small, "The Banquet Frieze from Poggio Civitate (Murlo)," *Studi etruschi*, 39, 1971, 59; Andrén, "Osservazioni," 2; and E. Fabbricotti, "Fregi fittili arcaici in Magna Grecia," *Atti e memorie della Società Magna Grecia*, n.s., 18–20, 1977–79, 168–69, who stress Corinthian influence on the architectural terracottas of the Greek south as well as those of central Italy.

4. Smethurst, "The Growth of the Roman Legend," 11–13; Astin, *Cato the Censor*, 98–100, 157–81, 205, 207–8, 222, and 228.

5. The other major expression of this type was the Forum of Augustus; Zanker, *Forum Augustum*, idem, *Power of Images*, 194–95, 201–3.

6. See, for example, E. Strong, *Roman Sculpture from Augustus to Constantine*, London, 1907, 42–44; Moretti, *Ara Pacis Augustae*, 216; I. Scott-Ryberg, "The Procession of the Ara Pacis," 91–94; Hanell, "Das Opfer des Augustus an der Ara Pacis," 33–123, esp. 73–74, 117–20; H. Malmström, *Ara Pacis and Virgil's Aeneid. A Comparative Study*, Mälmo, 1963; Booth, "Venus on the Ara Pacis," 871–79, esp. 876–77; Galinsky, "Venus in a Relief of the Ara Pacis Augustae," 223–43, esp. 223–24; idem, *Aeneas, Sicily, and Rome*, 191–241, esp. 192; Simon, *Ara Pacis Augustae*, 27–30; R. Brilliant, *Roman Art from the Republic to Constantine*, London, 1974, 238–40; E. La Rocca, *Ara Pacis Augustae in occasione del restauro della fronte orientale*, Rome, 1986, 46; and Zanker, *Power of Images*, 176, 182.

7. Among the more significant instances, see E. Strong, "La legislazione sociale di Augusto ed i fregi del recinto dell'Ara Pacis," *Quaderni di studi romani*, 2, 1939, 1–24; E. Welin, "Die beide Festtage der Ara Pacis Augustae," in *Dragama Martino P. Nilsson*, Acta Inst. Regni Sueciae, ser. 2, 1, 1939, 500–513; Scott-Ryberg, "Procession," 79–90; idem, "Rites of the State Religion in Roman Art," *MAAR*, 22, 1955, 38–48; Hanell, "Das Opfer des Augustus," Kleiner, "The Great Friezes of the Ara Pacis Augustae." 753–85; idem, *Roman Sculpture*, 92–93; Torelli, *The Typology and Structure of Roman Historical Reliefs*, 27–61; and G. M. Koeppel, "Maximus Videtur Rex: The *Collegium Pontificum* on the Ara Pacis Augustae," *Archaeological News*, 14, 1985, 18–22.

8. Notable exceptions are O. Deubner, "Pergamon und Rom. Eine kulturhistorische

Betrachtung," 112–14; Kleiner, "The Great Friezes," 754–66; idem, *Roman Sculpture*, 92–93; Borbein, "Die Ara Pacis Augustae." 242–66; Stucchi, "La chora Alexandreon in un rilievo del Museo del Louvre," 261–84; and Hölscher, *Römische Bildsprache als semantisches System*, 17, 34–35, and 45–49. For analogous studies on the Greek sources transformed by the Augustan poets, see Pasquali, *Orazio lirico. Studi*, 141–641 passim; J. V. Cody, *Horace and Callimachean Aesthetics*, Brussells, 1976, 15–44; P. G. Toohey, "A Note on Horace, *Odes*, I.38," *Maia*, 32, 1980, 171–74; J. Griffin, "Genre and Real Life in Latin Poetry," *JRS*, 71–72, 1981–82, 39–49; A. W. Bulloch, "Tibullus and the Alexandrians," *Proceedings of the Cambridge Philological Society*, 199, 1973, 71–89; Nisbet, "Vergil's Fourth Eclogue: Easterners and Westerners," 59–78; and P. R. Hardie, *Virgil's Aeneid. Cosmos and Imperium*, Oxford, 1986, 125–29.

9. Petersen, *Ara Pacis Augustae*, 161–5; Kraus, *Die Ranken der Ara Pacis*; Byvanck-Quarles van Ufford, "'Die Ranken der Ara Pacis.' Étude sur la décoration à rinceaux pendant l'époque hellénistique," 39–56; Börker, "Neuattisches und pergamenisches an den Ranken der Ara Pacis," 283–317; and Sauron, "Les modèles funéraires classiques de l'art décoratif néo-attique au Ier siècle av. J.-C.," 183–209, esp. 202 ff.

10. Andreae, *The Art of Rome*, 116; Bianchi Bandinelli, *Rome: The Center of Power*, 191.

11. Strong, *Roman Sculpture*, 61–62; Scott-Ryberg, "Procession," 80; H. Kähler, *The Art of Rome and Her Empire*, New York, 1963, 67–69. Also see Kraus, *Ranken*, 18–19, who touches briefly on the function of the floral friezes as a "*Naturbild*".

12. L'Orange, " Ara Pacis Augustae. La zona floreale," 7–16.

13. Petersen, *Ara Pacis Augustae*, 24 and 29; cf. Strong, *Roman Sculpture*, 61; idem, *CAH*, 10, 1934, 549; Ducati, *L'arte in Roma dalle origini al secolo VIII*, 118; H. Reimann, s.v. "Ara Pacis Augustae," *RE*, 18,1, 1942, 2089; Kraus, *Ranken*, 15; and Simon, *Ara Pacis Augustae*, 13; Pollini, "Studies in Augustan Historical Reliefs," 127; Kleiner, *Roman Sculpture*, 92.

14. L'Orange's interpretation has been accepted in its basic outlines by subsequent scholarship; see Simon, *Ara Pacis Augustae*, 13; Borbein, "Ara Pacis Augustae," 265; Zanker, *Power of Images*, 179–83.

15. Büsing, "Ranke und Figur an der Ara Pacis Augustae," 247–57.

16. Pollini, "The Acanthus of the Ara Pacis as an Apolline and Dionysiac Symbol of *Anamorphosis, Anakyklosis*, and *Numen Mixtum*," 181–217; Kellum, "What We See and What We Don't See. Narrative Structure and the Ara Pacis Augustae," 26–45.

17. Sauron, "Le message symbolique des rinceaux de l'Ara Pacis Augustae," 80–101.

18. As instances of this genre, Sauron, "Le message symbolique," 83–84, cites Vergil's Seventh Eclogue, lines 61–64, and the Hellenistic precedent of Kallimachos's "Debate of the Laurel and Olive." This format may derive, however, from ancient Near Eastern sources or traditions such as the "Dialogue of the Tamarisk and the Date Palm"; see S. Smith, "Notes on 'The Assyrian Tree,'" *Bulletin of the School of Oriental Studies, London*, 4, 1926–28, 70. Yet this appears to have been a purely literary phenomenon without analogy in the visual arts.

19. L'Orange, "La zona floreale," 8; Sauron, "Les modèles," 205–9.

20. See, for example, the remarks of Cicero on the comparable effects and qualities of painting, sculpture, and poetry or oratory; *De Oratore*, III,1,195–97, *De Officiis*, I,xli,147. On the close relation between literary and artistic expression among the Greeks, see T. B. L. Webster, *Greek Art and Literature 700–530 B.C.*, New York, 1960; idem, *Greek Art and Literature 530–400 B.C.*, Oxford, 1939; idem, *Art and Literature in Fourth-Century Athens*, London, 1956; idem, *Hellenistic Poetry and Art*, London, 1964; and more recently, the introduction in D. Castriota, *Myth, Ethos, and Actuality: Official Art in Fifth-Century B.C. Athens*, Madison, Wis., 1992, esp. 9–11.

21. See Torelli, *Typology*, 40–41, who has criticized this methodological dependence on Augustan poetry.

22. On the mediating role of the text, see above all U. Eco, *Opera aperta*, Milan, 1962 (partial Eng. trans. *The Open Work*, Cambridge, Mass., 1989); idem, *The Limits of Interpretation*, Bloomington and Indianapolis, 1990, esp. 44–63. On the text as invitation, idem, *The Role of the Reader. Explorations in the Semiotics of Texts*, Bloomington, 1979, 9–10 and 63–65; and S. Fish, *Is There a Text in This Class? The Authority of Interpretive Communities*, Cambridge, Mass., and London, 1980, 147–73, esp. 172–73. For the concept of shared interpretive strategies, Fish, 167 ff.; idem, *Doing What Comes Naturally: Change, Rhetoric, and the Practice of Theory in Literary and Legal Studies*, Durham, N.C., and London, 1989, 83, 141, 150–60; for a critical response, W. A. Davis, "The Fisher King: *Wille zur Macht* in Baltimore," *Critical Inquiry*, 10, June, 1984, 668–94, and S. Mailloux, *Rhetorical Power*, Ithaca and London, 1989, 9, 15, and 151–54. On the ideal or model reader, Fish, *Is There a Text in This Class*, 158–61; Eco, *Role of the Reader*, 7–11 and 41, note 6 (with references to earlier work along these lines); and Mailloux, 34–35; on literary competence more generally, J. Culler, *Structuralist Poetics*, Ithaca, N.Y., 1975, 113–30. In a lecture "The Creative Act," presented in 1957, M. Duchamp had already posited the active involvement of the viewer in the visual arts along these lines; see G. Battcock, ed., *The New Art*, New York, 1966, 23–26. I am indebted to my colleague Kristine Stiles for this reference. On the relevance of such theoretical models to the study of Athenian public monuments, see the latter part of the introduction in Castriota, *Myth, Ethos, and Actuality*, 15–16. For the issue of audience response in the context of the Augustan monuments, also see J. Elsner, "Cult and Sculpture: Sacrifice in the Ara Pacis Augustae," *JRS*, 81, 1991, 50–61.

23. Cf. the remarks of Cicero on the reception of poetry in *Orator*, LI,173 and LIII,177–78. Also see D. Summers, *The Judgment of Sense. Renaissance Naturalism and the Rise of Aesthetics*, Cambridge and New York, 1987, 127–32, esp. 129–30 and note 14.

Chapter I

1. Moretti, *Ara Pacis Augustae*, 27, fig. 15, right edge, center; 74–75, fig. 59, upper left.

2. Moretti, *Ara Pacis Augustae*, 49, fig. 38, right fragment, bottom; 73, fig. 57, right; 74, fig. 59, top left corner; 76 and 80, fig. 65, upper left and extreme right; tav. XIII.

3. Moretti, *Ara Pacis Augustae*, 44, and 45, fig. 32, center; tav. XIV, right.

4. Moretti, *Ara Pacis Augustae*, 74–75, fig. 59, extreme right, and fig. 60; 76 and 80, fig. 65; tav. XIII.

5. Moretti, *Ara Pacis Augustae*, 70–71, fig. 53, bottom.

6. Moretti, *Ara Pacis Augustae*, 77–78, fig. 62, upper right fragment, bottom edge.

7. Moretti, *Ara Pacis Augustae*, 75, fig. 60, upper right edge; tav. XIII, left.

8. Moretti, *Ara Pacis Augustae*, tav. XIV, bottom right.

9. Moretti, *Ara Pacis Augustae*, 19, fig. 9, center; 40, fig. 26, center, right; and 148–49, figs. 121–22; tav. XVII and XVIII. Moretti, 20, and 43, does not identify the roses here as such.

10. Cf. the preceding note. Even in the sections specifically devoted to a discussion of the floral friezes, Moretti, *Ara Pacis Augustae*, 146–51 and 273–74, accords the naturalistic plants little or no particular attention.

11. See, for example, Simon, *Ara Pacis Augustae*, 13; cf. Zanker, *The Power of Images*, 181.

12. Deubner "Pergamon und Rom," 113–14; Kraus, *Ranken*, 64–69, esp. 66; Börker, "Neuattisches und pergamenisches," 300–305.

13. *AVP* VII, 2, 317–23, no. 406; H. Hepding, "Die Arbeiten zu Pergamon, 1908–1909," *AM*, 35, 1910, 514–15; E. V. Hansen, *The Attalids of Pergamon*, Ithaca, N.Y., 1947, 328–29; Deubner, "Pergamon und Rom," Abb. 34; Kraus, *Ranken*, 66; Börker, "Neuat-

tisches und pergamenisches," 303–5, Abb. 12a–b; F. Naumann, *Die Ikonographie der Kybele in der phrygischen und der griechischen Kunst*, cat. no. 611, 265, and Taf. 46,3; and Schwarz, *Triptolemos. Ikonographie einer Agrar- und Mysteriengottheit*, R 19, 68 and 207.

14. For the identification of these plants see *AVP* VII, 2, 320–21, and Börker, "Neuattisches und pergamenisches," 303–4; Kraus, *Ranken*, 66, and Naumannn, *Ikonographie der Kybele*. The latter two authors mistake the laurel with bayberries for olive branches; however, the more even, lancelote proportion and grouping of the leaves is clearly that of laurel rather than olive (figs. 47 and 48).

15. *AVP*, VII, 2, 327–28, no. 411; Kraus, *Ranken*, 66.

16. Kraus, *Ranken*, 67 and 69, Taf. 21,2; Börker, "Neuattisches und pergamenisches," 300; *AVP* XI, 3, 115–20, no. 15, Taf. 91.

17. R. Horn and E. Böhringer, "Die Ausgrabungsarbeiten zu Pergamon im Jahre 1965," *AA*, 1966, 468–69, Abb. 45; Börker, "Neuattisches und pergamenisches," 300–301, Abb. 11; *AVP* XI, 4, 133–35, S 67, Taf. 61.

18. For the development of such ornament, see esp. Toynbee and Ward-Perkins, "Peopled Scrolls: A Hellenistic Motif in Imperial Art," 1–43.

19. For the identification of this figure, see the works cited in note 13 above. On the presence of the *tympanon* and *polos*, see Naumann, *Ikonographie der Kybele*, 265. For the connection with the Great Altar, Naumann, ibid., and Börker, "Neuattisches und pergamenisches," 303.

20. Naumann's identification, *Ikonographie der Kybele*, 265, of this animal as a horse, and of the thyrsos as a flaming torch is puzzling considering that the staff is clearly too thin to be a torch bundle, just as the leg proportions, claws, and ring tail of the animal can hardly be equine. Since the initial publication of this work, virtually all commentators have recognized this righthand figure as Dionysos; see the works cited just above in note 13. For earlier Classical and other Hellenistic depictions of Dionysos as panther rider, see C. Gasparri, "Dionysos," in *LIMC*, III, Munich, 1986, 461, nos. 430–33.

21. Here again see the works cited in note 13 above, especially Schwartz, *Triptolemos*, where numerous other depictions of this kind are discussed and illustrated.

22. With regard to the literary evidence, the best and most comprehensive treatment of this tradition remains Murr's *Die Pflanzenwelt in der griechischen Mythologie*. Also see C. Daremberg and E. Saglio, *Dictionnaire des antiquités grecques et romaines d'après les textes et les monuments*, Paris, 1877, s.v. "Arbores Sacrae," 356–62; the sections on *heilige Pflanzen und Tiere* under the entries for various Greek and Roman divinities in *RE*; A. Huxley and R. W. Taylor, *Flowers of Greece and the Aegean*, London, 1977; and more recently, H. Baumann, *The Greek Plant World in Myth, Art, and Literature*, tr. and augmented by W. T. Stearn and E. R. Stearn, Portland, Or., 1993.

23. *AVP* VII, 2, 321. Also see Schwartz, *Triptolemos*, 207, who identifies the kerykeion here as an allusion to Keryx, the father of the Eleusinian priestly family of the Kerykes, who also worshipped Hermes.

24. Only one of these actually survives; the other presumably decorated the corresponding point on the missing portion of the damaged slab. Since the kerykeion appears on the rear of both slabs for the sake of symmetry, it is clear that the decoration of the edges would similarly have matched.

25. Leningrad St. 1792; *ARV²* 1476,1; A. Furtwängler and K. Reichhold, *Griechische Vasenmalerei*, Berlin, 1904–32, Taf. 70; K. Schefold, *Untersuchungen zu der Kertscher Vasen*, Berlin and Leipzig, 1934, 40 ff., no. 368, Taf. 35; M. P. Nilsson, "Die eleusinische Religion," *Die Antike*, 18, 1942, 224 and Abb. 9; G. E. Mylonas, *Eleusis and the Eleusinian Mysteries*, Princeton, 1961, 210–11, fig. 85; G. Kerényi, *Eleusis. An Archetypal Image of Mother and Daughter*, Bollingen Series, 4, New York, 1967, 162–63, fig. 50; A. Delivorrias, "Aphrodite," in *LIMC*, II, Munich, 1984, 130, no. 1371; Gasparri, "Dionysos,"

LIMC, III, 468, no. 528; L. Beschi, "Demeter," in *LIMC*, IV, Munich, 1988, 877–78, no. 404; E. Simon, "Neue Deutung zweier eleusinischer Denkmäler des vierten Jahrhunderts," *Antike Kunst*, 9, 1966, 72–92, Taf. 17 and 19,1; idem, *Festivals of Attica. An Archaeological Commentary*, Madison (Wis.), 1983, 27 and pl. 9.

26. Amsterdam, Allard Pierson Museum, inv. 26 36; *RVA*, I, no. 408; Schwarz, *Triptolemos*, 56 and 160, V 144.

27. Delivorrias, "Aphrodite," *LIMC*, II, 130, no. 1371.

28. On the notion of the *Daseinsbild* in the context of divine assemblies, see N. Himmelmann-Wildschütz, "Die Götterversammlung der Sosias-Schale," *Marburger Winckelmann-Programm*, 1960, 41–48; H. Knell, *Die Darstellung der Götterversammlung in der attischen Kunst des VI. u. V. Jahrhunderts v. Chr. Ein Untersuchung zur Entwicklungsgeschichte des "Daseinsbildes"*, Darmstadt, 1965; idem, "Zur Götterversammlung am Parthenon-Ostfries," *Antaios*, 10, 1968, 38–54.

29. Winter, *AVP*, VII, 2, 321. For the quince and Aphrodite, see Baumann, *The Greek Plant World*, 139 and 142.

30. Delivorrias, "Aphrodite," *LIMC*, II, 130, nos. 1367–68 and 1370.

31. *ARV²* 1438,1; O. Palagia, "Apollon," *LIMC*, II, Munich, 1984, 296, no. 933.

32. *RVA*, I, no. 423; Palagia, "Apollon," *LIMC*, II, no. 934.

33. Pausanias, X,15,2; Strabo, XIII, 613; Murr, *Pflanzenwelt*, 159–60; L. R. Farnell, *Cults of the Greek States*, IV, Oxford, 1907, 130.

34. Daremberg and Saglio, *Dictionnaire*, 358; Murr, *Pflanzenwelt*, 92–94, 98.

35. A. Jolles, *RE* VIII, 2, 1913, s.v. "Horai," 2302–2303; Willrich, *RE* V, 2, 1905, s.v. "Eirene," 2128.

36. On the general connection between Dionysos and the Seasons or Eirene, see Scheibler, "Götter des Friedens in Hellas und Rom," 48; Simon, *Eirene und Pax. Friedesgöttinen in der Antike*, 59–62; idem, "Eirene/Pax," in *LIMC*, III, Munich, 1986, 704; V. Machaira, "Horai," in *LIMC*, V, Munich, 1990, 505–506, nos. 20–31. On Dionysos and the Seasons in Ptolemy's procession, see Athenaeus, *Deipnosophists*, 198 A–B, and Simon, *Eirene und Pax*, 67.

37. *ARV* 1152,8; *ARV²* 1316,3; H. A. Shapiro, *Personifications in Greek Art. The Representation of Abstract Concepts 600–400 B.C.*, Zurich, 1993, 45–50, 232, nos. 8–9; Scheibler, "Götter des Friedens," 48 and Abb. 9–10; Simon, *Eirene und Pax*, 60–61, Taf. 3,2; idem, "Eirene/Pax," *LIMC*, III, 704, nos. 11–12. The figures on both vases are all identified by inscriptions. For the connection of the vase to Euripides see Shapiro, 46–48.

38. E. Vikelas and W. Fuchs, "Zum Rundaltar mit archaistischem Götterzug für Dionysos in Brauron," *Boreas*, 8, 1985, 41–48, Taf. 2–5; Simon, "Eirene/Pax," *LIMC*, III, 704, no. 10; idem, *Eirene und Pax*, 61, Taf. 2; Shapiro, *Personifications*, 47–48, 232, no. 10.

39. In contrast to the interpretation of Fuchs, who identifies the seated female as Ariadne, see the preceding note.

40. *Homeric Hymns*, II, 54, 192, and 492.

41. *RVA* I, 193, 6; Alföldi, "Redeunt Saturnia Regna, VII: Frugifer-Triptolemos im ptolemäisch-römischen Herrscherkult," 567, Abb. 2; Delivorrias, "Aphrodite," *LIMC*, II, 130, no. 1368; Machaira, "Horai," *LIMC*, V, 508, no. 47.

42. For recent opinion on the Tazza, see E. La Rocca, *L'Età d'oro di Cleopatra: indagine sulla Tazza Farnese*, Rome, 1984; Pollitt, *Art in the Hellenistic Age*, 257–59 and 300, section f; Schwarz, *Triptolemos*, 59 and 169–73, G 1; D. Burr Thompson, "The Tazza Farnese Reconsidered," in H. Maehler and V. M. Strocka, eds., *Das ptolemäischen Ägypten. Akten des internationalen Symposions 27.–29. September 1976 in Berlin*, Mainz, 1978, 113–22; L. Abad Casal, "Horae," in *LIMC*, V, Munich, 1990, 520, no. 83; E. Dwyer, "The Temporal Allegory of the Tazza Farnese," *AJA*, 96, 1992, 255–82; and J. Pollini, "The Tazza

Farnese: *Augusto Imperatore 'Redeunt Saturnia Regna'*," *AJA*, 96, 1992, 283–300. For the plate, Schwarz, *Triptolemos*, 61, 177–81, T 1; G. Hafner, "Der Silberteller von Aquileia: kein 'Historisches Relief'," *AA*, 1967, 213–19; D. E. Strong, *Roman Art*, 2nd ed., annotated by R. Ling, Harmondsworth, 1988, 93, fig. 45; Alföldi, "Redeunt Saturnia Regna, VII," 566–68 and 570–76; Casal, "Horae", 520, no. 85; S. De Angeli, "Demeter/Ceres," *LIMC*, IV, Munich, 1988, 905, no. 164.

43. Olympian Ode, XIII,9–10; Lyr. Frag. adesp. 89 Bgk; cf. *RE*, vol. V, 2, 1905, s.v. "Eirene," 2129.

44. Nilsson, "Eleusinische Religion" (as in note 25 above), 224 and Abb. 10; E. La Rocca, "Eirene e Ploutos, *JDAI*, 89, 1974, 112–36, esp. 131; T. Hadzisteliou Price, *Kourotrophos. Cults and Representations of the Greek Nursing Deities*, Leiden, 1978, no. 659, 62, 127, 191; Scheibler, "Götter des Friedens," 48–49, Abb. 1; Simon, "Eirene/Pax," *LIMC*, III, 703–74, nos. 6–8; idem, *Eirene und Pax*, 62–64, Taf. 4–5. The cornucopia is not preserved on the extant Roman copies of this statue, but it is attested in the more contemporary replicas preserved in Attic vase painting, as Simon and La Rocca emphasize.

45. B. V. Head, *Historia Numorum. A Manual of Greek Numismatics*, Oxford, 1887, 86–87, and fig. 58; C. M. Kraay, *Archaic and Classical Greek Coins*, Berkeley and Los Angeles, 1976, 197, no. 719; S. Weinstock, "Pax and the Ara Pacis," *JRS*, 51, 1961, 44, pl. V, no. 1; Simon, "Eirene/Pax," *LIMC*, III, 701–702, no. 1–2; idem, *Pax und Eirene*, 61, Taf. 3,1; Scheibler, "Götter des Friedens," 48 and Abb. 11.

46. Simon, *Eirene und Pax*, 61.

47. Crawford, *Roman Republican Coinage*, 466, no. 450/2; 508, no. 494/41; 532, no. 529/4b. The obverses are often Concordia herself. For a Pax obverse, Crawford, 491, no. 480/24. For full figures of Pax with the caduceus, Crawford, 496, no. 485/1. Also see Weinstock, "Pax and the Ara Pacis" (as in note 45 above) 45–47, pl. V, nos. 3, 5, 8, 9, and 11.

48. Leningrad St. 1807; *ARV²* 1185,7; Stewart, "Dionysos at Delphi: The Pediments of the Sixth Temple of Apollo and Religious Reform in the Age of Alexander," 208, fig. 5; Simon, *Pax und Eirene*, 60 and Taf. 1,2; W. Lambrinudakis, "Apollon," *LIMC*, II, Munich, 1984, 279, no. 768a.

49. Homonoia had an altar in the sanctuary at Olympia (Pausanias, V,14,9), although the date here is uncertain. But her cult is attested for the third century B.C.; an altar in Athens, *IG*, vol. II,3, 103, no. 1663; a *temenos* in Thera, *IG*, vol. XII,3 Supplement, 295, no. 1336; and a temple at Tralles, Appian, XII,4,23; cf. Zwicker, *RE*, VIII,2, 1913, s.v. "Homonoia," 2266. also see H. A. Shapiro, "Homonoia," in *LIMC*, V, Munich, 1990, 476–79. On the identity to the Roman cult of Concordia, Zwicker, ibid; T. Hölscher, "Concordia," in *LIMC*, V, Munich, 1990, 479–98, esp. 492–94. On the foundation of the related Concordia cult in Republican Rome, also see R. Peter, in Roscher, *Lexikon*, s.v. "Concordia," 914–16; Aust, in *RE*, IV,1, 1900, s.v. "Concordia," 821–32.

50. Stater from Metapontum, 400–350 B.C.; Head, *Historia Numorum*, vol. 2, 77, fig. 38; R. S. Poole, *Catalogue of Greek Coins in the British Museum. Italy*, London, 1873, 244, no. 59; Zwicker, *RE*, VIII,2, 1913, s.v. "Homonoia," 2268.

51. Kallimachos, *Hymns*, VI, 134–37:

χαῖρε θεὰ καὶ τάνδε σάω πόλιν ἔν θ' ὁμονοίᾳ
ἔν τ' εὐηπελίᾳ, φέρε δ' ἀγρόθι νόστιμα πάντα·
φέρβε βόας, φέρε μᾶλα, φέρε στάχυν, οἶσε θερισμόν,
φέρβε καὶ εἰράναν, ἵν' ὃς ἄροσε τῆνος ἀμάσῃ.

52. Diodorus Siculus, XVI,60,3, and XXII,8,4.

53. Museo Nazionale, Rome, inv. 3Q; excavation inv. 446, fine-grained marble; height 14 cm., width 10 cm., depth 29 cm.

54. S. Haynes, "Drei neue Silberbecher im Britischen Museum," *Antike Kunst*, 4, 1961, 30–36, Taf. 16, 1–4; P. E. Corbett and D. E. Strong, "Three Roman Silver Cups," *British Museum Quarterly*, 23, 3, 1961, 68–83, figs. 3–4 and pls. XXXII a–b,d, and XXXV–XXXVII; and Strong, *Roman Art*, 89–92, figs. 41–42.

55. Only Börker, "Neuattisches und pergamenisches," 305, touched briefly upon the specific connection between these silver cups and the multi-fruited decoration on the slabs and the *Hallenstrasse* and Asklepeion fragments.

56. W. Helbig, *Führer durch die antiken Sammlungen klassischer Altertumer in Rom*, 4th ed., revised by H. Speier, Tübingen, 1963, vol. I, 401–402, no. 507; W. Amelung (with G. Lippold), *Die Sculpturen des Vatikanischen Museums*, III², Berlin, 1956, 101–103, no. 623, Taf. 29 and 49.

57. Moretti, *Ara Pacis Augustae*, tav. III and IV, where the original portions are shaded more darkly, and X, where the missing portions are entirely omitted.

58. Moretti, *Ara Pacis Augustae*, cf. 27, fig. 15, center, and 77, fig. 62, upper right fragment, bottom.

59. Moretti, *Ara Pacis Augustae*, cf. 49, bottom left and 28, fig. 16, left.

60. Moretti, *Ara Pacis Augustae*, 45, fig. 32, lower right.

61. Moretti, *Ara Pacis Augustae*, cf. 42, figs. 30 and 45, fig. 32, lower left.

62. Cf. Moretti, *Ara Pacis Augustae*, 42, figs. 30 and 74, fig. 59, center, left.

63. Cf. Moretti, *Ara Pacis Augustae*, tav. XI and XII.

64. Moretti, *Ara Pacis Augustae*, 49, fig. 38, bottom right.

65. Cf. Moretti, *Ara Pacis Augustae*, XI and XII, center.

66. Museo Nazionale, Rome, inv. 7H; excavation inv. 516; fine-grained Luni marble, height 12.5 cm., length 20 cm., depth 20 cm.; mistakenly identified in museum file as olive branch.

67. Moretti, *Ara Pacis Augustae*, 45, fig. 32, center, left. Moretti, 44, quotes A. Pasqui's description of the fragment containing this detail, "Scavi dell'Ara Pacis Augustae," *NS*, 1903, 569–70, which, although it notes the clusters of ivy further up, does not mention laurel. Kraus's statement, *Ranken*, 15, that the laurel appears in both long friezes is unsubstantiated.

68. The pilaster *AVP*, VII, 2, no. 411, has no divinities amidst the tendrils; only bottom portion remains. The tendril ornament on two similar pilasters, nos. 412–13, are crowned by Nikai. No. 411 may have included similar figures.

69. See *Webster's Third New International Dictionary*, Springfield, Mass., 1976, 1424, or *The New Encyclopaedia Britannica*, 15th ed., Chicago, 1988, Micropaedia, vol. 8, 72, for standard, classical conception of metonymy as it appears in Quintilian or Cicero, *Brutus Orator*, XXVII, 93; cf. S. J. Brown, *The World of Imagery. Metaphor and Kindred Imagery*, London, 1927 (reissued 1966), 149–62. Brown provides an extensive discussion of metonymy and the closely related concept of synecdoche, where an integral part or component of an entity is used to stand for the whole. For the more modern, theoretical approach of structural linguistics to the functions of metonymy and metaphor, see R. Jakobson, "Two Types of Language and Two Types of Aphasic Disturbances," in R. Jakobson and M. Halle, *Fundamentals of Language*, The Hague, 1956, 76–82; J. Kurylowicz, "Metaphor and Metonymy in Linguistics," *Zagadnienia Rodzajow Literackich*, 9, 1967, 5–9; R. J. Matthews and W. Ver Eecke, "Metaphoric-Metonymic Polarities: A Structural Analysis," *Linguistics: An International Review*, 67, March 1971, 34–53; U. Eco, "The Semantics of Metaphor," (originally published in 1971) in his collected essays, *The Role of the Reader*, 72–82; and P. Schofer and D. Rice, "Metaphor, Metonymy, and Synecdoche Revis(it)ed," *Semiotica*, 21,1/2, 1977, 121–49. Kurylowicz collapses the sometimes difficult distinction between metonymy and synecdoche. With the exception of the works by Eco, Schofer, and Rice, I am indebted to my colleague Kristine Stiles for alerting me to this linguistic research on metonymy.

70. Pausanias, I,31,1; Murr, *Pflanzenwelt*, 143; Roscher, *Lexikon*, I, s.v. "Dionysos," 1029; Farnell, *Cults of the Greek States*, V, 119.

71. Nonnos, *Dionysiaca*, XII,25 and XXII,90; *Greek Anthology*, IX,524,11 and 580; Aelian, *Varia Historia*, III,41,1; *Homeric Hymn*, XXVI,1 and 11; *Orphic Hymn*, XXX,5; *Phillipus*, 45 (*Greek Anthology*, XI,33); Pindar, *Olympian Ode*, II,30; C. Keil, *Sylloge inscriptionum boeticarum*, Leizig, 1847, XVI; Murr, *Pflanzenwelt*, 135 and 143; Farnell, *Cults of the Greek States*, V, 120.

72. Eustathius, *Erotica*, X, 6,10, and 15; Philostratos, *Vita Apollonii*, 16, and *Vitae Sophistarum*, init; Nonnos, *Dionysiaca*, XXIV,99 and XXXVIII,60; *Greek Anthology*, IX,477,1, 505,11, and 525,5; Hesychios, s.v. *Etymologium Magnum*, 250; Aristophanes in Hesychios (frag. 154); *Anacreontea*, XI,6; Plutarch, *Themistokles*, 15; Oppianus Apamensis, *Cynegetica*, I,365; Murr, *Planzenwelt*, 94 and 97; Farnell, *Cults of the Greek States*, IV, 124.

73. Athenaeus, *Deipnosophists*, III,109a, IV,618d, and X,146b; Aelian, *Varia Historia*, I,27; Pausanias, I,22,3; Aristophanes, *Lysistrata*, 835; Sophokles, *Oidipos at Kolonos*, 1600; Theokritos, X,42; *Orphic Hymn*, XL,3 and 5; *Orphica Lithica*, IV,1; *Phillipus*, 14 (*Greek Anthology*, VI,104); Hesychios, s.v. *anaxidora*; L. Preller and E. Plew, *Griechische Mythologie* 3rd ed., Berlin, 1872–75, I,631; Murr, *Pflanzenwelt*, 153–54; Farnell, *Cults of the Greek States*, III, 37.

74. *Iliad*, VI,175; *Odyssey*, II,1; *Anacreontea*, LIII,21; Plutarch, *Amatoriae Narrationes*, 756e; Murr, *Pflanzenwelt*, 83 and 159.

75. See Kraay, *Archaic and Classical Greek Coins*: for Zeus's thunderbolt, pl. 18, no. 328; for Athena's owl, pls. 10–12, nos. 175–219; for Apollo's swan, pl. 54, nos. 929–30.

76. *RVA*, Supplement, I, 84, no. 18; Mayo, *The Art of South Italy. Vases from Magna Graecia*, 129–32, no. 50; and Trendall, *Red Figure Vases of South Italy and Sicily*, fig. 208.

77. For such fuller representations, see Simon, *Die Götter der Griechen*, figs. 15–18, 20, 186, 189, and 192; Lambrinudakis, "Apollon," in *LIMC*, II, Munich, 1984, 227–28, nos. 342–50; P. Demargne, "Athena," *LIMC*, II, 976, nos. 198 and 203–207.

78. Philostratos, *Imagines*, I,31,18–22:

> πρὸς δὲ τὸν σύνδεσμον τῶν κλημάτον εἰ βλέποις καὶ τὰς
> ἐκκρεμαμένας αὐτῶν σταφυλὰς καὶ ὡς κατὰ μίαν αἱ ῥᾶγες,
> ἄσῃ τὸν Διόνυσον οἶδα καὶ ὦ πότνια βοτρυόδωρε.

79. L. Ziehen, s.v. "Panspermia," in *RE*, XVII, 3, 1949, 680.

80. Theophrastos, *Enquiry into Plants*, IX,8,7.

81. For the ambrosial variant, see Athenaeus, *Deipnosophists*, XI,473b–c, citing the treatise *Attic Words and Glosses*, by Philemon; for the cake, Euripides, Fragment 912. For a more precise description of the cake, see Athenaeus, XIV,648b, although there its function as an offering is not mentioned. Cf. Harrison, *Themis. A Study of the Social Origins of Greek Religion*, 298–300, and *RE*, XVIII, 3, 682. For Zeus Ktesios as god of granaries, M. Daraki, *Dionysos*, Paris, 1985, 52, and note 65.

82. Theopompos, quoted by the scholiast on Aristophanes' *Frogs*, 218, and *Acharnians*, 1076; Harrison, *Themis*, 291–92; *RE*, XVIII, 3, 680–81. Deubner, *Attische Feste*, 112–13; Parke, *Festivals of the Athenians*, 116; and Simon, *Festivals of Attica*, 93, make no mention of the *panspermia* and its significance. But see Daraki, *Dionysos*, 52, 57–58.

83. Moretti, *Ara Pacis Augustae*, 167, 171–78, fig. 133, figs. 136–41, tav. G; Kraus, *Ranken*, 70; Napp, *Bukranion und Gurlande*; M. Stephan, *Die griechische Girlande. Ein Beiträge zur griechischen Ornamentik*, esp. 35ff; M. Honroth, *Stadtrömische Girlanden. Ein Versuch zur Entwicklungsgeschichte römischer Ornamentik*; R. Turcan, "Les guirlandes dans l'antiquité classique," *Jahrbuch für Antike und Christentum*, 14, 1971, 92–139; P. Righetti, "Altari cilindrici a bucrani e festone in Grecia. Studio preliminare," *Xenia*, 3, 1982, 49–70. On the Roman assimilation of such garlands in the late Repubican and Augustan

periods: Napp, 17–29; Honroth, 9–22; and esp. von Hesberg, "Girlandenschmuck der republikanischen Zeit in Mittelitalien," 210–45.

84. Stephan, *Griechische Girlande*, 5; Honroth, *Stadtrömische Girlanden*, 7–9; Turcan, "Guirlandes dans l'antiquité classique" (as in note 83 above), 99–132; von Hesberg, "Girlandenschmuck," 202–203.

85. Stephan, *Griechische Girlande*, 54–55, 64; Honroth, *Stadtrömische Girlanden*, 8; Borbein, "Ara Pacis Augustae," 245.

86. The term *encarpa* appears only in Vitruvius, *De Architectura*, IV,1,7, where it describes architectural ornament; although *enkarpa* is included in Greek lexicons, they cite the latinized version of Vitruvius as the isolated example. I am indebted to Lawrence Richardson for pointing out to me that *encarpa* was probably concocted from the Greek by the Romans as a technical term, in keeping with standard practice at that time. For the more generic terms applied to garlands, see Stephan, *Griechische Girlande*, 3; Napp, *Bukranion und Girlande*, 3.

87. For the Grimani reliefs, see V. M. Strocka, "Die Brunnenreliefs Grimani," *Antike Plastik*, 4, 1965, Taf. 53 and 56; Bianchi Bandinelli, *Rome: The Center of Power*, fig. 206; Zanker, *Power of Images*, 177–79, fig. 138c.

88. *AVP* VII, 2, 337, no. 418, Taf. 41; Napp, *Bukranion und Girlande*, 5–6; Stephan, *Griechische Girlande*, 38–40; Hansen, *Attalids of Pergamon*, 329; Kraus, *Ranken*, 70, Taf. 22; for the inscription, *AVP* VIII, 1, 68, no. 131.

89. Stephan, *Griechische Girlande*, 51–52; Honroth, *Stadtrömische Girlanden*, 8–9. For Dionysian fruited garlands of this kind, see the well-known altar from the theater of Dionysos at Athens; Kraus, *Ranken*, Taf. 23; N. Travlos, *Pictorial Dictionary of Ancient Athens*, New York, 1971, 552, fig. 690; Righetti, "Altari cilindrici" (as in note 83 above), 53–54.

90. Ducati, *L'arte in Roma*, 118; Kähler, *Rome and Her Empire*, 67 and 69; Andreae, *Art of Rome*, 118; Simon, *Ara Pacis Augustae*, 13; Holliday, "Time, History, and Ritual on the Ara Pacis," 545.

91. Kraus, *Ranken*, 18–19, had already emphasized the distinctive modality between the more objective naturalism of the garlands or landscape depiction and the underlying decorative abstraction of floral friezes, the latter being "a picture of nature in the dress of ornament." But he saw this primarily as a means of instilling the friezes with ceremonial solemnity. For the very different, generalized image of copious vegetation in contemporary landscape or garden scenes, see M. M. Gabriel, *Livia's Garden Room at Prima Porta*, New York, 1955; B. A. Kellum, "The Construction of Landscape in Augustan Rome: The Garden Room at the Villa *ad Gallinas, Art Bulletin*, 76, 1994. 211–224; also see F. Le Corsu, "Un Oratoire pompéien consacré à Dionysos-Osiris," *RA*, 1967, 239–54; H. Sichtermann, "Gemälte Garten in pompejanischen Zimmern, *Antike Welt*, 4,3, 1974, 41–51; D. Michel, "Pompeijanische Gartenmalerei," in H. A. Cahn and E. Simon, eds., *Tainia. Roland Hampe zum 70. Geburtstag*, Mainz, 1980, 373–403; and R. Ling, *Roman Painting*, Cambridge and New York, 1991, 149–53, fig. 158. For the conceptual or ideological background of such paintings, P. Grimal, *Les jardins romains*, 2nd. ed., Paris, 1969, and W. F. Jashemski, *The Gardens of Pompeii, Herculaneum, and the Villas Destroyed by Vesuvius*, New Rochelle, N.Y., 1979. The garden painting from Primaporta contains many of the same species as the Pergamon reliefs and the Ara Pacis friezes; for a detailed description and illustration of these plants and flowers, see esp. Gabriel, 32–42, pls. 4, 8–14, 27, 31, and 34.

92. See the forthcoming work by the author, "Fantasy, Reality, and Metonymy in the Ancient Near Eastern Image of the Sacred Tree," in R. Latham and R. Collins eds., *Modes of the Fantastic; Selected Essays from the Twelfth International Conference on the Fantastic in the Arts*, Westport, Ct., expected 1995, 143–154.

93. For tendrils of this kind with only one or two naturalistic plants, see notes 151–

152 below. On the relative rarity of such floral ornament before the later Hellenistic period, see M. Pfrommer, *Metalwork from the Hellenistic East. Catalogue of the Collections*, Malibu, Cal., 1993, 30–31.

94. Initially this was the opinion of Wiegand as reported by Winter in *AVP* VII, 1, 318; cf. G. Richter, *A Handbook of Greek Art*, London and New York, 1969, 377, and Naumann, *Ikongraphie der Kybele*, 265.

95. *AVP* VII, 2, 319, fig. 406b. For the Boscoreale painting, see P. Lehmann, *Roman Wall Paintings from Boscoreale in the Metropolitan Museum of Art*, 196–97, 200, pls. XIII and XVI, and Ling, *Roman Painting*, fig. 28.

96. C. G. Yavis, *Greek Altars. Origins and Typology*, Saint Louis, Mo., 1949, 183–85; Etienne and Braun, *Ténos I. Le sanctuaire de Poseidon et Amphitrite*, 170–75.

97. Etienne and Braun, *Tenos I*, 117–20, pls. 27–29. For additional examples, see the study by Yavis cited in the preceding note.

98. Good examples of this kind from the fourth century B.C. appear on Delos and Olynthos; A. Plassart, *Les sanctuaires et les cultes de Mont Cynthe, Exploration archéologique de Delos*, XI, Paris, 1928, 206–209, figs. 174–75; D. M. Robinson, *Excavations at Olynthos. XII, Domestic and Public Architecture*, Baltimore, London, and Oxford, 1946, 189ff., pls. 160,1, 162,4, 163,1, 164,2, and 173,1; Yavis, *Greek Altars*, 69, nos. 6 and 10, figs. 84–85.

99. The slabs themselves are 0.92 m. high by 1.08 m. wide, and 21 cm. thick; *AVP* VII, 2, 317. The Ara Pacis altar is also largely reconstructed, although its form is securely documented on the basis of the tufa core of the podium and the marble barriers from the superstructure; see Moretti, *Ara Pacis Augustae*, 180–96, figs. 142–43, and tav. V–VII and XXXVIII.

100. Cf. those from Delos and Olynthos cited just above in note 98.

101. An unpublished decorative, voluted marble crest, now in the central courtyard of the Archaeological Museum at Bergama, is very similar to the barriers of the Ara Pacis. Presumably of Hellenistic date, it suggests how Greek precursors of the Ara Pacis barriers might have appeared.

102. Yavis, *Greek Altars*, 185–91, fig. 90.

103. The stepped podium here is based upon one found at Selinus in Sicily: E. Gàbrici, "Acropoli di Selinunte. Scavi e Topografia," *Monumenti antichi*, 33, 1929, 82–84, fig. 7 and tav. XVIII, 6.

104. H. A. Thompson, "The Altar of Pity in the Athenian Agora," *Hesperia*, 21, 1952, 60–82, esp. 79ff.

105. K. Lehmann and D. Spittle, *The Altar Court, Samothrace*, IV,2, Bollingen Series, LX, IV,2, New York, 1964, 17–146.

106. On the Kos altar, see L. Laurenzi, "Attività del Servizio Archeologico nelle isole italiane dell'Egeo nel Biennio 1934–1935," *Bollettino d'arte*, 30, 1936–37, 138, fig. 15; Lehmann and Spittle, *Altar Court*, 63–64, fig. 60. On the connections with the Ara Pacis, Lehmann and Spittle, 64, n. 12; and Borbein, "Ara Pacis Augustae," 248. For the fragments of the relief decoration with Dionysian scenes from the enclosure, O. Benndorf and G. Niemann, *Reisen in südwestlichen Kleinasien*, I, Vienna, 1884, 13 ff., Taf. II–IV.

107. Borbein, "Ara Pacis Augustae," 249–50. For the Artemis altar, see A. Bammer, "Der Altar des jüngere Artemision in Ephesos. Vorläufiger Bericht," *AA*, 1968, 400–423, Abb. 21, 28, and 32.

108. Borbein, "Ara Pacis Augustae," 248, note 22.

109. Etienne and Braun, *Ténos I*, 116–17, pl. 37, 3, and pl. 85, 1,2, and 4.

110. Borbein, "Ara Pacis Augustae," 245–46, 249. For the "petrification" theory, see Petersen, *Ara Pacis Augustae*, 33–35; A. Pasqui, "Per lo studio dell'Ara Pacis Augustae 1. Le origine e il concetto architettonico del monumento," *Studi romani*, 1, 1913, 293ff., 296, fig. 6; Ducati, *L'Arte in Roma*, 117; Riemann, *RE*, XVIII, 1, 2086; Kraus, *Ranken*, 18; Settis, "Die Ara Pacis. Quellen, Entstehungzeit, und allgemeine Fragestellung," 407

and 410; and Holliday, "Time, Ritual, and History," 545. While J. M. C. Toynbee ("The Ara Pacis Reconsidered and Historical Art in Roman Italy," 72–73 and pl. XXXVIb; and *Art of the Romans*, New York and Washington, 1965, 53) also embraced this thesis, in the first of these works, 91–92, she was prepared to acknowledge the impact of the Altar of the Twelve Gods as well. In contrast, Torelli, *Typology*, 30 and 57, note 12, adheres to the petrification theory and dismisses arbitrarily Thompson's arguments for a connection with the Athenian altar.

111. For the textile interpretation, see Pasqui, "Per lo studio dell'Ara Pacis," 293ff.; Ducati, *L'arte in Roma*, 117; Toynbee, "Ara Pacis Reconsidered," 77; idem, *Art of the Romans*, 53; Byvanck-Quarles van Ufford, "Décoration à rinceaux," 42.

112. Moretti, *Ara Pacis Augustae*, 188, fig. 151, and 192; reconstruction by the artist O. Ferretti.

113. Etienne and Braun, *Ténos I*, 170–71, note 364.

114. Ibid. Although they cite no specific examples, these authors have in mind the u- or pi-shaped altar complexes like the one from the Artemision at Ephesos discussed above, or the Altar of Athena at Priene; A. von Gerkan, "Der Altar der Athenatempels in Priene," *Bonner Jahrbucher*, 129, 1924, 15–35, Taf. I–III; M. Schede, *Die Ruinen von Priene. Kurze Beschreibung*, Berlin and Leipzig, 1934, 36–38, Abb. 44.

115. Borbein, "Ara Pacis Augustae," 249.

116. Moretti, *Ara Pacis Augustae*, 194–95, fig. 157.

117. Petersen, *Ara Pacis Augustae*, 34, fig. 21; Bianchi Bandinelli, *Rome: the Center of Power*, 191, fig. 205; O. J. Brendel, *Etruscan Art*, Harmondsworth, 1978, 166–67, fig. 109. Even Borbein, "Ara Pacis Augustae," 250, would trace the two-zone arrangement of the Ara Pacis to Italic sensibilities expressed in wall painting, although to contemporary works in the Second Style.

118. The standard work on Pergamene religious practice is still E. Ohlemutz, *Die Kulte und Heilgtümer der Götter in Pergamon*, where Eirene is not treated as a distinct cultic entity. However, see Pollini, "The Acanthus of the Ara Pacis," 190–92, who has also suggested the possible connection of the Pergamene slabs with a cult of Eirene, although on different grounds than those argued here.

119. For the most succinct presentation of the Athenian inspiration behind Pergamene art and the ideology that informed this usage, see Pollitt, *Art in the Hellenistic Age*, 81–82, 93–95, and 105. Also see A. Stewart, *Attika. Studies in the Athenian Sculpture of the Hellenistic Age*, London, 1979, 3–25 and 38–39; H.-J. Schalles, *Untersuchungen zur Kulturpolitik der pergamenischer Herrscher im dritten Jahrhundert vor Christus*, Istanbuler Forschungen, 36, Tübingen, 1985, 136–43; and Hardie, *Virgil's Aeneid*, 130–31.

120. Bohtz, *Das Demeter-Heiligtum*, 51–55, Taf. 30–33. Also see Ohlemutz, *Götter in Pergamon*, 204.

121. Moretti, *Ara Pacis Augustae*, 180–81, and figs. 142–43.

122. For the end block, see O. Dörpfeld, "Die Arbeiten zu Pergamon 1910–1911. I. Die Bauwerke," *AM*, 37, 1912, 248; and Bohtz, *Demeter-Heiligtum*, 55, and Taf. 32,1–2. Since it was found nearby (how near is not specified), Dörpfeld, the excavator, placed it provisionally on the lowest course of the damaged foundations of Altar D where it appears in Bohtz's Taf. 32,1–2. This placement suggests that the piece was the short end of an altar. Yet although over a meter wide, it is only a bit more than half a meter high, rather low for a monumental altar. It corresponds more to the width of nearby altars B and C, and perhaps it was originally elevated on one of these two foundations or podia, especially since Dörpfeld, 248, found evidence of later remodeling on both.

123. The portion of the main altar inscribed with Philetairos's name, for example, was found nowhere near the altar itself, but immured in the late Roman wall built over the retaining terrace on the south side of the sanctuary; Dörpfeld, *AM*, 37, 1912, 245–46; A. Ippel, "Die Arbeiten zu Pergamon 1910–1911. II. Die Inschriften," *AM*, 37, 1912,

282–83. In view of such indiscriminate looting and disturbance of the sanctuary in later times for building materials, none of the remains can be presumed to have been found near their original location.

124. On the date of the colonnades, see Bohtz, *Demeter-Heiligtum*, 58; Ohlemutz, *Götter in Pergamon*, 207–212; and Schalles, *Kulturpolitik der pergamenischen Herrscher*, 146–47. Ohlemutz, 209, however, does not think that Apollonis remodeled the existing series of altars. The precise chronology of the altar slabs and the related Pergamene reliefs with polycarpophoric ornament is difficult to fix since no piece comes from a datable archaeological context. Traditionally these works have been attributed to the royal period at Pergamon; *AVP* VII, 2, 322, 328; Kraus, *Ranken*, 64–68. Börker, however, "Neuattisches und pergamenisches," esp. 292–317, attempted on purely stylistic grounds to downdate the Pergamene reliefs and mosaics related to the Ara Pacis to the end of the Hellenistic period (see notes 137 and 138 below). But this late chronology has not been accepted; Pollitt, *Art in the Hellenistic Age*, 222; Rohde, *Pergamon. Burgberg und Altar*, 45; Pappalardo, "Il fregio con eroti fra girali nella 'Sala dei Misteri' a Pompei," 276 and note 61; M. Pfrommer, "Grossgriechischer und mittelitalischer Einfluss in der Rankenornamentik frühhellenistischer Zeit," 174; idem, *Studien zu alexandrinischer und grossgriechischer Toreutik frühhellenisticher Zeit*, 112 and note 692, 137; Reinsberg, *Studien zur hellenistischen Toreutik. Die antiken Gipsabgüsse aus Memphis*, 61; and especially G. de Lucca in *AVP* XI, 3, 118–19; idem, *AVP* XI, 4, 134–35; idem, "Hellenistische Kunst in Pergamon im Spiegel der megarischen Becher," in *Akten des XIII. internationalen Kongresses für klassische Archäologie. Berlin. 1988*, Mainz, 1990, 595–97.

125. See Hepding, *AM*, 35, 1910, 506–508, abb. 2–3, and *AVP* VII, 2, 325–26, no. 408, where these reliefs are assigned a Hellenistic date. For the later attribution, Ohlemutz, *Götter in Pergamon*, 216–17, and Bohtz, *Demeter-Heiligtum*, 26, 59, and Taf. 15 and 57–61.

126. Ohlemutz, *Götter in Pergamon*, 83 and 219–21.

127. This is in fact the date originally proposed by Winter, *AVP* VII, 2, 322.

128. Polybios, XXX,1–2, recounts how the Romans attempted to persuade Eumenes' brother Attalos to disrupt the unity of the kingdom, promising to support his authority over a separate and independent domain.

129. This speech is preserved in Polybios, XXIII,11,1–8; cf. Livy, XL,8.

130. Moretti, *Ara Pacis Augustae*, 70, fig. 53, lower left and center right; 72, fig. 55, top center; 75, fig. 60, bottom right; 80, fig. 65, bottom center.

131. Moretti, *Ara Pacis Augustae*, 32, fig. 20, top right and bottom.

132. Moretti, *Ara Pacis Augustae*, 40, fig. 26, left edge, center.

133. Moretti, *Ara Pacis Augustae*, 19, fig. 9, bottom left; 41, fig. 28.

134. Moretti, Ara Pacis Augustae, 71 and 274.

135. Toynbee and Ward-Perkins, "Peopled Scrolls," 8, dismissed such animals as peripheral to the general subject of inhabited tendril ornament; cf. J. M. C. Toynbee, *Animals in Roman Art and Life*, Ithaca and New York, 1973, 216, where she suggests that the frogs and lizards of the Ara Pacis friezes were carved for the pleasure of the artists, or for some general apotropaic purpose. Similarly, E. Walter-Karydi, "Die Entstehung der Grotteskenornamentik in der Antike," *RM*, 97, 1990, 149, dismissed the iconographic potential of the tiny animals of the Ara Pacis friezes, in contrast to the Apolline function of the swans. Only Kellum, "What We See and What We Don't See," 28ff., has investigated the significance of the little animals, although purely in contemporary Augustan terms, without considering the evidence of artistic precedent.

136. For specific instances of rabbits, butterflies, and grasshoppers, see note 162 below. For an Archaic example with rabbits, see H. von Brunn and T. Lau, *Die griechischen Vasen, ihr Formen- und Dekorationssystem*, Leipzig, 1879, Taf. XI, 4; Riegl, *Problems of Style. Foundations for a History of Ornament*, 185, fig. 107, and 355–56, annotation l.

137. *AVP* V, 1, 58–61, 63–64, and 71–73, Texttafel XXVII–XXXVIII and Taf. XVI–XIX; Toynbee and Ward-Perkins, "Peopled Scrolls," 7 and pl. III,2; Rohde, *Pergamon*, 45–46, Abb. 30–32; Pappalardo, "Il fregio con eroti," 276, fig. 19.

138. Kraus, *Ranken*, 66; Börker, "Neuattisches und pergamenisches," 296–300.

139. These are identified as apples in *AVP* V, 1, 64, and Taf. 37; cf. Kraus, *Ranken*, 66.

140. *AVP* V, 1, 61–63, Texttafel XXVI and Taf. V and XII–XV; Rohde, *Pergamon*, 40–41, Abb. 25–26.

141. Toledo Museum of Art, 75.11; "Treasures for Toldeo," *Museum News* (Toldeo Museum of Art),19, 1976, 49, ill; Oliver, *Silver for the Gods. 800 Years of Greek and Roman Silver*, no. 43; Reinsberg, *Toreutik*, 41, note 147, and 45; Pfrommer, *Toreutik*, 111, 115, 265, KBk 128, and Taf. 58a.

142. Naples, Museo Nazionale, inv. 25284–25285; P. Wuilleumier, *Le trésor de Tarente*, Paris, 1930, 70, fig. 4, pl. X,3; idem, *Tarente des origines à la conquête romaine*, Paris, 1939, 362 and pl. XXIV,5; T. Kraus, *Megarische Becher im Römisch-germanischen Zentralmuseum zu Mainz*, Manz, 1951, 19–20; L. Byvanck-Quarles van Ufford, "Les bols megariens. La chronologie et les rapports avec l'argenterie hellénistique," *BABesch*, 28, 1953, 19; idem, "Bols 'déliens' et bols de Popilius," *BABesch*, 49, 1974, 264 and fig. 4; D. E. Strong, *Greek and Roman Gold and Silver Plate*, 109, pl. 31a; Coarelli, "Arti figurative," 529–30, tav. 66a–b; Reinsberg, *Toreutik*, 45; Boriello, Lista, et al., *Le collezioni del Museo Nazionale di Napoli*, 93, ill., and 214, no. 65; Pfrommer, *Toreutik*, 111–14, 115–16, 119–20, and 172, FK 13 Taf. 56b and 57a–b.

143. Pfrommer, *Toreutik*, 42–124. This argument was already advanced by K. Parlasca, "Die Verhältnis der megarischen Becher zum alexandrinischen Kunsthandwerk," *JDAI*, 70, 1955, 129–54, esp. 137ff.; cf. Reinsberg, *Toreutik*, 36–42 and 55; S. I. Rotroff, *Hellenistic Pottery: Athenian and Imported Mold-Made Bowls*, The Athenian Agora, vol. 22, 1982, 7.

144. Byvanck-Quarles van Ufford, "Les bols mégariens," 15–19, figs. 14–15 and 17; D. B. Harden, "The Canosa Group of Hellenistic Glasses in the British Museum," *Journal of Glass Studies*, 10, 1968, 23–25, and 38–41, figs. 1–8, 34, and 37–39; A. Adriani, "Un vetro dorato alessandrino del Caucaso," *Bulletin de la Société Archéologique d'Alessandrie*, 42, 1967, 105–27, esp. 124; Reinsberg, *Toreutik*, 41 and 45; K. Parlasca, "Neues zur ptolemäischen Fayencekeramik," in N. Bonacasa and A. di Vita, eds., *Alessandria e il mondo ellenistico-romano. Studi in honore di Achille Adriani*, Studi e materiali, Istituto di Archeologia, Università di Palermo, vols. 5–6, Rome, 1984, 300–302, Taf. LIV,4–7; and Rotroff, *Hellenistic Pottery*, 8.

145. In addition to the works by Kraus, Byvanck-Quarles van Ufford, and Rotroff cited above in notes 142 and 143, see F. Courby, *Les vases grecs à reliefs*, Paris, 1922, 367–495, pls. XI–XV; J. Schäffer, *Hellenistische Keramik aus Pergamon*, Pergamenische Forschungen, Bd. 2, Berlin, 1968, 17–19, Abb. 12,2 and 14; G. Siebert, *Recherches sur les ateliers de bols à reliefs du Péloponnèse à l'époque hellénistique*, Bibliothèque de L'Écoles Françaises d'Athènes et de Rome, vol. 233, Paris, 1978; and A. Laumonier, *La céramique hellénistique à reliefs. 1. Ateliers «ioniens»*, Exploration Archéologique de Délos, Fasc. 31, Paris, 1977.

146. Pfrommer, *Toreutik*, 112 and 172; idem, *Metalwork from the Hellenistic East. Catalogue of the Collections*, Malibu, Cal., 1993, 31 and fig. 27. For a Pergamene attribution see Strong, *Greek and Roman Gold and Silver Plate*, 109–10; Coarelli, "Arti figurative," 529–30; Reinsberg, *Toreutik*, 45; Boriello, *Le collezioni*, 94.

147. Laumonier, *La céramique hellénistique*, 3 and 7.

148. Laumonier, *La céramique hellénistique*, 32–33, nos. 1238, 1327–1328, 1356, 1665, 2318, and pls. 3, 115. Also see the related bowls from the workshop of the potter Athenaios, ibid., 232–233, nos. 1209, 1406, 1992, pls. 52 and 127, and an unsigned fragment, 427, no. 1325, pl. 99. On the chronology and quality of Menemachos work,

Laumonier, 7, 11–12 and 21; idem, "Bols hellénistique à reliefs: un bâtard gréco-italien," *BCH*, Suppl. 1, 1973, 255.

149. See, for example, the silver bowls from Thrace and Nihawand in Iran, the Fayyum, Bulgaria, and the Artiukhov Barrow; Oliver, *Silver for the Gods*, nos. 35 and 40; R. Zahn, "Ein hellenistische Silberbecher im Antiquarium der Staatlichen Museen zu Berlin," *JDAI*, 82, 1967, 12–13, Abb. 5–6; D. Ahrens, "Berichte der Staatlichen Kunstsammlung," *Münchener Jahrbuch der bildenden Kunst*, 19, 1968, 232–33, nos. 3–4, Abb. 5–6; Kraus, *Megarische Becher*, 18–20, Taf. 4–6; Byvanck-Quarles van Ufford, "Les bols megariens," 19 and fig. 20; H. Küthmann, "Beiträge zur hellenistisch-römisch Toreutik," *JRGZM*, 5, 1958, 104–107, Taf. 6,1–2; Reinsberg, *Toreutik*, 41, 44, 162; and Strong, *Greek and Roman Gold and Silver Plate*, 114 and pl. 31B.

150. Reinsberg, *Toreutik*, is devoted primarily to this extensive set of casts, which were used to make copies of earlier metalwork. They include works of many styles and periods, drawn from various regions outside of Egypt; Reinsberg, 275.

151. T. Kraus, "Überlegungen zum Bauornament," in Zanker, ed., *Hellenismus in Mittelitalien*, 463–64, Abb. 7–8; idem, *Ranken*, 34–43, Taf. 6–7; Börker, "Neuattisches und pergamenisches," 308–309, Abb. 15; cf. W. von Sydow, "Ein Rundornament in Petrabbondante," *RM*, 84, 1977, Taf. 129,3, 131,2, and 284–87, 132,2; T. Hölscher, "Historische Reliefs," in *Kaiser Augustus und die verlorene Republik*, Mainz, 1988, 363–64, no. 199. The lack of impact of such polycarpophoric tendril ornament in Late Republican Italy is surprising considering the impact of Pergamene sculpture in Roman triumphal monuments of this period; see H. Meyer, "Rom, Pergamon und Antiochos III. Zu den Siegesreliefs von Sant'Omobono," *Bullettino comunale*, 94,1, 1991–92, 17–32.

152. For Neo-Attic vessels and marble furniture with grapes and/or poppy amidst the tendrils, see *AVP*, VII, 1, 323–25, no. 407; H. U. von Schoenbeck, "Ein hellenistisches Schallenornament," in *Mnemosynon Theodor Wiegand*, Munich, 1938, Taf. 19–21 and 23; Kraus, *Ranken*, Taf. 16–18; Byvanck-Quarles van Ufford, "Décoration à rinceaux," 55, fig. 18; Börker, "Neuattisches und pergamenisches," 289, Abb. 2–4; J. R. Mertens, *The Metropolitan Museum of Art. Greece and Rome*, New York, 1987, 111, fig. 81. One might discern a Pergamene impact in a fragmentary terracotta relief from Luni, where the delicately naturalistic grapevine branching off from the remnant of a larger tendril volute recalls the relief from the Ruler Temenos at Pergamon, or even the portions of Ara Pacis itself. Yet this piece could well be later than the second-century B.C. date attributed to it by Andrén, and in any case it too only documents the inclusion of grapevine. See Andrèn, *Architectural Terracottas*, 294 and 296, no. 17, pl. 97, no. 353; for the relief from the Ruler Temenos, *AVP*, V, 1, 72, Abb. 74; Kraus, Taf. 21; Börker, 301, Abb. 10.

153. Naples, Museo Nazionale, inv. 9997; Pernice, *Die hellenistische Kunst in Pompeji. VI, Pavimente und figürliche Mosaiken*, Berlin, 1938, 150–51, and Taf. 53; Boriello, *Le collezioni*, 116, no. 8. Like Pappalardo, "Il fregio con eroti," 278–79, Pernice mistook the grasshopper chased by the eros in the right border for a butterfly, but the large pair of inverted v's define the legs of a grasshopper rather than the wings of a butterfly; cf. the Hephaisteion mosaic, *AVP*, V, 1, Texttafel XXXVI. But Pappalardo is still correct in emphasizing the analogy of the eros and butterfly motif to the Hephaisteion mosaic since it does appear in the left border of the Fish Mosaic (fig. 65a). According to Pernice, 151, this work dates to the transition from the First to the Second Style, c. 100–90 B.C.

154. Naples, Museo Nazionale, 885; Pernice, *Pavimente*, 164, Taf. 64; K. Parlasca, "Das pergamenische Taubenmosaik und der sogennanten Nestor-Becher," *JDAI*, 78, 1963, 256–93; H. Meyer, "Zu neueren Deutungen von Asarotos Oikos und kapitolinischen Taubenmosaik," *AA*, 1977, 104–110; Boriello, *Le collezioni*, 118, no. 17.

155. Pernice, *Pavimente*, 35 and 94 and Taf. 8,2 (printed upside down); Byvanck-Quarles van Ufford, "Décoration à rinceaux," 49, fig. 11; A. Laidlaw, *The First Style in Pompeii. Painting and Architecture*, Archaeologia, 55, Rome, 1985, 202–203, fig. 49, and pl. 49c; A. Barbet, *La peinture murale romaine. Les styles décoratifs pompéiens*, Paris, 1985, 27, fig. 14. For the date, late second century B.C., see Byvanck-Quarles van Ufford, 49, and Laidlaw, 174.

156. Another, possibly similar First Style painted frieze appears in Oecus 22 in the House of Sallust; Pernice, *Pavimente*, 35, Taf. 8,1; Laidlaw, *The First Style in Pompeii*, 34–35 and pl. 49a–b. Pernice described it as a grapevine, although clusters of ivy are also discernible, and he thought that it might also once have contained tiny animals—birds and insects—as well.

157. Pappalardo, "Il fregio con eroti," esp. 254–60, figs. 1–10 and 12–17. Also see Pernice, *Pavimente*, 150, Taf. 43,2; Kraus, *Ranken*, 33 and Taf. 4.

158. Deubner, "Pergamon und Rom," 99–100, Abb. 7–10; Börker, "Neuattisches und pergamenisches," 305; Pappalardo, "Il fregio con eroti," 275–79; cf. Kraus, *Ranken*, 32.

159. Pernice, *Pavimente*, 164; Parlasca, "Pergamenische Taubenmosaik" (as in note 154 above), 256–93; Pollitt, *Art in the Hellenistic Age*, 221–22.

160. Pappalardo, "Il fregio con eroti," 280.

161. Kraus, *Ranken*, 32.

162. Although the exhuberant tendril ornament of Italiote Greek relief and vase painting often includes entire human figures or divinities, animals are much rarer. The Ganymede Painter seems to have had an exceptional penchant for including small birds and butterflies; cf. the neck ornament on the volute kraters in Melbourne, D 88/1969, Basel S 25, and another in a Swiss private collection; *RVA*, 795–96, no. 25, 1 and 3; M. Schmidt, D. Trendall, and A. Cambitoglou, *Eine Gruppe apulischer Grabvasen in Basel*, Basel, 1976, 10 ff., Taf. 3–5; and Trendall, *Red Figure Vases of South Italy and Sicily*, figs. 238 and 240. Also see Salzmann, *Untersuchungen zu den antiken Kieselmosaiken von den Anfängen bis zum Beginn der Tesseratechnik*, 16 and note 148 for additional bibliography and an excellent detail of the Basel vase, Taf. 96,4. Another exceptional scene appears on the shoulder of an Apulian lekythos attributed to the Underworld Painter where hares chase birds beneath an elaborate tendril pattern; Mayo, *Vases from Magna Graecia*, 133–36, no. 51. And despite the wealth of complex blossom types in Italiote Greek floral ornament analyzed by Pfrommer, "Rankenornamentik," 119–29, naturalistic plants like those in the Oecus 44 frieze are unknown in material of this kind. For an isolated Attic example of a tendril composition including a butterfly along with a female divinity, see the relief in the Acropolis Museum; Zagdoun, *La Sculpture archaïsante*, 134, pl. 43, fig. 158 (no. 11).

163. V. Spinazzola, *Le arti decorative in Pompei e nel Museo Nazionale di Napoli*, Milan, Rome, Venice, and Florence, 1928, tav. 21–22; O. Brendel, "Archäologische Funde in Italien," *AA*, 1934, 473–74, Abb. 19; Toynbee and Ward-Perkins, "Peopled Scrolls," 8; Zanker, *Power of Images*, 320 and fig. 252a–b.

164. Metropolitan Museum of Art, Rogers Fund 1910 (10.210.28); Mertens, *Greece and Rome*, frontispiece and 126–27, no. 96. This work is probably somewhat later than the Eumachia doorway, perhaps Julio-Claudian.

165. Von Hesberg, "Girlandenschmuck," 243–44.

166. On the influx of Hellenistic luxuries resulting from the conquest of Asia and the Attalid bequest, see Pliny, *Natural History*, XXXIII,52,148–49. On the diffusion of Hellenistic metalwork like the Civita Castellana bowls in this way, see Deubner, "Pergamon und Rom," 101; Strong, *Greek and Roman Gold and Silver Plate*, 109–110; Coarelli, "Le arti figurative," 530. For a more general treatment of Greek booty in Late Republican Rome,

see M. Pape, *Griechische Kunstwerke aus Kriegesbeute und ihre öffentliche Aufstellung in Rom von der Eroberung von Syrakus bis in augusteische Zeit*, Diss., Hamburg University, 1975, esp. 6–52.

167. See especially, Stewart, *Attika*, 57–59 and 65–98; Pollitt, "The Impact of Greek Art on Rome," esp. 156–64; idem, *Art in the Hellenistic Age*, 148, 150–63.

168. J. Onians, *Art and Thought in the Hellenistic Age: The Greek World View, 350–50 B.C.*, London, 1979, 129–33, fig. 133, 136, and 138–39. For a more empirical or scientific explanation, see B. Hughes Fowler, *The Hellenistic Aesthetic*, Madison, Wisc., 1989, 110–36, esp. 133 ff.

169. *AVP*, V, 1, 31–32, fig. 39, Texttafel XVIII and XXVI.

170. On the cult itself and its close ties to the Attalid dynasty, see H. von Prott, "Dionysos Kathegemon," *AM*, 27, 1902, 161–88; Ohlemutz, *Götter in Pergamon*, 90–96; J. Tondriau, "Dionysos, dieu royale," in *Mélanges offerts à H. Gregoire*, Brussels, 1953, 451; Hansen, *Attalids of Pergamon*, 401, 409–410, 417–20, and 425; Jeanmaire, *Dionysos. Histoire du culte de Bacchus*, 426–27 and 446–47; R. E. Allen, *The Attalid Kingdom. A Constitutional History*, Oxford, 1983, 104, 130–31, 148, 174, and 190, note 27; On the connection of this cult with the "Altargemach," Ohlemutz, 94–96; Simon, "Zum Fries der Mysterienvilla bei Pompeji," 111–72, esp. 166.

171. Metropolitan Museum of Art, inv. 06.1217.1, Rogers Fund, said to come from Madytos on the Asiatic side of the Hellespont; Toynbee and Ward-Perkins, "Peopled Scrolls," 4, and Pl. I,1; G. M. A Richter, *The Metropolitan Museum of Art. Handbook of the Greek Collection*, Cambridge, Mass., 1953, 156 and pl. 129d; G. Becatti, *Oreficerie antiche dalle minoiche alle barbariche*, Rome, 1955, tav. LXXXVI (cited there as unprovenanced); H. Hoffmann and P. Davidson, *Greek Gold. Jewelry from the Age of Alexander*, Boston, 1965, 67–68 and fig. 7b; B. Segall, *Griechische Goldschmiedekunst des 4. Jh. v. Chr.*, Wiesbaden, 1966, pl. 40; R. Higgins, *Greek and Roman Jewellery*, 2nd. ed., Berkeley and Los Angeles, 1980, 158 and pl.45c; Gasparri, "Dionysos," *LIMC*, III, 485, no. 746. Another unprovenanced gold diadem in a German private collection also contains grasshoppers and birds, although without the divine or mythological figures; Hoffmann and Davidson, 67–68, fig. 7a. The Metropolitan diadem is nearly identical to yet another from Abydos, thus confirming the provenance on the northwest Asiatic coast; Riegl, *Problems of Style*, 211, fig. 123; Segall, 22, Abb.1. Although Segall cited it as lost, this work has now been traced to the Victoria and Albert Museum; see A. Greifenhagen, "Römischer Silberbecher," *JDAI*, 82, 1967, 35–36, figs. 11–12. Oddly enough, though, the Abydos diadem has no grasshoppers.

172. *AVP*, VII, 2, 323–25, no. 407, Beiblatt 43; von Schoenbeck, in *Mnemosynon Theodor Wiegand*, 54 ff., Taf. 23; Börker, "Neuattisches und pergamenisches," 284–88, Abb. 2.

173. For drinking bowls or dishes with tendril borders of this type, see L. Byvanck-Quarles van Ufford, "Un bol d'argent hellénistique en Suède," *BABesch*, 42, 1973, 119–23, fig. 1a–c; Oliver, *Silver for the Gods*, 76–77, nos. 41–42, 79–81, nos. 43–44, and 90, no. 53. The last example also has a scene with a satyr grabbing a nymph, further underscoring the Dionysian content.

174. Pappalardo, "Il fregio con eroti," 257, 272–75. Even in Greek tradition more generally, Aphrodite and Dionysos were related as the parents of Priapos, as Pappalardo emphasizes. On Venus and Dionysos or Liber in Campania, see R. Schilling, *La religion romaine de Vénus depuis les origines jusqu'au temps d'Auguste*, Bibliothèque des Écoles Françaises d'Athènes et de Rome, fasc. 178, Paris, 1954, 19 and 286–87.

175. See note 162 just above.

176. G. M. A. Richter, "Two Silver Cups in Mr. J. P. Morgan's Collection," *Art in America*, 6, 1918, 171–76; A. Maiuri, *La Casa del Menandro e il suo tesoro di argenteria*,

Rome, 1933, 347–48, tav. XLV; L. Byvanck-Quarles van Ufford, "Le vases d'argent à échassiers conservés à Istanbul," in *Manselé Armagan. Mélanges Mansel*, Ankara, 1974, 337–40, pls. 117–18; Oliver, *Silver for the Gods*, 144–45, no. 96–97; F. Baratte, *Le trésor d'orfevrerie romaine de Boscoreale*, Paris, 1986, 49–52. For ceramic counterparts with insects, lizards and cranes, see A. Oxé, *Arretinische Reliefgefässe vom Rhein. Materialen zur römisch-germanisch Keramik*, Kommission des Deutschen Archäologischen Instituts, Heft 5, Frankfurt-am-Main, 1933, 43, no. 1598, Taf. LVI, 2a–b; 62–63, nos. 72a–b, Taf. XVI.

177. A. Giuliano, "Un rilievo da Faleri," *Prospettiva*, 5, 1976, 54–56; I. di Stephano Manzella, "Falerii Novi degli scavi degli anni 1821–1830 con un catalago degli ogetti, un appendice di documenti inediti e una pinata topografica," *Atti della Pontificia Accademia Romana di Archeologia*, ser. 3, XII,2, 1979, 96–98, no. 32; Zanker, *Power of Images*, 177–80, fig. 139a–b.

178. A. Levi, *La patera d'argento di Parabiago*, Istituto d'Archeologia e Storia dell'Arte, Opere d'Arte, 5, Rome, 1935; A. Alföldi, "Die Spätantike," *Atlantis*, 21, 1949, 69–72; M. J. Vermaseren, *The Legends of Attis in Greek and Roman Art*, Leiden, 1966, 27–29, pl. XVII; K. Shelton in K. Weitzmann, ed., *The Age of Spirituality. Late Antique and Early Christian Art, Third to Seventh Century*, New York, 1979, 185–86, no. 164.

179. Homeric Hymn, XXX,1–7:

> Γαῖαν παμμήτειραν ἀείσομαι, ἠυθέμεθλον,
> πρεσβίστην, ἣ φέρβει ἐπὶ χθονὶ πάνθ' ὁπόσ' ἐστίν,
> ἠμὲν ὅσα χθόνα δῖαν ἐπέρχεται ἠδ' ὅσα πόντον
> ἠδ' ὅσα πωτῶνται, τάδε φέρβεται ἐκ σέθεν ὄλβου.
> ἐκ σέο δ' εὔπαιδές τε καὶ εὔκαρποι τελέθουσι,
> πότναι, σεῦ δ' ἔχεται δοῦναι βίον ἠδ' ἀφελέσθαι
> θνητοῖς ἀνθρώποισιν·

180. For the Carthage relief as a more faithful replica of a Hellenistic prototype, see T. Schreiber, "Hellenistischen Reliefbilder und die augusteische Kunst," *JDAI*, 11, 1896, 89–96; G. Méautis, *Bronzes antiques du canton de Neuchâtel*, Neuchâtel, 1928, 17–28; Adriani, *Divigazioni*, 31–32, and more recently M.-Th. Picard-Schmitter, " 'L'Allegorie de l'Égypte' sur un relief provenant de Carthage," *RA*, 1971, 29–56; Torelli, *Roman Historical Reliefs*, 39–42; and Stucchi, "La chora Alexandreon in un rilievo del Museo del Louvre," 261–84, esp. 262–68, with a detailed summary of earlier opinion. The portion of the "Tellus" panel corresponding to the snake and frog on the Carthage relief is fully intact. Only the area below the pitcher is restored; see La Rocca, *Ara Pacis Augustae*, illustration, p. 120. Thus the lack of such creatures appears a deliberate choice.

181. See the works by Torelli and Stucchi cited in the preceding note.

182. For a different view asserting an almost exclusive reliance on Attic, classicizing sources for the tendril friezes, see Sauron, "Les modèles funéraires," 202–209; idem, "Le message esthétique des rinceaux de *L'Ara Pacis Augustae*," 3–40.

183. Pernice, *Pavimente*, 167–68, Taf. 68; Boriello, *Le collezioni*, 116–17, nos. 9–11; Pollitt, *Art in the Hellenistic Age*, 147–48, 205–208, and 225–26, figs. 221 and 240; Strong, *Roman Art*, 72–73 and fig. 29, and 341, note 72 with earlier bibliography.

184. On the access of the Roman public to Greek originals, see Pape, *Kriegesbeute* (as in note 166 above), esp. 41ff.

Chapter II

1. For images of Dionysos holding his grapevine: J. Boardman, *Athenian Red Figure Vases. The Archaic Period*, New York and Toronto, 1975, figs. 6 and 132; Gasparri, "Dionysos," *LIMC*, III, 482, nos. 709 and 710.

2. For gods and fantastic animals amidst the tendrils, see P. Arias, *L'Arte della Grecia*, Turin, 1967, fig. 126; P. Blome, *Die figürliche Bildwelt Kretas in der geometrischen und frfilharchaischen Periode*, Mainz, 1982, Taf. 16, 1; A. Lempesa, "To elephantino eidolio tou neou apo ta Samo," *Annuario della Scuola di Archeologia di Atene*, n.s. 45, 1983, 320, fig. 21; and A. Lane, *Greek Pottery*, London, 1963, 37, pl. 33a. For deities grasping tendrils, D. Levi, "Arkhades. Una città cretese all'alba della civiltà ellenica," *Annuario della Scuola di Archeologia di Atene*, 10–12, 1927–29, 330, fig. 437; P. Demargne, *The Birth of Greek Art*, New York, 1964, fig. 444, and Blome, Taf. 19, 1.

3. For ancient Near Eastern works where the god merges with or sprouts stylized tendrils, branches, or trees, see H. Frankfort, *Cylinder Seals. A Documentary Essay on the Art and Religion of the Ancient Near East*, London, 1939, 127 and pl. XLIV h; E. Porada and B. Buchanan, *Corpus of Ancient Near Eastern Seals in North American Collections. The Collection of the Pierpont Morgan Library*, Washington, D.C., 1948, no. 956E, pl. CXLV; W. Orthmann, *Der Alte Orient*, Propyläen Kunstgeschichte, vol. 14, Berlin, 1975, 236–37, figs. 136f and 136h, and fig. 137e. For gods or supernatural beings brandishing tendrils, Orthmann, 224 and fig. 126 a; M. E. L. Mallowan, *Nimrud and its Remains*, New York, 1966, figs. 392–93. For gods or supernatural beings amidst stylized vegetation, B. B. Piotrovskii, *Urartu. The Kingdom of Van and Its Art*, tr. P. S. Gelling, London, 1967, 64–65, fig. 44, and pl. 27a.

4. Pfrommer, "Rankenornamentik," esp. 129ff.

5. See note 26 in Chapter I.

6. The first thorough study of this imagery was B. Schauenburg, "Zur Symbolik der unteritalischer Rankenmotive," *RM*, 64, 1957, 198–221. Also see R. Lullies, "Abermals: zur Bedeutung des Kranzes von Armento," *JDAI*, 97, 1982, 91–117.

7. Schauenburg, "Unteritalische Rankenmotive," Taf. 36,2, 40,1, 42,1–2, and 45, 1 and 3; E. Bielefeld, "Eros in der Blume," *AA*, 1950, 62–64, fig. 5; Jucker, *Das Bildnis im Blätterkelch*, 197–98, 201, Abb. 121, 123, 125, and 128. For an example in monumental tomb relief sculpture of the late fourth or early third century B.C., see G. L'Arab, "L'Ipogeo Palmieri di Lecce," *MEFRA*, 103,2, 1991, 457–97, figs. 3 and 15.

8. *RVA* 193, no. 5; Jucker, *Bildnis im Blätterkelch*, 200, fig. 127; T. B. L. Webster, *The Art of Greece: The Age of Hellenism*, New York, 1966, 25 and ill. p. 22; F. Canciani, "Aurai," in *LIMC*, III, Munich, 1986, 52, no. 2; Trendall, *Red Figure Vases of South Italy and Sicily*, 93. For a discussion of Aura, see below, pp. 59 and 66–70.

9. Schauenburg, "Unteritalische Rankenmotive," Taf. 39, 2.

10. *RVA*, 732, no. 23/39, and 754, no. 23/231; Trendall, *Red Figure Vases of South Italy and Sicily*, 94–95, 98, 204, figs. 231, 236, 251, 384–85; Pfrommer, "Rankenornamentik," 127, Abb. 27; Delivorrias, "Aphrodite," *LIMC*, II, 114, no. 1168, and 118, no. 1215.

11. Delivorrias, "Aphrodite," *LIMC*, II, 108, 110, nos. 1097, 1107, 1109.

12. J. Kohte and C. Watzinger, *Magnesia am Maeander*, Berlin, 1904, 75, Abb. 65; Toynbee and Ward-Perkins, "Peopled Scrolls," 6, and pl. II; Walter-Karydi, "Die Entstehung der Grotteskenornamentik in der Antike," 139, and Taf. 35,2; Zagdoun, *La sculpture archaïsante dans l'art hellénistique et dans l'art romain du haut-empire*, 133. For the related figure in the acroterion, Kohte and Watzinger, 67, Abb. 57. For Neo-Attic marble thrones with Dionysos or Sabazios emitting acanthus tendrils in this way, see note 94 below.

13. For the metalwork parallels, see the unprovenanced gold diadem in the British Museum, F. H. Marshall, *Catalogue of the Jewellery, Greek, Etruscan, and Roman in the British Museum*, London, 1901, no. 1610, pl. VII; Toynbee and Ward-Perkins, "Peopled Scrolls," 5, note 6, and pl. II,1: exterior handle decorations on the gilt silver dish from the Scythian tomb at Chertomlyk; Bielefeld, "Eros in der Blume," *AA*, 63, Abb. 4; Byvanck-Quarles van Ufford, "Décoration à rinceaux," 52, fig. 14; M. I. Artamonov, *The Splendor of Scythian Art. Treasures from Scythian Tombs*, New York and Washington, 1969,

pl. 178: and the horse frontelet from the Tsymbalka Barrow; Artamonov, pl. 186; B. Piotrovsky, L. Galanina, and N. Grach, *Scythian Art*, Oxford and Leningrad, 1987, pl. 144; and Zagdoun, *La sculpture archaïsante*, 131–33, pl. 43, fig. 156 (no. 226). For the pebble mosaic from Vergina, Walter-Karydi, "Grotteskenornamentik," Taf. 35,1; Salzmann, *Untersuchungen zu den antiken Kieselmosaiken von den Anfängen bis zum Beginn der Tesseratechnik*, 114, Taf. 39,1–2. The imagery of this kind on the helmet mold from Mit Rahine near Memphis is later still; Toynbee and Ward-Perkins, 4–5; Byvanck-Quarles van Ufford, "Décoration à rinceaux,"43–44, fig. 4. On the Italiote Greek connections of the Mit Rahine helmet molds, and the later chronology for the Scythian material, see Pfrommer, "Rankenornamentik," 156ff., and 184. For this tendril-spewing format on Italiote Greek vases, see E. Gerhard, *Apulischer Vasenbilder des Königlichen Museums zu Berlin*, Berlin, 1845, pl. A 1; W. Zahn, *Ornamente aller klassischen Kunstepochen*, Berlin, 1870, Taf. 19; and Trendall, *Red Figure Vases of South Italy and Sicily*, 99, fig. 255.

14. K. Michel and A. Struck, "Die mittelbyzantinischen Kirchen Athens," *AM*, 31, 1906, 301, Beilage, Abb. 9–10; E. Simon, *Die Geburt der Aphrodite*, Berlin, 1959, 34, Abb. 20; C. Börker, "Zwei vergessene Giebel in Athen," *AA*, 1976, 276–77, Abb. 13–14; Delivorrias, "Aphrodite," *LIMC*, II, 98, no. 936.

15. London D 2, *ARV*² 862,22, from Kameiros; Delivorrias, "Aphrodite," *LIMC*, II, 97, no. 916. For the theme of Aphrodite riding on the goose or swan, see A. Kalkmann, "Aphrodite auf dem Schwann," *JDAI*, 1, 1886, 231–60; E. G. Suhr, "The Spinning Aphrodite in the Minor Arts," *AJA*, 67, 1963, 63–68, figs. 2–4; Galinsky, "Venus in a Relief of the Ara Pacis Augustae," 230–31 and pl. 52; idem, *Aeneas, Sicily, and Rome*, 205–210, figs. 142–44, 149, 150, 153; Simon, *Götter der Griechen*, 245–47, Abb. 233–35; idem, *Geburt der Aphrodite*, 34–35, Abb. 21; Delivorrias, 96–100, nos. 903–974.

16. Aischylos, Frag. 25 (44), preserved in Athenaeus, *Deipnosophists*, XIII,73,600b:

> ἐρᾷ μὲν ἁγνὸς οὐρανὸς τρῶσαι χθόνα,
> ἔρως δὲ γαῖαν λαμβάνει γάμου τυχεῖν,
> ὄμβρος δ' ἀπ' εὐνασθέντος οὐρανοῦ πεσὼν
> ἔκυσε γαῖαν· ἡ δὲ τίκτεται βροτοῖς
> μήλων τε βοσκὰς καὶ βίον Δημήτριον·
> δενδρῶτις ὥρα δ' ἐκ νοτίζοντος γάμου
> τέλειός ἐστι. τῶνδ' ἐγὼ παραίτιος.

Simon, *Götter der Griechen*, 246, first drew attention to this verse in connection with works like the Pistoxenos Painter's dish cited in the preceding note.

17. See especially works by the Syriskos Painter; Boardman, *Red Figure Vases*, fig. 204; D. C. Kurtz, *Athenian White Lekythoi. Patterns and Painters*, Oxford, 1975, 31 and 127–28, and pl. 8, 1b; Riegl, *Problems of Style*, 185–86, fig. 108; A. Hermony, H. Cassimatis, and R. Vollkommer, "Eros," in *LIMC*, III, Munich, 1986, 864–65, nos. 91–112, and 881, no. 364.

18. Andrén, *Architectural Terracottas*, 60–62, V:1, pl. 21, no. 68; Toynbee and Ward-Perkins, "Peopled Scrolls," 6, pl. I,2; Kraus, *Ranken* 26–31, Taf. 3; idem, in Zanker, *Hellenismus in Mittelitalien*, 461–62, Abb. 6; Byvanck-Quarles van Ufford, "Décorations à rinceaux," 48 and 50, fig. 9; Jucker, *Bildnis im Blätterkelch*, 164 ff., 174, 192, Abb. 53. Also see the late Etruscan cinerary urns with this imagery; Jucker, 198, Abb. 132–33. The latest example of this kind belongs to the beginning of the series of "Campana plaques" in the first century B.C.; Borbein, *Campanareliefs. Typologische und stilkritische Untersuchungen*, 13, and Taf. I,1–2.

19. Kraus, *Ranken*, 39–40, Taf. 9; M. Montagna Pasquinucci, *La decorazione architettonica del tempio del Divo Giulio nel Foro Romano*, Accademia Nazionale dei Lincei, Monumenti antichi, serie miscellanea, I,4, Rome, 1973, ill. p. 257, 265–72, tav. VIb–IXa;

T. Hölscher, "Historische Reliefs," in *Kaiser Augustus und die verlorene Republik*, 373–74, no. 206; Zagdoun, *La sculpture archaïsante*, 134–37, pl. 43, fig. 159 (no. 378); and Walter-Karydi, "Grotteskenornamentik," 148–49, Taf. 40,1. On a late Hellenistic Attic relief in the Acropolis Museum, a draped female figure similarly grasps the surrounding tendrils, although her body remains structurally distinct from the vegetation; Zagdoun, 134, pl. 43, fig. 158 (no. 11). For related imagery on Neo-Attic marble thrones where Dionysos or Sabzios spews forth tendrils, see note 94 below.

20. Von Rohden and Winnefeld, *Die antiken Terrakotten. IV,1. Architektonischen römische Tonreliefs der Kaiserzeit*, 189–92, 270, Taf. LXI; Zagdoun, *La sculpture archaïsante*, 135.

21. See especially the Apulian relief with Eros from Ceglie; Petersen, *Ara Pacis Augustae*, 163–64, Abb. 54; L. D. Caskey, *Museum of Fine Arts, Boston. Catalogue of Greek and Roman Sculpture*, Cambridge, Mass., 1925, 105, no. 49; A. W. Lawrence, *Later Greek Sculpture*, London, 1927, 54, pl. 90b; von Schoenbeck, "Hellenistisches Schallenornament," 56, pl. XXI,2; Toynbee and Ward-Perkins, "Peopled Scrolls," 6, pl. III,1. For Attic and Italiote Greek vase paintings with Eros in a tendril setting, see Hermony, Cassimatis, and Vollkommer, "Eros," in *LIMC*, III, 866–67, nos. 132–35 and 136–44.

22. For the plaque with Artemis or Diana, von Rohden and Winnefeld, *Römische Tonreliefs*, 203–204, 270, Taf. LXII; Zagdoun, *La sculpture archaïsante*, 136; for the one with the victories, von Rohden and Winnefeld, 206, Abb. 419; Hölscher, in *Kaiser Augustus und die verlorene Republik*, 374, Abb. 168.

23. H. G. Beyen, *Die pompejanische Wanddekoration vom zweiten bis zum vierten Stil*, The Hague, 1938, 15–16 and Abb. 230–32, 240–41, 248; Ling, *Roman Painting*, 37 and 41, figs. 36 and 40; Bragantini, et al., *Le decorazioni della villa romana della Farnesina, Museo Nazionale Romano. Le pitture*, 129–33, tav. 37–38, 45, and 50; Walter-Karydi, "Grotteskenornamentik," 138–46, Taf. 1, 34,2, 36,1, and 39; Zagdoun, *La sculpture archaïsante*, 137–38, pl. 44, fig. 160–61 (no. 422). Similar standing and seated female figures as well as erotes who merge with the tendrils appear in the vault stuccoes of the Farnesina Villa; Bragantini, et al., tav. 116, 121, 249, 251b, 253b, 255b; Walter-Karydi, Taf. 38. Also see M. De Vos, *L'Egittomania in pitture e mosaici romano-campani della prima età imperiale*, Études préliminaires aux religions orientales dans l'Empire romain, 84, 1990, 60ff.

24. See S. De Angeli, "Demeter/Ceres," in *LIMC*, IV, Munich, 1988, 894, no. 8.

25. The divergent approach of the Ara Pacis friezes is particularly clear with regard to theonomous tendril compositions in which the figures of the deities merge with the stylized vegetation—the so-called "grotesques"—whose currency falls off in official monuments sometime after 20 B.C., only to regain popularity in Neronian and later times. Recent scholarship has tended to explain this in terms of the incompatibility of the fanciful mixture of animal and vegetal forms with the ordered clarity and moderation basic to mature Augustan classicism. See Walter-Karydi, "Grotteskenornamentik," 148–52; Zagdoun, *La sculpture archaïsante*, 136–39; and Sauron, "Le message esthétique," 3–40.

26. Kraus, *Ranken*, 51. For unfolded drawings and an analysis of the ornament, Riegl, *Problems of Style*, 209–210, fig. 121, and 364–65, annotation c. For photographic illustrations, see P. Jacobsthal, *Ornamente griechischer Vasen. Aufnahmen/Beschreibungen und Untersuchung*, Berlin, 1927, Taf. 142–43; Byvanck-Quarles van Ufford, "Décoration à rinceaux," 50–52, fig. 12; Strong, *Greek and Roman Gold and Silver Plate*, pl. 21; Artamonov, *Scythian Art*, pls. 162–65 and 171–73; Piotrovsky, Galanina, and Grach, *Scythian Art*, pls. 265–66; and R. Rolle and Vjaceslav Murzin, "Erste Ergibnisse der modernen Untersuchungen am skythischen Kurgan bei Certomlyk," *Antike Welt*, 19,4, 1988, 3–14, Abb. 13.

27. New York, Metropolitan Museum of Art, inv. 22.50.1, Rogers Fund; G. M. A.

Richter and C. Alexander, "A Greek Mirror—Ancient or Modern," *AJA*, 43, 1947, 221–26, pl. XLII; D. von Bothmer, *A Greek and Roman Treasury* (reprinted from the *Metropolitan Museum of Art Bulletin*, Summer, 1984), New York, 1984, 51, no. 88. Although Richter only generally identifies the inhabitants of the tendril as birds, the short, rounded beaks, short legs, and the long necks of the four largest birds show that they are clearly swans or geese. Von Bothmer's identification of these birds as herons is incorrect.

28. W. Züchner, *Griechische Klappspiegel*, *JDAI*, Erganzungsheft, 14, 1942, 5–31, Abb. 2–10, Taf. 1–3, 5–6, 13–17, 22, and 24; A. Stewart, "A Fourth-Century Bronze Mirror Case in Dunedin," *Antike Kunst*, 24–34, esp. 32, pls. 8–10.

29. Züchner, *Griechische Klappspiegel*, Taf. 1–2, and 5; Simon, *Götter der Griechen*, 252, Abb. 244; *The Search for Alexander. An Exhibition*, Boston, 1980, 158–59, no. 112; Delivorrias, "Aphrodite," *LIMC*, II, 98, nos. 937–39.

30. Delivorrias, "Aphrodite," *LIMC*, II, 98, nos. 931 and 933; Schauenburg, "Unteritalische Rankenmotive," Taf. 39, 1–2.

31. E. Gerhard, *Etruskische Spiegel*, Berlin, 1843–97, vol. IV, pl. CCCXXI; Galinsky, *Aeneas, Sicily, and Rome*, 208, and fig. 150; R. Bloch, "Aphrodite/Turan," in *LIMC*, II, Munich, 1984, 170, no. 2.

32. Richter and Alexander, "A Greek Mirror" (as in note 27 above), 226.

33. Lucretius, *De Rerum Natura*, I,1–25:

> Aeneadum genetrix, hominum divomque voluptas,
> alma Venus, caeli subter labentia signa
> quae mare navigerum, quae terras frugiferentis
> concelebras per te quoniam genus omne animantum
> concipitur visitque exortum lumina solis:
> te, dea, te fugiunt venti, te nubila caeli
> adventumque tuum, tibi suavis daedala Tellus
> summittit flores, tibi rident aequora ponti
> placatumque nitet diffuso lumine caelum.
> nam simul ac species patefactast verna diei
> et reserata viget genitabilis Aura Favoni,
> aeriae primum volucres te, diva, tuumque
> significant initum perculsae corda tua vi.
> inde ferae pecudes persultant pabula laeta
> et rapidos tranant amnis: ita capta lepore
> te sequitur cupide quo quamque indicere pergis.
> denique per maria ac montis fluviosque rapacis
> frondiferasque domos avium composque virentis
> omnibus incutiens blandum per pectora Amorem
> efficis ut cupide generatim saecla propagent.
> quos quoniam rerum naturam sola gubernas
> nec sine te quicquam dias in luminis oras
> exoritur neque fit laetum neque amabile quicquam,
> te sociam studeo scribendis versibus esse
> quos ego de rerum natura pangere conor.

34. On Lucretius's image of Venus as the cosmic goddess on the Greek model, see Schilling, *Religion romaine de Vénus*, 346–58.

35. IV,91–96, tr. J. G. Frazer, *Ovid's Fasti* (Loeb Classical Edition), London and New York, 1931, 195.

36. Venus figures prominently in Vergil's *Aeneid* and Ovid's *Fasti*, just to cite the more

significant examples; for a succinct overview, see Schilling, *La religion romaine de Venus*, 358–74. In the religious-political sphere her role as genetrix was celebrated through the temple of the Forum Iulium, Augustan coinage, metalwork, and in the elaborate program of imagery in the Forum Augustum; Schilling, 324–46, pl. XXXI, 5 and 7; Zanker, *Forum Augustum*, passim; idem, *Power of Images*, 53, 195–201, 229–30; J. Liegle, "Die Münzprägung Octavians nach dem Siege von Actium und die augusteische Kunst," *JDAI*, 56, 1941, 97, 108–109; A. Wallace-Hadrill, "Image and Authority in the Coinage of Augustus," *JRS*, 76, 1986, 71, pl. II,6; T. Hölscher, "Geschichtsauffassung in der römische Repräsentationskunst. III. Polare Darstellungsmodi auf historischen Reliefs der Kaiserzeit," *JDAI*, 95, 1980, 282–83, Abb. 14 and 15. On the Venusian-Aeneadic theme in the Ara Pacis reliefs, see J. M. C. Toynbee, "The 'Ara Pacis Augustae,'" 155–56; Simon, *Ara Pacis Augustae*, 23–24.

37. Büsing, "Ranke und Figur," 247–57.

38. See Introduction, notes 13 and 16, and Chapter 4, note 35.

39. For literary sources associating the swan with Apollo, see Plato, *Phaedo*, 84E–85B; Kallimachos, Hymn to Apollo, II,5; Cicero, *Tusculan Disputations*, I,30,73. For examples in Greek art, see Lambrinudakis, "Apollon," *LIMC*, II, 227–28, nos. 342–50; B. V. Head, *British Museum Catalogue of Greek Coins. Ionia*, London, 1892, 19, nos. 17–20, pl. VI, 7–9; Mayo, *Magna Graecia*, 139–42, no. 54; *RVA*, 175, no. 63, pl. 57,2; and Trendall, *Red Figure Vases of South Italy and Sicily*, fig. 241. On the possible transference of the symbol from this sphere to Aphrodite, see Simon, *Geburt der Aphrodite*, 33–35. Nevertheless, the swan or goose as Aphrodite's attribute goes back at least to the late Archaic period; cf. the Boiotian statuettes; Simon, *Götter der Griechen*, 245, Abb. 233–34; Delivorrias, "Aphrodite," *LIMC*, II, 96, nos. 905–906.

40. *ARV²* 1439,2; Simon, *Geburt der Aphrodite*, 34–35, Abb. 21; Galinsky, *Aeneas, Sicily, and Rome*, 210 and fig. 153; Delivorrias, "Aphrodite," *LIMC* II, 97, no. 920. On an Apulian lekythos attributed to the Underworld Painter, Eros appears to be escorting the swan from Aphrodite over to Apollo; Mayo, *Magna Graecia*, 133–36, no. 51.

41. Ovid, *Metamorphosis*, X,702ff.; Statius, *Silvae*, II,4,22–23; Manilius, *Astronomica*, V,384; cf. Galinsky, "Ara Pacis Augustae," 231.

42. P. Herrmann, *Denkmäler der Malerei des Altertums*, Munich, 1904–31, vol. 2, 35, fig. 9; L. Curtius, *Die Wandmalerei Pompejis*, Leipzig, 1929, 410 and Abb. 223; Galinsky, *Aeneas, Sicily, and Rome*, fig. 140; Boriello, *Le collezioni*, 152–53, no. 213.

43. The identity is not quite certain since the neck of the bird is restored; see La Rocca, *Ara Pacis Augustae*, illustration, p. 120.

44. For the central figure as Tellus/Terra Mater: Petersen, *Ara Pacis Augustae*, 48–54; E. Strong, "Terra Mater or Italia," *JRS*, 27, 1937, 114–26; Settis, "Die Ara Pacis," 413–14. As Italia: A. W. Van Buren, "The Ara Pacis Augustae," *JRS*, 3, 1913, 134–41; Kleiner, *Roman Sculpture*, 96. As Venus: Galinsky, "Ara Pacis Augustae," 229 ff., esp. 233 ff.; idem, *Aeneas, Sicily, and Rome*, 203 ff., esp. 216; A. Booth, "Venus on the Ara Pacis," *Latomus*, 25, 1966, 873–79; M. C. J. Putnam, *Artifices of Eternity*, Ithaca, N.Y., 1986, 329. As Ceres: B. Stanley Spaeth, "The Goddess Ceres in the Ara Pacis Augustae and the Carthage Relief," *AJA*, 98, 1994, 65–100. As Pax, V. Gardthausen, *Der Alter des Kaiserfriedens, Ara Pacis Augustae*, Leipzig, 1908; Torelli, *Typology*, 41–42; Zanker, *Power of Images*, 172–75, 314–15; de Grummond, "Pax Augusta and the Horae on the Ara Pacis Augustae," 663–77. Also see H. Kenner, "Das Tellusrelief an der Ara Pacis," *Österreichisches Jahresheft*, 53, 1981, 42; and Koeppel, "Ara Pacis Augustae," 11–113. The thesis of Berczelly ("Ilia and the Divine Twins," 89–149, esp. 114 ff.), that this panel depicts the infants Romulus and Remus and their mother, is well argued but, in the writer's opinion, implausible. The various identifications of the lateral figures are nicely summarized by Spaeth, 67.

45. Horace, *Carmen Saeculare*, 29–32:

> fertilis frugum pecorisque Tellus
> spicea donet Cererem corona
> nutriant fetus acquae salubres
> et Iovis Aurae.

Cf. Petersen, *Ara Pacis Augustae*, 52; G. Rizzo, "Aurae velificantes," *Bullettino comunale*, 67, 1939, 141–68; Moretti, *Ara Pacis Augustae*, 232; Simon, *Ara Pacis Augustae*, 27; Zanker, *Power of Images*, 176.

46. F. L. Bastet, "Fabularum dispositas explicationes," *BABesch*, 49, 1974, 233–34, Abb. 20; Simon, *Ara Pacis Augustae*, 27 and pl. 32,1; Canciani, "Aurai," *LIMC*, III, 52, no. 1. The iconography of Aura is only briefly touched upon in K. Neuser's study of wind divinities in classical art, *Anemoi. Studien zur Darstellung der Winde und Windgottheiten in der Antike*, Archaeologica, 19, Rome, 1982, 25.

47. On the evidence of Pliny and the skyphos, Canciani, "Aurai," *LIMC*, III, 53, nos. 7–17, very tentatively identifies various other examples of Greek painting, coinage, gems, statuary as depictions of Aura. But de Grummond, "Pax Augusta," 669, and Spaeth, "The Goddess Ceres," 77–78, are especially critical of the identification of the Ara Pacis *velificantes* as Aurae.

48. Delivorrias, "Aphrodite," *LIMC*, II, 97, nos. 911, 919, and 922; A. Kalkmann, "Aphrodite auf dem Schwann," *JDAI*, 1, 1886, 231–60, Taf. 11; Simon, *Geburt der Aphrodite*, Abb. 18; E. G. Suhr, "The Spinning Aphrodite in the Minor Arts," *AJA*, 67, 1963, 63–68, pl. 13, fig. 2; Galinsky, "Ara Pacis Augustae," fig. 8; idem, *Aeneas, Sicily, and Rome*, fig. 143.

49. Galinsky, "Ara Pacis Augustae," fig. 10; idem, *Aeneas, Sicily, and Rome*, figs. 152 and 154. On the association of the *ketos* with nymphs and Nereids, see Spaeth, "The Goddess Ceres," 78–83.

50. Delivorrias, "Aphrodite," *LIMC*, II, 97–98, nos. 919, 921–22, and 938–39.

51. See esp. Matz, "Der Gott auf der Elefantenwagen," 725–29; and Bastet, "Fabularum" (as in note 46 above), 233–34. More recently, Spaeth, "The Goddess Ceres," 87–83, has identified the flanking figures in the "Tellus" panel as water nymphs or Nereids.

52. For Greek sculpture and vase painting with Aphrodite Velificans on the swan, Delivorrias, "Aphrodite," *LIMC*, II, 97–98, nos. 911, 914, 921, and 937–39: on the *ketos*, A. Furtwängler, *Die antike Gemmen*, Leipzig, 1900, Taf. 41, no. 42; Galinsky, "Ara Pacis Augustae," fig. 10. For additional depictions of Aphrodite Velificans without the swan or sea-serpent, Delivorrias, *LIMC*, II, 99–100, nos. 955, 957, 963, 967, and 972. Despite this evidence, the almost exclusive identification of the *velififcans* motif with Aphrodite advanced by Galinsky ("Ara Pacis Augustae," 230, and *Aeneas, Sicily, and Rome*, 206–207) seems extreme.

53. La Rocca, *Ara Pacis Augustae*, 46. Cf. de Grummond, "Pax Augusta," 669.

54. Rizzo, "Aurae velificantes" (as in note 45 above), 141–68. For the coin, R. S. Poole, *A Catalogue of the Greek Coins in the British Museum. Sicily*, London, 1876, 36–37, nos. 16–19; Canciani, "Aurai," *LIMC*, III, 53, no. 7. For the Campana plaques, Rizzo, fig. 4 and tav. IV; von Rohden and Winnefeld, *Römische Tonreliefs*, 256, Taf. XXXV, from the Esquiline Hill; cf. Moretti, *Ara Pacis Augustae*, 234–36, fig. 175; Canciani, 53, no. 21; Settis, "Die Ara Pacis," 426, no. 231. Despite his emphasis of the swan-riding format as Aphrodisian iconography, even Galinsky accepts Rizzo's interpretation of the coin as an Aura; "Ara Pacis Augustae," 231, and *Aeneas, Sicily, and Rome*, 208–209.

55. Delivorrias, "Aphrodite," *LIMC* II, 98, no. 946.

56. In this regard, see Borbein, *Campanareliefs*, 25–28.

57. Also see the use of the *velificans* motif in the late Hellenistic depictions of male wind gods, as on the Tazza Farnese (here, fig. 58) or the Tower of the Winds in Athens; Neuser, *Anemoi*, 172–75, 181–82, Abb. 42–43, and 49.

58. Simon, *Die Geburt der Aphrodite*, 102 ff.

59. A hymnal epigram by Posidippos; P. M. Fraser, *Ptolemaic Alexandria*, Oxford, 1972, 239.

60. Ovid, *Heroides*, XVI,23–24; cf. Horace, *Odes*, I,4,1–8. The evidence of Euripides and Ovid regarding Venus's association with the winds was already noted by Galinsky, "Ara Pacis Augustae," 231; idem, *Aeneas, Sicily, and Rome*, 210–11. On the identity of Zephyros with Favonius, see Pliny, *Natural History*, XVIII,77,337.

61. Pliny, *Natural History*, XVI,39,93, and XVIII,77,337; cf. Ovid, *Fasti*, IV, 319 ff., and Horace, *Odes*, I,4,1.

62. For Venus and Spring, see Ovid, *Fasti*, IV,125–30; Horace, *Odes*, I,4,1–8.

63. Pliny, *Natural History*, XIV,39,93–94.

64. Pliny, *Natural History*, XV,21,80.

65. The "head-in-tendril" variant of theonomous tendril ornament itself remained current in later Hellenistic Etruscan architectural terracottas and related works of the early "Campana" type; see notes 18 and 24, above. It also survived as a portrait format in Roman imperial funerary sculpture of a type that has been extensively studied by K. Schauenburg, "Zum Sarkophag der Avidia Agrippina," *JDAI*, 78, 1963, 294–317; and Jucker, *Bildnis im Blätterkelch*, 15–132.

66. For the Terra/Tellus on the Primaporta breastplate, see Zanker, *Power of Images*, fig. 137. On the problems of a seated Tellus, see Strong, "Terra Mater or Italia," 114–26. For the terrestrial, Tellurian aspect of the supposed Ptolemaic or Hellenistic model of the Ara Pacis panel, see Adriani, *Divigazioni*, 31–32; Torelli, *Typology*, 41–42; Stucchi, "La Chora Alexandreon," 269–84; and Picard-Schmitter, "'L'Allegorie de l'Égypte' sur un relief provenant de Carthage," *RA*, 1971, 29–56, who especially stresses the conflation of the Greek Gaia with the earlier Egyptian traditions of Isis.

67. Von Rohden and Winnefeld, *Römische Tonreliefs*, 4–5, Abb. 3–4, 248–49, Taf. XX; Jucker, *Bildnis im Blätterkelch*, 205, Abb. 130; De Angeli, "Demeter/Ceres," in *LIMC*, IV, 894, nos. 5–7.

68. Theokritos, *Idyll*, VII, 157: δράγματα καὶ μάκωνας ἐν ἀμφοτέραισιν ἔχοισα.

69. H. A. Grueber, *Coins of the Roman Republic in the British Museum*, London, 1910, vol. I, 496, nos. 3940–42, pl. XLIX,8; Crawford, *Roman Republican Coinage*, no. 427, pl. LI.

70. Rome, Museo Nazionale; Bianchi Bandinelli, *Center of Power*, fig. 38; A. Hochyli-Gysel, "Der Cereskopf im Züricher Kunsthaus," *Antike Kunst*, 17,2, 1974, 109–114, esp. 111ff.; De Angeli, "Demeter/Ceres," *LIMC*, IV, 895, no. 23; Spaeth, "The Goddess Ceres," 72, fig. 5. For a detail of the wheat crown on the "Tellus" panel, see Spaeth, 68–69, fig. 2.

71. For the Ceres issues, see Grueber, *Coins of the Roman Republic*, vol. I, 236, no. 1725, pl.XXXII,12; 314, nos. 2463–66, pl. XXXVIII,6; 353–57, nos. 2844–90, pl. XL,17–19; 486–87, nos. 3896–3900, pl. XLVIII,19; 576, no. 4233–34, pl. LVI, 14–15, vol. II, 576–78, nos. 21, 25–27, pl. CXXI, 13–16, and 81, notes and drawing; Crawford, *Roman Republican Coinage*, 367, nos. 321, 351, 378, 414, 427, 467, 494 (44a), pls. XLII, XLVI, XLVIII, LI, LV,and LX; and De Angeli, "Demeter/Ceres," *LIMC*, IV, 895, nos. 12–15 and 17–20. For Greek forerunners, Head, *A Guide to the Principal Coins of the Greeks from circa 700 B.C. to A.D. 270*, 56–57, nos. 8 and 16, pl. 31; Beschi, "Demeter," *LIMC*, IV, 861, nos. 162–75, 179, and 181–88. For the urn and the plaque, see Simon, *Augustus. Kunst und Leben um die Zeitenwende*, 171 and 174, Abb. 228–29; Sinn, *Stadtrömische Marmorurnen*, no. 1, Taf. 1a–d; De Angeli, 902, no. 145, and 903, no. 147.

72. See notes 40–42 for Chapter I, above. Thus Augustan Campana plaques also depicted the Horai clutching Ceres' wheat ears and poppy capsules together, just as one of the Horai on the Aquileia plate is crowned in wheat (fig. 59); see von Rohden and Winnefeld, *Römische Tonreliefs*, 89–91, 288, and pl. XCVII; Simon, *Augustus*, 129–30, Abb. 172a–b.

73. See note 44 for Chapter I, above. Cf. Galinsky, "Venus, Polysemy, and the Ara Pacis," 458, and Spaeth, "The Goddess Ceres," 93.

74. Galinsky, "Venus, Polysemy, and the Ara Pacis," 457–75; Torelli, *Typology*, 41–42; Kleiner, *Roman Sculpture*, 96–97.

75. On the connection or identity between Tellus and Ceres in Italian religion, see Cicero, *De Natura Deorum*, I,40, and Augustine, *De Civitate Dei*, IV,10; cf. Euripides, *Bacchae*, 274–75. Also see F. Altheim, *Terra Mater. Untersuchungen zur altitalischen Religionsgeschichte*, Giessen, 1931, 78 and 108–29; idem, *A History of Roman Religion*, tr. H. Mattingly, London, 1938, 120–22; J. Bayet, "Le Cerialia. Alteration d'un culte latin par le mythe grec," *Revue belge de philologie et d'histoire*, 29, 1951, 342–43 = J. Bayet, *Croyances et rites dans la Rome antique*, Paris, 1971, 110–11; H. Le Bonniec, *Le Culte de Cérès à Rome. Des origines à la fin de la République*, Paris, 1958, 29–33 and 48–107; G. Radke, *Die Götter Altitaliens*, Fontes et commentationes, Heft 3, Münster, 1962, 86–90; D. Sabbatucci, "La 'transcendenza' di Ceres," in *Ex orbe religionarum. Studia G. Widengren oblata*, Numen, Suppl. 21, Leiden, 1972, 313–19; W. Fauth, "Römische Religion im Spiegel der 'Fasti' des Ovid," in *ANRW*, 2, 16,1, Berlin, 1978, 167–160. On Tellus and Cybele see Lucretius, *De Rerum Natura*, VI,589–99, and a lost work of Varro quoted by Augustine, *De Civitate Dei*, VII,24 and 28. For Kybele and Demeter/Ceres, Euripides, *Helen*, 1301–1302, and Augustine, *De Civitate Dei*, VII,16. On Ceres and Venus see *CIL*, I², nos. 1541 and 1774–75; IX, nos. 3087, 3089; and X, nos. 680 and 5191; H. Dessau, *Inscriptiones Latinae Selectae*, Berlin, 1892–1916, no. 6371; Schilling, *Religion romaine de Vénus*, 20; Galinsky, "Ara Pacis Augustae," 243; idem, *Aeneas, Sicily, and Rome*, 238. Cf. Roman coins of 83 B.C. with Venus on the obverse and Ceres' grain ear on the reverse; Crawford, *Roman Republican Coinage*, no. 357, pl. XLVII; Galinsky, "Ara Pacis Augustae," 243, fig. 20a; idem, *Aeneas, Sicily, and Rome*, 238, fig. 164a. For Venus and Cybele, G. Calza, "Il santuario della Magna Mater a Ostia," *Memorie dell'Accademia Pontificia di Archeologia Romana*, ser. 3, VI,2, 1947, 183–206; R. Calza, "Sculture rinvenute nel santuario di Magna Mater a Ostia," *Memorie dell'Accademia Pontificia di Archeologia Romana*, ser. 3, VI,2, 1947, 207–24; A. Bartoli, "Il culto della Mater Deum Magna Idaea e di Venere Genetrice sul Palatino," *Memorie dell'Accademia Pontificia di Archeologia Romana*, ser. 3, VI,2, 1947, 229–39, figs. 11–12. Also see Spaeth, "The Goddess Ceres," 76–77.

76. Hanell, "Das Opfer des Augustus," 88–89, suggested that Pax might have appeared in the lost portion of the south processional frieze, but other scholars have argued that she is inherently present on the Ara Pacis; A. Momigliano, "The Peace of the Ara Pacis," *JWCI*, 5, 1942, 228; H. Kähler, "Die Ara Pacis und die augusteische Friedensidee," *JDAI*, 69, 1954, 89; Galinsky, "Ara Pacis Augustae," 242; idem, *Aeneas, Sicily, and Rome*, 237; Settis, "Ara Pacis Augustae," 414 and 423; Simon, *Eirene und Pax*, 74–75; and Kleiner, *Roman Sculpture*, 98.

77. Plutarch, *Moralia*, V,8,3, 683 F (Table-Talk, 3), and 365 A (*Isis and Osiris*, 35); Aelian, *Historia Varia*, III,41,1. Also see Farnell, *Cults of the Greek States*, V, 118–19; Otto, *Dionysos. Myth and Cult*, 156–70; Jeanmaire, *Dionysos*, 17 and 442; and Daraki, *Dionysos*, 34–41.

78. Also see Bruhl, *Liber Pater. Origine et expansion du culte dionysiaque dans le monde romain*, 17.

79. At Heraia in Arkadia, Pausanias, VIII,26,1; Nonnos, *Dionysiaca*, VII,304; Farnell, *Cults of the Greek States*, V, 123.

80. For the primary sources here, see notes 70 and 71 in Chapter I; cf. Farnell, *Cults of the Greek States*, V, 119–23; Otto, *Dionysos* 143–57.

81. Plutarch, *Moralia*, V,3,1 (675 F); Hesychios, s.v. *Endendros* ; Farnell, *Cults of the Greek States*, V, 118; Otto, *Dionysos*, 157; Jeanmaire, *Dionysos*, 18.

82. Boardman, *Red Figure Vases. The Archaic Period*, figs. 6, 132, 255–56; Simon, *Götter der Griechen*, 281–83, Abb. 274–75; 293, Abb. 282; Gasparri, "Dionysos," *LIMC*, III, 482, nos. 709 and 710.

83. Vases by Makron, the Villa Giulia Painter, and the Dinos Painter; Boetticher, *Baumkultus*, 103, 229–30, figs. 42–44; Daremberg-Saglio, *Dictionnaire*, I,1, 361, fig. 449; Farnell, *Cults of the Greek States*, V, 241–42, pl. XXXIII; Otto, *Dionysos*, pls. 1–2; C. Kerenyi, *Dionysos. Archetypal Image of Indestructible Life*, Princeton, 1976, figs. 84–85; Boardman, *Red Figure Vases. The Archaic Period*, fig. 311; idem, *Red Figure Vases. The Classical Period*, figs. 24 and 177; Gasparri, "Dionysos," *LIMC*, III, 426–27, nos. 33, 38, and 40–43. Also see Jucker, *Bildnis im Blätterkelch*, 169 and note 9. For the interpretation of the ritual on these vases, see Jeanmaire, *Dionysos*, 11–12 and 482 with earlier bibliography; Deubner, *Attische Feste*, 130 and Taf. 20,1; and Simon, *Festivals of Attica*, 100–101, and pl. 32.2.

84. Von Rohden and Winnefeld, *Römische Tonreliefs*, 73–74, 250, and Taf. XXIV; Jucker, *Bildnis in Blätterkelch*, 167, Abb. 50; Gasparri, "Dionysos/Bacchus," *LIMC*, III, 559, no. 265.

85. For an example of Dionysos and Ariadne amidst stylized tendrils in earlier Apulian vase painting, see Gasparri, "Dionysos," *LIMC*, III, 486, no. 762.

86. Schauenburg, "Unteritalischer Rankenmotive," 213–14 and notes 120–22.

87. See note 18, above. On the flanking erotes here, I. Krauskopf, "Eros (in Etrurien)," *LIMC*, IV, Munich, 1988, 5, no. 47.

88. Bruhl, *Pater Liber*, 120, 216, 219.

89. For the Cerveteri frieze, see note 18, above. On the sometime identity of Libera with Venus, see Augustine, *De Civitate Dei*, VI,9, and VII,2 and 3; Le Bonniec, *Cérès*, 302; Bruhl, *Liber Pater*, 17. As artistic evidence of this kind, one may also cite the Hellenistic Etruscan tomb pediment from Vulci now in the Villa Giulia; Bruhl, *Liber Pater*, pl. III; M. Cristofani, "Dionysos/Fufluns," in *LIMC*, III, Munich, 1986, 536, no. 62. There, Dionysos/Fufluns reclines with his consort, both holding thyrsoi. He is accompanied by his panther; his female counterpart, however, is attended by a small Eros and a swan. The latter elements, especially together, are readily suggestive of Aphrodite/Turan or Venus.

90. See note 174 in the Chapter I.

91. On the more general phenomenon of the small erotes as Dionysian acolytes, see R. Stuveras, *Le putto dans l'art romain*, Collection Latomus, 99, Brussels, 1969, 13–31.

92. For the Pergamon relief, see Chapter I, note 172; for the Roman vessel, Vatican Museum, Galleria dei Candelabri, Amelung, *Skulpturen*, III², 305–306, no. 41, Taf. 141.

93. For the goat and Dionysos, see note 101, below.

94. H. Möbius, "Eine dreiseitige Basis in Athen," *AM*, 51, 1926, 117–24, Taf. 19,2–3 and 20,2–3; Kraus, *Ranken*, 53, Taf. 12; Richter, "The Marble Throne on the Acropolis and its Replicas," 271–76, pls. 47–50; and Zagdoun, *La sculpture archaïsante*, 132–33, pl. 43, fig. 157 (no. 99).

95. Richter, "Marble Throne," 255–76. Cf. Zagdoun, *La Sculpture archaïsante*, 133.

96. Von Rohden and Winnefeld, *Römische Tonreliefs*, 170–71, Abb. 333–35; C. C. van Essen, *Précis d'histoire de l'art antique en Italie*, Collection Latomus, 42, 1960, 72 and pl. 38,2; Jücker, *Bildnis im Blätterkelch*, 9–10, Abb. 61; Simon, "Zur Bedeutung des Greifen in der Kunst der Kaiserzeit," 749–80, esp. 768, Taf. XLVI, Abb.2. For parallels in marble oscilla, see E. Dwyer, "On the Meaning of the Griffin Pelta," in G. Koepcke and M. B.

Moore, eds., *Studies in Classical Archaeology. A Tribute to Peter von Blanckenhagen*, Locust Valley, N.Y., 1979, 235–38, pl. LXI,3.

97. Borbein, *Campanareliefs*, 13 and 26.

98. Von Rohden and Winnefeld, *Römische Tonreliefs*, 71–72, Abb. 143, 291, Taf. CIV; Borbein, *Campanareliefs*, 36–38, Taf. 2–3. The example illustrated here, in the Louvre, is attributed to the Augustan period by Borbein.

99. A similar type of composition, and perhaps one that helped to inspire the makers of these Campana plaques, occurs on the bases of Augustan marble candelabra. There too a vegetalized kantharos surmounted by grapes appears at the center, but the flanking tendrils come not from the vessel itself, but from the winged silenes at the sides of the composition; Möbius, "Dreiseitige Basis," Taf. XVIII, bottom left; Kraus, *Ranken*, 53, Taf. 14; Cain, *Römische Marmorkandelaber*, 168, no. 57, Taf. 23,1–3, and 175–76, no. 76, Taf. 20 and 22.

100. Louvre, no. 3847; von Rohden and Winnefeld, *Römische Tonreliefs*, 209–210, 297, Taf. CXVIII,2; Sauron, "Les Modèles funéraires," 187, fig. 7 (mislabeled in the caption as fig. 8).

101. For the goat as the special offering to Dionysos or Liber, see Varro, *Res Rusticae*, I,2,19; Vergil, *Georgics*, II,393–95; Tibullus, II,1,57–58; Horace, *Odes*, III,8; Ovid, *Fasti*, 353–60; Martial, *Epigrams*, XXIV; Plutarch, *Moralia* (On Love of Wealth), 527 D. On Dionysos and the goat in Greece, see Deubner, *Attische Feste*, 136, 147, 241, and 251–52; and Otto, *Dionysos*, 167–69; in Roman decorative sculpture and metalwork, von Hesberg, "Einige Statuen mit bukolischer Bedeutung in Rom," 297–317; idem, "Eine Marmorbasis mit dionysischen und bukolischen Szenen," *RM*, 87, 1980, 255–81. For Augustan altars to Dionysos decorated with goat heads, see note 111, below.

102. H. P. Bühler, *Antike Gefässe aus Edelsteinen*, Mainz, 1973, 45–47, no. 18, Farbtafel I; Coarelli, "Arti figurative," 534, tav. 72a–b.

103. Cain, *Römische Marmorkandelaber*, 176–77, no. 77, Taf. 55,3–4, Taf. 57,3, and Taf. 83,3, and Taf. 87,1–4.

104. Cain, *Römische Marmorkandelaber*, 176–177. Cain has also pointed out the similarity of the large acanthus leaves on the top of the base to the pilaster capitals of the Ara Pacis.

105. There is little doubt that these impressive marble fittings were familiar to the Roman public; see Cain, *Römische Marmorkandelaber*, 18–21, on the various contexts, public and private, in which the marble candelabra were displayed.

106. E. Pernice and F. Winter, *Der Hildesheimer Silberfund*, Berlin, 1901, 39–40, Taf. XII–XVI; Oliver, *Silver for the Gods*, 129–30, no. 83.

107. Pernice and Winter, *Hildesheimer Silberfund*, 29, Taf. VI–VII. For related imagery in ceramic relief ware, see A. Oxé, *Arretinische Reliefgefässe vom Rhein. Materialen zur römisch-germanisch Keramik*, Kommission des Deutschen Archäologicshen Instituts, Heft 5, Frankfurt-am-Main, 1933, 43, no. 1598, Taf. LVI, 2a–b, and 63, no. 73, Taf. XVII.

108. Museo Chiaramonti, no. 1958; Amelung, *Skulpturen*, I, 760, no. 660C, Taf. 81, bottom center.

109. Museo Chiaramonti, nos. 1496, 1534, 2099, 2107, Amelung, *Skulpturen*, I, 619–20, nos. 467C and 467D, 701, nos. 585–86, Taf. 65 and 74, bottom; Galleria dei Candelabri, Amelung, III², 180, no. 36, Taf. 79; 186, no. 42, Taf. 88; 193, no. 54, Taf. 90–91; 198, no. 63, Taf. 94.

110. Villa Adriana, Lapidario.

111. Galleria dei Candelabri, Amelung, *Skulpturen*, III², 146, no. 62, Taf. 68; E. Simon in W. Helbig, *Führer durch die öffentlichen Sammlungen klassischer Altertümer in Rom. I, Die Päpstlichen Sammlungen im Vatikan und Lateran*, 4th ed., rev. H. Speier, Tübingen, 1963, 405–406, no. 511.

112. Museo Gregoriano Profano, inv. 10111–17; Simon in Helbig (Speier), *Führer*, I,

782–83, no. 1080; K. Schefold, "Das neue Museum im Vatican," in *Zur griechische Kunst. Hansjörg Blösch zum sechzigsten Geburtstag am 5. Juli, 1972*, Antike Kunst, Beiheft, Berlin, 1973, 91 with note 48, Taf. 31, 3–4; von Hesberg,"Bukolischer Bedeutung," 300; Bianchi Bandinelli, *Center of Power*, 220–21, pl. 248; F. Sinn, *Die Grabdenkmäler 1. Reliefs, Altäre, Urnen*, Vatikanische Museen, Museo Gregoriano Profano Ex Laterense, vol. I,1, 1991, 56–58, no. 26, Taf. 174–77, where the findspot is left as unknown.

113. Von Hesberg, "Bukolischer Bedeutung," 300, Taf. 66,1.

114. Simon, in Helbig (Speier), *Führer*, I, 783, no. 1080; von Hesberg, "Bukolischer Bedeutung," 300; Sinn, *Die Grabdenkmäler 1. Reliefs, Altäre, Urnen*, 58.

115. Kellum, "What We See and What We Don't See," 35–37.

116. Parke, *Festivals of the Athenians*, 98–100.

117. M. P. Nilsson, *The Dionysiac Mysteries of the Hellenistic and Roman Age*, Lund, 1957, 47, note 7, and 53.

118. E. Langlotz, *Die Kunst der Westgriechen*, Munich, 1973, Abb. 73; Gasparri, "Dionysos," *LIMC*, III, 469, no. 538; H. Prückner, *Die lokrischen Tonreliefs; Beitrag zur Kultgeschichte*, Mainz, 1968, 78 and 124, type 109. Cf. other plaques from the same site where Dionysos confronts an enthroned Persephone and Hades; Prückner, type 107, Taf. 25,1–5.

119. On the temple itself and its foundation, see Le Bonniec, *Cérès*, 254–63.

120. Le Bonniec, *Cérès*, 279–310.

121. Bruhl, *Liber Pater*, 119–22.

122. Le Bonniec, *Cérès*, 299–301.

123. Le Bonniec, *Cérès*, 144–48, 277, 301, 325–27, 471.

124. Coins of G. Titus, M. Volteius, C. Vibius, and C. N. Pansa: Crawford, *Roman Republican Coinage*, no. 341,6, pl. XLIV,13; no. 385,3, pl. XLIX,5; no. 449,2–3, pl. LIII,11–12; Le Bonniec, *Cérès*, 371–75,.

125. Bruhl, *Liber Pater*, 135.

126. Le Bonniec, *Cérès*, 144–48; R. J. Ball, *Tibullus the Elegist: A Critical Survey*, Göttingen, 1983, 150–63.

127. H. Graillot, *Culte de Cybèle, Mère des Dieux, à Rome et dans l'empire romain*, Paris, 1912, 77.

128. Cicero, *De Natura Deorum*, II,23,60: sine Cerere et Libero friget Venus.

129. Schilling, *Religion romaine de Vénus*, 136; Le Bonniec, *Cérès*, 298. Cf. Horace, *Odes*, III,21 ff.

Chapter III

1. On the Hellenistic tradition, see J. Tondriau, "Les thiases dionysiaques royaux de la cour ptolémaïque," *Chronique d'Égypte*, 21, no. 41, 1946, 149–71; idem, "Le point culminant du culte des souverains," *Les études classiques*, 15, 1947, 110–13; idem, "Comparisons and Identifications of Rulers with Deities in the Hellenistic Period," *Review of Religion*, 13, 1948–49, 24–45, esp. 27ff.; idem, "La dynastie ptolémaïque et la religion dionysiaque," *Chronique d'Égypte*, 25, no. 50, 1950, 283–316; and Jeanmaire, *Dionysos*, 446–68. Also see the articles by Tondriau and von Prott, cited above in Chapter I, note 170.

2. See above all P. Lambrechts, "La politique «apollinienne» d'Auguste et du culte impérial," *La Nouvelle Clio*, 5, 1953, 65–82; J. Gagé, "Actiaca," *Mélanges d'archéologie et d'Histoire, l'École Française de Rome*, 53, 1936, 37–100; idem, *Apollon romain. Essai sur le culte d'Apollon et le developpement du «ritus Graecus» à Rome des origines à Auguste*, esp. 479–594; H. Jucker, "Apollo Actius und Apollo Palatinus auf augusteischen Münzen,"

Museum Helviticum, 39, 1982, 82–106; and Zanker, *Power of Images*, 33–100. A notable exception here is B. Kellum, "The City Adorned: Programmatic Display at the *Aedes Concordiae Augustae*," in K. A. Raaflaub and M. Toher, eds., *Between Republic and Empire: Interpretations of Augustus and His Principate*, 282–83, who briefly outlines the continued Augustan interest in Dionysos; idem, "What We See and What We Don't See," 32–33. Also see Brisson, "Rome et l'âge d'or: Dionysos ou Saturne?" 979, note 280. But see in contrast C. R. Long, "The Pompeii Calendar Medallions," *AJA*, 96, 1992, 489, who has attempted to explain the continued popularity of Liber in Augustan times by suggesting that the Romans considered him to be distinct from the Greek Bacchus or Dionysos.

3. See K. Scott, "Octavian and Antony's 'De sua Ebrietate,'" *Classical Philology*, 24, 1929, 137 and 139; J. Griffin, "Augustan Poetry and the Life of Luxury," *JRS*, 66, 1976, 87; idem, "Propertius and Antony," *JRS*, 67, 1977, 17–26; Zanker, *Power of Images*, 52–53, 57–65.

4. In addition to the works cited just above in note 1, see H. Jeanmaire, "La politique religieuse d'Antoine et de Cléopâtre," *RA*, ser. 5, 19, 1924, 241–61; idem, *Le Messianisme de Virgile*, esp. 177ff.; idem, *La Sibylle et le retour de l'âge d'or*, esp. 55–98; Immisch, "Zum antiken Herrscherkult," 13–36; and W. W. Tarn, "Alexander Helios and the Golden Age," *JRS*, 22, 1932, 135–60. For Antony as "New Dionysos" and also as a descendant or reincarnation of Herakles, see Plutarch, *Antony*, 4,1–2 and 24,3, 60,2–3.

5. Hoffmann, *Wandel und Herkunft der sibyllinischer Bücher in Rom*, 13ff.; Gagé, *Apollon romain*, 19–54, 62–68, 134–35, and 421ff., esp. 445–78.

6. Von Prott, "Dionysos Kathegemon," 162; E. Bikerman, *Institutions des Seleucides*, Paris, 1938, 236–57, esp. 253; R. A. Hadley, "Hieronymus of Cardia and Early Seleucid Mythology," *Historia*, 18, 1969, 150–51. For the epigraphic evidence of Antiochos I, *CIG*, 3595; W. Dittenbeger, *Orientes Graecae Inscriptiones Seleucae*, Leipzig, 1903–1905, no. 212,14 and no. 237,5–6; B. A. Müller, *RE*, ser. II, vol. 2A,1, 1921, s.v. "Seleukos," 1232. In an inscription of Antiochos III, the king assumes Apollo as a surname; *CIG* 4458, and Dittenberger, no. 245. On the tradition that Apollo had similarly begotten Octavian, see Suetonius, *Augustus*, 94,4.

7. P. Gardner, *Catalogue of the Greek Coins in the British Museum. The Seleucid Kings of Syria*, London, 1878, 8–11, nos. 3–22, 24–33; 25–26, nos. 1–27; 28, nos. 49–51; 31, nos. 1–7; 34, nos. 1–9; 37, no. 33; 44, nos. 1–2; 45, nos. 1–5; 52–55, nos. 16–26, 33, 42; 58–59, nos. 7–13; 63–64, nos. 6–14.

8. Carettoni, *Das Haus des Augustus auf dem Palatin*, Taf. X,1; Simon, "Apollon/ Apollo," in *LIMC*, II, 405, no. 290; B. Andreae, "Wandmalerei augusteischer Zeit," in *Kaiser Augustus und die verlorene Republik*, Berlin, 1988, 286–87, no. 134. For the coin parallels, Gardner, *Seleucids*, 13, no. 56, pl. IV,12; E. T. Newell, *The Coinage of the Eastern Seleucid Mints*, New York, 1938, vol. 1, 72, nos. 195–96, pl. XVI, 17–18. The relation of the painting to Seleucid numismatic precedent has so far not been observed in the literature. But on Augustus and numismatic imagery of divine association used by Hellenistic monarchs, see J. Pollini, "Man or God: Divine Assimilation and Imitation in the Late Republic and Early Empire," in Raaflaub and Toher, eds., *Between Republic and Empire: Interpretations of Augustus and His Principate*, 347–48.

9. Bikerman, *Institutions des Seleucides*, 237, 242, 245; *CIG* 3595 and 4458; Dittenberger, *Orientes Graecae Inscriptiones Seleucae*, no. 245,37–38; Müller, *RE*, ser. II, vol. 2A,1, s.v. "Seleukos," 1231–33.

10. On the Ficus, the grotto, and the hut, see Dionysius of Halicarnassus, *Roman Antiquities*, I,32,3–4, I,79, 5, 8 and 11; Ovid, *Fasti*, II,389–92; Solinus, I,18; Propertius, IV,1,9. On choosing the name Augustus over Romulus, Seutonius, *Augustus*, 7; Dio Cassius, LIII,16,6–8; K. Scott, "The Identification of Augustus with Romulus-Quirinus," *Transactions and Proceedings of the American Philological Association*, 56, 1925,

82–105, esp. 85ff.; W. Burkert, "Caesar and Romulus-Quirinus" *Historia*, 11, 1962, 356–76; Wiseman, "Cybele, Virgil, and Augustus," 125–26.

11. P. Zanker, "Der Apollontempel auf dem Palatin. Ausstattung und politische Sinnbezüge nach der Schlacht von Actium," *Città e architettura nella Roma imperiale*, Analecta Romana, Suppl. no. 10, Odense, 1983, 21–40; idem, *Power of Images*, 51–52.

12. For the most recent discussions of the monument, K. Kraft, "Der Sinn des Mausoleums des Augustus," *Historia*, 16, 1967, 189–206; D. Kienast, *Augustus*, Darmstadt, 1982, 340; and Von Hesberg in *Kaiser Augustus und die verlorene Republik*, 245–49. On the connection with Hellenistic Greek royal mausolea, see H. Thiersch, "Die alexandrinishe Königsnekropole, *JDAI*, 25, 1910, 88–89; M. L. Bernhard, "Topographie d'Alexandrie: le tombeau d'Alexandrie et le mausolée d'Auguste," *RA*, 1956,1, 129–56; and von Hesberg, 248. In contrast E. Kornemann, *Das Mausoleum und Tatenbericht des Augustus*, Berlin, 1921, 9–12, 93–94, and "Zum Augustusjahr," *Klio*, 31, 1938, 83, also stressed the local Italic or "Romulan" precedents and connotations. Zanker, *Power of Images*, 72–77, emphasized the simultaneous impact of local and eastern Hellenistic forerunners.

13. Zanker, *Power of Images*, 79–100.

14. On the use of classicism in Augustan official art, see note 158 in Chapter IV, below.

15. For D. Mustili ("L'Arte augustea," in *Augustus. Studi in occasione del bimillenario Augusteo*, Rome, 1938, 308 and 370–71), Augustan art was in essence a more equilibriated and harmonious fusion of the many alternatives inherited from earlier Greek and Italian art. On the residual impact of Hellenism in Augustan art, also see A. Wallace-Hadrill's response to Zanker, "Rome's Cultural Revolution," *JRS*, 79, 1989, 157–64, esp. 163ff.

16. See Hölscher, *Römische Bildsprache*, 17, 46, and 48 with Taf. 8. Also compare the more pronounced overlapping of figures in the procession to the figure groupings in the Telephos frieze of the Great Altar at Pergamon or the frieze from the Temple of Hekate at Lagina; A. Stewart, *Greek Sculpture. An Exploration*, New Haven and London, 1990, 212–13, and 225, figs. 714, 716, 828, and 830; R. R. R. Smith, *Hellenistic Sculpture. A Handbook*, London, 1991, fig. 199.4. Similarly the Telephos frieze and paintings from Delos parallel the landscape elements of the mythic and allegorical panels; Stewart, 212–13, figs. 712–13; Smith, figs. 198–99.1–3; and Hölscher, Taf. 10, 1–2.

17. See esp. M. I. Rostovtzev, *Mystic Italy*, New York, 1927; F. Cumont, *Les religions orientales dans le paganisme romain*, 4th ed., Paris, 1929, 198–204; G. Méautis, "Les aspects religieux de 'l'Affaire' des Bacchanales," *REA*, 42, 1940, 467ff.

18. J.-M. Pailler, *Bacchanalia. La répression de 186 av. J.-C. à Rome et en Italie: vestiges, images, tradition*, Bibliothèque des Écoles Françaises de Rome et d'Athènes, fasc. 270, Paris, 1988, 136–37, 148, and 394–98; W. Burkert, *Ancient Mystery Cults*, Cambridge, Mass., 1987, 33; also see R. J. Rouselle, *The Roman Persecution of the Bacchic Cult, 186–180 B.C*, New York, 1982; and Bruhl, *Liber Pater*, 82–116. In attributing the spread of the orgiastic Bacchic cult to the activities of a nameless or ignoble Greek, Livy, XXXIX,8,3, notes that he came by way of Etruria, just as the priestess Paculla Annia was Campanian, XXXIX, 13,9.

19. See J. A. North, "Religious Toleration in Republican Rome," 85–103, esp. 91–98.

20. Livy, XXXIX,18,7–9; cf. H. H. Scullard, *Roman Politics 220–150 B.C.*, Oxford, 1951, 154–55. The temple of Liber at St. Abbondio near Pompeii survived the proscriptions and destructions of the late 180s B.C., and so, presumably, did the one on the Aventine; Bruhl, *Liber Pater*, 116, and 121–22. Even in the Hellenistic East, Dionysian initiation rites were closely supervised and regulated by the state, as documented by the

edict of Ptolemy IV Philopator in 210 B.C.; Nilsson, *Dionysiac Mysteries*, 11ff; G. Zuntz, "Once More the So-Called 'Edict of Philopator on the Dionysiac Mysteries' (BGU 211)," *Hermes*, 91, 1963, 228–39; Fraser, *Alexandria*, II, 345 ff; Burkert, *Ancient Mystery Cults*, 33.

21. For Ennius, see E. H. Warmington, *Remains of Old Latin* (Loeb Clasical Library), vol. I, London, 1967, 260–61; cf. Brisson, "Rome et l'âge d'or," 933 and note 76. For the terracottas, see P. Pensabene and M. R. Sanzi di Mino, *Museo Nazionale Romano. Le Terrecotte. III,1, Antefisse*, Rome, 1983, nos. 71–72, 121–39, 145, 147, 165–66, 170–81, and 232. For the coins, see Bruhl, *Liber Pater*, 42; Crawford, *Roman Republican Coinage*, no. 266, 3, pl. XXXVIII, 15.

22. M. J. Price, "Mithridates VI Eupator Dionysus and the Coinages of the Black Sea," *Numismatic Chronicle and Journal*, 8, 1968, 1; B. C. McGing, *The Foreign Policy of Mithridates VI Eupator King of Pontos*, Mnemosyne, Suppl. 89, Leiden, 1986, 97–99; Verniesel and Zanker, *Die Bildnisse des Augustus*, 78.

23. See note 120, below.

24. Crawford, *Roman Republican Coinage*, no. 341,2, pl. XLIV,9; no. 343,2a–b, pl. XLV,5; no. 385,3, pl. XLIX,5; Bruhl, *Liber Pater*, pl. I, 5–6, 12–13. For the Liber coins of the Cassii, Bruhl, 42–43, pl. I,5–6; Crawford, no. 386, pl. XLIX; cf. no. 266, 3, pl. xxxviii.

25. R. Günther, "Der politisch-ideologische Kampf in der römischen Religion in den letzten zwei Jahrhunderten v. u. Z.," *Klio*, 42, 1964, 225, 274; cf. H. H. Scullard, *Rome. From the Gracchi to Nero*, London, 1970, 412, no. 29.

26. Bruhl, *Liber Pater*, 41–45.

27. See especially the Villa of the Mysteries and the villas at Boscoreale, and Soluntum; Beyen, *Die pompejanische Wanddekoration vom zweiten bis zum vierten Stil*, vol. I, 44–46, 65, 81, 91, 227–33, 236–38, Abb. 6a–c, 14, 21–22, 61a, 62c, 65, and 87–88; Engemann, *Architekturdarstellungen des frühen zweiten Stils. Illusionistische römische Wandmaleraei in der ersten Phase und der Vorbilder in der realen Architektur*, 98–101, 103, Taf. 14–16, 31, 33,1, 35, and 60; Allroggen-Bedel, *Maskendarstellungen in der römisch-kampanischen Wandmalerei*, 115–17, nos. 1–4; 134–135, nos. 33–44; and 167, no. 98; Ling, *Roman Painting*, 25 and pl. IXA–C; Napp, *Bukranion und Girlande*, 35.

28. H. J. Rose, "The Departure of Dionysos," *Annals of Archaeology and Anthropology*, 11, 1924, 25–30; cf. Immisch, "Zum antiken Herrscherkult," 21. Fraser, *Alexandria*, II, 349, note 124, suggests that this story may not have been Octavian's doing, but a popular response to events. But even in this case, it seems that Octavian would have attempted to exploit it.

29. On the analogy between Vergil's portrayal of Actium and the mythic Gigantomachy or Titanomachy, see Hardie, *Virgil's Aeneid*, 98–100.

30. For the Actian symbolism of the Palatine plaques, see the article by Kellum in note 95 below.

31. Horace, *Epodes*, IX,36–38:

> metire nobis Caecubum
> Curam metumque Caesaris rerum iuvat
> dulci Lyaeo solvere.

32. For the range of Dionysian types, Cain, *Römische Marmorkandelaber*, 122–31,and Beilage 9–13. For individual examples, see Cain's catalogue, nos. 10, 22–23, 27, 50, 53, 57–58, 60, 65, 73, 76–78, 85, 87, 89, 110, 122–23, and 156.

33. Cain, *Römische Marmorkandelaber*, nos. 58 and 73.

34. Von Rohden and Winnefeld, *Römische Tonreliefs*, 30–82; cf. Pensabene and Sanzi di Mino, *Museo Nazionale Romano. Terrecotte, III,1*, nos. 236–41.

35. Sinn, *Stadtrömische Marmorurnen*, 57, 59, 75–77. Among the urns of this period, decoration consisting of garlands or tendrils with birds, insects, reptiles, frogs, etc., is also prevalent; cf. nos. 6–7, 10, 18, 26, 53, 55, 61, 112, and 122.

36. Silver kantharoi from the Hildesheim Treasure, Pernice and Winter, *Hildesheimer Silberfund*, 39–40, Taf. XIII–XVI; Oliver, *Silver for the Gods*, no. 83; silver cup said to be from Asia Minor, C. Vermeule, "Augustan and Julio-Claudian Court Silver," *Antike Kunst*, 6, 1963, 33 ff., pl. 14, figs. 1, 3, and 5; Oliver, no. 76. The cups with such imagery from the Berthouville Treasure are probably somewhat later; E. Babelon, *Le Trésor d'argenterie de Berthouville*, Paris, 1916, 94–96, pls. XI–XIII. For a good discussion of the origin and development of these bucolic trappings, see Geyer, *Das Problem des Realitätsbezuges in der dionysischen Bildkunst der Kaiserzeit*, 166–74; for the Hildesheim kantharoi, Geyer, 171–72.

37. For Centaurs and erotes at the shrines, see the Julio-Claudian cups from the Casa dell'Argenteria in Pompeii and Berthouville; Boriello, *Le collezioni*, 93–95, 208–210, nos. 31–33; Babelon, *Le Trésor de Berthouville*, 88–91, pls. IX–X. For the more abstract arrangement, see the cups and bowl from the Hildesheim Treasure, Pernice and Winter, *Hildesheimer Silberfund*, 35–36, Taf. XI–XII; and the Augustan cup from Vize in Thrace, E. Künzl, "Der augusteische Silbercalathus im Rheinischen Landesmuseum, Bonn," *Bonner Jahrbucher*, 169, 1969, 332–36, Bilder 9–11. A pair of silver cups from the Boscoreale Treasure decorated with cult trappings, fruits, and animals corresponds more closely to the mode of still life, but even here they allude to the worship of Dionysos and the other deities of seasonal, earthly renewal; W. N. Schumacher, "Zwei Becher aus Boscoreale, *RM*, 86, 1979, 249–69, Taf. 58–59.

38. See G. H. Chase, *The Loeb Collection of Arretine Pottery*, New York, 1908, pl. II, nos. 50–54, pl. VII, no. 223, pl. IX, nos. 3–5 and 14, pl. XII, no. 218, and XIII, nos. 225 and 228, and pp. 46–47, 49, 108, 111–14; H. Dragendorff and C. Watzinger, *Arretinische Reliefkeramik*, Reutlingen, 1948, Taf. 6, nos. 52–67, Taf. 7, nos. 70–87, Taf. 12, nos. 184–85, pp. 74–78, 182–84, and 192–93; A. Stenico, *La ceramica arretina*, Cisalpino, 1966, vol. I, tav. 22, 109, and tav. 24, no. 115; Oxé, *Arretinische Reliefgefässe vom Rhein*, Taf. XXV, no. 115, and Taf. LXVI, nos. 286–87, pp. 75 and 106.

39. V. M. Strocka, "Die Brunnenreliefs Grimani," *Antike Plastik*, Lieferung IV, Berlin, 1965, 87–102, where these reliefs are dated to the Neronian period. For an Augustan date, see B. Palma, "Il rilievo tipo 'Grimani' da Palestrina," *Prospettiva*, 6, July 1976, 46–49; F. Zevi, "Proposta per un interpretazione dei rilievi Grimani," *Prospettiva*, 7, Oct. 1976, 38–41; A. Giuliano, "Un quarto rilievo della serie Grimani," *Xenia*, 9, 1985, 41–46; Zanker, *Power of Images*, 177–79.

40. Strocka, "Die Brunnenreliefs Grimani," 90, has stressed the Dionysian presence emphasized by the thyrsos and the trappings depicted on the votive monument and its relation to the setting of burgeoning natural life.

41. Bragantini, *Farnesina*, 138, 193, and tav. 73–74, 77–79, 112–14; Gasparri, "Dionysos," *LIMC*, III, 553, no. 169. For the painting, Bragantini, 136 and tav. 68. The bust of Dionysos (Bragantini 62, fig. 53) recalls the more dignified image of the god on the contemporary marble candelabra. For the iconography of the stuccoes, see F. Matz, "Dionysiake Telete. Archäologische Untersuchungen zum Dionysoskult in hellenistischer und römischer Zeit," *Akademie der Wissenschaft und Literatur, Mainz. Abhandlungen der geistes- und sozialwissenschaftlichen Klassen*, Mainz, 1964, 394ff.

42. See note 92 below.

43. Beyen, *Pompejanische Wanddekoration*, I, 240, II, Abb. 232 ; Napp, *Bukranion und Girande*, 40–41; von Hesberg, "Girlandenschmuck," 224–25; Allroggen-Bedel, *Maskendarstellungen*, 4ff., 31, and 161, no. 92; Simon, *Augustus*, 190–91, Abb. 248.

44. Hölscher, in *Kaiser Augustus und die verlorene Republik*, 393–94, no. 222.

45. Bruhl, *Liber Pater*, 133–39.

46. Cf. Ovid, *Fasti*, III,789–90; Propertius, *Elegies*, II,2,9–10; II,17,1–20; IV,1,62–64; and IV,6,73–86. On Liber as the special protector and inspirer of the Augustan poets, see Bruhl, *Liber Pater*, 133–44, esp. 139–42; Pasquali, *Orazio lirico*, 11–15; W. Wili, *Horaz und die augusteische Kultur*, Basel, 1965, 194–95; E. T. Silk, "Bacchus and the Horatian Recusatio," *Yale Classical Studies*, 21, 1969, 195–212; and C. Witke, *Horace's Roman Odes. A Critical Examination*, Mnemosyne, Suppl. 77, Leiden, 1983, 8–11, 16–17.

47. Ode, I,27,2–4:

> tollite barbarum
> morem, verecundumque Bacchum
> sanguineis prohibite rixis.

Also see Pasquali, *Orazio lirico*, 11ff.

48. On Horace and the catalogue of heroes, see Bellinger, "The Immortality of Alexander and Augustus," 93–100, esp. 97ff.; Wili, *Horaz*, 144–45, 205–206; Doblhofer, "Zum Augustusbild des Horaz," 325–39; idem, *Die Augustuspanegyrik des Horaz*, 122–41; Witke, *Horace's Roman Odes*, 39–41.

49. Epistle II,1,5–15:

> Romulus et Liber Pater et cum Castore Pollux,
> post ingentia facta deorum in templa recepti,
> dum terras hominumque colunt genus, aspera bella
> componunt, agros assignant, oppida condunt,
> ploravere suis non respondere favorem
> speratum meritis . . .
> praesenti tibi maturos largimur honores.

50. Ode I,12, 49–56:

> gentis humanae pater atque custos. . .
> orte Saturno, tibi cura magni
> Caesaris fatis data: tu secundo
> Caesare regnes.
>
> ille seu Parthos Latio imminentes
> egerit iusto domitos triumpho,
> sive subiectos Orientis orae
> Seras et Indos.

51. Ode III,3,9–16:

> hac arte Pollux et vagus Hercules
> enisus arces attigit igneas
> quos inter Augustus recumbens
> purpureo bibet ore nectar.
>
> hac te merentem, Bacche pater, tuae
> vexere tigres, indocili iugum
> collo trahentes: hac Quirinus
> Martis equis Acheronta fugit.

52. Ode IV,8, 22–34:

> quid foret Iliae
> Mavortisque puer, si taciturnitas

obstaret meritis invida Romuli?
. . . sic Iovis interest
optatis epulis impiger Hercules,
clarum Tyndaridae sidus ab infimis
quassas eripiunt aequoribus rates,
ornatus viridi tempora pampino
Liber vota bonos ducit ad exitus.

53. The achievement of divinity as the reward of moral excellence and service to mankind is also the basic theme of Cicero's *Dream of Scipio*; see Bellinger, "Alexander and Augustus," 97, and Doblhofer, *Augustuspanegyrik*, 133–34 and 141. Diodorus Siculus, VI,1,2, and VI,6,1, briefly offers a similar rational for the immortality attained by Dionysos and the Dioskouroi.

54. Pasquali, *Orazio lirico*, 676–79 and 681–87; Bellinger, "Alexander and Augustus," 93–100; Doblhofer, *Augustuspanegyrik*, 131–34. The emphasis that Horace places on the jealousy of the contemporaries of these great heroes is especially reminiscent of the rationale that Alexander's admirers used to deflect criticism from their attempt to accord divine honors to the young king.

55. Strabo, *Geography*, I,5,5; Pliny, *Natural History*, VII,95; XV,42,144; Philostratos, *Life of Apollonios*, II,9; Arrian, *Indica*, V,8–9; Mannsperger, "Apollo gegen Dionysos. Numismatische Beiträge zu Octavians Rolle als Vindex Libertatis," 388; D. Michel, *Alexander als Vorbild für Pompeius, Caesar und Marcus Antonius. Archäologische Untersuchung*, Collection Latomus, 94, Brussels, 1967, 27–34; E. E. Rice, *The Grand Procession of Ptolemy Philadelphus*, Oxford, 1983, 83–85. This was probably a two-way process; the sources on Alexander say that he consciously emulated these mythic forerunners, but it is also likely that the mythology of Dionysos was specifically elaborated to provide a precedent for Alexander's exploits. See Jeanmaire, *Dionysos*, 351–90.

56. On Antony and Alexander, see Tarn, "Alexander Helios"; Michel, *Alexander als Vorbild*, 109–32. On Augustus and Alexander, see Bellinger, "Alexander and Augustus"; and D. Kienast, "Augustus und Alexander," *Gymnasium*, 76, 1969, 430–56. On the seal, Suetonius, *Augustus*, 18 and 50; cf. A. Bruhl, "Le souvenir d'Alexandre le Grand et les romains," *Mélanges d'histoire et d'archéologie de l'École Française de Rome*, 47, 1930, 202–210; H. U. Instinsky, *Die Siegel des Kaisers Augustus*, Baden-Baden, 1962; Kienast, 435; Doblhofer, *Augustuspanegyrik*, 135. Perhaps even before Actium Octavian had begun to imitate the features of Alexander in his coin portraits; W. H. Gross, "Ways and Roundabout Ways in the Propaganda of an Unpopular Ideology," in R. Winkes, ed., *The Age of Augustus*, Louvain-La-Neuve and Providence, R.I., 1986, 36. On the post-Actian emulation of Alexander, also see E. S. Gruen, "Augustus and the Ideology of War and Peace," in Winkes, *Age of Augustus*, 68–72.

57. For a thorough treatment of the theme of Oriental conquest in Augustan poetry, see H. D. Meyer, *Die Aussenpolitik des Augustus und die Augusteische Dichtung*, Cologne and Graz, 1961, and M. Wissemann, *Die Parther in der augusteischen Dichtung*, Frankfurt and Bern, 1982.

58. *Carmen Saeculare*, 53–56:

Iam mari terraque manus potentes
Medus Albanasque timet secures,
iam Scythae responsa petunt superbi
nuper et Indi.

59. *Fasti*, III,719–20:

Sithonas et Scythicos longum narrare triumphos
et domitas gentes, turifer Inde, tuas.

60. *Aeneid*, VIII, 685–88:

> Hinc ope barbarica variisque Antonius armis
> victor ab Aurorae populis et litore rubro,
> Aegyptum viresque Orientis et ultima secum
> Bactra vehit, sequiturque (nefas) Aegyptia coniunx.

61. On Actium as a symbol of victory over the Orient, see R. Syme, *The Roman Revolution*, Oxford, 1966, 297–98; G. Binder, *Aeneas und Augustus. Interpretationen zur 8. Buch der Aeneis*, Meisenheim-am-Glan, 1971, 232–35, 250–51, and 268–70; Wissemann, *Die Parther*, 42; Y. A. Dauge, *Le Barbare. Recherches sur la conception romaine de la barbarie et de la civilisation*, Collection Latomus, 176, Brussels, 1981, 157, 403, 700, 752; W. Eder, "Augustus and the Power of Tradition: The Augustan Principate as Binding Link Between Republic and Empire," in Raaflaub and Toher, eds., *Between Republic and Empire: Interpretations of Augustus and His Principate*, 100; and M. Wyke, "Augustan Cleopatras: Female Power and Poetic Authority," in A. Powell, ed., *Roman Poetry and Propaganda in the Age of Augustus*, Bristol, 1992, 104–105. On the allusion to the Athenian victory over the Persians, see T. Hölscher, "Actium und Salamis," *JDAI*, 99, 1984, 182–203; idem, in "Historische Reliefs, in *Kaiser Augustus und die verlorene Republik*, 356–57, 370–71, cat. nos. 202–203; R. Cohon, "Vergil and Pheidias; the Shield of Aeneas and of Athene Parthenos," *Vergilius*, 37, 1991, 29–30 with note 30; and Wyke, 106–108.

62. Servius, *Commentarii in Vergilii Aeneis*, VIII,728: Araxes hic fluvius Armeniae quem pontibus nisus est Xerxes conscendere. Cui Alexander Magnus pontem fecit, quem fluminis incrementa ruperunt. Postea Augustus firmiore ponte eum ligavit, unde ad Augusti gloriam dixiti 'pontem indignatum Araxes.' Like Servius, Wissemann, *Die Parther*, 38–41, takes Vergil's reference as the Anatolian Araxes. However, C. J. Fordyce (*P. Vergili Maronis Aeneidis Libri VII–VIII. Commentary*, Oxford, 1977) points out the fallacy of Servius's claim about Augustus's bridge in Armenia, although he misses the connection with Alexander and the Araxes in Persia. P. R. Hardie ("*Imago Mundi*: Cosmological and Ideological Aspects of the Shield of Achilles," *JHS*, 105, 1985, 11–31, esp. 28ff.) also discounts the allusion to Alexander as fictitious, arguing that he bridged the Euphrates, not the Araxes in Persia. But the latter is attested; see Diodorus Siculus, XVII,69,1; Quintus Curtius, *History of Alexander*, V,5,1–4.

63. Propertius, IV,6,76–86:

> Bacche, soles Phoebo fertiles esse tuo.
> ille paludosos memoret servire Sycambros,
> Cepheam hic Meroen fuscaque regna canat,
> his referat sero confessum foedere Parthum:
> "Reddat signa Remi, mox dabit ipse sua:
> sive aliquid pharetris Augustus parcet Eois,
> differat in pueros ista tropaea suos.
> gaude, Crasse, nigras si quid sapis inter harenas:
> ire per Euphraten ad tua busta licet."
> sic noctem patera, sic ducam carmine, donec
> iniciat radios in mea vina dies.

64. H. Mattingly, *Coins of the Roman Empire in the British Museum*, vol. I, London, 1923, ci–ciii, and 3–4, nos. 10–11 and 18–20, pl. 1, nos. 7–10; Grueber, *Coins of the Roman Republic*, vol. 2, 62–64, pl. LXVI, nos. 3–8.

65. Grueber, *Coins of the Roman Republic*, vol. 2, 62, pl. LXVI,3; Mattingly, *Coins of the Roman Empire*, 3, no. 7, pl. 1, no. 5. Zanker, *Power of Images*, 188, sees the Dionysian aspect of these coins as inappropriate to the larger Augustan program of imagery, and attributes it to the moneyer's lack of judgment, rather than to official policy. Neverthe-

less these coins correspond fully to the themes of ruler glorification in contemporary Augustan poetry.

66. Matz, "Elefantenwagen," 747. For the Hellenistic prototypes, Matz, 738; R. S. Poole, *Catalogue of Greek Coins in the British Museum. The Ptolemies, Kings of Egypt,* London, 1883, 11, nos. 93–94, pl. II,10–11. The obverse has Ptolemy I; the figure in the elephant chariot on the reverse is the king or perhaps Alexander. In the great procession of Ptolemy II Philadelphos (Athenaeus, *Deipnosophists,* 200 D and 202 A), Dionysos was shown in his Indian triumph, riding atop an elephant, while a statue of Alexander was borne in a quadriga pulled by elephants, precisely like the coins; see Rice, *The Grand Procession,* 85.

67. *Aeneid,* VI,794–805:

> super et Garamantas et Indos
> proferet imperium (iacet extra sidera tellus
> extra anni solisque vias, ubi caelifer Atlas
> axem umero torquet stellis ardentibus aptum):
>
> .
>
> nec vero Alcides tantum telluris obivit,
> fixerit aeripedem cervam licet, aut Erymanthi
> pacarit nemora, et Lernam tremefecerit arcu:
> nec qui pampineis victor iuga flectit habenis
> Liber, agens celso Nysae de vertice tigris.

68. For Balbus and the Garamantes, see Pliny, *Natural History,* V,5,36; *CAH,* X, 346. For the Ethiopians, Dio Cassius, LIV,5,4; Pliny, VI,181ff.; *Res Gestae,* 26; *CAH,* X, 241–42. On Ethiopia as the land of Atlas, *Aeneid,* IV,481–82.

69. E. Norden, "Ein Panegyricus auf Augustus in Vergils Aeneis," *Rheinisches Museum für Philologie,* n.s. 54, 1899, 466–82; idem, *P. Vergilius Maro Aeneis Buch VI,* Leipzig, 1903, 315–18; Meyer, *Aussenpolitik,* 27–28; Doblhofer, *Augustuspanegyrik,* 136.

70. Head, *Principal Coins of the Greeks,* 69, 74, nos. 5–6, pl. 42, 5–6. On the role of the hero catalogue as *soteres,* see Doblhofer, *Augustuspanegyrik,* 129.

71. A. Roes and W. Vollgraff, "Le canthare de Stevensweert," *Monuments Piots,* 46, 1952, 39–67; L. H. M. Brom, *The Stevensweert Kantharos,* The Hague, 1952. On the date of this cup, see Strong, *Greek and Roman Gold and Silver Plate,* 115.

72. Zanker, *Power of Images,* 57–76; idem, in *Kaiser Augustus und die verlorene Republik,* 624–25. But see Eder ("The Augustan Principate as Binding Link," in Raaflaub and Toher, eds., *Between Republic and Empire,* 72), who stresses how, after Actium, Augustus strove to leave behind the imagery and events of the "Octavian" phase.

73. Sauron, "Le Message symbolique," 92–101.

74. See Sauron, "Le Message symbolique," 97 and fig. 1. On the evidence for the laurel, see Chapter I, above, p. 24.

75. Jeanmaire, *Le Messianisme de Virgile,* 59–60; Matz, "Elefantenwagen, 759–60; Panofsky, *A Mythological Painting by Poussin in the National Museum, Stockholm,* 36–44; Günther, "Politische-ideologische Kampf," 246–47; Stewart, "Dionysos at Delphi," 205–27. For the most in-depth treatment of this divine interaction, see the studies of Panofsky and Stewart.

76. Aischylos, frag. 341, *Saturnalia,* I,18,6: ὁ κισσεὺς Ἀπόλλων, ὁ Βακχεῖος, ὁ μάντις.

77. Attributed by Macrobius, *Saturnalia,* I,18,6, to Euripides' *Lykimnios:* δέσποτα φιλόδαφνε Βάκχε, Παιὰν Ἄπολλον εὔλυρε.

78. *Homeric Hymn,* 26,9: κισσῷ καὶ δάφνῃ πεπυκασμένος· αἱ δ' ἅμ' ἔποντο. For the tree idol with laurel see the stamnos by the Dinos Painter, Chapter II, note 83.

79. Athens, National Museum.

80. On the worship of Dionysos at Delphi, also see Roscher, *Lexikon der griechischen und römischen Mythologie*, I, 1033; Cook, *Zeus*, vol. II, Cambridge, 1925, 233–67; Otto, *Dionysos*, 202–208; G. W. Elderkin, *The First Three Temples at Delphi: Their Religious and Historical Significance*, Princeton, 1962; Bruhl, *Liber Pater*, 6 and 57.

81. Stewart, "Dionysos at Delphi," 206–12. For a discussion of Philodamos's poem and a full copy of the text, see Stewart, 210–11 and 216–20. Also see Otto, *Dionysos*, 144.

82. Plutarch, *Moralia*, 388 F:

> ὁ θεὸς καὶ ἀίδιος πεφυκώς, ὑπὸ δή τινος εἱμαρμένης γνώμης
> καὶ λόγου μεταβολαῖς ἑαυτοῦ χρώμενος ἄλλοτε μὲν εἰς πῦρ
> ἀνῆψε τὴν φύσιν πάνθ᾽ ὁμοιώσας πᾶσιν, ἄλλοτε δὲ
> παντοδαπὸς ἔν τε μορφαῖς καὶ ἐν πάθεσι καὶ δυνάμεσι
> διαφόροις γιγνόμενος, ὡς γίγνεται νῦν ὁ κόσμος, ὀνομάζεται
> δὲ τῷ γνωριμωτάτῳ τῶν ὀνομάτων. κρυπτόμενοι δὲ τοὺς πολλοὺς
> οἱ σοφώτεροι τὴν μὲν εἰς πῦρ μεταβολὴν Ἀπόλλωνά τε τῇ
> μονώσει Φοῖβόν τε τῷ καθαρῷ καὶ ἀμιάντῳ καλοῦσι. τῆς δ᾽ εἰς
> πνεύματα καὶ ὕδωρ καὶ γῆν καὶ ἄστρα καὶ φυτῶν ζῴων τε
> γενέσεις τροπῆς αὐτοῦ καὶ διακοσμήσεως τὸ μὲν πάθημα καὶ
> τὴν μεταβολὴν διασπασμόν τινα καὶ διαμελισμὸν αἰνίττονται·
> Διόνυσον δὲ καὶ Ζαγρέα καὶ Νυκτέλιον καὶ Ἰσοδαίτην αὐτὸν
> ὀνομάζουσι. . . . καὶ ᾄδουσι τῷ μὲν διθυραμβικὰ μέλη παθῶν
> μεστὰ καὶ μεταβολῆς πλάνην τινὰ καὶ διαφόρησιν ἐχούσης. . . .
> τῷ δὲ παιᾶνα, τεταγμένην καὶ σώφρονα μοῦσαν.

83. For this krater, see Chapter I, note 48. For various other works of this kind see Lambrinudakis, "Apollon," *LIMC*, II, 277–80, nos. 755–81.

84. H. B. Walters, *Corpus vasorum antiquorum*, British Museum, fasc. 8, London, 1931, 8, no. 232, pl. 96; Lambrinudakis, "Apollon," *LIMC*, II, 227, no. 344.

85. Stewart, "Dionysos at Delphi," 211–15. On the resultant difficulties of identification, see B. S. Ridgway, *Catalogue of the Classical Collection. Rhode Island School of Design. Classical Sculpture*, Providence, 1972, 69–70.

86. E. Simon, "Die Tomba dei Tori und die etruskische Apollonkult," *JDAI*, 88, 1973, 27–42, esp. 35ff.

87. I. Krauskopf, "Apollon/Aplu," in *LIMC* II, Munich, 1984, 342–44, nos. 36–43 and 51, and 347, nos. 77–78.

88. J. B. Ward-Perkins and A. Claridge, *Pompeii. A.D. 79*, vol. II, Boston, 1978, no. 192; Boriello, *Le collezioni*, 162, no. 281.

89. Lucan, *Pharsalia*, V,72–74:

> Parnasos gemino petit aethera colle,
> Mons Phoebo Bromioque sacer, cui numine mixto,
> Delphica Thebanae referunt trieterica Bacchae.

Also see Panofsky, *Mythological Painting*, 38.

90. Simon, "Apollo in Rom," 206 and 212–15.

91. O. Elia, "Lo Stibadio dionisiaco in pitture pompeane," *RM*, 69, 1961, 118–27; H. Sichtermann, "Göttlicher Enthusiasmus. Dionysisches und apollinisches auf römischen Sarkophagen des 3. nachchristlichen Jahrhunderts," *RM*, 86, 1979, 351–74.

92. G. Carettoni, "Due nuovi ambiente dipinti sul Palatino," *Bollettino d'arte*, 46, 1961, 189–99; idem, *Das Haus des Augustus*, 23–27, Taf. 6–8, Taf. C, E, F, and H; idem, "La decorazione pittorica della Casa di Augusto sul Palatino," *RM*, 90, 1983, 377–78, Taf. 92–94, Farbentafel 1–2,1; Engemann, *Architekturdarstellungen*, 111, Taf. 63–64; Allroggen-

Bedel, *Maskendarstellungen*, 159–61, no. 91; Barbet, *Peinture romaine*, 42–43, fig. 23; Ling, *Roman Painting*, 35–37, figs. 33–34.

93. E. Reisch, s.v. "Agyieus," *RE* I,1, 1893, 909–13; M. W. de Visser, *Die nicht menschengestaltigen Götter der Griechen*, Leiden, 1903, 65–69; Harrison, *Themis*, 406–10; Cook, *Zeus*, II, 143–66; H. V. Herrmann, *Omphalos*, Orbis Antiquus, Heft 13, Münster, 1959, 36; E. Simon, *Die Vierjahrzeiten-Altar in Würzburg*, Stuttgart, 1967, 27–28; Künzl, "Silbercalathus," 352–58; Picard-Schmitter, "Bétyles hellénistiques," 60–66 and 76–77; D. Burr Thompson, *Ptolemaic Oinochoai and Portraits in Faience. Aspects of the Ruler-Cult*, 62–69; di Filippo-Balestrazzi, Gasperini, and Balestrazzi, "L'emiciclo di Pratomedes a Cirene: la testimonianza di un culto aniconico di tradizione dorica," 126–53, esp. 126–29 and 148–53; E. di Filippo-Balestrazzi, "Apollon Agyieus," in *LIMC*, II, Munich, 1984, 327–32; Cain, *Römische Marmorkandelaber*, 77–81; Sinn, *Stadtrömische Marmorurnen*, 73–74. For the connection of the Palatine painting with this tradition, see Picard–Schmitter, 73–76; di Filippo-Balestrazzi et al., 146–47; di Filippo-Balestrazzi, 329, no. 13; Carettoni, *Das Haus des Augustus*, 27; E. Winsor Leach, *The Rhetoric of Space. Literary and Artistic Representations of Landscape in Republican and Augustan Rome*, Princeton, 1988, 218–19.

94. Di Filippo-Balestrazzi et al., "L'emiciclo di Pratomedes a Cirene."

95. G. Carettoni, "Terrecotte 'Campana' dallo scavo del tempio di Apollo Palatino," *Rendiconti dell'Accademia Pontificia Romana di Archeologia*, 44, 1971–72, 123–39, fig. 5; idem, "Nuova serie di grandi lastre fittili 'Campana,'" *Bollettino d'arte*, 58, 1973, 75–87, fig. 15; idem, "Die «Campana»-Terrakotten vom Apollo-Palatinus-Tempel," in *Kaiser Augustus und die verlorene Republik*, 267–72, no. 123; Simon, "Apollo in Rom," 219, Abb. 5; Zanker, "Apollontempel," 34–35, Abb. 7–8; Simon, *Augustus*, 128–29, Taf. 7; and B. Kellum, "Sculptural Programs and Propaganda in Augustan Rome: The Temple of Palatine Apollo," in Winkes, ed., *The Age of Augustus*, 169–76 (reprinted in E. D'Ambra, *Roman Art in Context. An Anthology*, Englewood Cliffs, N.J., 1993, 75–83).

96. Carettoni, *Das Haus des Augustus*, Taf. C and D.

97. Künzl, "Silbercalathus," 348–50, 370, Bild 29; W. J. Peters, *Landscape in Romano-Campanian Mural Painting*, Assen, 1963, 44–45, esp. figs. 33 and 152. For the stucco examples from the villa under the Farnesina gardens, see Bragantini, *Farnesina*, tav. 72, 77, and 111; Simon, *Augustus*, 131–33, Abb. 174–77; Andreae, *Art of Rome*, fig. 280.

98. For the Toledo cup, Oliver, *Silver for the Gods*, 116–18, no. 76; the Praeneste relief, Strocka, "Die Brunnenreliefs Grimani," 90 and Taf. 56a. A columnar stele topped by a spherical vessel also appears in the Dionysian shrine depicted on the Augustan silver cup from Vicarello, where a Bacchic *thiasos* takes place; Künzl, "Silbercalathus," 363–65, Bilder 25–27; Oliver, 142–43, no. 95; Simon, *Augustus*, 146, Abb. 192. Such columnar stelai in scenes of rustic Dionysian worship remained current on later Roman sarcophagi; Lehmann and Olsen, *Dionysiac Sarcophagi*, 15, 41, and fig. 12. On the Dionysian connection of such columnar stelai, especially with adjacent trees, see K. Boetticher, *Der Baumkultus der Hellenen*, Berlin, 1856, 89, 537–38, and fig. 12.

99. For complete views of the south and west walls, see Carettoni, *Das Haus des Augustus*, Taf. 8, and farbtafeln B, C, and E. The *pera*, *syrinx*, *lagobolon*, and *tympana* are also scattered across the rustic Dionysian scene on the Julio-Claudian glass relief from the house near the Porta Marina in Pompeii; Bianchi Bandinelli, *Center of Power*, fig. 226; Boriello, *Le collezioni*, 226–27, no. 51.

100. Harpokration, s.v. "Agyieus"; Suidas, s.v. "Aguiai"; Visser, *Nicht menschengestaltigen Götter*, 66. Picard-Schmitter, "Bétyles hellénistiques," 60–66 stressed the connection of the conical pillar or "baitylos" with Dionysos-Osiris in Ptolemaic Egypt. In addition, wall paintings and reliefs in which the conical pillar is bedecked with stag heads or antlers, bow, quiver, and torches, indicate that this type of monument was also associated with the cult of Artemis or Diana; Boetticher, *Baumkultus der Hellenen*,

77–78, 537, and fig. 10; Cook, *Zeus*, II, 153–54, fig. 93; Cain, *Römische Marmorkandelaber*, 188–89, no. 105, Taf. 66,4, 67,3, and 83,2. For the paintings, especially the one in the central *triclinium* in the "House of Livia," see Cook, 144–45, figs. 86–87; Beyen, *Pompejanische Wanddekoration*, II, Abb. 234 and 235b; Künzl, "Silbercalathus," 354, 356–57, 372–73; di Filippo-Balestrazzi, et al., "L'emiciclo di Pratomedes a Cirene," 147–48, figs. 42–43; Simon, *Augustus*, 188–89, Abb. 245 and 247; idem, *Götter der Griechen*, 167, abb. 149; E. Simon, "Artemis/Diana," in *LIMC*, II, Munich, 1984, 810, no. 39.

Following Künzl, "Silbercalathus," 373, Simon, 810, no. 38, would interpret the Agyieus monument in the Room of the Masks as part of an Artemis shrine, in keeping with the painting from the nearby House of Livia, although the former lacks additional attributes of Artemis or Diana beyond the quiver, which is sooner Apollo's. Conversely, attempts to deny the Artemisian sense or setting of the conical pillar in the Livia painting seem equally arbitrary; C. Picard, "Le pseudo-bosquet «Bosquet d'Artémis» dans la «Casa di Livia» au Palatin," *RA*, 1955, 226–28.

101. M. Rostowzew, "Die hellenistisch-römische Architekturlandschaft," *RM*, 26, 1911, 114–16, 130, Taf. 11,3; Cook, *Zeus*, II, 157, fig. 98; Schäfer, *Hellenistische Keramik aus Pergamon*, 76–77, and 96, E 11 A, Taf. 23; Geyer, *Realitätsbezuges in der dionysischen Bildkunst*, 166.

102. J. E. Harrison, *Prolegomena to the Study of Greek Religion*, Cambridge, 1922, 518–19, fig. 146; Cook, *Zeus*, II, 152, fig. 92; Zanker, *Power of Images*, 289, fig. 226; Simon, *Augustus*, 208, Abb. 263; H. von Hesberg, "Das münchner Bauernrelief. Bukolische Utopie oder Allegorie individuellen Glücks?" *Münchner Jahrbuch der bildenden Kunst*, ser. 3, 37, 1986, 7–27.

103. Von Hesberg, "Einige Statuen mit bukolischer Bedeutung," 307 and Taf. 75,1–2; Boriello, *Le collezioni*, 208, nos. 30–31.

104. Harrison, *Themis*, 407, fig. 120; Cook, *Zeus*, II, 165, fig. 109; W. Fuchs, *Die Vorbilder der neuattischen Reliefs*, *JDAI*, Erganzungsheft, 20, Berlin, 1959, 154 and 175; di Filippo-Balestrazzi, "Apollon Agyieus," *LIMC*, II, 329, no. 24.

105. E. Simon, "Dionysischer Sarkophag in Princeton," *RM*, 69, 1962, 149–53.

106. Vergil, *Eclogue*, V, 29–31:

> Daphnis et Armenias curru subiungere tigris
> instituit, Daphnis thiasos inducere Bacchi
> et foliis lentas intexere mollibus hastas.

Jeanmaire, *Messianisme de Virgile*, 169–76, has stressed the mystic Dionysian quality of the *boukoloi* of Theokritos's *Idylls* which Vergil adapted for the Eclogues. Also see Pasquali, *Orazio lirico*, 3–4.

107. P. Grimal, "Art décoratif et poésie au siècle d'Auguste," in *Art décoratif à Rome à la fin de la république et au début du principat*, Table Ronde, École Française de Rome, Rome, 1981, 323–24.

108. Beyen, *Pompejanische Wanddekoration*, I, Abb. 22–23, 94, and 100; Engemann, *Architekturdarstellungen*, Taf. 33,1; Ling, *Roman Painting*, fig. 32 and pl. IIIA.

109. L. Richardson and S. Cerutti, "Vitruvius on Stage Architecture and Some Recently Discovered Scaenae Frons Decorations," *Journal of the Society of Architectural Historians*, June 1989, 172–79. On the basis of the studies of Beyen and Little, Carettoni (*Das Haus des Augustus*, 23 and 26) had already argued for the direct impact of stage scenery in these paintings; cf. Simon, *Augustus*, 184–85, Abb. 240 and Taf. 28; and Leach, *Rhetoric of Space*, 214–18.

110. Otto, *Dionysos*, 86–91.

111. Lehmann, *Boscoreale*, 92–93; Allroggen-Bedel, *Maskendarstellungen*, 64ff., esp. 73–74; Engemann, *Architekturdarstellungen*, 98–99.

112. Engemann, *Architekturdarstellungen*, 100–101. Alternatively it is also possible that the masks alluded more generally to the divine patronage of literary and theatrical performance which was part of sophisticated domestic entertainment; E. Winsor Leach, "Patrons, Painters and Patterns. The Anonymity of Romano-Campanian Painting and the Transition from the Second to the Third Style," in B. K. Gold, *Roman Literary and Artistic Patronage*, Austin, 1982, 154–55; idem, *Rhetoric of Space*, 216.

113. Athenaeus, *Deipnosophists*, 198 E; Lehmann, *Boscoreale*, 92. Cf. Rice, *Procession of Ptolemy*, 60.

114. Cook, *Zeus*, II, 155–57, figs. 95–96; Adriani, *Divigazioni*, 20, and figs. 74–76; Picard-Schmitter, "Bétyles hellénistiques," 79–81, fig. 23a–c; Pollitt, *Hellenistic Age*, 254 and 273, fig. 274. The most thorough monograph is that of Thompson, *Ptolemaic Oinochoai*, esp. 23–75.

115. For Apollo under the Ptolemies, see Fraser, *Alexandria*, 196–97. The particular divine association of the pillar on these vessels is hard to determine. Picard-Schmitter, "Bétyles hellénistiques," 79–81, leaves it open. Thompson, *Ptolemaic Oinochoai*, 66–69, considers a connection with Isis, with whom the queen is assimilated here, but then gravitates toward identifying the pillar as an Apolline symbol. On the evidence of the approximately contemporary hemicycle of Pratomedes in nearby Cyrene, Di Filippo-Balestrazzi ("L'emiciclo di Pratomedes a Cirene," 147–48, and note 151, and "Apollon Agyieus," *LIMC*, II, 328, no. 1) supports the latter possibility; cf. L. Robert, "Sur un décret d'Ilion et sur un papyrus conçernant des cultes royaux," *Essays in Honor of C. Bradford Welles*, American Studies in Papyrology, I, New Haven , 1966, 209–10.

116. Picard-Schmitter, "Bétyles héllenistiqes," 79–80, fig. 23a–c; Thompson, *Ptolemaic Oinochoai*, pls. XXIX–XL, no. 112.

117. For the oinochoai with the *dikeras*, see Thompson, *Ptolemaic Oinochoai*, nos. 1–3, pls. I–IV. On the *dikeras* in the Room of the Masks and Ptolemaic tradition, Picard-Schmitter, "Bétyles hellénistiques," 82–85.

118. K. Fittschen, "Zur Herkunft und Entstehung des 2. Stils," in Zanker, *Hellenismus in Mittelitalien*, 539–63.

119. The standard work is still C. H. V. Sutherland, *The Cistophori of Augustus*, London, 1970.

120. Mannsperger, "Apollon gegen Dionysos," 381–404; Alpert, "Die Entwicklung der Cistophoren und der Machtkampf zwischen Marc Anton und Octavian-Augustus," 238–50; idem, *Das Bild des Augustus auf den frühen Reichsprägungen. Studien zur Vergöttlichung des ersten Princeps*, Speyer, 1981, 137–38; W. Trillmich, "Münzpropaganda," in *Kaiser Augustus und die verlorene Republik*, 505–506, nos. 320–21.

121. Tarn, "Alexander Helios," 148–51. For the original Pergamene issues of this kind, see W. Wroth, *A Catalogue of Greek Coins in the British Museum. Greek Coins of Mysia*, London, 1892, 123–26, nos. 86–128, pl. XXVI,1–6.

122. Grueber, *Coins of the Roman Republic*, II, 502–503, nos. 133–37, pl. 114,3–4; Sutherland, *Cistophori*, 86–87; Mannsperger, "Apollon gegen Dionysos," 384–86, Taf. XXI,3–6; Alpert, "Cistophoren und der Machtkampf," 244–45, Abb. 5–6; Trillmich, "Münzpropaganda," nos. 503, 311–12.

123. Grueber, *Coins of the Roman Republic*, II, 536, no. 240, pl. 117,2; Mannsperger, "Apollon gegen Dionysos," 384–86, Taf. XXIII,11–12; Trillmich, "Münzpropaganda," nos. 503, 311–12.

124. See note 120 just above.

125. Simon, "Apollo in Rom," 216, who is especially critical of Mannsperger's study.

126. Mannsperger, "Apollon gegen Dionysos," 390–91, Taf. XXII,3–4; Alpert, "Cistophoren und der Machtkampf," 246–47, Abb. 7–8.

127. Alpert, "Cistophoren und der Machtkampf," 248.

128. Crawford, *Roman Republican Coinage*, no. 353,1–2, pl. XLVI,13–14. For the identification of the obverse, Crawford, 369, and Luce, *AJA*, 72, 1968, 25–26. On the Dionysian character of the reverse, see A. B. Cook, *Zeus*, I, Cambridge, 1914, 713, nos. 2–3; Alföldi, "Redeunt Saturnia Regna, III: Jupiter-Apollo and Veiovis," *Chiron*, 2, 1972, 225–27; and von Hesberg, "Einige Statuen mit bukolischer Bedeutung," 297–317.

129. Head, *Principal Coins of the Greeks*, 79 and pl. 44,4.

130. For this view of Augustan art more generally, also see the study by Kunze cited in note 158 for Chapter IV, below.

131. See note 5 above.

132. On the ties to Aristocratic families, see Liegle, "Münzprägung," *JDAI*, 56, 1941, 91–119; Immisch, "Herrscherkult," 25 and 31–32. On the impact of the Trojan connection, Mannsperger, "Apollon gegen Dionysos," 394; Alpert, "Cistophoren und der Machtkampf," 248.

133. K. Kraft, "Zum Capricorn auf den Münzen des Augustus," *Jahrbuch für Numismatik und Geldgeschichte*, 17, 1971, 24–26; R. Scheer, "Vindex Libertatis," *Gymnasium*, 78, 1971, 182–89; Mannsperger, "Apollon gegen Dionysos," 399–400.

134. Bruhl, *Liber Pater*, 41–45.

135. See p. 105, above.

136. For the Brauron altar, see Chapter I, note 38, above. For the Augustan base, Cain, *Römische Marmorkandelaber*, 174, no. 73, Taf. 9,4, and Taf. 68, 2 and 4. The relief in the Louvre with Dionysos as leader of the Horai is a Roman copy of the sort of Archaistic Neo-Attic prototype behind this Augustan base; Pollitt, *Hellenistic Age*, 182–83, fig. 192; Gasparri, "Dionysos," *LIMC*, III, 473, no. 596. For the Arretine examples see Oxé, *Arretinische Reliefgefässe vom Rhein*, 78–80, nos. 132–33, Taf. XXXII–XXXIV, and M. T. Marabini Moevs, "Penteteris e le tre Horai nella pompe di Tolomeo Filadelfo," *Bollettino d'arte*, March-April, 1987, 2–27, figs. 3, 5, 6, 9, and 51.

137. Wroth, *Greek Coins of Mysia*, 123, no. 86.

138. Pliny, *Natural History*, XXXV, 131. See Kellum, "Display at the *Aedes Concordiae Augustae*," in Raaflaub and Toher, eds., *Between Republic and Empire*, 281–83.

139. "Zur Bedeutung des Greifen," 750–52 and 764.

140. Simon, "Zur Bedeutung des Greifen," 763–70; cf. Lehmann and Olsen, *Dionysiac Sarcophagi*, 30–31; Elia, "Lo Stibadio dionisiaco in pitture pompeane," 122–23. For Greek examples of Apollo as griffin-rider in vase painting and coinage, see Lambrinudakis, "Apollon," *LIMC*, II, 229–30, nos. 363–70. For Dionysos in a chariot drawn by griffins, Gasparri, *LIMC*, III, 463, nos. 461–62.

141. Jucker, *Bildnis im Blätterkelch*, 172; Simon, "Zur Bedeutung des Greifen," 765.

142. E. Simon, "Zur Augustusstatue von Prima Porta," *RM*, 64, 1957, 59–60; Verneisel and Zanker, *Die Bildnisse des Augustus*, 46. For illustrations, also see Simon, *Augustus*, 54, Abb. 57; Zanker, *Power of Images*, fig. 148b.

143. Jucker, *Bildnis im Blätterkelch*, 171–74; Simon, "Zur Bedeutung des Greifen," 768. The ivory rhyta or drinking horns from the Parthian capital of Nysa also demonstrate the Dionysian and Eastern background of such imagery. There, the ends of the vessels are decorated with horned lion-griffins like those on the Ara Pacis, which also emerge from acanthus calyces; see M. E. Masson and A. Pugachenkova, *The Parthian Rhytons of Nysa*, Monografie di Mesopotamia, vol. 1, Florence, 1982, 48–84, and Pfrommer, *Metalwork from the Hellenistic East*, 47. I am indebted to Sharon Herson for alerting me to the analogies posed by the rhyta.

144. For the type of Hellenistic models behind the god with the griffins on this plaque, see H. Möbius, *Ornamente griechischer Grabstelen klassischer und nachklassicher Zeit*, Berlin, 1929, 72, A28, and Taf. 64; idem, "Dreiseitige Basis," 121, Taf. 19; Richter, "Marble Throne," 273; Jucker, *Bildnis im Blätterkelch*, 173, Skizze 23.

145. Von Rohden and Winnefeld, *Römische Tonreliefs*, 173, 244, and Taf. VI,2. For the Greek analogs, bronze reliefs from the Mahdia shipwreck, see W. Fuchs, *Der Schiffsfund von Mahdia*, Tübingen, 1963, 24, no. 21, Taf. 28, 1–2.

146. Simon, "Zur Bedeutung des Greifen," 769.

147. Travlos, *Pictorial Dictionary of Athens*, 547, fig. 684; Möbius, "Dreiseitige Basis," 121; Richter, "Marble Throne," 273–74.

148. Simon, "Zur Bedeutung des Greifen," 770–75, Abb. 5. For the griffin and Nemesis, also see Elia, "Lo Stibadio dionisiaco in pitture pompeane," 123.

149. Simon, "Zur Bedeutung des Greifen," 764.

150. Ridgway, *Catalogue of the Rhode Island School of Design. Classical Sculpture*, 106–107, no. 43. The foreparts of the griffins are destroyed, but the winged leonine bodies make their identification secure.

151. Pollini, "The Acanthus of the Ara Pacis," 214 and notes 191–95.

152. Pollini, "The Acanthus of the Ara Pacis," 193–213, passim.

153. Propertius, *Elegies*, IV,6,76: Bacche, soles Phoebo fertilis esse tuo.

Chapter IV

1. L'Orange, "La zona floreale," 10–11.

2. The prophetic Apolline and sibylline meaning of Vergil's *Cumaeum carmen* is attested by Servius's commentary on lines 4 and 10: "'ultima Cumaei venit iam carminis aetas': sibyllini, quae cumana fuit et saecula per metalla divisit. Dixit etiam quis quo saecula imperaret, et solem ultimum id est decimum voluit. Novimus autem eundem esse Apollinem, unde dixit 'tuus iam regnat Apollo.' Dixit etiam finitis omnibus saeculis rursus eandem innovari." Also see Gagé, *Apollon romain*, 481; Gatz, *Weltalter, goldene Zeit, und sinnverwandte Vorstellungen*, 87–103; Du Quesnay, "Vergil's Fourth Eclogue," 41 and 76–77; Nisbet, "Virgil's Fourth Eclogue: Easterners and Westerners," 59–60; and M. Wifstrand-Schiebe, *Das ideale Dasein bei Tibull und die Goldzeitkonzeption bei Vergil*, Acta Universitatis Upsaliensis, Studia latina upsaliensis, 13, Uppsala, 1981.

3. The bibliography on the identity of the child is large and controversial; for a good summary, see H. Mattingly, "Virgil's Fourth Eclogue," *JWCI*, 10, 1947, 14–19; and the recent studies of Nisbet, "Easterners and Westerners," 59–79, esp. 62–64; and Du Quesnay, "Vergil's Fourth Eclogue," 25–99, esp. 31–39.

4. See, for example, Simon, *Ara Pacis Augustae*, 13; Sauron, "Le Message symbolique," 83, 87 ff., 101; La Rocca, *Ara Pacis Augustae*, 20; Zanker, *Power of Images*, 179–83; and most recently Holliday, "Time History, and Ritual," 544–45, 554–56. Only Galinsky, "Venus, Polysemy, and the Ara Pacis Augustae," 464–65, has remained circumspect with regard to L'Orange's thesis.

5. For evidence on the public performance of Vergil's poetry, including the Eclogues, see Suetonius, *Life of Vergil* (Loeb Classical Library Edition), *Suetonius*, tr. J. C. Rolfe, London and New York, 1925, vol. 2, 464ff., sections 26–29 and 32. I am indebted to C. J. Herington for this reference.

6. Alföldi, *"Redeunt Saturnia Regna*, II: An Iconographic Pattern Heralding the Return of the Golden Age in or around 139 B.C.," *Chiron*, 3, 1973, 131–42; idem, *"Redeunt Saturnia Regna*, IV: Apollo und die Sibylle in der Epoche der Bürgerkriege," *Chiron*, 5, 1975, 165–92.

7. Hoffmann, *Sibyllinischer Bücher in Rom*, 10 and 12–26; Gagé, *Apollon romain*, 130–39, and 421–44.

8. See Gatz, *Weltalter, goldene Zeit*, 90, who stresses that the return of the Golden Age is not attested in Classical literature before Vergil. On the debt to Hesiod and Aratos,

see H. C. Baldry, "Who Invented the Golden Age," *Classical Quarterly*, n.s. 1–2, 1951–52, 82–92, esp. 88–89; A. Wallace-Hadrill, "The Golden Age and Sin in Augustan Ideology," *Past and Present*, 95, 1982, 20; and du Quesnay, "Vergil's Fourth Eclogue," 41–42.

9. On these concepts and their impact upon Greek and Roman thought, see Trompf, *The Idea of Historical Recurrence in Western Thought*, 4–115 and 200–204.

10. See Trompf, *Historical Recurrence*, 76–77, Gatz, *Weltalter, goldene Zeit*, 108–10; Günther, "Politisch-ideolologische Kampf," 218ff.

11. Plato, *Timaeus*, 39 C–D; Cicero, *De Natura Deorum*, II, 51–52; Censorinus, *de natali*, Ch. 18; B. L. van der Waerden, "Das grosse Jahr und die ewige Wiederkehr," *Hermes*, 80, 1952, 129–30; B. Sticker, "Weltzeitalter und astronomische Perioden," *Saeculum*, 4, 1953, 241–49; M. Eliade, *The Myth of the Eternal Return*, New York, 1954, 122; R. van den Broek, *The Myth of the Phoenix according to Classical and Early Christian Traditions*, Leiden, 1972, 71–72.

12. Van den Broek, *Myth of the Phoenix*, 75 and 103–104; cf. Eliade, *Eternal Return*, 87. The account of Manilius's treatise is preserved in Pliny, *Natural History*, X, 3–5. Berossos's work is known only from the disparate quotations in later authors; see F. Jacoby, *Die Fragmente griechischen Historiker*, IIIC,1, Leiden, 1958, 364–95. The fragment connecting Berossos with the doctrine of the Great Year is preserved in Seneca, *Quaestiones Naturales*, III,29. Some have questioned the attribution to Berossos of the portions of this corpus that deal with cosmic return; see Jacoby, 395–97, W. G. Lambert, "Berossus and Babylonian Eschatology," *Iraq*, 38,2, 1976, 171–73, and A. Kuhrt, "Berossus' *Babyloniaka* and Seleucid rule in Babylonia," in A. Kuhrt and S. Sherwin-White, eds., *Hellenism in the East. The Interaction of Greek and Non-Greek Civilizations from Syria to Central Asia after Alexander*, Berkeley and Los Angeles, 1987, 36–44. However, the authenticity of the astronomical fragments within the *Babyloniaca* has been strongly and repeatedly upheld, first by P. Schnabel, *Berossus und die babylonisch-hellenistische Literatur*, Leipzig, 1923, 17–19, then by R. Drews, "The Babylonian Chronicles and Berossus," *Iraq*, 37,1, 1975, 50–54, and most recently by S. M. Burstein, *The Babyloniaca of Berossus*, Sources and Monographs from the Ancient Near East, 1,5, Malibu, 1978, 15–16 and 30–32. Also see A. Momigliano, *Alien Wisdom. The Limits of Hellenization*, London, New York, and Melbourne, 1975, 92, and even Kuhrt, 47–48 and 55–56.

13. Van den Broek, *Myth of the Phoenix*, 70, 76, and 106–107.

14. Simon, *Eirene und Pax*, 67. For the source on this part of the procession, see Athenaeus, *Deipnosophists*, 198 A–B. On Eniautos more generally, Harrison, *Themis*, 185–86, 369. Also see Brisson, "Rome et l'âge d'or," 930, who interprets the Dionysian symbolism of the procession in connection with the Golden Age theme.

15. *Aeneid*, VI, 789–94:

> hic Caesar et omnis Iuli
> progenies, magnum caeli ventura sub axem.
> hic vir, hic est, tibi quem promitti saepius audis,
> Augustus Caesar, Divi genus, aurea condet
> saecula qui rursus Latio regnata per arva
> Saturno quondam.

16. For the date, development, and background of the third book in this oracular corpus, see Fraser, *Alexandria*, 708–16; V. Nikiprowetzky, *La Troisième Sibylle*, Études juives, 9, Paris, 1970; and Collins, *The Sibylline Oracles of Egyptian Judaism*, 21–33 and 35–71. Nikiprowetzky, 195–225, argued for a date in the first century B.C., but Fraser and Collins have made a much stronger case for the preceding century; cf. H. W. Parke, *Sibyls and Sibylline Prophecy in Classical Antiquity*, London and New York, 2, 1988.

17. E. Norden, *Die Geburt des Kindes*, Leipzig, 1924, 50–58, 87, 90, 145ff.; Jeanmaire,

La Sibylle, 49–143, esp. 113–19; du Quesnay, "Vergil's Fourth Eclogue," 77–81; Nisbet, "Easterners and Westerners," 60–61, 66–68, and 71.

18. Collins, *Sibylline Oracles*, 25–32 and 101–102; Nikiprowetsky, *La Troisième Sibylle*, 88–112.

19. Parke, *Sibyls and Sibylline Prophecy*, 144. For the passage in Alexander (cf. *Oracula Sibyllina*, III,97–104), see F. Jacoby, *Die Fragmente der griechischen Historiker*, IIIA, Leiden, 1940, 111. On Alexander and Berossos, Burstein, *The Babyloniaca of Berossus*, 6, and 15, note 16.

20. Cf. *Works and Days*, 248–73.

21. *Works and Days*, 117: *Oracula Sibyllina*, III, 263:
 ἐσθλὰ δὲ πάντα τοῖσι μόνοις καρπὸν τελέθει
 τοῖσιν ἔην· καρπὸν δ' ἔφερε ζείδωρος ἄρουρα.
 ζείδωρος ἄρουρα.
 Works and Days, 101: *Oracula Sibyllina*, 271:
 πλείη μὲν γὰρ γαῖα κακῶν, πᾶσα δὲ γαῖα σέθεν πλήρης
 πλείη δὲ θάλασσα. καὶ πᾶσα θάλασσα.

On the close parallels between Hesiod and the imagery of this kind in other, and probably later, books of the *Oracula Sibyllina*, see Gatz, *Weltalter, goldene Zeit*, 79–83.

22. *Oracula Sibyllina*, III, 652–54:

καὶ τότ' ἀπ' ἠελίοιο θεὸς πέμψει βασιλῆα
ὃς πᾶσαν γαῖαν παύσει πολέμοιο κακοῖο,
οὓς μὲν ἄρα κτείνας οἷς δ' ὅρκια πιστὰ τελέσσας.

23. I. Engnell, *Studies in Divine Kingship in the Ancient Near East*, Uppsala, 1943, 4–15; J. Tondriau, *Le culte des souverains dans la civilisation gréco-romaine*, Tournai, 1957, 208–212; E. Otto, *Gott und Mensch nach der aegyptischen Tempel-inschriften der griechisch-römischen Zeit*, Abhandlungen der Heidelberger Akademie der Wissenschaften, Philosophische-historische Klasse, 1964, 63ff.; Collins, *Sibylline Oracles*, 41–43. The association of the king and justice of the sun god is well attested in the royal ideology of the ancient Near East as well, esp. on the stele of Hammurabi; H. Frankfort, *The Art and Architecture of the Ancient Orient*, Harmondsworth, 1985, 119–21 with notes 35–36, fig. 134. Also see Günther, "Politisch-ideologische Kampf," 236–37 and 239–40, who has emphasized the impact of the old oriental association of justice and the sun god on Greek theology.

24. Collins, *Sibylline Oracles*, 43.

25. Fraser, *Alexandria*, 711–13; Collins, *Sibylline Oracles*, 43–44.

26. Fraser, *Alexandria*, 696–704. Also see p. 150, and note 28 just below.

27. Theokritos, *Idylls*, XVI,88–97, and XVII,97–105.

28. On these decrees and their connection with the Aristeas letter, see W. Schubart, "Das hellenistische Königsideal nach Inschriften und Papyri," *Archiv für Papyrusforschung*, 12, 1936, 14.

29. E. Buchner, "Solarium Augusti und Ara Pacis," *RM*, 83, 1976, 319–65; reissued and amplified as *Die Sonnenuhr des Augustus*, Mainz, 1982, 7–55; idem, "Horologium Solarium Augusti," in *Kaiser Augustus und die verlorene Republik*, 240–45. More recently, M. Schutz, "Zur Sonnenuhr des Augustus am Marsfeld," *Gymnasium*, 97, 1990, 432–57, has questioned many of the details of Buchner's arguments and reconstruction, as well as his use of the archaeological evidence.

30. Eliade, *Eternal Return*, 130–37; Günther, "Politisch-ideologische Kampf," passim, esp. 220–59.

31. Fabricius and Schuchhardt, *Die Inschriften von Pergamon*, AVP, VIII, 1, 153–59, no. 246, lines 31–33.

32. Ibid., 158.

33. On possible Ptolemaic precedent of this kind, see A. Alföldi, "Die neue Welther-rscher der vierten Ekloge Vergils," *Hermes*, 65, 1930, 377–82; idem, *"Redeunt Saturnia Regna*, VI: From the Aion-Plutonios of the Ptolemies to the Saeculum Frugiferum of the Roman Emperors," in *Greece and the Eastern Mediterranean in Ancient History and Prehistory. Studies Presented to Fritz Sachermeyer*, Berlin and New York, 1977, 1–30; idem, *"Redeunt Saturnia Regna*, VII: Frugifer-Triptolemos im ptolemäisch-römischen Herrscherkult," 553–606.

34. On the special relation of the Cumaean Sibyl to Apollo, also see Tibullus, *Elegies*, II,5,15ff. For the coins with the Sibyl and the laurel, see note 41, below.

35. Petersen, *Ara Pacis Augustae*, 29; Toynbee, *Animals in Roman Life and Art*, 260. On the swan as symbol of Apollo's Golden Age, Simon, *Ara Pacis Augustae*, 28; Zanker, *Power of Images*, 182; Buchner, "Solarium Augusti," *RM*, 83, 1976, 347; Pollini, "Studies in Augustan Historical Reliefs," 127; idem, "The Acanthus of the Ara Pacis," 203–205, and 214. On the specifically oracular associations of the swan in this context, Pollini, 182; cf. Holliday, "Time, History, and Ritual," 545 and note 30.

36. Pollini, "The Acanthus of the Ara Pacis," 197–99. What remains uncertain, how-ever, is whether the Greeks and Romans definitely equated the palmette with the actual date-palm. The connection is plausible enough, but the term "palmette" is modern, and to the writer's knowledge, there are no primary sources where the Greek or Latin terms for the palm were applied to the ornamental form in question.

37. Plutarch, *Moralia*, 388 E; also see Pausanias, X,19,3; Euripides, *Bacchae*, 298ff. On the prophetic side of Dionysos, see Otto, *Dionysos*, 144; Jeanmaire, *Dionysos*, 187–98.

38. Jeanmaire, *Dionysos*, 188.

39. See H. Lewy, *Sobria Ebrietas*, Giessen, 1929, 43–44, 46–47, and 50–63; H. North, "Sophrosyne in Greek Literary Criticism," *Classical Philology*, 43, 1948, 13–16; Stewart, "Dionysos at Delphi," 214.

40. See pp. 102 and 122.

41. Crawford, *Roman Republican Coinage*, no. 411, pl. L, no. 23. On this sibylline coin-age, also see Alföldi, "Apollo und die Sibylle," 165–92, esp. 182 ff.

42. Nisbet, *"Easterners and Westerners,"* 65 and note 79; Jeanmaire, *Messianisme de Vir-gile*, 29. But see Brisson, "Rome et l'âge d'or," 950–66, who argues for the Dionysian aspect of the *puer* in the Eclogue.

43. Vergil, *Georgics*, II, 2–6:

> nunc te, Bacche, canam, nec non silvestria tecum
> virgulta et prolem tarde crescentis olivae.
> huc, pater, o Lenaee (tuis hic omnia plena
> muneribus, tibi pampineo gravidus autumno
> floret ager, spumat plenis vindemia labris).

44. *Georgics*, II, 143–44: sed gravidae fruges et Bacchi Massicus umor / implevere.

45. *Georgics* II, 173–74: salve, magna parens frugum, Saturnia Tellus, / magna virum.

46. *Georgics*, II, 532–40:

> hanc olim veteres vitam coluere Sabini
> hanc Remus et Frater, sic fortis Etruria crevit
> scilicet et rerum facta est pulcherrima Roma
> septemque una sibi muro circumdedit arces.
> ante etiam sceptrum Dictaei regis et ante
> impia quam caesis gens est epulata iuvencis,
> aureus hanc vitam in terris Saturnus agebat:

> necdum etiam audierant inflari classica, necdum
> impositos duris crepitare incudibus ensis.

As further evidence of the Dionysian emphasis that Vergil applied to the Golden Age here, Simon, "Mysterienvilla," 148, drew attention to the derivative poetry of Calpurnius Siculus and the *Carmina Einsidlensia* of the Neronian period. On the latter, also see the commentaries of R. Verdière, *T. Calpurnii Siculi, Der laude Pisonis et Bucolica et Annaei Lucani De Laude Caesaris Einsidlensia quae dicitur carmina*, Collection Latomus, 19, Brussels, 1954, 269–70; D. Korzeniewski, *Hirtengedichte aus neronischer Zeit*, Darmstadt, 1971, 115–16; and W. Huss, "Die Propaganda Neros," *L'Antiquité classique*, 47, 1978, 139–40. Also see Brisson, "Rome et l'âge d'or," 966–79.

47. Georgics, 385–96:

> nec non Ausonii, Troia gens missa, coloni
> versibus incomptis ludunt risuque soluto,
> oraque corticibus summunt horrenda cavatis,
> et te, Bacche, vocant per carmina laeta, tibique
> oscilla ex alta suspendunt mollia pinu.
> hinc omnis largo pubescit vinea fetu,
> complentur vallesque cavae saltusque profundi
> et quocumque deus circum caput egit honestum.
> ergo rite suum Baccho dicemus honorem
> carminibus patriis lancesque et liba feremus,
> et ductus cornu stabit sacer hircus ad aram,
> pinguiaque in veribus torrebimus exta colurnis.

48. On the concept of this vestigial Golden Age in later Greek philosophy and Roman literature, see K. Reckford, "Some Appearances of the Golden Age," *Classical Journal*, 54,2, 1958, 79–87, esp. 79–84.

49. *Aeneid*, VII, 202–204:

> neve ignorate Latinos
> Saturni gentem, haud vinclo nec legibus aequam,
> sponte sua veterisque dei se more tenentem.

50. Fourth Eclogue, 17: pacatumque reget patriis virtutibus orbem.

51. Horace, *Odes*, IV,15,25–32:

> nosque et profestis lucibus et sacris
> inter iocosi munera Liberi
> cum prole matronisque nostris,
> rite deos prius adprecati
>
> virtute functos more patrum duces
> Lydis remixto carmine tibiis
> Troiamque et Anchisen et almae
> progeniem Veneris canemus.

52. On Cybele's role here, see Wiseman, "Cybele, Virgil, and Augustus, " 120–22. On the parallel between Venus and Cybele as simultaneus protectors of Aeneas, see C. Bailey, *Religion in Vergil*, Oxford, 1935, 176–77; Galinsky, "Ara Pacis Augustae," 237; idem, *Aeneas, Sicily, and Rome*, 224–25.

53. Simon, "Mysterienvilla," 149. On the identity of the Great Mother with Rhea as wife of Kronos/Saturn, see Lucretius, *De Rerum Natura*, II, 629–39. The Roman goddess Ops was also identified as the wife of Saturn, although she did not figure at all within

the legend of the Golden Age, or in Augustan poetry generally, where the Trojan associations of the Great Mother made her a more effective substitute for Rhea; see P. Pouthier, *Ops et la conception divine de l'abondance dans la religion romaine jusqu'à la mort d'Auguste*, Bibliothèque des Écoles Françaises d'Athènes et de Rome, 242, Paris, 1981, 220–310, esp. 221–37, 296–98, and 303–306.

54. F. Bömer, "Kybele in Rom. Geschichte ihre Kultes als politisches Phänomen," *RM*, 71, 1964, 130–81; K. Schillinger, *Untersuchungen zur Entwicklung des Magna Mater-Kultes im Westen des römischen Kaiserreiches*, Universität Konstanz, 1979.

55. Crawford, *Roman Republican Coinage*, 500–501, no. 491, n. 2, pl. LVIII,18. For the identification of the obverse as the Sibyl, see A. Alföldi, "Der Einmarsch Octavians in Rom, August 43 vor Chr.," *Hermes*, 86, 1958, 481–82; idem, "Apollo und die Sibylle," 189.

56. Hanell, "Das Opfer des Augustus," 117–20; Simon, *Ara Pacis Augustae*, 28; Galinsky, "Ara Pacis Augustae," 239; idem, *Aeneas, Sicily and Rome*, 227–28.

57. Booth, "Venus on the Ara Pacis," 873–74, 876–77; Galinsky, "Ara Pacis Augustae," 233–35.

58. For Cybele with the poppies and wheat ears of Demeter in early imperial statuary and gems, see M. Bieber, *The Statue of Cybele in the J. Paul Getty Museum*, Getty Museum Publications, 3, 1968, 5, 12, pls. 2–3 and 27. At Sikyon, Pausanias, VI,2, describes a seated statue of Aphrodite by Kanachos in which the goddess holds not only her apple, but the poppies of Demeter. On Roman coins of 83 B.C. with Venus on the obverse, Ceres' grain ear appears on the reverse; Crawford, *Roman Republican Coinage*, no. 357, pl. XLVII; Galinsky, "Ara Pacis Augustae," 243, fig. 20a; idem, *Aeneas, Sicily, and Rome*, 238, fig. 164a.

59. *Aeneid*, VI, 781–94:

> en huius, nate, auspiciis illa incluta Roma. . .
> septemque una sibi muro circumdabit arces,
> felix prole virum: qualis Berecyntia Mater
> invehitur curru Phrygias turrita per urbes,
> laeta deum partu, centum complexa nepotes,
> omnis caelicolas, omnis supera alta tenentis.
> huc geminas nunc flecte acies, hanc aspice gentem
> Romanosque tuos. hic Caesar et omnis Iuli
> progenies, magnum caeli ventura sub axem.
> hic vir, hic est, tibi quem promitti saepius audis,
> Augustus Caesar, Divi genus, aurea condet
> saecula qui rursus Latio regnata per arva
> Saturno quondam.

60. On this explicit comparison between Roma and Cybele, see U. Knoche, *Vom Selbstverständnis der Römer*, Gymnasium, Beiheft, 2, Heidelberg, 1962, 165–66 (reissued from *Gymnasium*, 59, 1952, 324–29).

61. Galinsky, "Ara Pacis Augustae," 242; idem, *Aeneas, Sicily, and Rome*, 236–37.

62. Vergil, *Georgics*, I,7–8 and 147–49; Tibullus, II,3,68–70.

63. Tibullus, I,3,35 and 45:

> quam bene Saturno vivebant rege. . .
> ipsae mella dabant quercus.

Cf. Vergil, Fourth Eclogue, 30, where the oaks will yield honey in the coming Golden Age.

64. G. Orwell, *1984*, San Diego, New York, and London, 1949.

65. On this aspect of Vergil's use of the Golden Age theme, see Wallace-Hadrill, *Past and Present*, 95, 1982, 29–36.

66. Smethurst, "The Growth of the Roman Legend," 11–12; idem, "Cicero and Isocrates," 270; E. Burck, "Drei Grundwerte der römischen Lebensordnung (Labor, Moderatio, Pietas)," *Hermes*, 58,2, 1951, 160–83, esp. 163–64.

67. Cato's remarks here are recorded by Livy, XXXIV,4,3–4. See Pollitt, "The Impact of Greek Art on Rome," 158–59; and Zanker, *Power of Images*, 23–24.

68. Pliny, *Natural History*, XXXIII,52, 148–49. Cf. Livy, XXXIX,6,7–XXXIX,7,5. Also see Astin, *Cato the Censor*, 76. Pliny, XXXIII,150, makes the same point concerning the impact of the spoils from the fall of Corinth and Carthage.

69. Livy, XXV,40,1–3; the translation is taken from Pollitt, "The Impact of Greek Art on Rome," 158.

70. See Pollitt, "The Impact of Greek Art on Rome," 158.

71. Pollitt, "The Impact of Greek Art on Rome," 159.

72. North, *Sophrosyne. Self-Knowledge and Self-Restraint in Greek Literature*, 273–75. For a detailed treatment of famous Romans from the period of the Early Republic and the Punic Wars as exempla of the old morality, see M. Rambaud, *Cicéron et l'histoire romaine*, Paris, 1953, 27–35.

73. North, *Sophrosyne*, 285–290; F. Klingner, "Über die Einleitung des Historien Sallusts," *Hermes*, 63, 1928, 165–92; Reckford, "Some Appearances of the Golden Age" (as in note 48 above), 81; A. J. Woodman, *Rhetoric in Classical Historiography. Four Studies*, London and Sydney, 1988, 124–34.

74. North, *Sophrosyne*, 293–97. See especially *Odes* I,20; I,22; II,15; III,1; III,6; III,16; and *Epode* II.

75. On Vergil's debt to Cato's *De Agricultura* here, see Burck, "Drei Grundwerte" (as in note 66 above), 165–66 and 179.

76. F. Brown, *New Soundings on the Regia: The Evidence for the Early Republic*, Fondation Hardt, Entretiens, Geneva, 1967, 57ff.; idem, "La protostoria della Regia," *Rendiconti della Pontificia Accademia Romana di Archeologia*, 47, 1974–75, 15; F. Coarelli, *Il Foro Romano. Periodo archaico*, Rome, 1983, 57–67, esp. 62–64, 60, fig. 16; I. Iacopo, "Documentazione archeologica sulla Regia," in I. Dondero and P. Pensabene, eds., *Roma repubblicana fra il 509 e il 270 A.C.*, Rome, 1982, 37–46, figs. 6,7, and 15. For the Athenian building, J. M. Camp, *The Athenian Agora. Excavations in the Heart of Athens*, London, 1986, 44, fig. 27.

77. On the Capitoline temple, see F. C. Giuliani, "Architettura e tecnica edilizia," in Dondero and Pensabene, eds., *Roma repubblicana*, 29–31, figs. 2–3. On the sculpture by Vulca, see Pliny, *Natural History*, XXXV,157, and M. R. Di Mino, "Note sulla decorazione coroplastica a Roma dal VI al IV secolo A.C.," in Dondero and Pensabene, 70 and 72.

78. Pliny, *Natural History*, XXV,154 and XXXV,15; Le Bonniec, *Le culte de Cérès*, 256–63.

79. Andrén, *Architectural Terracottas from Etrusco-Italic Temples*, 343, no. 371, 409, no. 442, pls. 104 and 126; T. Gantz, "Terracotta Figured Friezes from the Workshop of Vulca," *Opuscula romana*, X:1, Stockholm, 1974, 1–9; M. Cristofani, ed., *La grande Roma dei Tarquini. Roma, Palazzo delle esposizioni, 12 giugno–30 settembre 1990, Catalogo della Mostra*, Rome, 1990, 92–95, 115–30, and 199–205; Di Mino, "Note sulla decorazione coroplastica a Roma," in Dondero and Pensabene, eds., *Roma repubblicana*, 73 and tav. 14,2. The latter article provides a useful survey of sculpture in Rome from late Archaic to Hellenistic times.

80. O. Brendel, *Etruscan Art*, Harmondsworth, 1978, 355, note 8; T. Dohrn, *Die ficoronische Ciste in der Villa Giulia in Rom*, Monumenta artis romanae, vol. XI, Berlin, 1972, 45–46; G. Foerst, *Die Gravierungen der praenestinischen Cisten*, Archaeologia, 7, Rome, 1978, 49–50.

81. Also see Smethurst, "Growth of the Roman Legend," 9–10, on the additional textual evidence for a more cosmopolitan aspect or outlook of Roman legal and religious institutions at this time.

82. G. E. R. Lloyd, *Polarity and Analogy; Two Types of Argumentation in Early Greek Thought*, Cambridge, 1966.

83. Here see Smethurst, "Growth of the Roman Legend," 11–12, and especially the chapter "Cato and the Greeks," in the recent study by Astin, *Cato the Censor*, 157–81; for the specific Greek sources behind Cato's *Origines*, see 222 and 227–29. Also see C. W. Wooten, *Cicero's Philippics and their Demosthenic Model: The Rhetoric of Crisis*, Chapel Hill, N.C., 1983, 16, 19–20, 168–69, and 171.

84. Smethurst, "Cicero and Isocrates," 262–320, esp. 297–306. The best illustration of Isokrates here is his *Panegyrikos* (IV), esp. 75–105. On this text and its intent, also see Jaeger, *Paideia: The Ideals of Greek Culture*, vol. 4, 74–83.

85. Cf. Cicero, *De Officiis*, I,42,150–51; *Pro Sexto Roscio*, XVIII,50–51.

86. Xenophon *Oikonomikos*, IV,2–25; IV,4; and V,1–13. On the parallels between the Greek and Roman versions of this theme, see A. C. van Geytenbeek, *Musonius and Greek Diatribe*, Assen, 1963, 129–32. On Xenophon's farmer-soldier ideal, see Jaeger, *Paideia*, vol. 4, 165–81.

87. On these and other borrowings in Cato, see Astin, *Cato the Censor*, 162, 178, and 188. Varro makes specific reference to Xenophon's writing on agriculture at the beginning of his own treatise; *Res Rusticae*, I,1,8.

88. See R. Hoïstad, *Cynic Hero and Cynic King*, Uppsala, 1948, 77–83; Jaeger, *Paideia*, vol. 3, 160–61 and 166. The model for Persian achievement and decline here seems to elaborate upon the closing scene of Herodotos's *History*, where Kyros admonished the Persian nobility not to succumb to the softness and luxury of the lands that they conquered, but to adhere to the hard discipline of their heritage, lest they themselves be conquered in turn.

89. Cicero, Letter to Quintus, frag. I,123; cf. Hoïstad, *Cynic Hero*, 78, note 3, and 82.

90. For the king as "gardener" or *nukarribu*, see the "Legend of Sargon of Akkad" in G. Widengren, *The King and the Tree of Life in Ancient Near Eastern Religion (King and Saviour IV)*, Uppsala Universitets Arsskrift, 1951:4, Uppsala, 1951, 15; on the king as royal farmer, S. M. Paley, *King of the World. Ashur-nasir-pal II of Assyria 883–859 B.C.*, Brooklyn, N.Y., 1976, 22–24.

91. For specific passages in Cicero, see *Republic*, I,34; II,51; V,5; V,8; VI,1; and VI,13; *De Oratore*, I,211; *Laws*, III,32; *De Domo*, 66; and *Philippics*, 14,17. On the meaning or sense of these terms, see C. N. Cochrane, *Christianity and Classical Culture*, Oxford, 1944, 59ff.; Smethurst, "Cicero and Isocrates," 291–92; North, *Sophrosyne*, 282–83.

92. See *The Commonwealth. Marcus Tullis Cicero*, tr. and introduction by G. H. Sabine and S. B. Smith, Columbus, 1929, 95–98.

93. A. E. Douglas, *Cicero, Greece, and Rome*, Oxford, 1968, 32; Woodman, *Rhetoric in Classical Historiography*, 137; and Eder, "Augustus and the Power of Tradition: The Augustan Principate as Binding Link Between Republic and Empire," in Raaflaub and Toher, eds., *Between Republic and Empire*: 71–122, esp. 79–80, 91, and 100.

94. Xenophon, *Agesilaos*, 5,2–3; 10,1; and 11,11; Isokrates, *Evagoras*, 23, 45, 49. On the king as paradigm, see *Agesilaos*, 10,2; *Kyropaideia*, VIII,1,30; and Isokrates, *Nikokles*, 43–44. Concerning Isokrates' views on kingship, see North, *Sophrosyne*, 145–47; on the ethical conception of kingship in Greek thought more generally, see Jaeger, *Paideia*, vol. III, 95–100. For the more charismatic and militaristic aspects of Greek kingship, see H.-J. Gehrke, "Der siegreiche König. Überlegungen zur hellenistischen Monarchie," *Archiv für Kulturgeschichte*, 64,2, 1982, 247–77.

95. Xenophon, *Kyropaideia*, VIII,1,22; cf. Musonius, VIII, and the fragments of Archytas and Diotogenes preserved in Stobaeus, IV,1, 132, 135–38; IV,5,61; and IV,7,61.

See R. Goodenough, "The Political Philosophy of Hellenistic Kingship," *Yale Classical Studies*, I, 1928, 59–60 and 63–65; L. Delatte, *Les traités de la royauté d'Ecphante, Diotogène et Sthenidas*, Bibliothèque de la Faculté de Philosophie et Lettres de L'Université de Liége, fasc. 97, Paris, 1942, 245; and A. Jagu, *Musonius Rufus. Entretiens et fragments. Introduction, traduction et commentaire*, Hildesheim and New York, 1979, 45, note 50.

96. Pseudo-Ekphantos, Stobaeus, IV,7,64; see Delatte, *Traités de la royauté*, 177–81.

97. Goodenough, "Hellenistic Kingship," 59; cf. E. Kantorowicz, "Deus per Naturam, Deus per Gratiam. A Note on Medieval Political Theory," *Harvard Theological Review*, 45, 1952, 267–68. On the actual date of these texts, see Delatte, *Traités de la royauté*, 87, 108, and 284–86.

98. The relevant sections are 209–11, 215, 222, and 279–80. On the date and content, see Fraser, *Alexandria*, 696–700.

99. See especially Cicero's *Philippics* II,25,63; III,3,9; III,11,28–29; III,13,35; and XIII,8,18; cf. A. Roberts, *Mark Antony. His Life and Times*, Upton-on-Severn, 1988, 292, and for the Attic precedent, Wooten, *Cicero's Philippics and their Demosthenic Model*, passim.

100. Trompf, *Historical Recurrence*, 4–6.

101. Sabine and Smith, *On the Commonwealth*, 96; North, *Sophrosyne*, 282.

102. Trompf, *Historical Recurrence*, 56.

103. Trompf, *Historical Recurrence*, 51–53.

104. Woodman, *Rhetoric in Classical Historiography*, 131.

105. On Augustus and Romulus, above, Chapter III, p. 90, with note 10; Grant, *Roman Myths*, 110–13; and and D. F. Kennedy, "'Augustan' and 'Anti-Augustan': Reflections on Terms of Reference," in A. Powell, *Roman Poetry and Propaganda in the Age of Augustus*, Bristol, 1992, 42–45. The fifth-century Athenian leader Kimon cultivated a similar analogy or affiliation with the mythic king Theseus as his precedent or analog; see A. Podlecki, "Cimon, Skyros, and Theseus' Bones," *JHS*, 91, 1971, 141–43; C. Delvoye," Art et politique à Athènes à l'époque de Cimon," in *Le Monde grec. Hommages à Claire Préaux*, Brussels, 1975, 803–807; J. N. Davie, "Theseus the King in Fifth-Century Athens," *Greece and Rome*, 29, 1982, 25–34;A. Molle, *Étude de l'iconographie de Thesée en relation avec la politique de Cimon*, Paris, 1968; W. den Boer, "Theseus. The Growth of a Myth in History," *Greece and Rome*, 16, 1969, 3,7 and 9; R. J. Connor, "Theseus in Classical Athens," in A. Ward, ed., *The Quest for Theseus*, New York, 1970, 157–67.

106. On the analogies between Augustus and Numa, also see Grant, *Roman Myths*, 141–42; and Kennedy, "'Augustan' and 'Anti-Augustan,'" in Powell, *Roman Poetry and Propaganda*, 42–45.

107. Grant, *Roman Myths*, 141.

108. Moretti, *Ara Pacis Augustae*, 215–17; Simon, *Ara Pacis Augustae*, 24; Koeppel, "Ara Pacis Augustae," 110–11; F. Canciani, "Aineias," in *LIMC*, I, Munich, 1981, 391, no. 165; Kleiner, *Roman Sculpture*, 93 and 96. Elaborating upon earlier opinion, Rose, "'Princes' and Barbarians on the Ara Pacis," 462–63, has now identified the figure behind Aeneas as his Trojan companion Achates; he sees Iulus as the sacrificial attendant immediately in front of Aeneas.

109. Moretti, *Ara Pacis Augustae*, 241–44; Simon, *Ara Pacis Augustae*, 24–25; Dulière, *Lupa Romana. Recherches d'iconographie et essai d'interpretation*, 96–101; Koeppel, "Ara Pacis Augustae," 108–109; Zanker, *Power of Images*, 205–206; Kleiner, *Roman Sculpture*, 96.

110. Simon, *Ara Pacis Augustae*, 25. For typical examples, see J. P. Small, "Faustulus," in *LIMC*, IV, Munich, 1988, 130–32; E. Strong, "Sulle tracce della lupa romana," *Scritti in honore di Bartolomeo Nogara*, Vatican City, 1937, 475–500, tav. LXVIII; Moretti, *Ara Pacis Augustae*, 243, fig. 177, 261–62, figs. 185–86; Zanker, *Power of Images*, 205, fig. 158.

111. For the Parthenon frieze, Boardman, *Greek Sculpture. The Classical Period*, fig. 94, figs. 22 and 45; for the Altar of the Lares, Moretti, *Ara Pacis Augustae*, 260, fig. 183; P. Zanker, "Der Larenaltar im Belvedere des Vaticans," *RM*, 1969, 205–18, esp. 214–15; E. L. Harrison, "The Seated Figure on the Belvedere Altar," *RA*, 1971, 71–73; A. Alföldi, *Die zwei Lorbeerbaume des Augustus*, Bonn, 1973, 30–31; Canciani, "Aineias," *LIMC*, I, 391, no. 164; Hölscher, in *Kaiser Augustus und die verlorene Republik*, 394–96, no. 223; Kleiner, *Roman Sculpture*, 102–103. On the connection between the Lares Altar and the Lupercal panel, see Dulière, *Lupa Romana*, 98, and fig. 89.

112. Berczelly , "Ilia and the Divine Twins," 99 and 109–10.

113. Grant, *Roman Myths*, 105 and 108–109, has emphasized the significant role of Numitor within the Romulus myth.

114. Berczelly, "Ilia and the Divine Twins," 100–106. On the rarity of Mars in Lupercal scenes and the innovative aspect of the Ara Pacis version, see Dulière, *Lupa Romana*, 101 and 134–35; for the few exceptions, which post-date the Ara Pacis, see E. Simon, "Ares/Mars," in *LIMC*, II, Munich 1984, 551–52, nos. 408, 410, 412–413. On the so-called "Ara Casali" in the Vatican, Mars looks on as the twins are first abandoned in the Tiber; see E. Simon in W. Helbig, *Führer durch die öffentlichen Sammlungen klassischer Altertümer in Rom. I, Die Päpstlichen Sammlungen im Vatikan und Lateran*, Fourth Edition, revised by H. Speier, Tübingen, 1963, I, 216–18, no. 268; Dulière, vol. 2, 20, no. 38 and fig. 99. For examples of Mars and Ilia, Berczelly, "Ilia and the Divine Twins," fig. 6; Aichholzer, *Darstellungen römischer Sagen*, University of Vienna, 1983, 68–76, Abb. 141–72.

115. For Athena accompanying the heroes, see K. Schefold, *Myth and Legend in Early Greek Art*, New York, 1966, figs. 16 and 17; J. Boardman, *Athenian Black Figure Vases*, New York, 1974, fig. 68; idem, *Athenian Red Figure Vases. The Archaic Period*, fig. 26. For Apollo in the Olympia pediment see A. F. Stewart, "Pindaric *Dike* and the Temple of Zeus at Olympia," *Classical Antiquity*, 2,1, 1983, 133–44; and N. D. Tersini, "Unifying Themes in the Sculpture of the Temple of Zeus at Olympia," *Classical Antiquity*, 6,1, 1987, 146–52. On Vanth and Charu in painting from the François Tomb at Vulci, F. Coarelli, "Le pitture della Tomba François a Vulci: una proposta di lettura," *Dialoghi di archeologia*, ser. 3, 1, 1983,2, 43–69, esp. 48 and figs. 5–6; Foerst, *Die Gravierungen der praenestinischen Cisten*, 52–53, with references to earlier scholarship; and R. Brilliant, *Visual Narratives. Storytelling in Etruscan and Roman Art*, Ithaca and London, 1984, 33–34. On the Altar of the Augustan Lares see Zanker, "Der Larenaltar" (as in note 111 above), 215.

116. See Strong, "Sulle tracce della lupa romana," tav. LXVIII,1–2; LXX,1; LXXI, 1–4; and LXXII–LXXIII; Aichholzer, *Darstellungen römischer Sagen*, Abb. 229–30, 234, and 237–60; Dulière, *Lupa Romana*, figs. 29–33, 60–64, and 242–54; R. Weigel, "Lupa Romana," in *LIMC*, VI, Munich, 1992, 293–96, nos. 3–4, 9–10, 12–13, 20, 22, 28–30.

117. Zanker, *Power of Images*, 205–206.

118. On the Forum statues, see Ovid, *Fasti*, V, 563–66; Zanker, *Forum Augustum*, 16–17; idem, *Power of Images*, 201–203; Canciani, "Aineias," *LIMC*, I, 390, no. 146. On the analogy to the west panels of the Ara Pacis, *Power of Images*, 203.

119. *Historia Augusta*, Alexander Severus, 28,6; see Zanker, *Forum Augustum*, 14 with note 65 and Falttafel A; idem, *Power of Images*, 194, 210–11, fig. 149.

120. Zanker, *Forum Augustum*, 25; idem, *Power of Images*, 214.

121. Toynbee, "The Ara Pacis Augustae," 155; Hanell, "Das Opfer des Augustus," 74 and 93; Simon, *Ara Pacis Augustae*, 24; cf. N. Hannestad, *Roman Art and Imperial Policy*, Aarhus, 1986, 73–74, and Zanker, *Power of Images*, 203–207; on Agrippa and Iulus, see Rose, "'Princes' and Barbarians on the Ara Pacis," 462–67. On Augustus and the *pietas* of Aeneas, also see R. Gordon, "The Veil of Power: Emperors, Sacrificers and Benefactors," in M. Beard and J. North, eds., *Pagan Priests. Religion and Power in the Ancient*

World, Ithaca, N.Y., 1990, 209–11. Some have also suggested an analogy between Gaius and Lucius and the two infants in the Tellus relief; Berczelly, "Ilia and the Divine Twins, 145–46; Rose, 467; Galinsky, "Venus, Polysemy, and the Ara Pacis Augustae, 458–59. M. D. Fullerton, "The *Domus Augusti* in Imperial Iconography of 13–12 B.C.," *AJA*, 89, 1985, 473–81, suggests less convincingly that the twins in the Lupercal panel prefigured the two young Caesars, with Augustus himself corresponding to Mars. On the paired comparison of Aeneas and Romulus to Augustus, also see the new interpretation of the Sorrento base by B. O. Aichler, "The Sorrento Base and the Figure of Mars," *Archaeological News*, 15,1, 1990, 11–16.

122. For the wall paintings in Pompeii which presumably reflect the armored statues of Aeneas and Romulus in the Forum Augustum, see Zanker, *Forum Augustum*, 17, Abb. 40–41; idem, *Power of Images*, 202–203, fig. 156. Zanker too emphasizes the more active, martial, or triumphal presentation for Aeneas and Romulus in the Forum; cf. E. S. Gruen, "Augustus and the Ideology of War and Peace," in R. Winkes, ed., *The Age of Augustus*, Louvain-La-Neuve and Providence, R.I., 1986, 60–61; idem, "The Imperial Policy of Augustus," in Raaflaub and Toher, *Between Republic and Empire*: 1990, 412–13.

123. Simon, *Ara Pacis Augustae*, 25. T. Tracy ("Who Stands Behind Aeneas on the Ara Pacis," in *Daidalikon. Studies in Memory of Raymond V. Schoder, S. J.*, Wauconda, Ill., 1989, 375–76) has has taken this further, identifying the figure behind Aeneas as his mother, Venus, although, in the writer's opinion, not convincingly.

124. For the inscription on which the hymn is preserved, G. Henzen, *Acta Fratrum Arvalium*, Berlin, 1874, CCIV; for an analysis of the language and content, E. Norden, *Aus altrömischen Priesterbüchern*, Lund, 1939, 111–244; Radke, *Götter Altitaliens*, 202–203. For a translation, E. H. Warmington, *Remains of Old Latin* (Loeb Classical Edition), vol. 4, London, 1967, 250–53.

125. Cf. the bloodless offering to Mars for the health of the cattle described by Cato earlier in Chapter LXXXIII. Also see A. Kilgour, "The Ambarvalia and the Sacrificium Deae Diae," *Mnemosyne*, ser. 3, 6, 1938, 226–27.

126. Here see esp. G. Dumézil, *Archaic Roman Religion*, tr. P. Krapp, Chicago and London, 1966, 213–41, who favors the more warlike view but reviews the debate thoroughly.

127. U. W. Scholz, *Studien zum altitalischen und altrömischen Marskult und Marsmythos*, Heidelberg, 1970, esp. 45 and 78–79.

128. Kilgour, "Ambarvalia" (as in note 125 above), 235–36.

129. Moretti, *Ara Pacis Augustae*, 155 and 242. Berczelly, "Ilia and the Divine Twins," 100, misidentifies these branches as oak or part of an oak tree.

130. Moretti, *Ara Pacis Augustae*, 242. Koeppel, however, "Ara Pacis Augustae," doubts that the four fragments with the laurel were part of this panel because their relief is lower than that of the adjacent figure of Mars. The laurel fragments are indeed small and shallow; they do not extend all the way through the wall to the interior surface of the enclosure, so they cannot be fixed within the panel on the basis of the garland decoration inside the monument like the righthand figure of "Faustulus." Yet all four of these fragments fit together continuously, and Moretti states explicitly that the lowermost fragment makes a join with the left shoulder of Mars; *Ara Pacis Augustae*, 155, cf. figs. 110 and 124.

131. Julius Obsequens, 19,78.

132. Julius Obsequens, 19,78. Ovid, *Fasti*, III,139–40, also documents the placing of laurel on the doors of the Regia and the Curia as well in honor of Mars on the Calends of March.

133. L. Deubner, "Zur römischen Religionsgeschichte," *RM*, 36, 1921, 17–23; G. Dumézil, "Les cultes de la *Regia*, les trois fonctions et la triade Jupiter Mars Quir-

inus," *Latomus*, 12, 1953, 128–39; idem, *Archaic Roman Religion*, 173–74, 207; Scholz, *Marskult*, 26–28; Coarelli, *Il Foro Romano*, 64.

134. Scheid, *Les Frères arvales. Recrutement et origine sociale sous les empereurs julio-claudiens*, 352–60; idem, *Romulus et ses frères. Le college des frères arvales, modèle du culte public dans la Rome des empereurs*, Bibliothèque des Écoles Françaises d'Athènes et de Rome, fasc. 275, Rome, 1990, 13–19; E. Olhausen, "Über die römischen Ackerbrüder," *ANRW*, 16,1, 1979, 820–32; cf. Aulus Gellius, VII,7,8; Pliny, *Natural History*, XVIII,6.

135. Scheid, *Les Frères arvales*, 361–64.

136. Scheid, *Les Frères arvales*, 335–42; idem, *Romulus et ses frères*, 677–99.

137. J. Gagé, "Les sacerdoces d'Auguste et ses réformes religieuses," *Mélanges d'archéologie et d'histoire*, 48, 1931, 98–99.

138. Scheid, *Les Frères arvales*, 343–64; idem, *Romulus et ses frères*, 690–94; cf. R. Syme, *Some Arval Brethren*, Oxford, 1980, 2.

139. Henzen, *Acta Fratrum Arvalium*, XLII; Scott-Ryberg, "Rites of the State Religion," 97, note 35; Scheid, *Romulus et ses frères*, 424–26.

140. Zanker, *Forum Augustum*, 17–18; idem, *Power of Images*, 201–203.

141. Pollini, "Studies in Augustan 'Historical' Reliefs," 88 ff. and pl. VI; cf. Hannestad, *Roman Art and Imperial Policy*, 68.

142. Hannestad, *Roman Art and Imperial Policy*, 73.

143. Here see Alföldi, "Frugifer-Triptolemos," 570–78, with a review of earlier opinion.

144. For the Telephos frieze, see Pollitt, *Art in the Hellenistic Age*, 198–205, figs. 213 and 218, and Chapter III, note 16 above. Deubner, "Pergamon und Rom," 95–96, Abb. 1–2, stressed the analogy between the Telephos and Romulus myths in Hellenistic and Roman art, although not specifically with reference to the Great Altar and the Ara Pacis. For the Campana plaques with the Lupercal and Telephos, see von Rohden and Winnefeld, *Römische Tonreliefs*, vol. IV, 96–97, Taf., CXXVII, 1–2; Dulière, *Lupa Romana*, vol. 1, 101 and 135 with fig. 80, and vol. 2, 67–68, cat. no. 184; Small, "Faustulus," *LIMC*, IV, 131–32, no. 3.

145. The bibliography on the Stoa and its paintings is large; for more recent discussions, see E. Thomas, *Mythos und Geschichte. Untersuchungen zum historischen Gehalt griechischer Mythendarstellungen*, Cologne, 1976, 39–40; T. Hölscher, *Griechische Historienbilder des 5. und 4. Jahrhunderts vor Chr.*, Würzburg, 1973, 70–73, 77–78; and D. Castriota, *Myth, Ethos and Actuality. Official Art in Fifth Century B.C. Athens*, Madison, Wi., 1992, 78–89.

146. Pollitt, *Hellenistic Age*, 90–93.

147. Kraus, *Ranken*, 16, 65, and 68.

148. Reinsberg, *Toreutik*, 67–68, 303–304, cat. no. 20, Abb. 33. This cast seems to be a more direct parallel for the tendril panels than the Attic marble reliefs adduced by Sauron, "Les Modèles funéraires," 183–209. On the transition from Classical tendril ornament with simpler spiral volutes to the type with internal blossoms, see Riegl, *Problems of Style*, 207–24.

149. Although it too appears similar to the long friezes, the well-known Hildesheim Krater displays the same structure as the Chertomlyk amphora; Pernice and Winter, *Der Hildesheimer Silberfund*, Taf. XXXII–XXXIII; U. Gehrig, *Hildesheimer Silberfund in der Antikenabteilung Berlin*, Berlin, 1967, Taf. 2–4; Zanker, *Power of Images*, 185, fig. 144. The structure of the pattern is especially clear in the unrolled drawings: Walter-Karydi, "Die Entstehung der Grotteskenornamentik," Taf. 40,2; E. Künzl, "Romanisierung am Rhein," in *Kaiser Augustus und die verlorene Republik*, 576–77, no. 403. Tendril patterns on various other toreutic works and mosaics of the Hellenistic period also utilized a radial, circular arrangement to fill larger flat fields and the roughly conical surfaces of

vessels. See the late Hellenistic silver rhyton in the Getty Museum: Pfrommer, *Metalwork from the Hellenistic East*, 192, cat. no. 74; the Mit Rahine molds and the shallow bowls from Tarentum and Chertomlyk: Byvanck-Quarles van Ufford, "Décoration à rinceaux," figs. 5, 7, and 15, and Reinsberg, *Toreutik*, Abb. 17, 20, and 22; and for mosaics: Salzmann, *Antiken Kieselmosaiken*, cat. nos. 118 and 130, Taf. 20 and 39. One pavement from Pella substitutes rotational symmetry as an alternative; Salzmann, cat. no. 105, Taf. 38.

150. On the textile, see L. Stephani, "Erklärung der einiger Kunstwerke der Kaiserlichen Ermitage und anderen Sammlungen," *Compte rendu de la Commission Impériale Archéologique, St. Petersbourg*, 1878–79, Atlas, pl. III, no. 2; E. Minns, *Scythians and Greeks*, Cambridge, 1913, fig. 113; Byvanck-Quarles van Ufford, "Décoration à rinceaux," 42, fig. 3; Richter, *Handbook of Greek Art*, 380, fig. 506.

151. On the distinction between continuous and intermittent tendril compositions, see the glossary entries for these terms on pp. 399 and 401–402 of Riegl's *Problems of Style*, with citations for the relevant portions of Riegl's text.

152. For fig. 89b, Naples 3244, and the closely related Berlin F 3290, see E. Pernice, *Die hellenistische Kunst in Pompeji. IV Geffässe und Geräte aus Bronze*, Berlin and Leipzig, 1925, 15, Abb. 21; P. Jacobsthal, *Ornamente Griechischer Vasen. Aufnahmen/Beschreibungen and Untersuchung*, Berlin, 1927, Taf. 111 a and d; *RVA* 426, nos. 58–59. For Attic and closely related Apulian examples with acanthusized tendrils, see B. Shefton, "The Krater from Baksy," in D. Kurtz and B. Sparkes, eds., *The Eye of Greece. Studies in the Art of Athens*, Cambridge, 1982, 149–81, figs. 4 and 43d; idem, "The Baksy Krater Once More and Some Observations on the East Pediment of the Parthenon," in *Kotinos. Festschrift für Erika Simon*, H. Froning, T. Hölscher, and H. Mielsch, eds., Mainz, 1992, 241–51, pl. 56,2; K. Schauenburg, "Göttergeliebte," *Antike und Abendland*, 10, 1961, 77–79, Taf. 1, Abb. 1; *RVA* 396, no. 11.

153. On this distinction between the flatter and more spatial types of tendril ornament in Classical and Hellenistic times, see Riegl, *Problems of Style*, 178–87, 207–20, and 363–67, annotations a–m.

154. See Kraus, *Ranken*, 18 and 51, who tended to play down the role of metalwork or textiles in favor of marble relief precedents. His approach was wholly supported by Börker, "Neuattisches und pergamenisches," passim. But see Byvanck-Quarles van Ufford, "Décoration à rinceaux," esp. 42–47 ands 50–53, who reasserted the possible impact of the minor arts on the Ara Pacis friezes.

155. For the mirror, see Chapter II, note 27. On the Roman collection of Greek bronze, see Strabo, *Geography*, VIII,6,23, and for Greek silver, Pliny, *Natural History*, XXXIII,49–55,139–57.

156. See note 110 for Chapter I.

157. Galinsky, "Venus, Polysemy, and the Ara Pacis," 465; Coarelli, *Roma*, 3rd ed., 205.

158. On the Classical background of the Ara Pacis, see especially Kleiner, "The Great Friezes," 754–66; idem, *Roman Sculpture*, 92–93; and Hölscher, *Römische Bildsprache*, 34–35 and 46. On the Augustan preference for the Classical style and the moralizing propagandistic overtones of this choice, see Zanker, *Power of Images*, 239–63; idem, "Klassizismus und Archaismus. Zur Formensprache der neuen Kultur," in *Kaiser Augustus und die verlorene Republik*, 622–35; Hölscher, *Römische Bildsprache*, 33–49, 44–59; M. Kunze, "Ideologische und künstlerische Voraussetzungen des frühkaiserzeitlichen Klassizismus-Anfänge der klassizistichen Reliefkunst in Rom," *Wissenschaftliche Zeitschrift der Humboldt Universität zu Berlin*, 25,4, 1976, 489–97, esp. 492ff.; G. Gullini, *Il «classicismo» Augusteo: cultura di regime*, Rome, 1978; R. Brilliant, "Augustus and Hadrian: Classical and Classicizing Modes," in *Florilegium Columbianum. Essays in Honor of*

Paul Kristeller, New York, 1987, 23–28. Hölscher, 33–49 and 54–59, argues specifically that in Roman art classicism came to be applied as the appropriate mode for dignified, state ceremonial.

159. See Chapter III, note 16, above.

160. G. Koeppel, "Historical Relief Sculpture in the Age of Augustus," in R. Winkes, ed., *The Age of Augustus*, 98–106, esp. 95–99; cf. L. Banti, *Etruscan Cities and their Culture*, London, 1973, 82; B. M. Felletti Maj, *La tradizione italica nell'arte romana*, Rome, 1977, 93; M. Pallottino, *Etruscan Painting*, Geneva, 1952, 128; and P. J. Holliday, "Processional Imagery in Late Etruscan Funerary Art," *AJA*, 94, 1990, 82 and note 45.

161. Simon, *Ara Pacis Augustae*, 22. On the specifically imperial connotations of the laurel that evolved under the Principate, see Alföldi, *Die zwei Lorbeerbäume des Augustus*, 30–37.

Conclusion

1. Zanker, *Power of Images*, 57–65, esp. 63ff., 247–50, and the bibliography cited on 360–61. On the Atticism/Asianism polarity, also see Hölscher, *Römische Bildsprache*, 72–73; G. Kennedy, *The Art of Rhetoric in the Roman World*, Princeton, 1972, 96–99, 240–45, 350–55, 378–84.

2. Hölscher, *Römische Bildsprache*,15–16. Also see the articles by Mustili and Wallace-Hadrill cited in note 15 for Chapter III, above.

3. Hölscher, *Römische Bildsprache*, 11–12.

4. Hölscher, *Römische Bildsprache*, 13, 17, and 49–50.

5. O. J. Brendel, *Prolegomena to the Study of Roman Art*, New Haven and London, 1979, 160–61.

Selected Bibliography

Frequently Cited Sources

Adriani, A., *Divigazioni intorno ad una coppa paesistica del Museo di Alessandria*, Documenti e ricerche d'arte alessandrina, III–IV, Rome, 1959.

Aichholzer, P., *Darstellungen römischer Sagen*, University of Vienna, 1983.

Alföldi, A., 1973, "*Redeunt Saturnia Regna*, II: An Iconographical Pattern Heralding the Return of the Golden Age in or around 139 B.C.," *Chiron*, 3, 131–42.

———, 1975, "*Redeunt Saturnia Regna*, IV: Apollo und die Sibylle in der Epoche der Bürgerkriege," *Chiron*, 5, 165–92.

———, 1979, "*Redeunt Saturnia Regna*, VII: Frugifer-Triptolemos im ptolemäisch-römischen Herrscherkult," *Chiron*, 9, 553–606.

Allroggen-Bedel, A., *Maskendarstellungen in der römisch-kampanischen Wandmalerei*, Munich, 1974.

Alpert, R., "Die Entwicklung der Cistophoren und der Machtkampf zwischen Marc Anton und Octavian-Augustus," *Numismatisches Nachrichten Blatt*, 20, 1977, 238–50.

Altertümer von Pergamon, Deutsches Archäologisches Institut.

V, 1. G. Kawerau and T. Wiegand, *Die Paläste der Hochburg*, Berlin and Leipzig, 1930.

VII, 2. F. Winter, *Die Skulpturen mit Ausnahme der Altarreliefs, mit einem Beiträge von Jakob Schrammen*, Berlin, 1908.Z

VIII, 1. E. Fabricius and C. Schuchhardt, *Die Inschriften von Pergamon*, Berlin, 1890.

XI, 3. O. Ziegenhaus with G. de Lucca, *Das Asklepeion*, Berlin, 1981.

XI, 4. G. de Lucca, *Das Asklepeion*, Berlin, 1984.

XIII. C. H. Bohtz, *Das Demeter-Heiligtum*, Berlin, 1981.

Amelung, W. (with G. Lippold). *Die Sculpturen des Vaticanischen Museums*. Vols. I–III. Berlin, 1903–56.

Andreae, B., *The Art of Rome*, New York, 1977.

Astin, A. E., *Cato the Censor*, Oxford, 1978.

Bellinger, A., "The Immortality of Alexander and Augustus," *Yale Classical Studies*, 15, 1957, 93–100.

Berczelly, L., "Ilia and the Divine Twins," *Acta Institutae Romanae Norvegicae*, 5, 1985, 89–149.

Beyen, H. G., *Die pompejanische Wanddekoration vom zweiten bis zum vierten Stil*, The Hague, 1938.

Bianchi Bandinelli, R., *Rome: The Center of Power*, New York, 1970.

Bohtz, C. H., *Das Demeter-Heiligtum*, AVP, XIII, Berlin, 1981.

Booth, A., "Venus on the Ara Pacis," *Latomus*, 25, 1966, 871–79.

Borbein, A. H., 1968, *Campanareliefs. Typologische und stilkritische Untersuchungen*, RM, Erganzungsheft, 14, Heidelberg.

———, 1975, "Die Ara Pacis Augustae. Geschichtliche Wirklichkeit und Programm," *JDAI*, 90, 242–66.

Boriello, M. R., M. Lista, et al., *Le collezioni del Museo Nazionale di Napoli*, Rome, 1986.

Börker, C., "Neuattisches und pergamenisches an den Ranken der Ara Pacis," *JDAI*, 88, 1973, 283–317.

Bragantini, I., et al., *Le decorazioni della villa romana della Farnesina, Museo Nazionale Romano. Le pitture*, II,1, Rome, 1982.

Brisson, J.-P., "Rome et l'âge d'or: Dionysos ou Saturne?" *MEFRA*, 100, 2, 1988, 917–82.

Bruhl, A., *Liber Pater. Origine et expansion du culte dionysiaque dans le monde romain*, Bibliothèque des Écoles Françaises d'Athènes et de Rome, fasc. 175, Paris, 1953.

Büsing, H., "Ranke und Figur an der Ara Pacis Augustae," *AA*, 1977, 2, 247–57.

Byvanck-Quarles van Ufford, L., " 'Die Ranken der Ara Pacis.' Étude sur la décoration à rinceaux pendant l'époque hellénistique," *BABesch*, 30, 1955, 39–56.

Cain, H.-U., *Römische Marmorkandelaber*, Beiträge zur Erschliessung hellenistischer und kaiserzeitlicher Skulptur und Architektur, Bd. 7, Mainz, 1985.

Carettoni, G., *Das Haus des Augustus auf dem Palatin*, Mainz, 1983.

Coarelli, F., "Arti figurative," in *La Cultura ellenistica*, ed. R. Martin, R. Bianchi Bandinelli, et. al., Milan, 1977.

———, *Roma*, 3rd ed., Rome, 1983.

Collins, J. J., *The Sibylline Oracles of Egyptian Judaism*, Society of Biblical Literature, Dissertation Series, 13, Missoula, Mont., 1974.

Cook, A. B., *Zeus: A Study in Ancient Religion*, vols. I–III, Cambridge, 1914–40.

Crawford, M. H., *Roman Republican Coinage*, Cambridge, 1974.

Daraki, M., *Dionysos*, Paris, 1985.

de Grummond, N. Thomson, "Pax Augusta and the Horae on the Ara Pacis Augustae," *AJA*, 94, 1990, 663–77.

de Lucca, G., *Das Asklepeion*, AVP XI,4, Berlin, 1984.

Deubner, L., *Attische Feste*, Berlin, 1956.

Deubner, O., "Pergamon und Rom. Eine kulturhistorische Betrachtung," *Marburger Jahrbuch der Kunstwissenschaft*, 15, 1949–1950, 95–115.

di Filippo-Balestrazzi, E., L. Gasperini, and M. Balestrazzi, "L'emiciclo di Pratomedes a Cirene: la testimonianza di un culto aniconico di tradizione dorica," *Quaderni dell'archeologia della Libia*, 8, 1976, 126–53.

Doblhofer, E., 1964, "Zum Augustusbild des Horaz," *Rheinisches Museum für Philologie*, n.s., 107, 325–39.

———, 1966, *Die Augustuspanegyrik des Horaz*, Heidelberg.

Ducati, P., *L'arte in Roma dalle origini al secolo VIII*, Bologna, 1938.

Dulière, C., *Lupa Romana. Recherches d'iconographie et essai d'interpretation*, Études de philologie, d'archéologie et d'histoire ancienne, Institut Belgique de Rome, Brussels and Rome, 1979.

Du Quesnay, I. M., "Vergil's Fourth Eclogue," *Arca. Classical and Medieval Texts, Papers and Monographs*, 2, 1976, 25–99.

Eder, W., "Augustus and the Power of Tradition: The Augustan Principate as Binding Link Between Republic and Empire," in Raaflaub and Toher, eds., *Between Republic and Empire*.

Elia, O., "Lo Stibadio dionisiaco in pitture pompeane," *RM*, 69, 1961, 118–27.

Engemann, J., *Architekturdarstellungen des frühen zweiten Stils. Illusionistische römische Wandmalerei in der ersten Phase und der Vorbilder in der realen Architektur*, *RM*, Erganzungsheft, 12, Heidelberg, 1967.

Étienne, R., and J.-P. Braun, *Ténos I. Le sanctuaire de Poseidon et Amphitrite*, Bibliothèque des Écoles Françaises d'Athènes et de Rome, fasc. 263, Paris, 1986.

Farnell, L. R., *Cults of the Greek States*, I–V, Oxford, 1894–1909.

Fraser, P. M., *Ptolemaic Alexandria*, Oxford, 1972.

Gagé, J., *Apollon romain. Essai sur le culte d'Apollon et le developpement du «ritus Graecus» à Rome des origines à Auguste*, Bibliothèque des Écoles Françaises d'Athènes et de Rome, fasc. 182, Paris, 1955.

Galinsky, G. K., 1967, "Venus in a Relief of the Ara Pacis Augustae," *AJA*, 70, 223–43.

———, 1969, *Aeneas, Sicily, and Rome*, Princeton.

———, 1992, "Venus, Polysemy, and the Ara Pacis Augustae," *AJA*, 96, 457–75.

Gatz, B., *Weltalter, goldene Zeit und sinnverwandte Vorstellungen*, Spudasmata, 16, 1967.

Geyer, A., *Das Problem des Realitätsbezuges in der dionysischen Bildkunst der Kaiserzeit*, Beiträge zur Archäologie, 10, Würzburg, 1977.

Grant, M., *Roman Myths*, New York, 1984.

Grueber, H. A., *Coins of the Roman Republic in the British Museum*, London, 1910.

Günther, R., "Der politisch-ideologische Kampf in der römischen Religion in den letzten zwei Jahrhunderten v.u. Z.," *Klio*, 42, 1964, 208–97.

Hanell, K., "Das Opfer des Augustus an der Ara Pacis," *Acta Inst. Rom. Regni Sueciae, Opuscula Romana*, 2, 1960, 33–123.

Harrison, J. E., *Themis. A Study of the Social Origins of Greek Religion*, Cambridge, 1927.

Head, B. V., *A Guide to the Principal Coinage of the Greeks, from circa 700 B.C. to A.D. 270*, London, 1932.

Hölscher, T., *Römische Bildsprache als semantisches System*, Heidelberg, 1987.

Hoffmann, W., *Wandel und Herkunft der sibyllinischer Bücher in Rom*, Leipzig, 1933.

Holliday, P. J., "Time, History, and Ritual on the Ara Pacis," *Art Bulletin*, 72, 4, 1990, 542–57.

Honroth, M., *Stadtrömische Girlanden. Ein Versuch zur Entwicklungsgeschichte römischer Ornamentik*, Sonderschriften des Österreichischen Archäologischen Institutes in Wien, Bd. 18, 1971.

Immisch, O., "Zum antiken Herrscherkult," *Aus Roms Zeitenwende, Das Erbe des Alte*, 20, 1931, 13–36.

Jaeger, W., *Paideia: The Ideals of Greek Culture*, New York, 1944.

Jeanmaire, H., 1930, *Le Messianisme de Virgile*, Paris.

———, 1939, *La Sibylle et le retour de l'âge d'or*, Paris.

———, 1970, *Dionysos. Histoire du culte de Bacchus*, Paris.

Jucker, H., *Das Bildnis im Blätterkelch*, Olten, Lausanne, and Freiburg, 1961.

Kaiser Augustus und die verlorene Republik, Berlin, 1988.

Kawerau, G., and T. Wiegand, *Die Paläste der Hochburg, AVP* V,1, Berlin and Leipzig, 1930.

Kellum, B., "What We See and What We Don't See. Narrative Structure and the Ara Pacis Augustae," *Art History*, 17, 1, March 1994, 26–45.

Kleiner, D. E. E., 1978, "The Great Friezes of the Ara Pacis Augustae. Greek Sources, Roman Derivatives, and Augustan Social Policy," *MEFRA*, 90, 753–85; repr. in E. D'Ambra, *Roman Art in Context. An Anthology*, Englewood Cliffs, N. J., 1993, 27–52.

———, 1992, *Roman Sculpture*, New Haven and London.

Koeppel, G. M., "Ara Pacis Augustae," *Bonner Jahrbucher*, 187, 1987, 101–57.

Kraus, T., *Die Ranken der Ara Pacis*, Berlin, 1953.

Künzl, E., "Der augusteische Silbercalathus im Rheinischen Landesmuseum, Bonn," *Bonner Jahrbucher*, 169, 1969, 322–92.

Le Bonniec, H., *Le Culte de Cérès à Rome. Des origines à la fin de la République*, Paris, 1958.

Lehmann, P., *Roman Wall Paintings from Boscoreale in the Metropolitan Museum of Art*, Cambridge, Mass., 1953.

L'Orange, H. P., " Ara Pacis Augustae. La zona floreale," *Acta archaeologicam et artium historiam pertinenta*, 1, 1962, 7–16; reissued in idem, *Likeness and Icon: Selected Studies in Early Classical and Medieval Art*, Odensee, 1973, and in English, "The Floral Zone of the Ara Pacis," in idem, *Art Forms and Civic Life*, New York, 1985, 211–30.

Mannsperger, D., "Apollon gegen Dionysos. Numismatische Beiträge zur Octavians Rolle als Vindex Libertatis," *Gymnasium*, 80, 1973, 381–404.

Matz, F., "Der Gott auf der Elefantenwagen," *Abhandlungen der Akademie der Wissenschaften und Literatur in Mainz*, geistes- und sozialwissenschaftlichen Klasse, Heft 10, 1952.

Mayo, M. E., *The Art of South Italy. Vases from Magna Graecia*, Richmond, Va., 1982.

Möbius, H., "Eine dreiseitige Basis in Athen," *AM*, 51, 1926, 117–24.

Moretti, G., *Ara Pacis Augustae*, Rome, 1948.

Murr, J., *Die Pflanzenwelt in der griechischen Mythologie*, Innsbruck, 1890; repr. Gröningen, 1969.

Napp, A. E., *Bukranion und Girlande. Beiträge zur Entwicklungsgeschichte der hellenistischen und römischen Dekorationskunst*, University of Heidelberg, 1930.

Naumann, F., *Die Ikonographie der Kybele in der phrygischen und der griechischen Kunst*, Tübingen, 1983.

Nisbet, R. G. M., "Vergil's Fourth Eclogue: Easterners and Westerners," *BICS*, 25, 1978, 59–78.

North, H., *Sophrosyne. Self-Knowledge and Self-Restraint in Greek Literature*, Ithaca, N.Y., 1966.

Ohlemutz, E., *Die Kulte und Heligtümer der Götter in Pergamon*, Giessen, 1940; repr. Darmstadt, 1968.

Oliver, A., *Silver for the Gods. 800 Years of Greek and Roman Silver*, Toledo, 1977.

Otto, W. F., *Dionysos. Myth and Cult*, Bloomington and London, 1973.

Panofsky, E., *A Mythological Painting by Poussin in the National Museum, Stockholm*, Nationalmusei Skriftserie, 5, Stockholm, 1960.

Pappalardo, U., "Il fregio con eroti fra girali nella 'Sala dei Misteri' a Pompeii," *JDAI*, 97, 1982, 251–80.

Parke, H. W., *Festivals of the Athenians*, Ithaca, N.Y., 1977.

Pasquali, G., *Orazio lirico. Studi*, 2nd ed., Florence, 1964.

Pernice, E., *Die hellenistische Kunst in Pompeji. VI, Pavimente und figürliche Mosaiken*, Berlin, 1938.

Petersen, E., *Ara Pacis Augustae*, Sonderschriften des Österreichischen Archäologischen Institutes in Wien, Bd. 2, Vienna, 1902.

Pfrommer, M., 1982, "Grossgriechischer und mittelitalischer Einfluss in der Rankenornamentik frühhellenistischer Zeit," *JDAI*, 97, 119–90.

———, 1987, *Studien zu alexandrinischer und grossgriechischer Toreutik frühhellenistischer Zeit*, Deutsches Archäologisches Institut, Archäologische Forschungen, Bd. 16, Berlin.

Picard-Schmitter, M.-Th., "Bétyles hellénistiques," *Monuments Piots*, 57, 1971, 43–88.

Pollini, J., 1978, "Studies in Augustan Historical Reliefs," Ph.D. diss., University of California, Berkeley.

———, 1993, "The Acanthus of the Ara Pacis as an Apolline and Dionysiac Symbol of *Anamorphosis, Anakyklosis*, and *Numen Mixtum*," in M. Kubelík and M. Schwarz, eds., *Von der Bauforschung zur Denkmalpflege. Festschrift für Alois Machatschek*, Vienna, 181–217.

Pollitt, J. J., 1978, "The Impact of Greek Art on Rome," *TAPA*, 108, 155–74.

———, 1986, *Art in the Hellenistic Age*, Cambridge.

Raaflaub, K. A., and M. Toher, eds., *Between Republic and Empire: Interpretations of Augustus and His Principate*, Berkeley, Los Angeles, and Oxford, 1990.

Reinsberg, C., *Studien zur hellenistischen Toreutik. Die antiken Gipsabgüsse aus Memphis*, Hildesheim, 1980.

Richter, G. M. A., 1964, "The Marble Throne on the Acropolis and its Replicas," *AJA*, 58, 4, 271–76.

———, 1969, *A Handbook of Greek Art*, London and New York.

Riegl, A., *Problems of Style. Foundations for a History of Ornament*, tr. E. Kain, annotations by D. Castriota, Princeton, 1992.

Rohde, E., *Pergamon. Burgberg und Altar*, Munich, 1982.

Roscher, W. H., *Ausführliches Lexikon der griechischen und römischen Mythologie*, Leipzig, 1884–1937; repr. Hildesheim and New York, 1978.

Rose, C. B., "'Princes' and Barbarians on the Ara Pacis," *AJA*, 94, 1990, 453–67; repr. in E. D'Ambra, *Roman Art in Context. An Anthology*, Englewood Cliffs, N. J., 1993, 53–74.

Salzmann, D., *Untersuchungen zu den antiken Kieselmosaiken von den Anfängen bis zum Beginn der Tesseratechnik*, Berlin, 1982.

Sauron, G., 1979, "Les Modèles funéraires classiques de l'art décoratif néo-attique au Ier siècle av. J.-C.," *MEFRA*, 91,1, 183–209.

———, 1982, "Le Message esthétique des rinceaux de l'*Ara Pacis Augustae*," *CRAI*, Jan.–Mar., 80–101.

———, 1988, "Le Message esthétique des rinceaux de l'*Ara Pacis Augustae*," *RA*, 1, 3–40.

Schalles, H. J., *Untersuchungen zur Kulturpolitik der pergamensicher Herrscher im dritten Jahrhundert vor Christus*, Istanbuler Forschungen, 36, Tübingen, 1985.

Schauenburg, B., "Zur Symbolik der unteritalischer Rankenmotive," *RM*, 64, 1957, 198–221.

Scheibler, I., "Götter des Friedens in Hellas und Rom," *Antike Welt*, 15, 1984, 39–57.

Scheid, J., *Les Frères arvales. Recrutement et origine sociale sous les empereurs julio-claudiens*, Paris, 1975.

Schilling, R., *La Religion romaine de Vénus depuis les origines jusqu'au temps d' Auguste*, Bibliothèque des Écoles Françaises d'Athènes et de Rome, fasc. 178, Paris, 1954.

Schwarz, G., *Triptolemos. Ikonographie einer Agrar- und Mysteriengottheit*, Grazer Beiträge, Zeitschrift für die klassische Altertumswissenschaft, Suppl. Bd. 2, Horn-Graz, 1987.

Scott-Ryberg, I., "The Procession of the Ara Pacis," *MAAR*, 19, 1949, 91–94.

Settis, S., "Die Ara Pacis. Quellen, Entstehungzeit, und allgemeine Fragestellung," in *Kaiser Augustus und die verlorene Republik*, Berlin, 1988, 400–426.

Simon, E., 1961, "Zum Fries der Mysterienvilla bei Pompeji," *JDAI*, 76, 111–72.

———, 1962, "Zur Bedeutung des Greifen in der Kunst der Kaiserzeit," *Latomus*, 21, 749–80.

———, 1968, *Ara Pacis Augustae*, New York.

———, 1969, *Die Götter der Griechen*, Munich.

———, 1978, "Apollo in Rom," *JDAI*, 93, 202–27.

———, 1986, *Augustus. Kunst und Leben in Rom um die Zeitenwende*, Munich.

———, 1988, *Eirene und Pax. Friedesgöttinen in der Antike*, Sitzungsberichte der Wissenschaftlichen Gesellschaft an der Johann Wolfgang Goethe-Universität Frankfurt-am-Main, Bd. 24, 3, Wiesbaden and Stuttgart.

Sinn, F., *Stadtrömische Marmorurnen*, Mainz, 1987.

Smethurst, S. E., 1949, "The Growth of the Roman Legend," *Phoenix*, 9, 1–14.

———, 1953, "Cicero and Isocrates," *TAPA*, 84, 262–320.

Spaeth, B. Stanley, "The Goddess Ceres in the Ara Pacis Augustae and the Carthage Relief," *AJA*, 98, 1994, 65–100.

Stephan, M., *Die griechische Girlande. Ein Beiträge zur griechischen Ornamentik*, Friedrich-Wilhelms Universität, Berlin, 1931.

Stewart, A., "Dionysos at Delphi: The Pediments of the Sixth Temple of Apollo and Religious Reform in the Age of Alexander," in B. Barr Sharrar and E. Borza, *Studies in Macedonian Art and Culture*, Washington, D.C., 1976, 205–27.

Strocka, V. M., "Die Brunnenreliefs Grimani," *Antike Plastik*, Lieferung IV, Berlin, 1965, 87–102.

Strong, D. E., *Greek and Roman Gold and Silver Plate*, Ithaca, N.Y., 1966.

Strong, E., "Sulle tracce della lupa romana," *Scritti in honore di Bartolomeo Nogara*, Vatican City, 1937, 475–501.

Stucchi, S., "La chora Alexandreon in un rilievo del Museo del Louvre," *Rendiconti dell'Accademia Nazionale dei Lincei*, Classe di scienze morali, storiche e filologiche, Ser. 8, 39, 1985, 261–84.

Tarn, W. W., "Alexander Helios and the Golden Age," *JRS*, 22, 1932, 135–60.

Thompson, D. Burr, *Ptolemaic Oinochoai and Portraits in Faience. Aspects of the Ruler-Cult*, Oxford, 1973.

Tondriau, J., "Comparisons and Identifications of Rulers with Deities in the Hellenistic period," *Review of Religion*, 13, 1948, 24–47.

Torelli, M., *The Typology and Structure of Roman Historical Reliefs*, Ann Arbor, 1982.

Toynbee, J. M. C., 1953, "The Ara Pacis Reconsidered and Historical Art in Roman Italy," *Proceedings of the British Academy*, 39, 67–95.

———, 1961, "The 'Ara Pacis Augustae'", *JRS*, 51, 153–56.

Toynbee, J. M. C., and J. B. Ward-Perkins, "Peopled Scrolls: A Hellenistic Motif in Imperial Art," *Papers of the British School at Rome*, 18, 1950, 1–43.

Trendall, A. D., *Red Figure Vases of South Italy and Sicily*, London, 1989.

Trompf, G. W., *The Idea of Historical Recurrence in Western Thought*, Berkeley, Los Angeles, and London, 1979.

von Hesberg, H., 1979, "Einige Statuen mit bukolischer Bedeutung in Rom," *RM*, 86, 297–317.

———, 1981, "Girlandenschmuck der republikanischen Zeit in Mittelitalien," *RM*, 88, 210–45.

von Prott, H., "Dionysos Kathegemon," *AM*, 27, 1902, 161–188.

von Rohden, H., and H. Winnefeld, *Die antiken Terrakotten. IV, 1. Architektonischen römische Tonreliefs der Kaiserzeit*, Berlin and Stuttgart, 1911.

Walter-Karydi, E., "Die Entstehung der Grotteskenornamentik in der Antike," *RM*, 97, 1990, 137–152.

Winter, F., *Die Skulpturen mit Ausnahme der Altarreliefs, AVP*, VII, 2, Berlin, 1908.

Wiseman, T. P., "Cybele, Virgil, and Augustus," in T. Woodman and D. West, eds., *Poetry and Politics in the Age of Augustus*, Cambridge, London, and New York, 1984, 117–128.

Woodman, A. J., *Rhetoric in Classical Historiography. Four Studies*, London and Sydney, 1988.

Yavis, C. G., *Greek Altars. Origins and Typology*, Saint Louis (Mo.), 1949.

Zagdoun, M.-A., *La Sculpture archaïsante dans l'art hellénistique et dans l'art romain du haut-empire*, Bibliothèque des Écoles Françaises d'Athènes et de Rome, fasc. 269, Athens and Paris, 1989.

Zanker, P., 1968, *Forum Augustum*, Tübingen.

———, ed., 1976, *Hellenismus in Mittelitalien*, Abhandlungen der Akademie der Wissenschaften in Göttingen, ser. 3, 97, 1, Göttingen.

———, 1979, *Die Bildnisse des Augustus. Herrscherbild und Politik im kaiserlichen Rom*, Munich.

———, 1988, *The Power of Images in the Age of Augustus*, tr. A. Shapiro, Ann Arbor.

Ziegenhaus, O., with G. de Lucca, *Das Asklepeion, AVP* XI, 3, Berlin, 1981.

Index

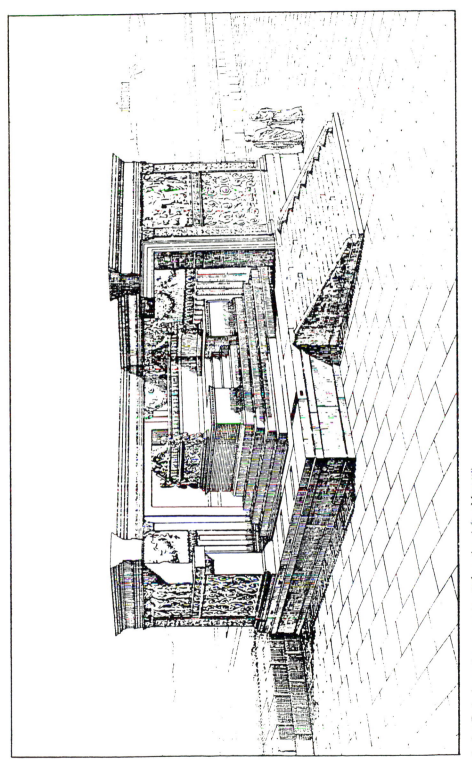

1. Ara Pacis Augustae, reconstructed section (after Moretti).

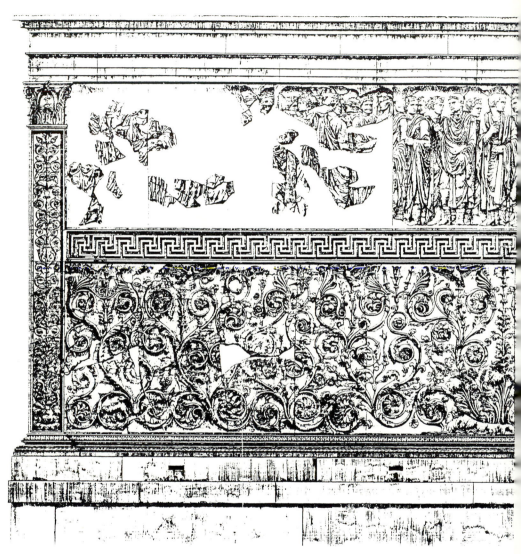

2. Ara Pacis Augustae, south flank (after Moretti).

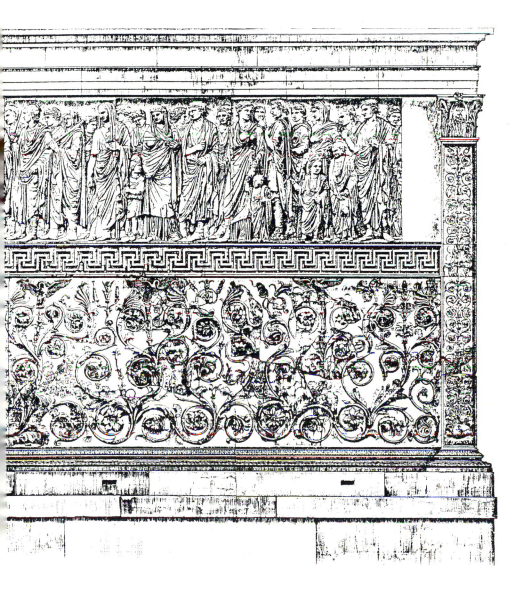

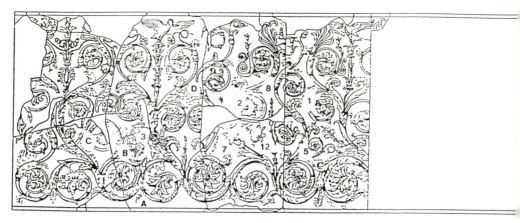

3. Ara Pacis Augustae, south floral frieze (adapted from Moretti).
1. Ivy. 2. Ivy. 3. Grapevine. 4. Rose. 5–12. Indeterminate Blossoms.
A. Lizard. B. Bird. C. Bird. D. Butterfly.

4. Ara Pacis Augustae, north floral frieze (adapted from Moretti).
1. Laurel. 2. Ivy. 3. Ivy. 4. Ivy. 5. Grapevine. 6. Grapevine. 7. Oak. 8. Poppy. 9. Rose.
10–18. Indeterminate Blossoms. A. Snake and Young Birds. B. Frog. C. Lizard. D. Lizard.

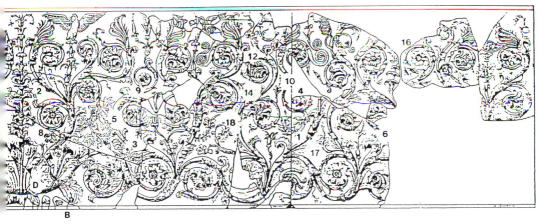

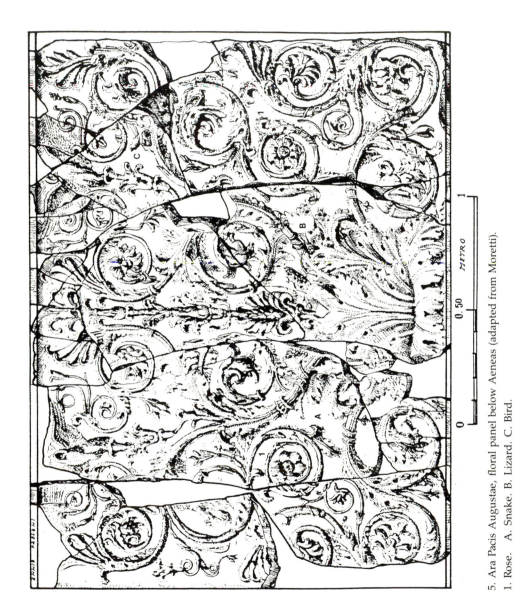

5. Ara Pacis Augustae, floral panel below Aeneas (adapted from Moretti).

1. Rose. A. Snake. B. Lizard. C. Bird.

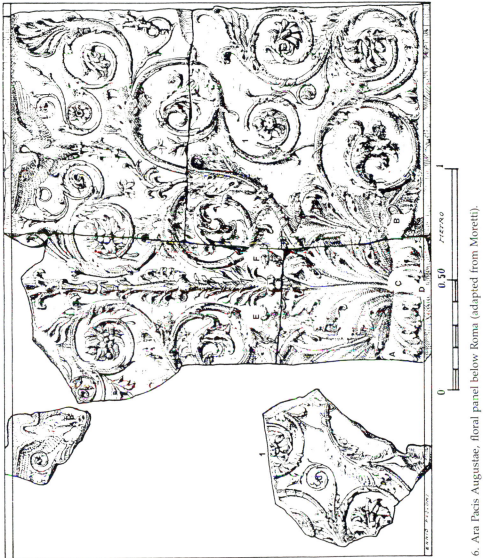

6. Ara Pacis Augustae, floral panel below Roma (adapted from Moretti).

1. Rose. A. Lizard. B. Snake. C. Bird. D. Grasshopper. E. Bird and Grasshopper. F. Birds.

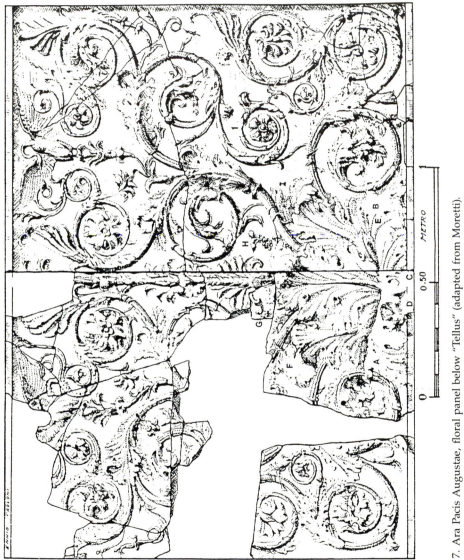

7. Ara Pacis Augustae, floral panel below "Tellus" (adapted from Moretti).

1. Rose A. Lizard. B. Snake. C. Grasshopper. D. Frog. E. Scorpion. F. Snake. G. Grasshopper. H. Birds.
I. Snail.

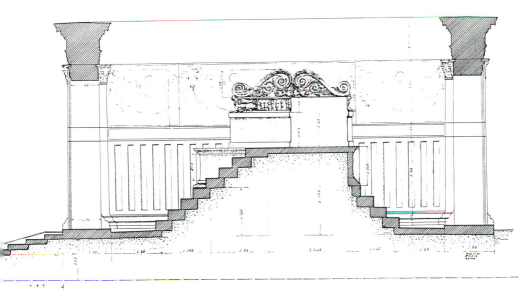

8. Ara Pacis Augustae, altar, section (after Moretti).

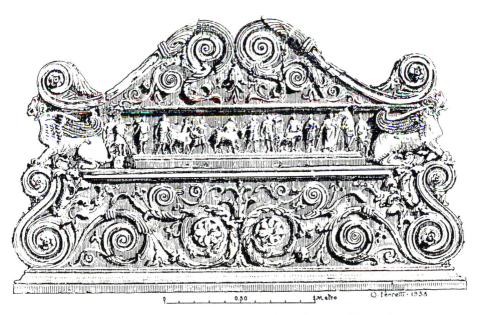

9. Ara Pacis Augustae, hypothetical reconstruction of altar barrier with acanthus ornament (after Moretti).

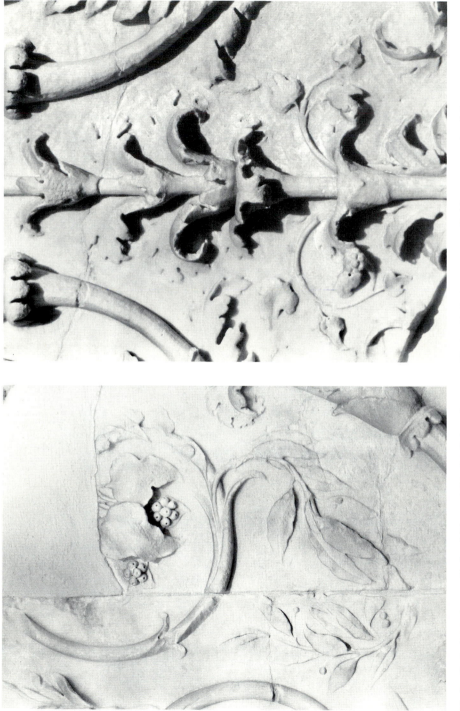

10. Ara Pacis Augustae, north floral frieze, right, detail: laurel and ivy.

11. Ara Pacis Augustae, north frieze, center, detail: ivy.

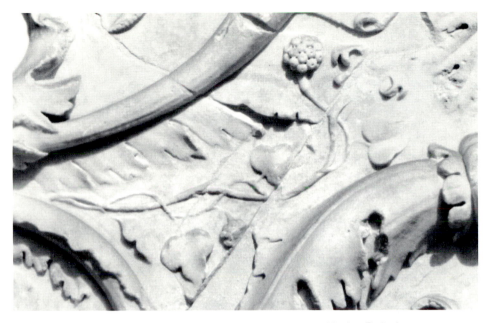

12. Ara Pacis Augustae,
north floral frieze, left,
detail: ivy.

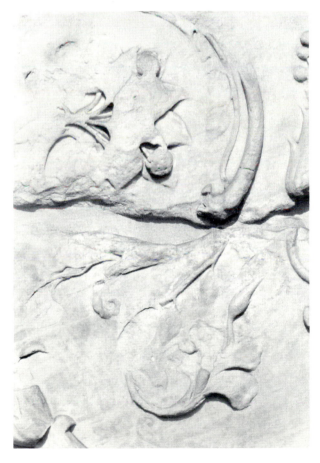

13. Ara Pacis Augustae,
south floral frieze, left,
detail: ivy.

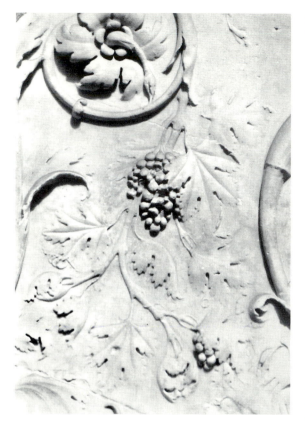

14. Ara Pacis Augustae, north floral frieze, right, detail: grapevine.

15. Ara Pacis Augustae, south floral frieze, left, detail: grapevine and bird.

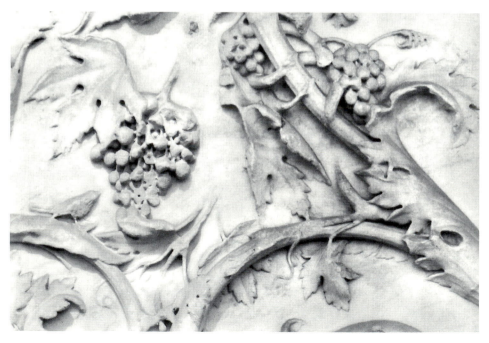

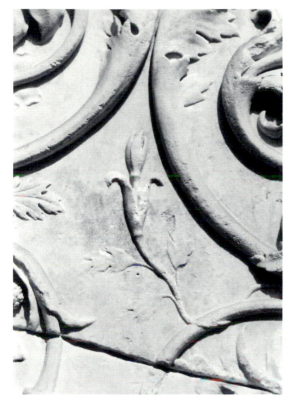

16. Ara Pacis Augustae, north floral frieze, left, detail: oak.

17. Ara Pacis Augustae, north floral frieze, center left, detail: poppy.

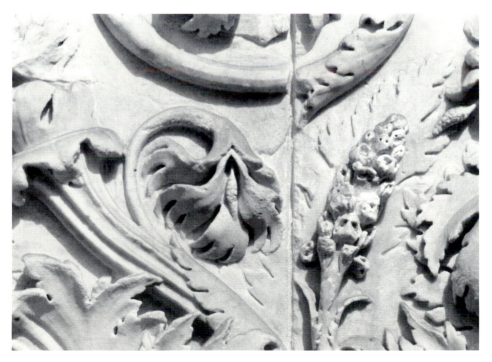

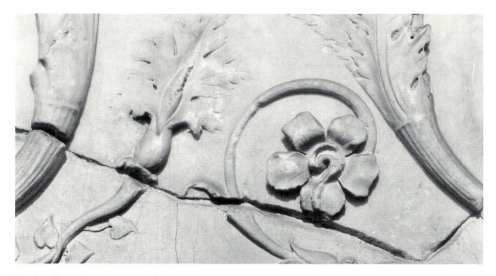

18. Ara Pacis Augustae, south
floral frieze, right, detail: rose.

19. Ara Pacis Augustae, south
floral frieze, left, detail: flower.

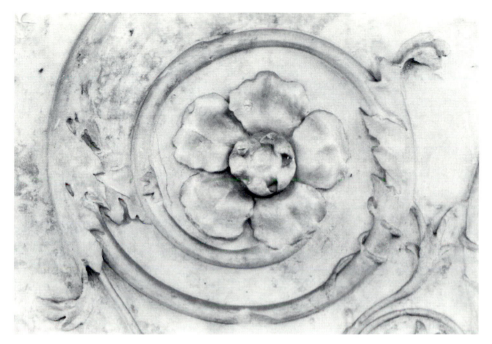

20. Ara Pacis Augustae, east facade, floral panel below Roma, right half, detail: rose.

21. Marble relief fragment with branch of laurel, from the excavations of the Ara Pacis, Museo Nazionale Romano delle Terme, Rome.

22. Marble relief fragment with ear of wheat, from the excavations of the Ara Pacis, Museo Nazionale Romano delle Terme, Rome.

23. Ara Pacis Augustae, north floral frieze, center, detail: snake and birds.

24. Ara Pacis Augustae, north floral frieze, center, detail: frog.

25. Ara Pacis Augustae, north floral frieze, center, detail: lizard.

26. Ara Pacis Augustae,
south floral frieze, left,
detail: lizard.

27. Ara Pacis Augustae,
south floral frieze, left,
detail: butterfly.

28. Ara Pacis Augustae, west facade, floral panel below Aeneas, detail: snake.

29. Ara Pacis Augustae, west facade, floral panel below Aeneas, detail: lizard.

30. Ara Pacis Augustae, east facade, floral panel below Roma, detail: lizard.

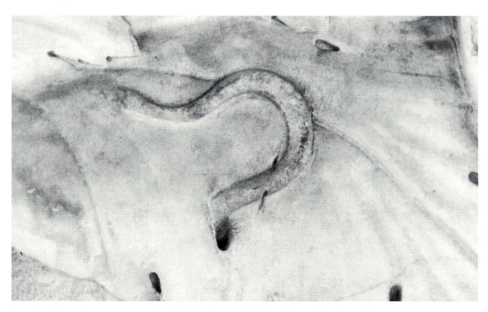

31. Ara Pacis Augustae, east facade, floral panel below Roma, detail: snake.

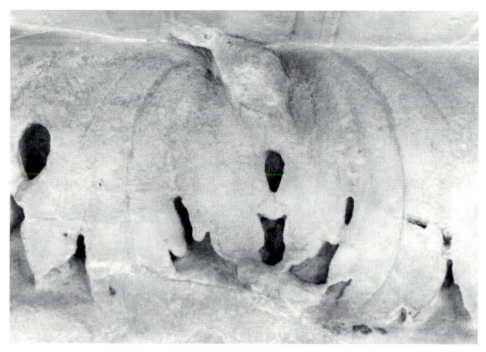

32. Ara Pacis Augustae, east facade, floral panel below Roma, detail: bird and grasshopper.

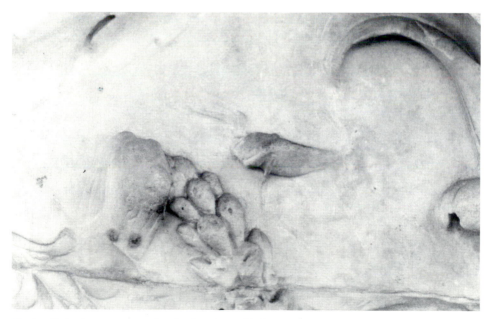

33. Ara Pacis Augustae, east facade, floral panel below Roma, detail: bird and grasshopper.

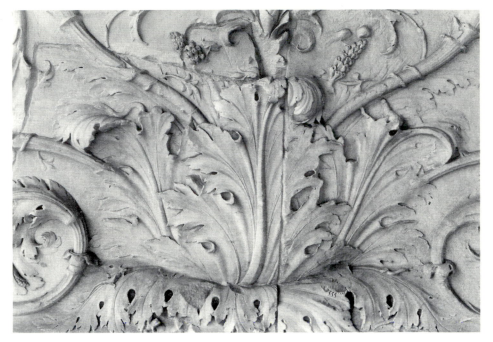

34. Ara Pacis Augustae, east facade, floral panel below "Tellus," detail: calyx with lizards, snakes, frog, scorpion, grasshoppers, snail, and birds.

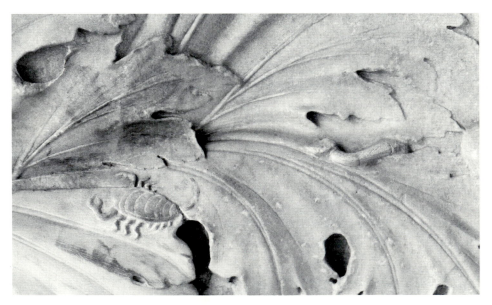

35. Ara Pacis Augustae, east facade, floral panel below "Tellus," detail: scorpion and snake.

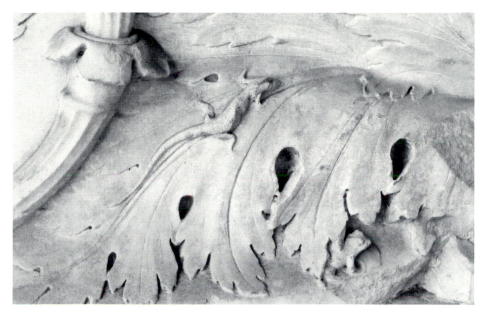

36. Ara Pacis Augustae, east facade, floral panel below "Tellus," detail: lizard and frog.

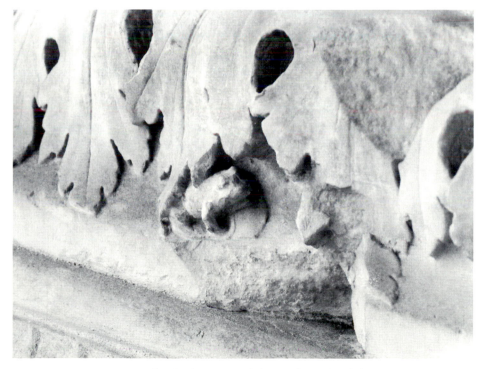

37. Ara Pacis Augustae, east facade, floral panel below "Tellus," detail: frog.

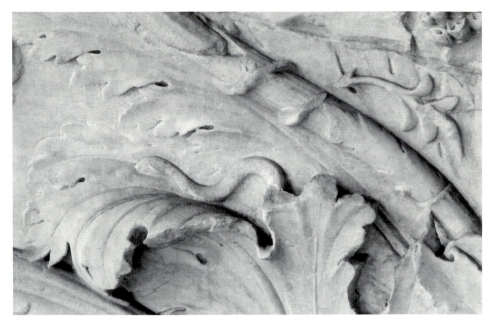

38. Ara Pacis Augustae, east facade, floral panel below "Tellus," detail: snake.

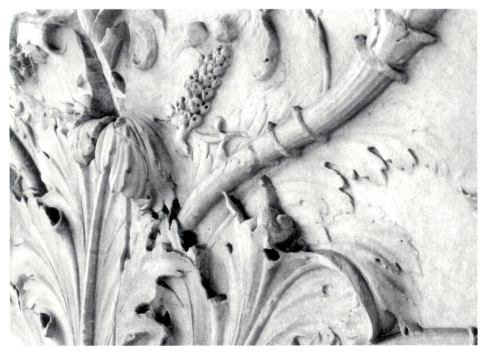

39. Ara Pacis Augustae, east facade, floral panel below "Tellus," detail: birds and snail.

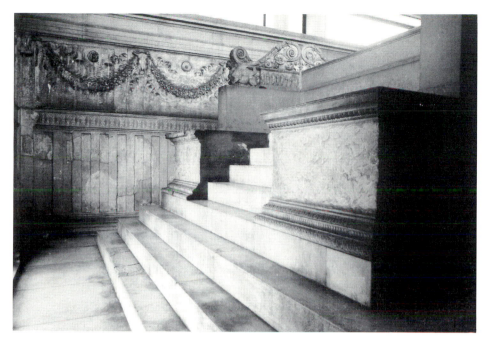

40. Ara Pacis Augustae, interior view with altar.

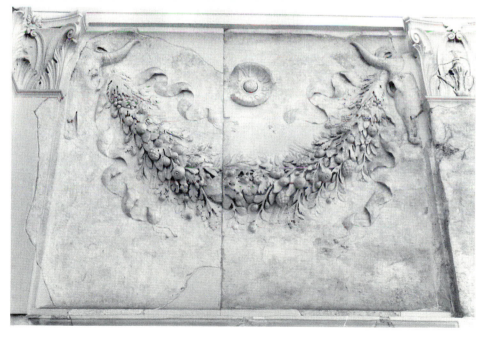

41. Ara Pacis Augustae, interior, detail: garland frieze.

42. Ara Pacis Augustae, interior, detail: griffin on altar barrier.

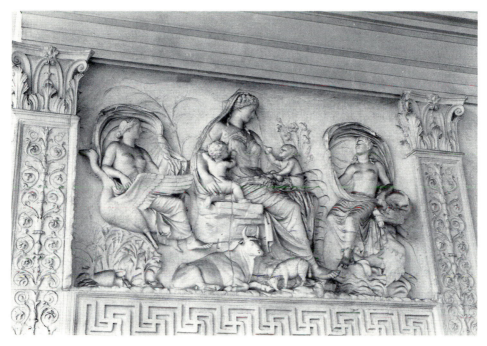

43. Ara Pacis Augustae, east facade, "Tellus" relief.

44. Ara Pacis Augustae, east facade, "Tellus" relief, detail: crane.

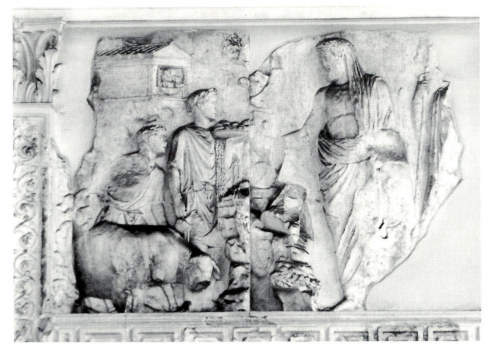

45. Ara Pacis Augustae, west facade, Aeneas relief.

46. Ara Pacis Augustae, west facade, relief with Mars.

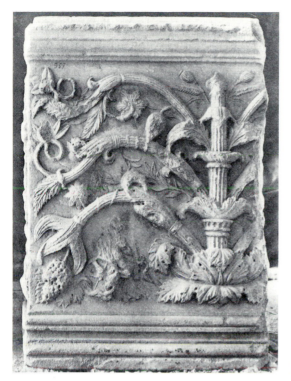

47. Marble relief slab from Pergamon, Archaeological Museum, Istanbul.

48a. Marble relief slab from Pergamon, Archaeological Museum, Istanbul.

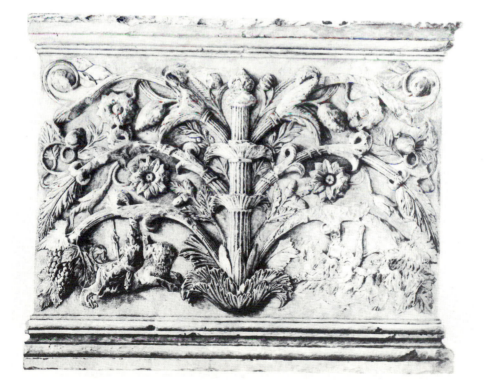

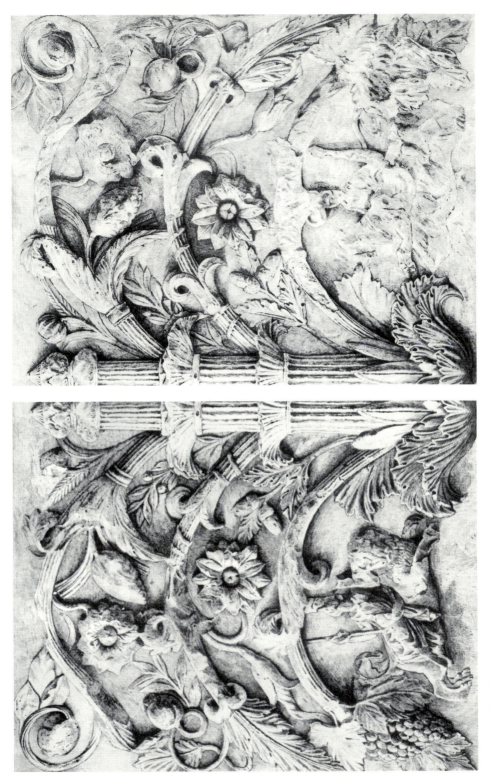

48b.–c. Marble relief slab from Pergamon, Archaeological Museum, Istanbul.

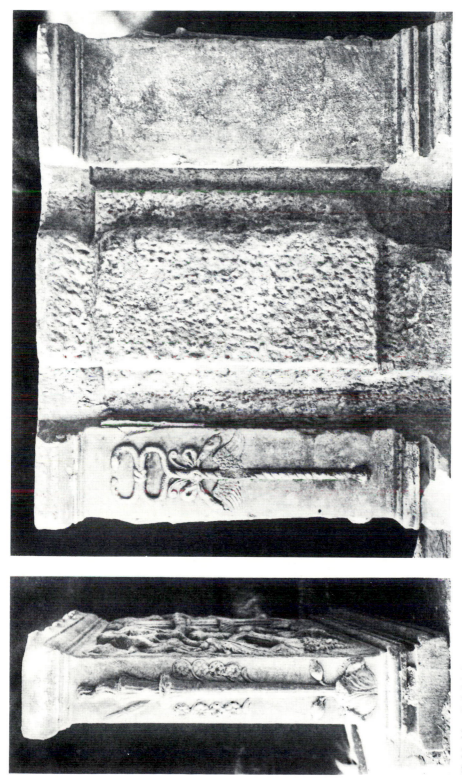

49. Marble relief slab from Pergamon, edge and reverse of fig. 48.

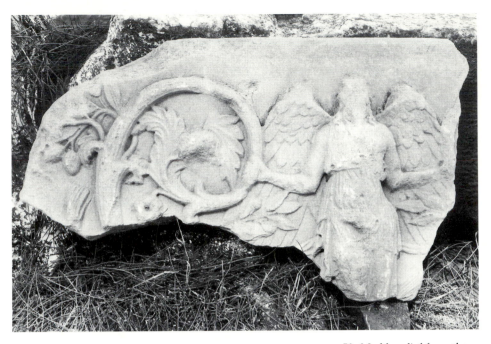

50. Marble relief from the
Asklepeion at Pergamon,
Bergama Museum.

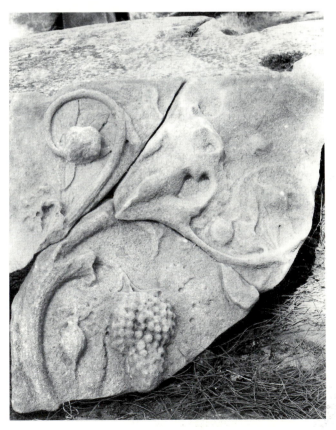

51. Marble relief from
the covered street or
Hallenstrasse at Pergamon,
Bergama Museum.

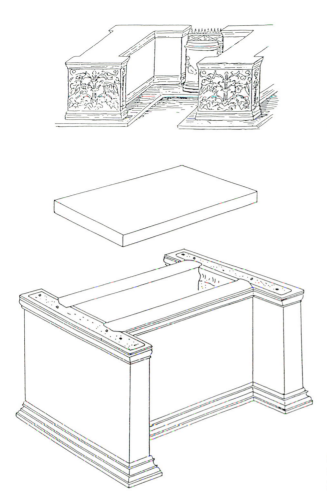

52a. Reconstruction of the Pergamene slabs as parapet frontons (after Winter).

52b. Proposed reconstruction of the Pergamene slabs, exploded view of the structure.

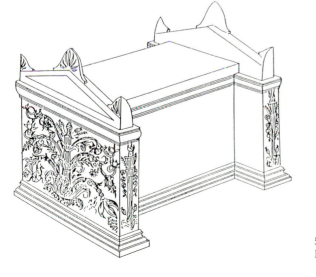

53. Reconstruction of the Pergamene slabs as an altar.

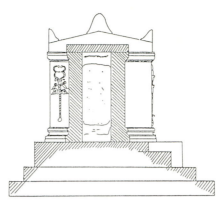

54a. Reconstruction of the Pergamene slabs as an altar on a stepped podium, section.

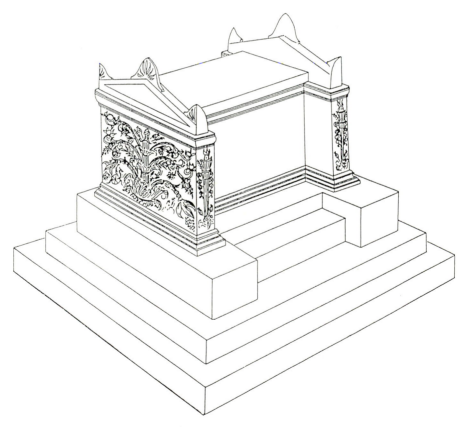

54b. Reconstruction of the Pergamene slabs as an altar on a stepped podium.

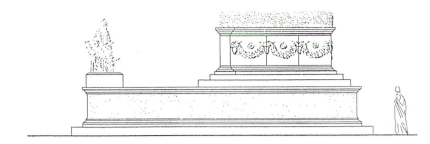

55a. Altar of Poseidon and Amphitrite at Tenos, reconstructed elevation (after Etienne and Braun).

55b. Altar of Poseidon and Amphitrite at Tenos, reconstructed section (after Etienne and Braun).

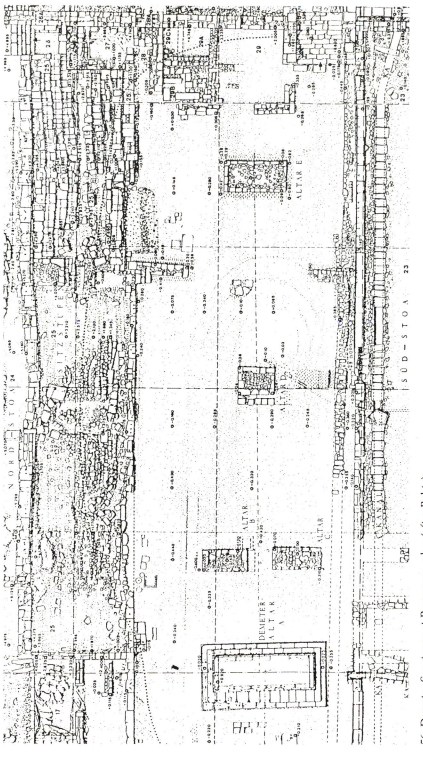

56. Demeter Sanctuary at Pergamon, plan (after Bohtz).

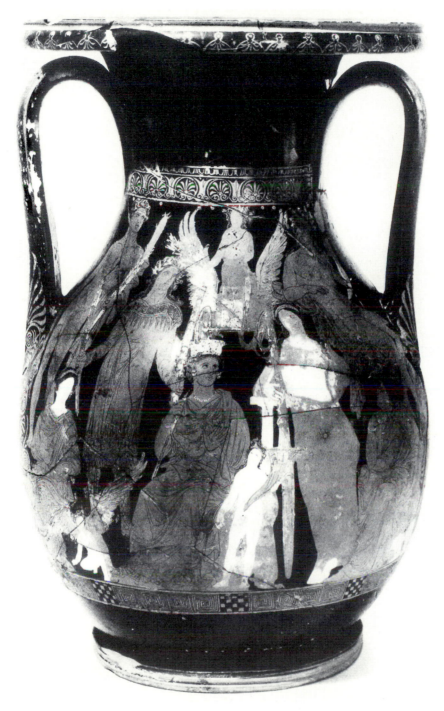

57. Attic Red-Figure "Eleusinian Pelike," Hermitage Museum, St. Petersberg.

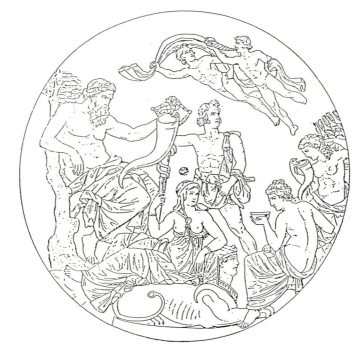

58. Tazza Farnese, Museo Archeologico Nazionale, Naples (after Furtwängler).

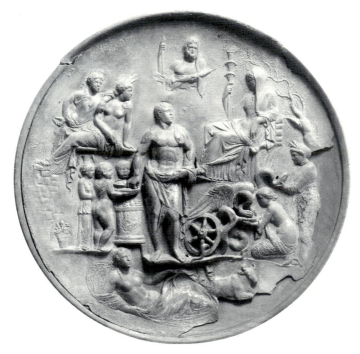

59. Silver relief plate from Aquileia, Kunsthistorisches Museum, Vienna.

60. Marble chariot with floral orna-
ment in relief, Sala della Biga, Vatican,
details: a. Poppies and wheat. b. Rose.

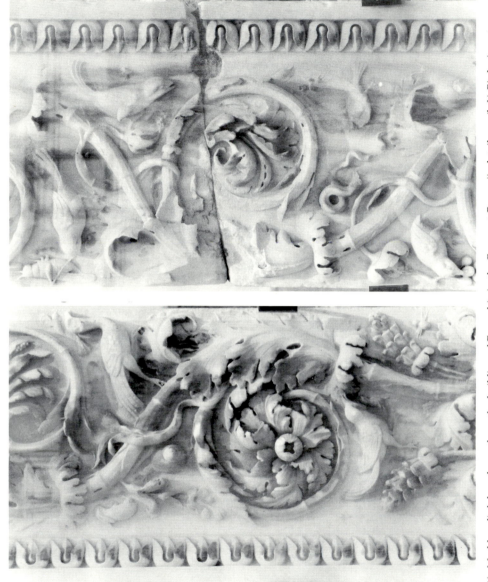

61. Marble relief door frame from the building of Eumachia in the Forum at Pompeii, details: a. (left) Birds, insects, rabbits, snail, and peacock. b. (right) Snake, birds, snail, and grasshopper.

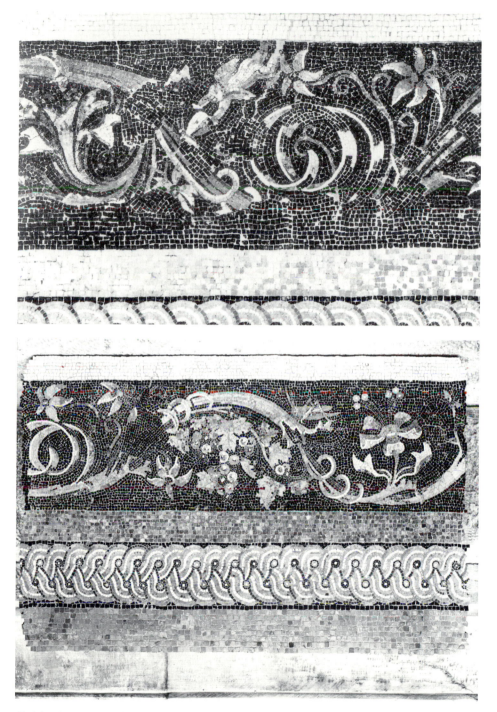

62. Mosaic pavement by Hephaisteion from Palace V at Pergamon, Berlin Pergamon Museum, details: a. (top) Eros and butterfly. b. (bottom) Grapes and grasshopper.

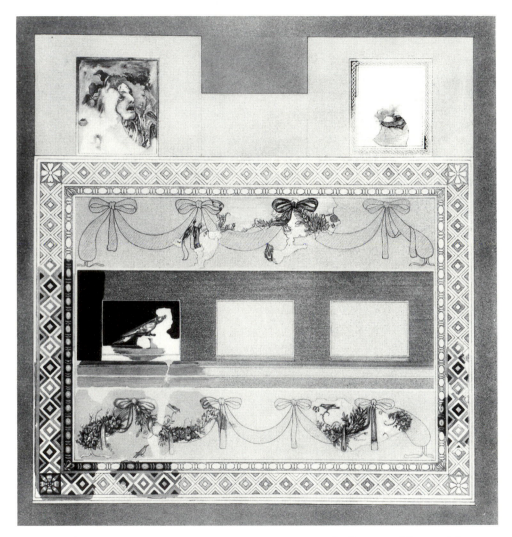

63. Mosaic from the "Altargemach" in Palace V at Pergamon, Berlin Pergamon Museum (after Kawerau and Wiegand).

64a. Silver relief bowl from Civita Castellana, Museo Archeologico Nazionale, Naples, detail: Lizard and bee.

64c. Silver relief bowl from Civita Castellana, Museo Archeologico Nazionale, Naples, detail: Bird and insect.

64b. Silver relief bowl from Civita Castellana, Museo Archeologico Nazionale, Naples, detail: Snake and frog.

65. Fish Mosaic from the House of the Faun at Pompeii, Museo Archeologico Nazionale, Naples, details: a. (top) Eros and butterfly. b. (middle) Erotes, grasshopper, and rabbit. c. (bottom) Erotes, birds, and snail.

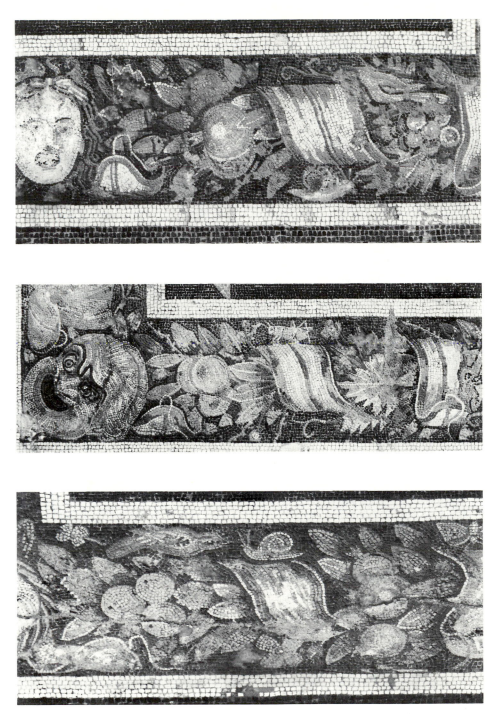

66. Dove Mosaic from the House of the Doves at Pompeii, Museo Archeologico Nazionale, Naples, details: a. Garland with bird and snail. b. Grasshopper. c. (bottom) Mouse, bird, snail, and butterfly.

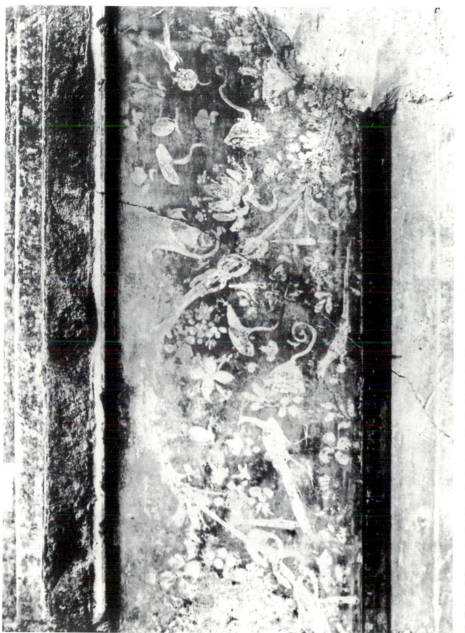

67. Painted frieze in the First Style from Oecus 44 in the House of the Faun, Pompeii.

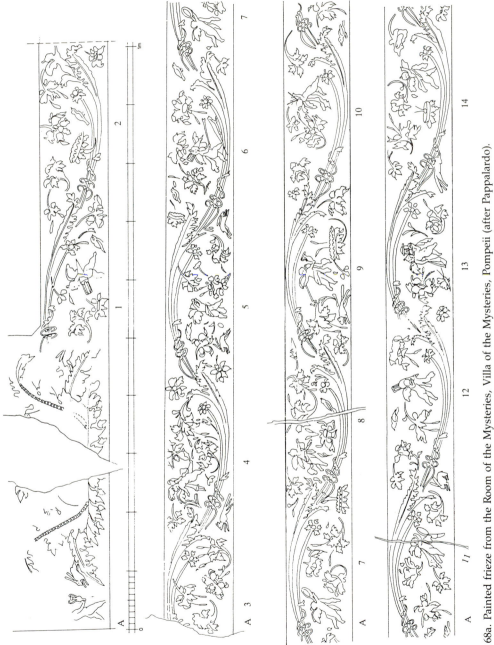

68a. Painted frieze from the Room of the Mysteries, Villa of the Mysteries, Pompeii (after Pappalardo).

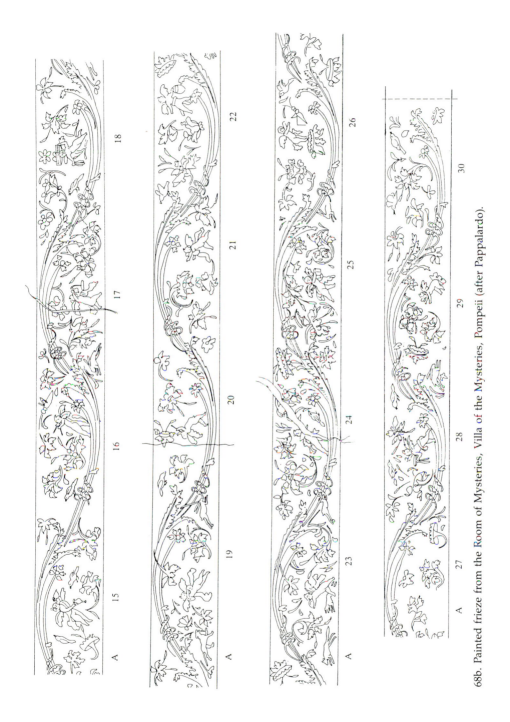

68b. Painted frieze from the Room of Mysteries, Villa of the Mysteries, Pompeii (after Pappalardo).

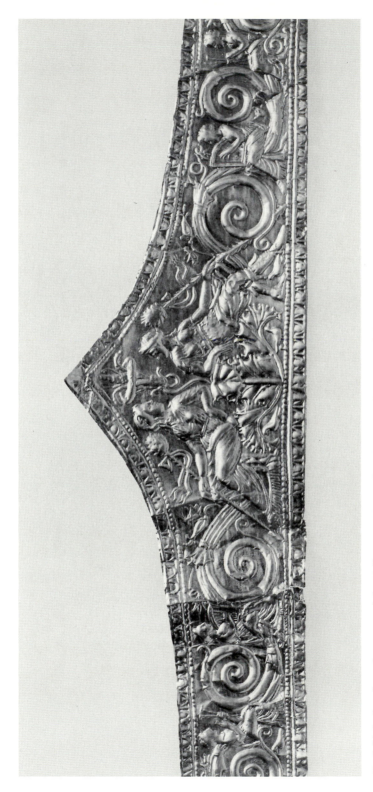

69. Gold diadem from the region of the Hellespont, Metropolitan Museum of Art, New York.

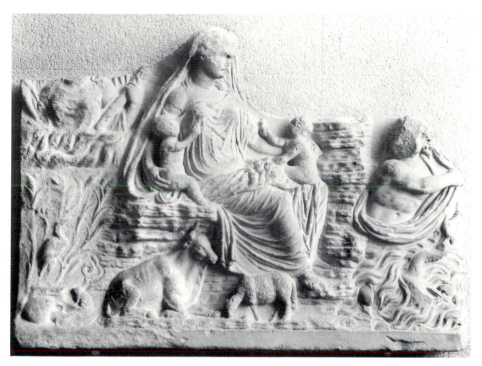

70. Marble relief from Carthage, Louvre, Paris.

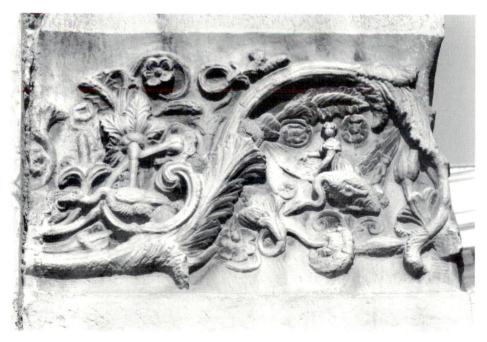

71. Marble relief from the Little Metropolis, Athens.

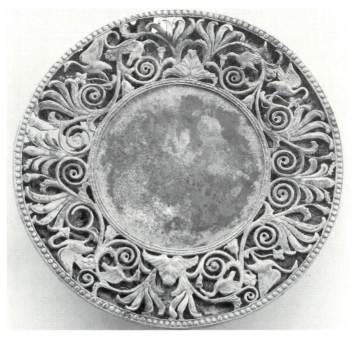

72. Bronze mirror frame, Metropolitan Museum of Art, New York.

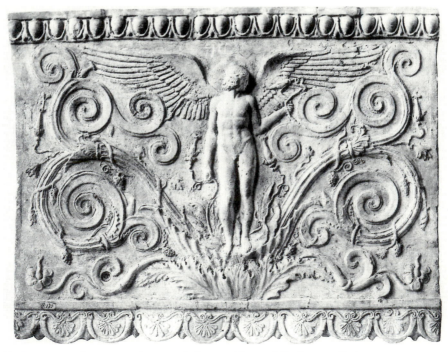

73. Terracotta "Campana" plaque with Eros amidst tendrils, Louvre, Paris.

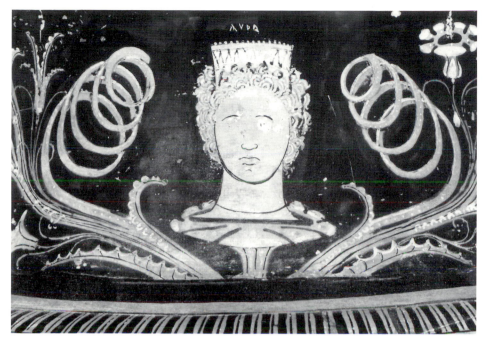

74. Apulian volute krater, British Museum, London, detail: Bust of Aura amidst tendrils.

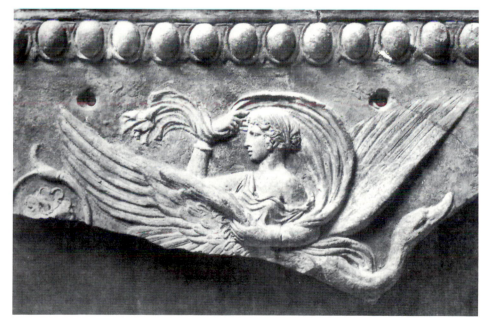

75. Terracotta "Campana" plaque with goddess, Antiquario Communale, Rome.

76. Altar of the Augustan Lares, Museo Gregoriano Profano, Vatican.

77. Terracotta "Campana" plaque with Dionsyos/Sabazios, Museo Nazionale Romano delle Terme, Rome.

78. Terracota "Campana" plaque with the infant Dionysos, British Museum, London.

79. Terracotta
"Campana" plaque
with satyrs,
Louvre, Paris.

80. Terracota
"Campana" plaque
with tendrils and
female attendants,
Louvre, Paris.

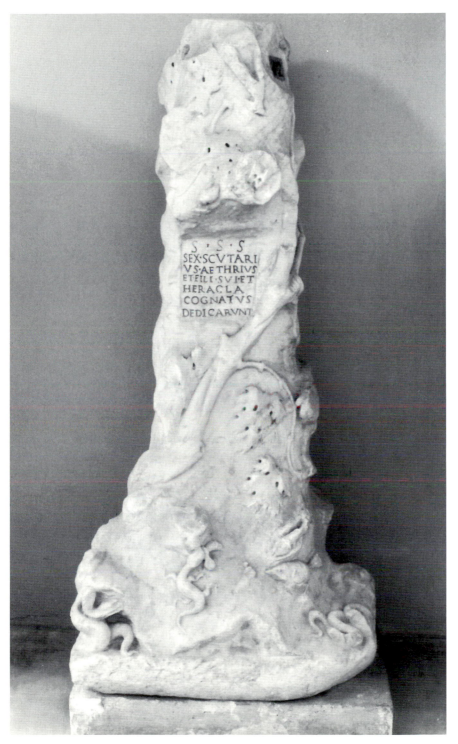

S · S · S
SEX·SCVTARI
VS·AE THRIVS
ET FILI·SVI·ET
HERACLA
COGNATVS
DEDICARVNT.

81a. Marble votive sculpture of Sextus Scutarius and his family, Museo Chiaramonti, Vatican: a. View of whole monument.

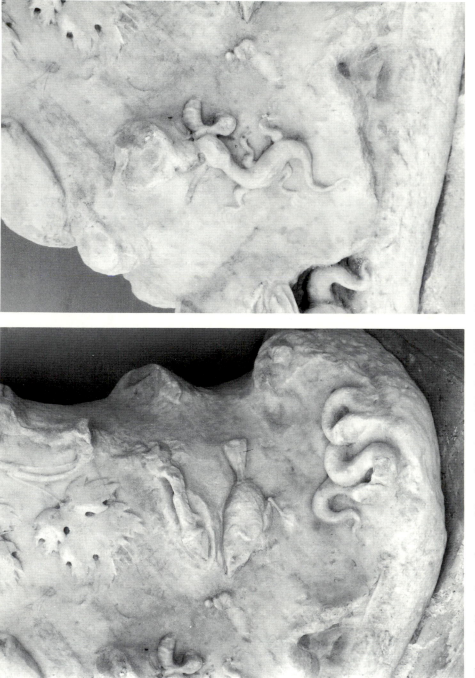

81b.–c. Marble votive sculpture of Sextus Scutarius and his family, Museo Chiaramonti, Vatican, details: b. (left) Bird, snake, and insect. c. (right) Lizard and insect.

83. Marble pilaster with animals and Dionysian trappings in vines, Villa Adriana, Lapidario, Tivoli, details: a. (left) Lizard, mouse, mask, and timbrels. b. (right) Bird and *cista mystica*.

82. Marble pilaster with animals amidst vines, Museo Chiaramonti, Vatican.

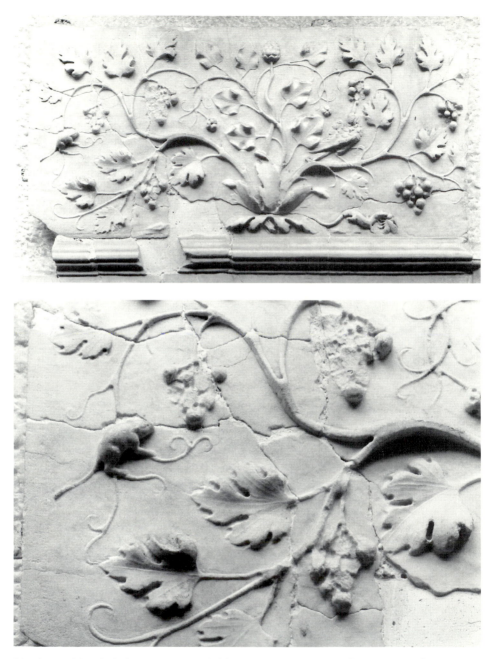

84a.–b. Marble reliefs from a tomb, probably outside Rome, Museo Gregoriano Profano, Vatican, details: a. (top) View of ivy and grapevine. b. (bottom) Mouse.

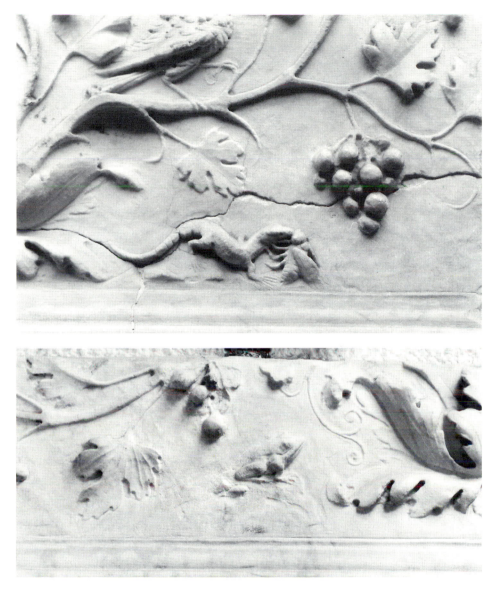

84c.–d. Marble reliefs from a tomb, probably outside Rome, Museo Gregoriano Profano, Vatican, details: c. (top) Lizard and insect. d. (bottom) Frog.

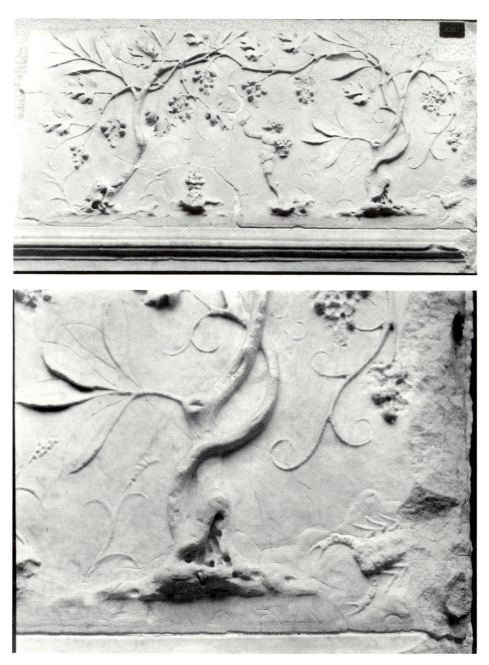

84e.–f. Marble reliefs from a tomb, probably outside Rome, Museo Gregoriano Profano, Vatican, details: e. (top) View of Priapos among vines. f. (bottom) Scorpion.

85a.–b. Wall paintings from the "Room of the Masks" in the House of Augustus on the Palatine, Rome, details: a. (left) South wall. b. (right) West wall.

85c.–d. Wall paintings from the "Room of the Masks" in the House of Augustus on the Palatine, Rome, details: c. (top) West wall, mask. d. (bottom) South wall, tympanon.

85e. Wall paintings from the "Room of the Masks" in the House of Augustus on the Palatine, Rome, details: e. West wall, swans.

86. Wall painting from the right *ala* in the "House of Livia" on the Palatine, Rome.

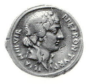

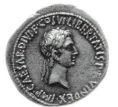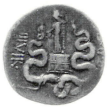

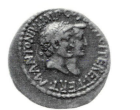

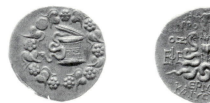

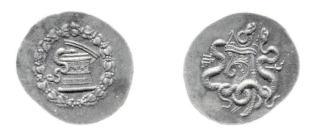

87. Coins (obverse left, reverse right): a.–b. (first row) Denarii issued by Petronius Turpilianus, 18 B.C. c. (second row) Augustan Cistophorus, 28 B.C. d. (third row) Cistophorus of Antony, 39 B.C. e. (fourth row) Proconsular Cistophorus, Ephesos, 58–57 B.C. f. (fifth row) Cistophorus, Pergamon, second century B.C.

88a. Drawing of embroidered textile from the Pavlovsky Kurgan in the Crimea, Hermitage Museum, St. Petersburg.

88b. Unrolled drawing of tendril ornament on gilt silver amphora from Chertomlyk, Hermitage, St. Petersburg.

88c. Gilt silver amphora from Chertomlyk, Hermitage, St. Petersburg.

89a. Drawing of tendril ornament on gypsum cast or mold from Mit Rahine near Memphis, Pelizaeus-Museum, Hildesheim.

89b. Unrolled drawing of tendril ornament on Apulian hydria, circle of the Lycurgus Painter, Museo Archeologico Nazionale, Naples.

89c. Drawing of the north floral frieze of the Ara Pacis with the vegetal detail partially eliminated to reveal the tendril matrix.

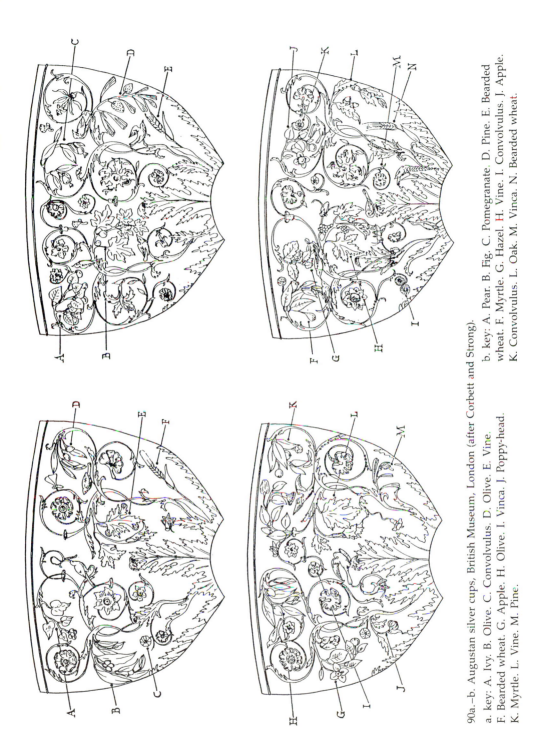

90a.–b. Augustan silver cups, British Museum, London (after Corbett and Strong).

a. key: A. Ivy. B. Olive. C. Convolvulus. D. Olive. E. Vine. F. Bearded wheat. G. Apple. H. Olive. I. Vinca. J. Poppy-head. K. Myrtle. L. Vine. M. Pine.

b. key: A. Pear. B. Fig. C. Pomegranate. D. Pine. E. Bearded wheat. F. Myrtle. G. Hazel. H. Vine. I. Convolvulus. J. Apple. K. Convolvulus. L. Oak. M. Vinca. N. Bearded wheat.

91a. Botanical Appendix: a. Rose.

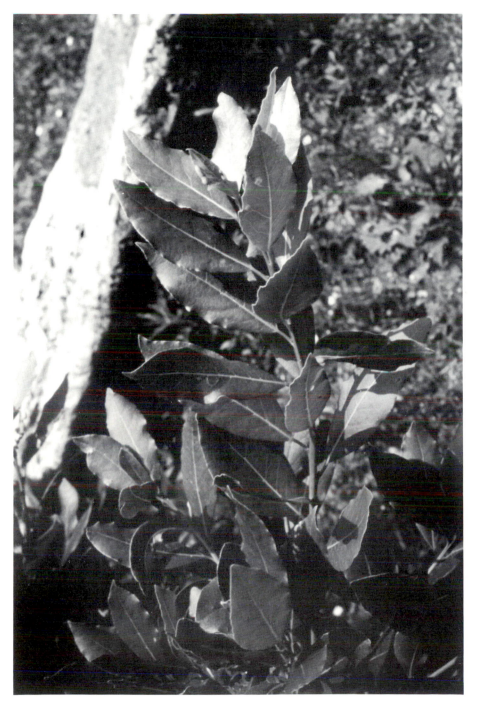

91b. Botanical Appendix: b. Laurel.

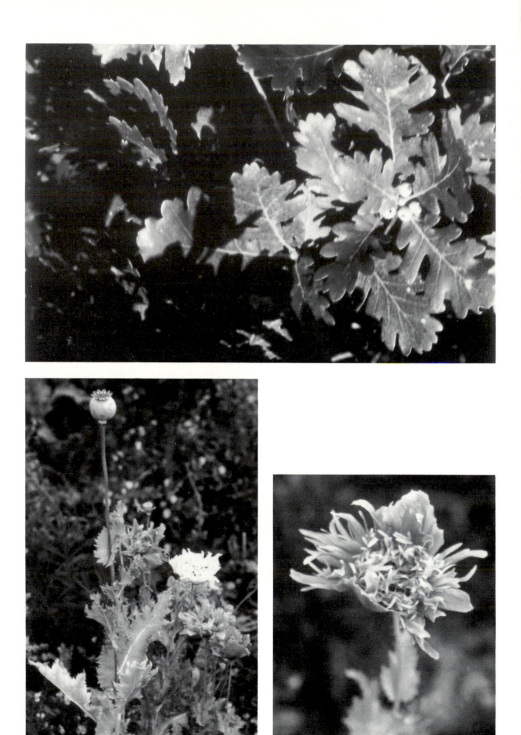

91c.–e. Botanical Appendix: c. (top) Oak. d.–e. (bottom) Poppy.